Foreword

WITHDRAWN

THE FASHION DESIGN DIRECTORY

An A–Z of the World's Most Influential Designers and Labels

Marnie Fogg

Thames & Hudson

First published in the United Kingdom in 2011 by
Thames & Hudson Ltd, 181A High Holborn,
London WC1V 7QX

© 2011 Quintessence

This book was designed and produced by
Quintessence
226 City Road
London EC1V 2TT

Project Manager	Kelly Thompson
Editors	Catherine Hooper, Becky Gee
Designer	Nicole Kuderer
Design Assistant	Alison Hau
Picture Research	Jo Walton, Helena Baser, Olivia Young
Production Manager	Anna Pauletti
Editorial Director	Jane Laing
Publisher	Tristan de Lancey

British Library Cataloguing-in-Publication Data
A catalogue record for this book is available from the British Library

ISBN 978-0-500-28948-8

Printed in China

To find out about all our publications, please visit **www.thamesandhudson.com**. There you can subscribe to our e-newsletter, browse or download our current catalogue, and buy any titles that are in print.

CONTENTS

FOREWORD

The extraordinary and diverse creative activity of 125 internationally known designers is recognized in this book, which includes the history of iconic and influential labels such as Balenciaga and Chanel as well as contemporary practitioners. With the constant regeneration of couture houses by the introduction of fresh new talent all, however, continue to make their mark in the 21st century. Fashion is by its nature subject to change. When I launched my own label in 2003, colour and print were very much peripheral to mainstream fashion. Now they are pivotal.

Change in fashion is given momentum by many things, including the introduction of new technologies, but for me and many other designers the creative process is rooted in fine art – certain things can only be done by hand. Combining this with the demands of manufacture and marketing is what provides the challenge to the contemporary designer. All of those featured in this book have successfully navigated their way through the fashion system from early beginnings, whether as a graduate or through the industry, to establish a business. A profile of each of these designers is illustrated with historically important images of iconic fashionable dress from past and present collections, providing a comprehensive guide to the key personalities and major participants of this significant and important global industry.

JONATHAN SAUNDERS, London

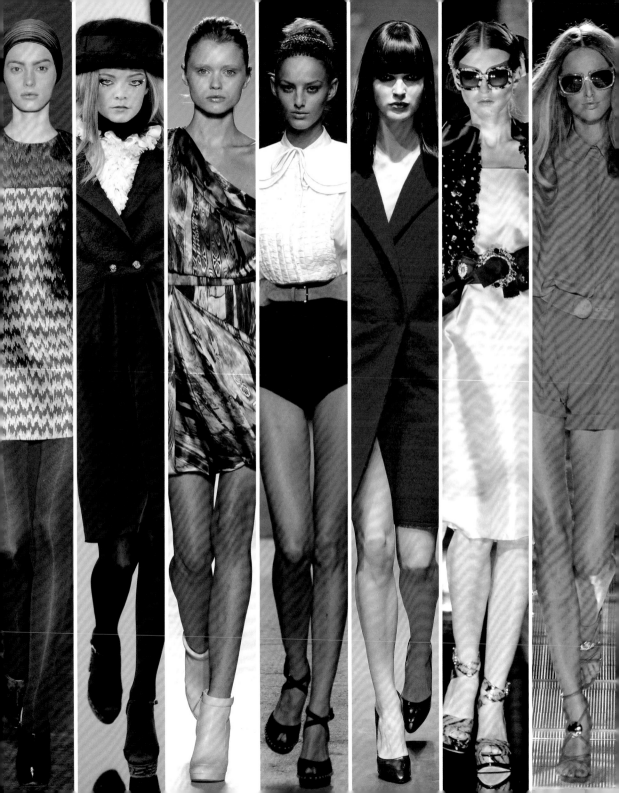

A BRIEF HISTORY OF FASHION

Placing individual fashion designers within a cultural and historical context requires a definition of the term 'fashion'. Paris has been at the centre of fashion since the 19th century, when Charles Frederick Worth (1826–95) transformed dressmaking from a craft into a business. Worth demanded that clients travel to the couturier to choose from a series of designs that were then made to measure, requiring several fittings for a perfect fit, rather than women dictating their requirements to the dressmaker in their own home. Haute couture (literally, high-quality sewing) refers only to this bespoke process. Worth also displayed new lines on mannequins in a series of parties and events, the precursor of the fashion show.

To qualify as haute couture, a garment must be entirely handmade by one of the eleven Paris couture houses currently registered to the Chambre Syndicale de la Haute Couture. Each house must employ at least twenty people in workshops in Paris and show a minimum of seventy-five new designs a year. The couture garment is as exquisite on the inside as the outside, and every seam is perfectly calibrated to fit the client's body, from the first toile (the design cut from a type of muslin for fitting purposes) to the final piece.

Couture on the catwalk presents an extreme view that cannot be replicated by ready-to-wear mass manufacturers. The 'Fédération Française de la Couture, du Prêt-à-Porter des Couturiers et des

► **A lavish frou-frou dress displays the S-shaped corset typical of the belle époque.**

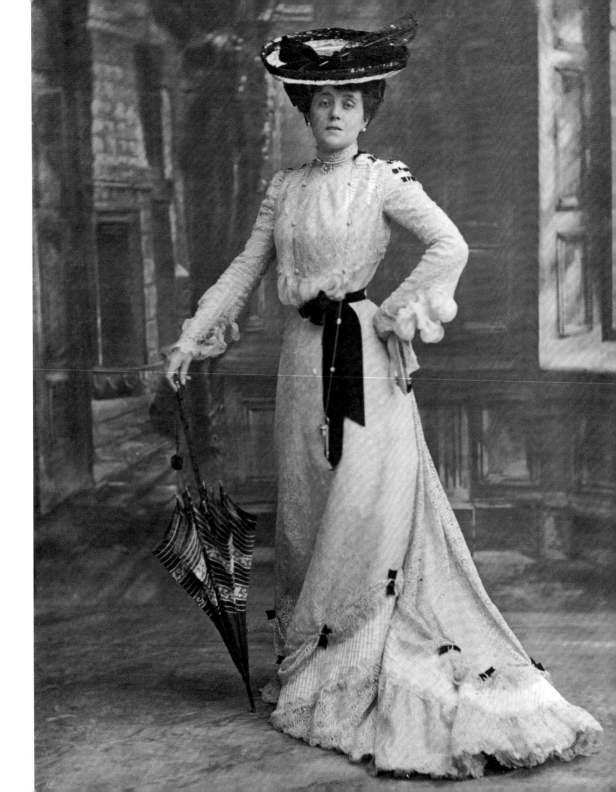

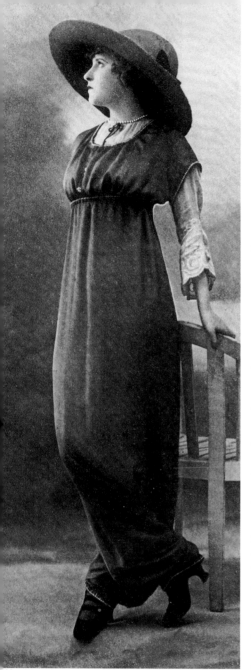

▲ Paul Poiret introduced avant-garde styles into society, as seen with this divided skirt, 1911.

Créateurs de Mode' embraces this distinction by listing a further ninety-two international design houses that are members outside the haute couture category. Haute couture itself is fuelled by the traditional skills of the artisans in the atelier, the name given to the workshop or studio where the couturier's vision is interpreted by the embroiderers, plumassiers, beaders, braid makers, knitters, print designers and practitioners, corsetières, weavers and leather workers – all skilled craftspeople whose trades are impossible to make available for the mass market.

The painstaking process of couture fittings for the frou-frou and lace of the first decade of the 20th century was replaced by the colourful exoticism of Parisian couturier Paul Poiret (1879–1944). Influenced by the extravagant colours and allure of the Ballets Russes, Poiret deployed richly embellished fabrics and exuberant jewelled turbans for his influential Directoire line of 1908, which discarded the corset in favour of a tubular silhouette. The orientalist spectacle of the ballet – particularly *Scheherazade* (1910) under the directorship of Serge Diaghilev and with costumes and set designs by Léon Bakst – radically altered the Western world's aesthetic values. Almost overnight, the corseted bustled silhouette disappeared, and the straight line replaced the voluptuous curves of women's dress. However, women were literally shackled by the introduction of Poiret's hobble skirt, which prevented the wearer from walking in any but the smallest of steps.

It was to take the genius of Gabrielle 'Coco' Chanel (1883–1971; see p.86) to release women from the constraints of early 20th-century fashion and make it relevant to the modern age. Chanel, through her association with the English 'Boy' Capel, discovered a passion for sportswear. With his help, she launched herself as a dressmaker and developed a simplicity of style that subverted the idea of fashion as display. She claimed in 1914 that she was 'in attendance at the death of luxury', a comment on the end of the belle époque and the true beginning of the new century. Adopting a single-jersey knitted fabric, previously used for men's underwear, Chanel designed the three-piece cardigan suit – an edge-to-edge jacket, a pullover and a knee-length skirt – which became a mainstay of women's wardrobes. The simple elegant lines of the clothes responded to the new interest in sporting activities and the post-war

cult of the body. Garments no longer required lengthy fittings or upkeep in an era when domestic staff were no longer available.

After World War I, a seismic shift in all aspects of life took place, discarding the discredited attitudes, hierarchies and prejudices of the pre-war world. Manifestos of cultural revolution appeared, the arts influenced fashion and the avant-garde became mainstream. The applied arts flourished in the late 19th century and the first decades of the 20th century. The Wiener Werkstätte (Vienna Workshops enterprise) of 1903 to 1932 was a huge influence on surface pattern design during this period. With its roots in the Arts and Crafts Movement, the studio progressed from producing exclusive furnishing fabrics to gradually introducing fashion fabrics. These then became increasingly available with the invention of the silk-screen printing process in 1907, providing the market with the first fashion fabrics in bulk. Printed pattern is inextricably linked to bohemian dress, which was worn by avant-garde artists, freethinkers and writers during the earlier decades of the 20th century, and associated with artistic and sexual freedoms. Flowing robes from eclectic sources, such as those from London store Liberty (see p.188), came to represent an alternative to mainstream fashion and have remained a constant theme throughout fashion history, from the Bloomsbury Group of the 1920s in London to the hippie fashions of the 1960s.

As hemlines rose and necklines dropped, the waistline disappeared altogether, resulting in the fashionable garçonne look of the mid 1920s. The minimalist style of modernism, a movement that rejected the use of decoration, was evidenced in Chanel's 'little black dress' of 1926, and in the streamlined fashions of Parisian couturiers Jean Patou (1880–1936) and Jeanne Lanvin (1847–1946; see p.184). The radically simpler clothes of the 1920s offered women a greater freedom of movement, in spite of the rubber 'flatteners' worn to suppress the bosom beneath the chemise. The chemise was a straight low-waisted dress that hung from the shoulder and grew ever shorter as the decade progressed, rising to just above the knee in 1927. The newly tanned and exercised body fresh from the tennis court or ski slope embraced this new near-nudity. The modern movement demanded the pursuit of the perfect form and this included not only streamlining products, such as automobiles and architecture, but also women's bodies. The loose flowing lines of the chemise appealed to

▼ **Stage star Adele Astaire models the understated 'little black dress' in 1928.**

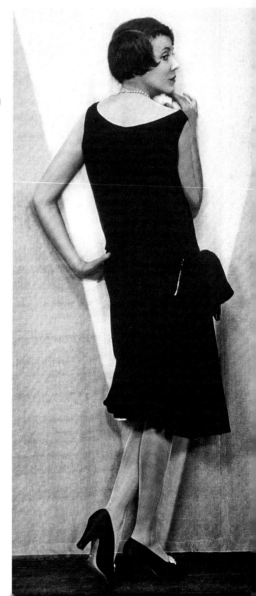

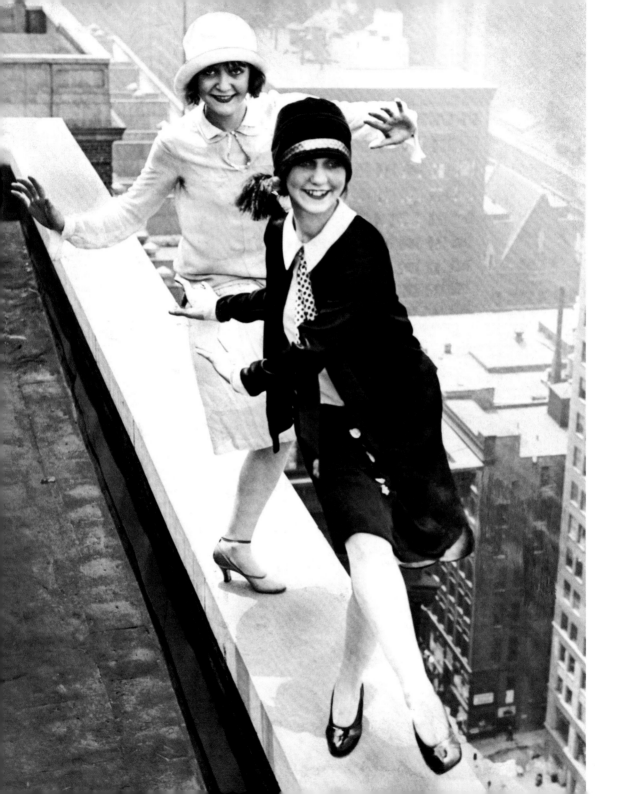

◄ **Free-spirited flappers dance the 'turkey trot' on the edge of a Chicago roof in 1926.**

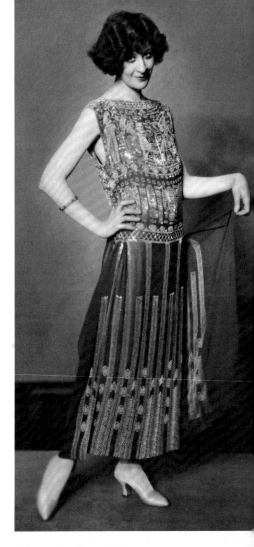

the 'flapper' – a notoriously precocious young woman who flouted the conventional dress and behaviour of the day, used cosmetics, smoked cigarettes, rouged her kneecaps and was epitomized by the heroine Iris Storm in Michael Arlen's novel *The Green Hat* (1924).

Androgynous silhouettes and greater freedom of movement resulted in the demise of the great Parisian couturiers such as Baron Christoff von Drecoll and Jacques Doucet (1853–1929), and even Poiret found himself out of step with the developing aesthetic of the time. Couture was now evolving from serving a few wealthy clients into an industry. Recognizing its commercial potential, Patou travelled to New York in 1925 and hired six women to return to Paris with him and work as mannequins. This well-publicized action brought couture to the attention of the US fashion-conscious elite.

Decoration and embellishment during this period reflected the shapes of art deco, with stepped forms, sunray motifs and zigzags translated into embroidery, beadwork or appliqué. Art deco began in Europe in the early years of the 20th century, although it was not universally popular until the 1925 Exposition Internationale des Arts Décoratifs et Industriels Modernes (International Exposition of Modern Industrial and Decorative Art) in Paris. It was a confluence of many trends: the arts of Africa, Egypt and Mexico, and the streamlined technology of the 'speed age', including modern aviation and the growing ubiquity of the motor car. The discovery of Tutankhamun's tomb in 1922 added to the designer vocabulary of the era. Widespread press coverage of this event, including newsreel footage of archaeological digs and reports that included Howard Carter's remark that he could see 'marvellous things' on peering into the tomb, heralded an obsession with all things Egyptian, from scarabs, snakes and pyramids to hieroglyphs and sphinxes – a craze that endured well into the 1930s.

The machine age brought with it innovation and new materials. It was inevitable that these would infiltrate fashion from their architectural or product design origins. Plastics were one of the most significant cultural phenomena of the 20th century, changing the way objects were produced, designed and used. Their chief property was their ability to be moulded or shaped into different forms under pressure or heat. The revolutionary injection-moulding process was used to produce handbags, buttons and brooches.

▲ **Comedian Fanny Brice models a tubular dress embellished with art deco patterning in 1925.**

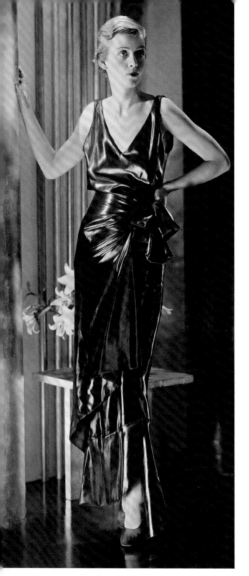

▲ **A draped 1930 décolleté dress in cire satin by Schiaparelli epitomizes screen siren glamour.**

► **Summer dresses from 1946 by Claire McCardell, pioneer of American sportswear.**

Jean Patou dropped the hemline and raised the waistline in 1929, a sudden and dramatic change in shape, and Coco Chanel quickly followed his lead. The 'bright young things' of the previous decade disappeared from view, along with the shimmering short skirts and the wayward ways of the flappers. US designers followed suit, and Hollywood found itself with a backlog of films made before 'the fall', in which all the heroines were already *démodé* in their diminutive skirts. Not only the hemlines fell; so, too, did the Dow Jones Index. The consequence of the Wall Street Crash, together with the political uncertainty in Europe, brought a new sobriety to every aspect of cultural life, including fashion. Fortunes disappeared overnight. Harder times were reflected in the long, lean look; the youthful, sporty silhouette that had dominated the previous decade gave way to womanly curves accentuated by tailoring, which assumed a new importance. Exponent of the severely tailored suit, as well as witty creator of Dadaist-inspired concoctions such as the *trompe l'oeil* bow sweater, Elsa Schiaparelli (1890–1973) designed garments that challenged the wearer and combined the avant-garde with high-octane glamour. Born into a family of wealthy intellectuals, the designer was a close friend of the poets, philosophers and artists of the day, including Salvador Dalí, Man Ray and Pablo Picasso. Schiaparelli launched her first collection in 1929.

Hollywood experienced a 'Golden Age' when the stock market crashed. The cinema screen provided escapism, presenting glamorous stars such as Carole Lombard and Mae West wearing halter-neck evening dresses that revealed the line of the body, the result of a revolutionary new cutting technique. Parisian couturier Madeleine Vionnet (1876–1975) abandoned the traditional practice of tailoring body-fitted fashion and instead expertly manipulated the cloth to drape and cling to the body by aligning the straight grain of the cloth to a piece cut on the bias. (The grain is defined by the warp and weft intersection of the woven fabric.) Costume designer Gilbert Adrian (1903–59) appropriated this technique in the film *Dinner at Eight* (1933); his bias-cut backless dress for blonde bombshell Jean Harlow introduced Parisian couture to the mass market and brought the white silk and satin of the boudoir into mainstream fashion. Chief designer at Metro-Goldwyn-Mayer from the mid 1920s to 1941, Adrian left the movie industry to open his own fashion outlet

in Los Angeles, showing both ready-to-wear and bespoke clothes. His deployment of geometric woven fabrics in tailored suits and understated draped evening wear was instrumental in Hollywood replacing Paris as the arbiter of fashionable style.

A new wave of romanticism heralded the end of the 1930s. Queen Elizabeth II's crinolines, designed by court dressmaker Norman Hartnell (1901–79) for her state visit to Paris in 1938, and the costumes worn in films such as *Gone With the Wind* (1939) indicated a return to feminine fashion. However, the outbreak of World War II had a profound impact on fashionable dress. The conscription of women in Europe and the United States made military uniform a familiar daily sight on the streets, and even civilian daywear retained the practical features of clothes worn by the armed services. The upturned triangle of the silhouette was formed by the short fitted tailored jacket, which had a squared-off shoulder line and narrow revers, partnered with a straight skirt to just below the knee, with a pleat at the back for ease of movement. The British Board of Trade issued a Civilian Clothing Order in 1942 forbidding the use of any extraneous detailing, as did the American War Production Board with its Regulation L-85.

The fashion industry in the United States evolved very differently from that of France. Without the tradition of the atelier, and with the interruption of the occupation of Paris by the Nazis in the 1940s, US fashion developed its own style: 'American sportswear'. This was fuelled by the creative genius of home-grown designers such as Claire McCardell (1905–58) and Norman Norell (1900–72), both of whom had worked for fashion entrepreneur Hattie Carnegie (1889 –1956), the originator of the term 'spectator sportswear'. Different from active sportswear, these practical clothes – constructed from innovative materials and with creative cutting techniques – placed ready-to-wear at the forefront of fashion, a manufacturing model that the European fashion industry would be eager to imitate once the war was over. With Parisian couture now dormant – although Lucien Lelong (1889–1958) remained as president of the Chambre Syndicale de la Couture Parisienne from 1937 to 1946 – the opportunity arose for US designers to fill the gap for luxurious fashion. Specializing in simple, conservative, elegant and extremely expensive clothes, Mainbocher (he elided his name from Main Rousseau Bocher; 1891–1976) was the first US designer to open

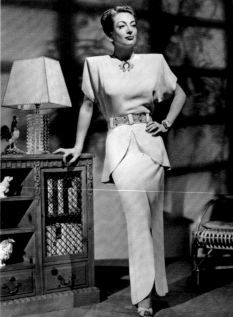

▼ **The assertive tailoring of Adrian, modelled in 1946 by film actress Joan Crawford.**

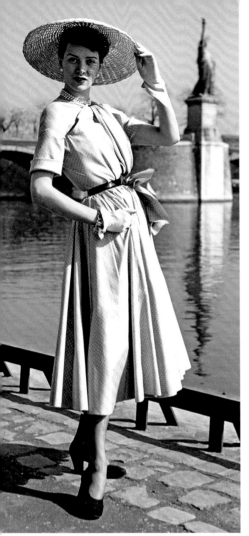

▲ **A full-skirted day dress from Dior, an informal version of the post-war New Look, 1948.**

a dressmaking establishment in Paris in 1930, returning to the United States at the onset of World War II. Equally luxurious, yet considered works of art rather than wearable fashion, were the designs of foremost US designer Charles James (1906–78), who established his own business in New York in 1945. Diametrically opposed to the American sportswear ethos, his complex and highly engineered garments were typified by the Four-leaf Clover gown of 1953, made from ivory duchesse satin with a rigid infrastructure.

Although peace had been declared, food and clothes rationing was still in place when Parisian couturier Christian Dior (1905–57; see p.92), financially supported by textile magnate Marcel Boussac, presented his Corolle line of 1947. Dubbed the 'New Look' by Mrs Carmel Snow of *Harper's Bazaar*, the collection was not only reported in the fashion press, but was also considered newsworthy on a wider level. Until his untimely death ten years later, Dior repeatedly changed the fashion silhouette, ensuring columns of print coverage and sustaining continued press interest in his role as fashion arbiter. As he wrote in his autobiography *Dior By Dior* (1957), 'In the world today, haute couture is one of the last repositories of the marvellous … high fashion need not be directly accessible to everyone: it is only necessary that it should exist in the world for its influence to be felt.'

In defiance of post-war rationing, Dior's New Look portrayed a nostalgic form of femininity and was a celebration of luxury. Huge, crinoline, calf-length skirts were supported by layers of stiffened petticoats, and the 'waist cinches' or 'waspies' marked the return of the hourglass figure. The padding that formerly resided in the shoulders, Dior moved to the hips. The internal infrastructure of the garments resulted in an exaggeratedly female silhouette, perceived by some critics as representative of a reactionary and idealized form of femininity, more suited to a life of leisure than the workplace.

The New Look was enormously influential and spearheaded the revival of Paris as the centre of fashion. In the United States, the New Look segued into the Sweetheart line, supplied most famously by costume designers Edith Head (1897–1981) for Elizabeth Taylor and Helen Rose (1904–85) for Grace Kelly. The heart-shaped bodice, corseted waist and full skirt became a fashion staple and formed the basic shape of the dress worn on the all-important prom night, with cotton versions appearing as daywear in the form of the shirtwaist dress.

As the decade progressed, the silhouette became less extreme and clothing became less contoured to the body. Chanel reopened her house in 1954. In opposition to the structured clothes of Dior, whom Chanel viewed with limited respect, she offered her relaxed pared-down aesthetic of wearable suits that had been so successful before the war. The simple construction and shape of these suits made them easy for manufacturers to copy, and although the fabrics and detailing were inferior to the bespoke garments, they provided an affordable elegance for the consumer. In 1957, couturier Cristóbal Balenciaga (1895–1972; see p.56) produced the sack dress, a forerunner of the simple shifts that were to appear during the next decade, and in 1958 women were further freed from the tyrannical waspie and corset with the introduction of the chemise dress.

The high fashion of the 1950s, which celebrated the elegant grown-up woman, with the emphasis on grooming and a ladylike demeanour, was overturned with the advent of 1960s youth culture. However, the first stirrings of change had begun in 1955, when Mary Quant (1934–) opened the clothing shop Bazaar on London's King's Road. Scaling up children's clothes – knee socks and pinafore dresses – and oversized rugby shirts worn as dresses, and employing a colour palette of mustard, purple and ginger, Quant offered a fresh, youthful look for the post-war baby boomers (born in 1946–47), who were eager to participate in the social and sexual revolution.

At the same time, Hollywood film stars such as Marlon Brando and James Dean were redefining masculinity, providing a brooding presence in such films as *The Wild One* (1953) and *Rebel Without a Cause* (1955). These icons of the silver screen replaced the double-breasted business suit of their fathers with a white T-shirt, leather jacket and denim jeans. Initially an item of durable rural workwear, first manufactured by Levi Strauss in the 19th century, jeans came to stand for youthful rebellion to a generation of beatniks, teenage misfits and, subsequently, hippies.

The womanly curves of the hourglass figure were over, and only the 'blissful girls and crazy dollies' – as popular British periodical *Petticoat* called them – could wear the skimpy futuristic fashions of the 1960s. Unlike the carapace of Dior's New Look, these clothes did not force the body to assume an unnatural shape. As hemlines rose ever higher in the mid 1960s, the chemise dress evolved. The high-waisted empire

▼ **Gamine models in miniskirts and knee-boots in front of the Quant daisy logo, 1967.**

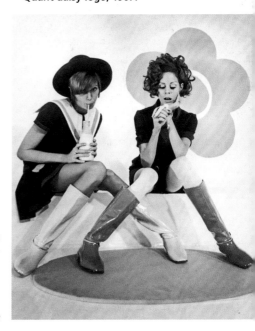

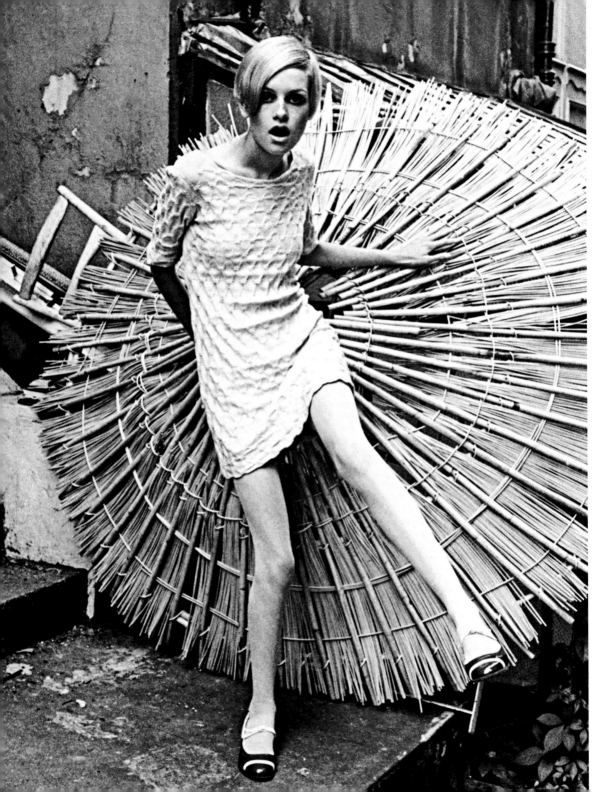

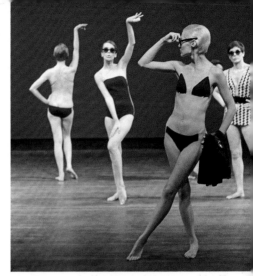

line allowed for the horizontal line of the hips to be accentuated, often with a wide buckled belt but more frequently with the insertion of a panel of a different fabric, which was occasionally transparent.

Elements of nudity were becoming acceptable. With a reputation as the most radical of US designers, Rudi Gernreich (1922–85) was renowned for liberating the body from the limitations of clothing. His experiments with undress culminated in the topless bathing suit of 1967, modelled by his inspiration and muse, the model Peggy Moffitt. Gernreich was also responsible for developing the concept of unisex interchangeable clothes for men and women, such as floor-length kaftans and bell-bottom trousers.

Tights or pantyhose replaced the need for stockings and suspenders, and allowed for greater elevation of the hemline. This new freedom from the constraints of 1950s foundations – pointy bras and restricting girdles – was more to do with modernity than seduction. These new looks even infiltrated the then-ladylike pages of British *Vogue*, through the endeavours of Marit Allen, editor of the 'Young Ideas' section. Teenagers were finding a voice that was not only about skirt lengths, but rather a new social order, which included the democratization of fashion. Friends sold to friends in the boutiques that sprang up on the periphery of all the major cities, but most tellingly in London, where consumers no longer shopped in Bond Street but sought out the proliferation of new boutiques on the King's Road and Carnaby Street. The youth movement and the styles on the street during the 1960s changed the fashion hierarchy and challenged the haute couture system. A group of Parisian couturiers including Pierre Cardin (1922–; see p.246), André Courrèges (1923–), Emanuel Ungaro (1933–; see p.294) and Paco Rabanne (1934–) responded by introducing futuristic fashions that used the latest high-tech synthetic sports fabrics inspired by the first man in space, Russia's Yuri Gagarin. Cardin spearheaded the movement with his 'Space Age' collection in 1964, which included gaberdine tabards in bright colours with deep-set armholes and cut-out midriffs worn over skinny ribbed jumpers and tights. Courrèges produced his Moon Girl range: thigh-high mini-dresses that bypassed the curves of the body entirely, worn with astronaut helmets; bonnets that stood away from the contours of the head, outsize white sunglasses and mid-calf boots with a cut-out toe.

▲ **Swimwear from
iconoclast Rudi
Gernreich in 1968.**

▲ **Pierre Cardin mixes
architectural form
and fashion in 1969.**

▼ Definitive up-town
dressing with a streamlined
pyjama suit in polka dots
from Halston in 1974.

Haute couture was further undermined by the decision of the couturiers to introduce ready-to-wear. Yves Saint Laurent (1936–2008; see p.320), who opened his own prêt-a-porter house in 1962 – having previously headed Dior – launched Rive Gauche, and a series of boutiques that represented his distinct, Left Bank avant-garde formula. The European fashion industry was quick to adapt to the US business model of mass production, and by the middle of the 1960s ready-to-wear was a dominant component of the industry. It was produced in standard sizes and bought directly by the consumer from department stores or the designer's stand-alone boutiques. Couture fashion was no longer influential or even perceived as desirable. This situation was further exacerbated by the retirement of Balenciaga in 1967 and the death of Chanel in 1971.

During this period Parisian couture was also under pressure from the Italian designers showing in Milan, now replacing Rome as the centre of Italian fashion, and emerging as the fourth fashion capital, alongside Paris, London and New York. Iconic brands such as Fendi (see p.124), Gucci (see p.136) and Prada (see p.250) became well-established names between 1945 and 1965, a period known as the *ricostruzione* (reconstruction) in Italy, when the country began to develop a design industry that was to influence the world. The economic aid from the United States during this period encouraged these family firms to consolidate their design and manufacturing activities in an era of post-war regeneration and creativity. Italy is renowned for the quality of its textiles, from silk printing by companies such as Montano on the shores of Lake Como to the knitted textiles of Krizia and Missoni (see p.218). Giorgio Armani (1934–; see p.50), who began his label in 1975, deconstructed the male suit and brought Italian menswear to the forefront of international fashion, and in so doing led the Italian womenswear industry to aspire to – and in due course to attain – the same stature.

The style confusion of the 1970s – a combination of nostalgia, the 1940s revisited, the New Romantics, disco fever and punk – resolved itself at the end of the decade into a singular aesthetic: a contemporary version of American sportswear – practical fashion designed for the contemporary woman, epitomized by the modernist code of milliner and later designer Roy Halston (1932–90; see p.142). At the height of his success in the mid 1970s, Halston promulgated

a pared-down minimalism using luxurious fabrics in understated garments, particularly the shirtwaist dress. His direct heir, US designer Calvin Klein (1942–; see p.80), continued this tradition of ease and wearability in a neutral palette of taupe, beige, ivory, cream and grey, with the unique selling point that everything was available from a single visit to one designer.

While US ready-to-wear designers such as Klein and Diane von Furstenberg (1946–; see p.106) continued to produce flattering, practical fashion, Italian label Versace (see p.306) was clothing the glamazon – a woman who embodied a voluptuous predatory glamour. At the same time, Azzedine Alaïa (1940–; see p.54) sculpted the body with his body-con bandage dresses, and the United Kingdom's Vivienne Westwood (1941–; see p.314) was providing a bricolage of pattern and structure based in part on 18th-century tailoring and African prints for her 1981 collection 'Pirates'. During the 1980s, fashion crossed over from being a minority interest into a major preoccupation. In an era of so much disposable income, every major city became home to a plethora of architect-designed retail emporia – the destination of the yuppie, the young urban professional.

Throughout the decades of punk, power dressing and minimalism, and the promulgation of the avant-garde, haute couture continued to be considered irrelevant and out of date, with an ageing demographic. This situation changed when German-born Karl Lagerfeld (1938–; see p.182) was invited to become artistic director of the house of Chanel in 1983. He rejuvenated the label and increased its appeal to a younger, edgier clientele, a significant contribution being the sexing up of the original Chanel 2.55 'gilt & quilt' bag and his deconstruction of the signature two-piece tweed suit.

Couture was now having to evolve from being the provider of bespoke clothing into mass production (albeit on an elevated level) of branded items, in response to the increasing domination in fashion of the global corporate behemoths. The world's largest luxury conglomerate was founded in 1987 with the merger between Moët Hennessy and Louis Vuitton: LVMH (see p.190). This brought together the champagne, spirits and luxury leather goods divisions, some of which had been established more than two centuries previously. Subsequent mergers have resulted in a fashion and accessories industry that is now dominated by two huge multinational concerns.

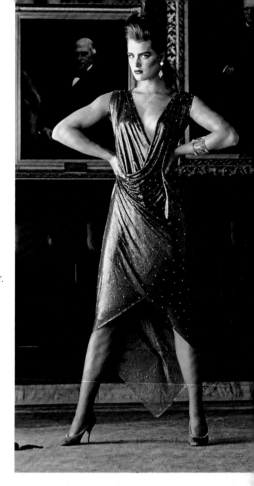

▲ **The glamazon: a gym-honed Brooke Shields, stage and screen actor, wears Versace in 1983.**

The first, LVMH, includes the fashion labels Céline (see p.84), Donna Karan (see p.114), Fendi, Givenchy (see p.132), Loewe, Marc Jacobs (see p.196) and Pucci (see p.260), and a stake in Hermès (see p.146). Its rival for supremacy in the luxury market, the Gucci Group, has a whole or partial interest in Alexander McQueen (see p.38), Balenciaga, Bottega Veneta (see p.72), Stella McCartney (see p.284) and Yves Saint Laurent.

No single trend encompasses the whole fashion story at one time, although of the multifarious strands in the fashion spectrum the work of one couturier, designer or trend may prove more dominant than others in the fashion press. This may represent a turning point, a reaction to what has gone before, or even an iconoclastic moment, as was the case with grunge fashion signifying the end of the ostentatious 1980s. Associated with the Seattle youth culture and bands such as Nirvana and Pearl Jam, it was a street style comprising oversized checked flannel shirts, distressed denim and vintage floral cotton dresses worn with heavy boots. Although short-lived and commercially unsuccessful, grunge was commoditized by US designers Marc Jacobs (1963–) for label Perry Ellis, and Anna Sui (1964–; see p.44) in 1991. It also fuelled the desire for a new realism in fashion recorded by photographers Corinne Day and Juergen Teller, and started the career of fashion supermodel and influential style icon Kate Moss. 'Heroine chic', as it was labelled, inevitably succumbed to the need for aspirational fashion, exemplified in the 1990s by Tom Ford (1961–) at Gucci, the most covetable label of the decade. During this period, haute couture achieved a new relevance with the appointment of John Galliano (1960–; see p.172), first at Givenchy and then at Christian Dior, paving the way for similar attempts by the couture industry to rejuvenate its labels by employing younger, more cutting-edge designers.

Although sales are increasing in number, with a contemporary customer base comprising the wives of the Russian oligarchs and new super-rich from China, couture is still a loss-leader. The value to the label lies in the publicity engendered by the spectacular twice-yearly fashion shows and the concomitant global press attention and associative glamour. These endorse and underpin the true moneymakers: the cosmetic ranges and accessories of the label, particularly the 'must-have' handbag. Luxury fashion houses no

▼ A barely there black lace dress, with plunging décolleté and abbreviated skirt represents the knowing, overt sexuality of the Gucci label during the 1990s.

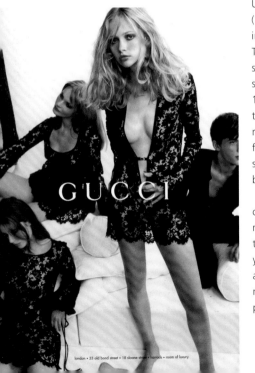

GUCCI

london · 33 old bond street · 18 sloane street · harrods · room of luxury

longer offer only bespoke clothing, but are now also in the business of mass-producing diverse products that provide widespread label recognition and impart to the consumer – by the purchase of a scarf, a lipstick or a bottle of scent – some of the label's mystique. These products are vital to the commercial validity of the brand, the revenue from which is powered by lucrative licensing deals.

The branding of products has existed since the inception of mass manufacturing in the 19th century. It was a marketing system that replaced anonymous commodities with universally recognized products identified by their trademarks, logos and packaging, and which, in the fashion industry, came to include the more elusive quality of an easily identified aesthetic. Branding is the means by which fashion is propelled into the marketplace so that it becomes both an accessible and a covetable commodity. It brings with it associations that are carefully configured by strategists to appeal to a very particular consumer, one that aspires to the immediately identifiable and singular cachet of the label.

Globalization in the 1980s rendered branding a tangible asset. Luxury fashion houses such as Gucci and Prada, and designers such as Paul Smith (1946–; see p.240) and Donna Karan (1948–) eagerly extended the arc of their brands to encompass the design and development of accessories, fragrances, cosmetics and lifestyle products such as furniture, soft furnishings, paint and fabrics. Vital to the continuing success of a label, however, is the protection of the brand from untoward associations. Unwise licensing deals that may prove commercially viable at the start can ultimately damage and undermine the reputation of a label. Pierre Cardin (see p.246) is an example of this. In the 1960s and early 1970s, the name Cardin stood for cutting-edge fashion. However, following a series of worldwide licensing deals, the brand became devalued as increasing amounts of merchandise over which the designer had no direct control began to appear on the market. The subsequent deterioration in quality of design and manufacture eroded the magical exclusivity engendered by a big name. Brands are now aware of the problem and therefore deploy the restructuring process known as 'verticalization' – taking over the means of production in order to keep a tighter rein on their global image and to uphold the quality of the product.

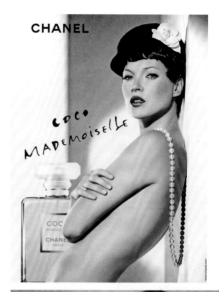

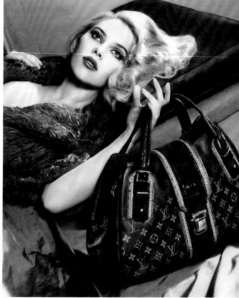

▲ Hallmark Chanel pearls
▲ and white camellia in a
2005 perfume advertisement.

▲ Instant identification with
the LV logo in this 2007
Louis Vuitton advert.

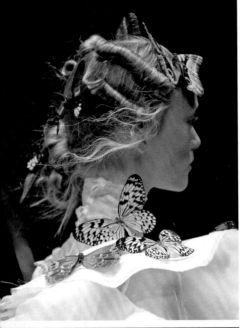

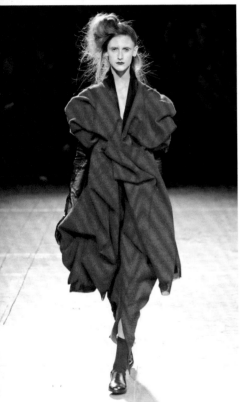

◄ **Dishevelled fragile beauty by Alexander McQueen in 2006.**

Couture fashion is continually challenged by the work of avant-garde designers. Since the 1960s, British art schools have provided the point of encounter between fashion, street culture and music, in a unique educational experience that crosses disciplines between the graphic, plastic and performing arts. The graduate fashion shows of London's Central Saint Martins College of Art & Design, whose alumni include Alexander McQueen (1969–2010), Hussein Chalayan (1970–; see p.154), John Galliano, Matthew Williamson (1971–; see p.210) and Stella McCartney (1971–), are attended by the world's press and fashion representatives keen to recruit new talent. In a saturated global market, companies such as Gucci have to keep expanding, and recruiting new talent is the chief way to ensure that the label remains 'relevant'.

Radical fashion is implicitly a phenomenon that challenges preconceptions, and nowhere is this more evident than in the austere and intellectual clothes of Japanese designers Rei Kawakubo (1942–) of Comme des Garçons (see p.102), Issey Miyake (1938–; see p.158) and Yohji Yamamoto (1943–; see p.318). First shown on the Paris catwalks in 1983, the clothes challenged the concept of fashion with experimental cutting techniques and distressed surfaces in an era accustomed to lavish excess and seductive fashion. Dubbed 'Hiroshima chic' by US journalists, the clothes remained marginal to mainstream fashion until the more minimalistic and monochrome era of the late 1980s and 1990s.

Creativity is a deeply mysterious process. The wellspring of ideas may be purely cerebral, to do with concepts that preoccupy the designer, or may be fuelled by external sources – a fleeting image, a painting in an exhibition or historical dress, not to mention the relentless referencing of previous decades. The tireless appropriation of once-defunct houses in an attempt by investors to trade in on the labels' past successes is common practice. Halston, Ossie Clark (1942–96) and even the immutable Vionnet are grist to fashion's commercial mill.

The designer's art is to transmute such ephemera into fashion that, beyond all else, people want to wear, for many complex and conflicting reasons: because it makes them feel beautiful; look remarkable, exceptional, rich, different, the same. Timing is all. Jean-Jacques Picart, a veteran of fashion PR and co-founder of the

Lacroix house, once remarked to the couturier, 'Fashion is like a banana. When it is green, it is not good. And when it is black, it is not good. But too early is worse than too late. The skill is to be there at the right time.' Not only the right time, but also with the right garment and seen worn by the right person. Fashion is predominantly aspirational. How many sales are predicated on the choice of the Hollywood stylist and star, a process that marries celebrity to style and results in millions of dollars of free publicity for the fashion house? Occasionally, the relationship between designer and muse can falter. The designer may be too closely associated with a certain personality, such that the public continues to stereotype the label when the actress/model has long been out of fashion.

Designers such as Jean Paul Gaultier (1952–; see p.164) are known as 'créateurs' rather than couturiers, and their designs are no less influential than, and often just as expensive as, the couture garments, even though they are shown in March and September at the prêt-à-porter shows. In recessionist times, there is a market for what is now defined by the fashion business as 'contemporary clothes', designer garments at more accessible prices, exemplified by labels such as Alexander Wang (see p.42) and Thakoon (see p.288).

Fashion and sport have frequently displayed a close correlation since the importance of physical exercise was recognized in the 1920s, when Jean Patou purveyed a range of tennis-inspired outfits and French tennis player René Lacoste placed an emblem of a crocodile on the left breast of his shirts in 1927 – an early example of branding. During the unprecedented financial prosperity of the 1980s, sport became commercialized. Global labels and big brands such as Adidas and Nike began to market sportswear with the same sophisticated marketing strategies as fashion. The emergence of urban sportswear respected the provenance of the design in performance and practicality, but also took into account the desirability of label exclusivity on the street. Allied to the increasing collaborations with contemporary designers such as Stella McCartney for Adidas and Hussein Chalayan for Puma, performance sportswear is now an integral element of mainstream fashion.

Marketing strategies and ways of selling have become increasingly radical as new technologies are harnessed by the modern fashion industry. Internet bimonthly clothing diaries disseminate products to

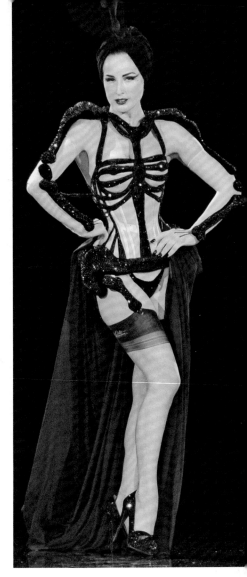

▲ An appropriation of the corset by Jean Paul Gaultier modelled by Dita von Teese in 2010.

◄ Yohji Yamamoto radically reappraises Western dress conventions with his singular aesthetic, 2008.

a particular audience. Fashion has never been as widely documented as it is now, with fashion bloggers becoming as influential as fashion editors since information no longer has to filter through the print media. Customers can buy items straight from the runway, by 3D live streaming, a process called 'Runway to Reality' first seen at the 2010 show for British label Burberry (see p.74). This method of reaching the core customer radically changes the existing system of buying and production, allowing the customer direct access to the catwalk and short-circuiting the preferences of the buyer. Select customers are invited to thirty or so stores around the world for a private screening of each season's show and, with iPad in hand, can place immediate orders. This instant feedback heightens the commercial success of the brand, enabling the company to know straightaway which items to put into production and which to discard.

Fashion is now less seasonal and more in demand then ever. No longer are there just two collections a year. The pre-collections, sometimes called resort or cruise lines, consist of more commercial pieces than those seen on the catwalk. The garments go into the stores to be viewed in private by favoured customers and are shown to just a small number of photographers and buyers. These lines often now narrow the gap between the autumn and spring seasons, and are also an opportunity for the label to test the water and experiment with themes without the financial risk of a major collection. Although not garnering the press coverage of the runway collections, these 'in-between' lines are increasingly being allocated larger amounts of the buyers' budgets.

The consequences of instantaneous global dissemination make it hard to differentiate between the one-season wonder, the two-year span of a new darling of the press, 'the next big thing' and the designer who will have a lasting impact. The 21st century is seeing a growing phenomenon of 'designer mobility'. When global brands bestride international cultural barriers, the validity of diversity in the origins of the designers – either by birth or education – increases. International alliances are growing in evidence. Since 2000, there have been many examples of successful transnational design initiatives: Yohji Yamamoto and Adidas, Uniqlo and Jil Sander (1943–; see p.170), Marios Schwab (1978–; see p.202) and Halston. The traffic in designers between fashion capitals, particularly bold young

creatives trained in internationally renowned and populated schools, is further indication of the evolving lingua franca of fashion, driven by the globalization of media, travel and production.

Haute couture is once more at the apex of modern fashion; what is seen on the catwalk influences current trends and the ready-to-wear market. Nicolas Ghesquière (1971–) at Balenciaga and Lucas Ossendrijver (1970–) at Lanvin have been driving forces behind change, the former redefining the contemporary silhouette and the latter changing the way men think about style. Longevity for a designer comes with commercial resilience, which is the outcome of creative resilience and the ability to dovetail a personal vision with a particular market. This is an art, a craft and a skill that should never be underestimated.

This book provides an extensive inventory of internationally recognized fashion brands and designers from the beginning of the 20th century to the present day. Organized alphabetically, it charts the history of each brand, including the influential looks, key collections and most iconic moments throughout their development.

▼ **Live streaming at the Burberry Prorsum show, London Fashion Week 2010.**

3.1 PHILLIP LIM

www.31philliplim.com

Restrained, urban and feminine, Phillip Lim's 3.1 label offers five clothing collections a year comprising easy-to-wear unassuming garments that feature unexpected details, such as hand-stitched lapels or appliquéd embellishments, more usually associated with high-end fashion.

Born in Thailand of Chinese parentage, Phillip Lim (1973–) was brought up in California. His mother was a dressmaker, a definition Lim applies to himself, evident in the accomplished tailoring of his garments. After attending California State University, Lim abandoned his studies to pursue a career in fashion, initially working in the Beverly Hills department store Barneys, where he came across the label Katayone Adeli. Working first as an intern and then as a design assistant with the company, Lim remained behind in Los Angeles when Adeli moved her business to New York. In 2000, Lim co-founded his first fashion label, Development, where he remained until 2004. In 2005, he launched 3.1 as a women's line with his business partner Wen Zhou, the number signifying their mutual age of thirty-one.

The label expanded to include menswear in 2007, providing well-tailored basics that generally incorporate an aspect of maritime uniform such as the pea coat. Lim creates pieces that offer value for money without sacrificing quality or style. In 2007, he won the Council of Fashion Designers of America's Swarovski Award for Emerging Talent in Womenswear. His first stand-alone store opened in New York's SoHo in 2007, with subsequent stores opening in Los Angeles, New York, Seoul and Tokyo.

◀ **A shell-pink trouser suit in a collection of subtle draped and gathered pieces for 2009.**

2008

A decorous collection for men and women of simple tailoring and luxurious fabrics.

A wrap skirt, with the fabric caught up on one hip and fanned out into a flourish of concertinaed pleats (a feature also used at the neckline of knee-length dresses), is worn with a top of horizontally pleated chiffon. Elsewhere in the autumn/ winter collection, Lim presents an oversized woman's white shirt, a style for which he is renowned, the smock top pleated from the neck. It is worn with black trousers and a black tasselled rope in place of a tie. The understated tailoring relies on richly figured brocades for effect, in shades of royal blue and silver.

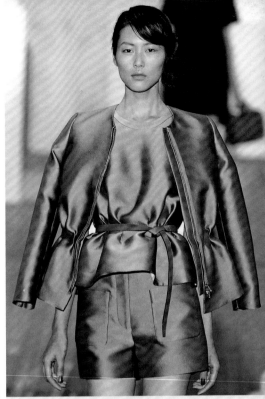

2007

A breakthrough collection of fresh separates for men and women.

A bib-fronted playsuit is rendered elegant by the layers of organdie on the blouse beneath, which has Lim's favourite Peter Pan collar shape. However, the hit of the collection is the piece Lim designed with Koi Suwannagate: a simple white T-shirt-style dress with three-quarter sleeves and decorated with clusters of hand-sculpted appliquéd rosettes, which secured Lim's status as New York's newest fashion star.

2011

Lim continues the tradition of US ready-to-wear, pioneered by Claire McCardell: easy-to-wear clothes with minimum decoration.

A jacket with gathered waist and set-in sleeves is bereft of embellishment and is partnered with an equally unadorned T-shirt caught in at the waist with a casually looped tan leather belt. They are worn over tailored shorts and are elevated out of the ordinary by the use of luxurious duchesse satin. Equally severe are cropped dresses in black – the only decoration a small collar in tan leather – and black satin tops worn with tailored trousers. Geometric layers – a striped shirt and a fine sweater with a skirt dissected with a black apron – form wearable outfits in tones of tan and taupe, with accents of saxe blue. Evening wear includes shift dresses in nude, constructed from solid rows of vertical sequins, with delicate black embroidery on the transparent sleeves.

ACNE

www.acnestudios.com

The über-cool Swedish giant brand Acne espouses directional simplicity while remaining resolutely anti-fashion and anti-seasonal trends. Initially established in 1996 as a creative consultancy to build brands in the fashion, entertainment and technology industries, the label stands for 'Ambition to Create Novel Expressions'. Co-founder of the collective Jonny Johansson (1969–) was propelled into the fashion business in 1997 by the success of an initial run of 100 pairs of jeans in raw denim with red stitching, produced mainly for friends. The name of the brand, which is also a skin condition, resulted in some initial reluctance from suppliers, such as British department store Harrods, to stock the label, and Barneys of New York requested that the labels be printed tone on tone. In 1998, the now London-based designer Ann-Sofie Back joined Acne to design womenswear, which today is headed by Frida Bard. Johansson initially concentrated on menswear design, but was replaced by Central Saint Martins College of Art & Design graduate Christopher Lundmann.

The Acne Film branch of the company has worked with director Ridley Scott in Los Angeles. Other projects include Acne Digital, Acne Creative and *Acne Paper* (the company's covetable oversized fashion magazine). All work out of a former bank in the heart of Stockholm. Womenswear and menswear by Acne is sold in 650 stores in forty-five countries, with ten stand-alone stores, including one in New York's SoHo and one in Paris's Jardin du Palais Royal. The flagship store in London's Dover Street sells jeans, ready-to-wear, furniture, jewelry and the Lanvin for Acne collections.

◀ **Reworked garment stereotypes and an interplay of fabric textures for A/W 11/12.**

2007 A range of monolithic forms in starkly sombre hues: black, charcoal and dark grey marl.

An androgynous range of mannish oversized garments is central to the collection, such as the cardigan-style shirtwaister layered over plains. Other looks are completed entirely in black with tights, shoes and mega bags. A voluminous satin parka is worn over a zip-covered cocktail dress, while a charcoal tweed overcoat has a bustier playsuit beneath. Both dress and playsuit remain resolutely black, except for the glimmer of showy metallic zips used to contort extra folds of cloth into gathers and tightly draped openings.

2010 A second season of denim collaboration between minimal Acne and feminine Lanvin.

Fine denim, sourced from traditional cotton indigo production in Japan, is draped in the cross-fertilized styles of Acne's Frida Bard and Lanvin's Alber Elbaz. Swags and drapes resonate with Parisian tradition, whereas studs and double-row top-stitched hems chime with an edgier workwear vein. The colours are denim blue, black and grey, and the grown-up silhouette follows the line of the body in dresses ending at mid-thigh. Evening wear also incorporates the metal stud, which becomes lavish in-built jewelry.

2009 A 1980s revival from jumpsuits to shredded denim and from T-shirt dressing to layering beneath oversized jackets.

A take on the 1980s peg-top-skirted dress is accessorized with a Stetson and green socks. Elsewhere, the easy line of dresses, from shifts to sacks and voluminous sweatshirts, is given variation with colour – black, silver grey, peach, sky and electric blue – and with the addition or omission of banded legwear. Tights are striped in opaque and transparent black, attaining a similar visual effect as the horizontally shredded denim and chiffon harem pants, broad-banded in satin. The fabrics remain monochrome, with such details as gathers, rib trims and textural changes, leaving accents to be created by a heavy metallic necklace or a battered ten-gallon hat.

AGNÈS B.

www.agnesb.com

Epitomizing French style, agnès b. adopts an acute graphic vocabulary drawn from the staples of the urban wardrobe. Born Agnès Troublé (1941–) in Versailles, the designer was working in Paris flea markets in the 1960s when she was famously 'headhunted' to work on French *Elle*. She collaborated with Dorothée Bis, V de V and Pierre d'Alby before working under her own trade name 'agnès b.', which references her first husband Christian Bourgois, in 1973. Two years later, she opened her first Paris boutique in the rue du Jour. From the outset, her shops have been spaces of artistic exchange: she is a long-term collaborator with Jonas Mekas, Yoko Ono, Gilbert & George and Louise Bourgeois. In 1984, the designer also established an art gallery at 3, rue du Jour, and later founded the audiovisual production company Love Streams to produce independent cinema.

The agnès b. aesthetic is inspired by film noir, historic costume and a sense of French identity. The pearl popper cardigan and long-line stripy T-shirts made from rugby shirt fabric are among the designer's signature pieces. She annually reinterprets these classics, showing them alongside feminine pieces such as dresses in idiosyncratic but demure prints or in her favourite red.

The label is particularly popular in Japan, where Agnès collaborated with designer Riku Suzuki in 1984. Her iconic exclamation mark logo is instantly recognizable, appearing on Seiko watches (1989), luggage and a limited edition Smart car. In 1996, her contribution to modern French style was recognized in the Pompidou Centre's exhibition devoted to her popper cardigan, and in 2000, she was decorated with the Chevalier de la Légion d'honneur.

◄ **A boudoir-inspired cocktail dress of layered frilled lace worn over shorts for A/W 10/11.**

1988 Power dressing meets body-con leisurewear in a tailored matching dress and jacket.

An orange sheath dress with a strapless bustier bodice reflects the body-sculpted fashions of the era, as do the exaggerated shoulders on the matching jacket. The piped edges of the turned-back cuffs and centre-front fastening add a delicate detail typical of the label. Agnès b. opened her first US boutique in SoHo, New York in 1981, where she showed all her collections – for women, men and children. In 1987, she launched her own perfume (LE b.), followed by a skincare and cosmetics range and a maternity collection.

2011 Uncomplicated wardrobe staples incorporating graphic single-colour prints and stripes.

Shown privately off-schedule at the Paris ready-to-wear shows, the collection includes this precisely tailored skirt suit in bold stripes, broken horizontally. A tan suede double-breasted coat with storm flaps and a check lining is worn over a mauve, almost sheer, knitted dress. Single-colour prints in red and black appear on knee-length sheath dresses, while white polka dots on black chiffon provide a more youthful silhouette. Tailored trouser suits are pared down and worn with a cropped T-shirt. Pea coats are shown in shocking pink towelling.

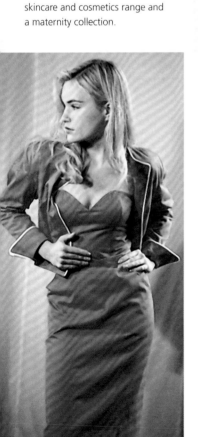

2007 A collection of knitted separates, colour-blocked 1960s-inspired dresses and understated crisp trouser suits.

The signature popper cardigan in baby blue with bracelet-length sleeves, matched with a madras-checked knee-length gathered skirt, represents archetypal French chic. In red, the cardigan partners a confirmation dress with serried rows of frills. A knitted sweater dress in terracotta features a gathered frill at the scooped neckline and on the elbow-length sleeves. A saucy sailor wears a peaked cap and a ribbon-threaded white broderie anglaise bra and flounced skirt beneath a tailored navy blazer, in contrast to a demure grey knit dress with an empire-line waist and Quaker collar and cuffs in white crochet.

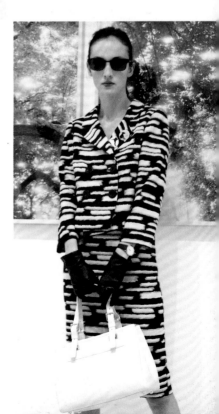

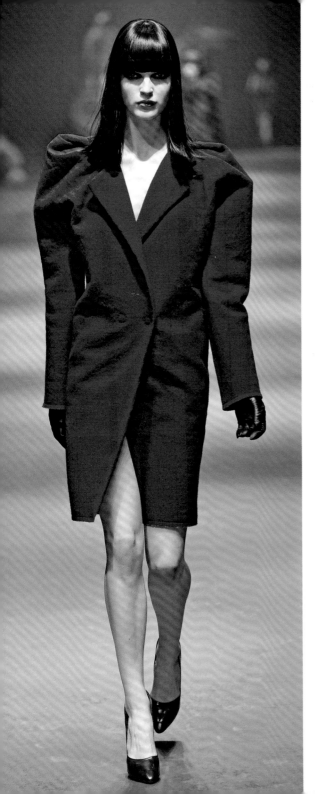

ALBER ELBAZ

One of the few designers who still works within the traditions of French couture, Alber Elbaz (1961–) generates a refined and glamorous look predicated on technical brilliance and a singular vision. Born in Morocco and brought up in Israel, Elbaz lived for a decade in New York. While there, he was apprenticed to Geoffrey Beene, one of the most respected fashion designers of the 20th century, whose hallmark is understated luxury and elegance. After seven years with the designer, Elbaz moved to Paris in 1996 to head the couture house Guy Laroche, which was followed by a brief period as head of ready-to-wear at Yves Saint Laurent (see p.320) in 1998. Three collections later, Elbaz was ousted when the Gucci Group took over the label and he was replaced by Tom Ford.

Regarded as one of the most desirable and commercially successful labels in the world, the venerable house of Lanvin (see p.184) languished in a near moribund state prior to the appointment of Elbaz as artistic director in 2001. He assumed his post after Shaw-Lan Wang, a Taiwanese publishing magnate, bought a controlling interest in the company in the same year. Elbaz uses all the techniques and skills of the couturier's atelier for his Goddess dresses, lightweight trench coats (now a Lanvin signature garment) and ruffled gowns in luxurious fabrics. The company is small compared to the size of its reputation and influence, allowing Elbaz responsibility for every detail of the label, including the Lanvin shopping bags, which are printed with Paul Iribe's 1907 illustration of Jeanne Lanvin and her daughter Marguerite. Fans of Elbaz's clothing include Nicole Kidman, Kate Moss and Sofia Coppola.

◀ **Origami-like folds lend volume to the shoulders of a cashmere coat for Lanvin in 2010.**

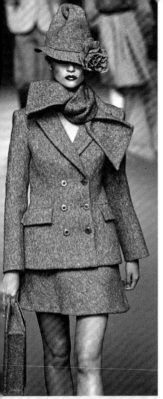

2000

The third and final catwalk collection by Alber Elbaz for Yves Saint Laurent.

A shirt in supple glove leather is gathered into a high pleated neckline, finished with a twist, and is tucked into a below-the-knee pencil skirt. Evidencing a rigorously disciplined collection, the range signals a pared-down modern elegance with emphasis on an elongated silhouette with neck detail. References to classic YSL pieces – 'le smoking' is reworked as an oversized Crombie coat – are combined with austere fly-fronted coats and fluid all-encompassing dresses in gathered chiffon with long sleeves, caught at the waist with a narrow belt.

1997

A collection for luxury French fashion house Guy Laroche.

Promoting a total look: an A-line double-breasted seven-eighths jacket and a flared skirt in tweed are worn with a perky outsize bow at the neck, a high-domed hat with textile corsage and a tweed clutch. The collection includes two-piece suits with softly tailored jackets with cinched-in waists, worn with a pencil skirt or wide-legged trousers, and a cream twinset, partnered with a black maxi-skirt.

2007

As creative director of Lanvin, Elbaz offers a futuristic collection with a 1980s resonance and utilitarian detailing in modern fabrics.

A parachute silk cocktail dress, with a puffball skirt, is gathered into a high neckline at the front and falls to the waist at the back – one of the subtle references to the styles of the 1980s. The collection also includes a pale grey multi-pocketed ciré jumpsuit and a cream double-breasted coat with exaggerated shoulders and tight on the hip. Futuristic trouser suits, with high-necked tunic tops and narrow trousers in cream, and halter-neck cropped dresses with zipped and patched pockets provide a utilitarian alternative. Evening wear features densely pleated bands of chiffon decorating the tops of strapless bodices, the ends left frayed, in fuchsia or gold on black. Or, the bands form the bra-shaped top of a full-skirted cocktail dress.

ALBERTA FERRETTI

www.albertaferretti.com

A byword for full-on femininity, Alberta Ferretti (1950–) creates delicate elaborately beaded chiffon dresses that epitomize romantic and ethereal chic. Born in Cattolica on the Adriatic coast, Ferretti opened her first boutique in her native city when she was eighteen. In 1974, she launched her own label and, in 1980, she founded the luxury goods company Aeffe with her brother Massimo, which manufactures and distributes clothing for Jean Paul Gaultier (see p.164), Moschino (see p.222) and Narciso Rodriguez (see p.228). Ferretti showed her first collection in Milan in 1981. In 1984, she launched a bridge line – Ferretti Jeans Philosophy – which later became Philosophy di Alberta Ferretti.

In 1998, the designer opened an in-store boutique at Bergdorf Goodman selling her signature and Philosophy di Alberta Ferretti lines. This was followed by a free-standing store in New York's SoHo exclusively for Philosophy, her lower priced line intended for younger women. In contrast to most designers, Ferretti started boutiques for her secondary lines prior to opening a flagship store for her signature collection on West Broadway in Manhattan.

The strength of the label lies in the distinctive and focused approach of the designer. Ferretti does not offer full-blown glamour or edgy sportswear, but instead confines her collections to what she does best: layered and pleated chiffon party dresses, princess coats and elegant little-girl knits. The label added lingerie and beachwear in 2001, and a wedding dress line in 2010.

◄ **Inspired by the flapper styles of the 1920s, the 2010 collection features bias-cut silk-satin pieces.**

2003 Juxtaposed to good effect, chiffon and crochet are the main components in this collection.

The pin-tucked powder-blue chiffon dress has crochet detailing at the midriff and shoulder. Elsewhere in the collection, draped, ruched, pleated and tucked chiffon mini-dresses in shades of saxe-blue, chocolate and khaki compete with 1960s-inspired cropped crochet dresses for romantic effect. Midriff-baring loose jersey trousers with embroidery on the sides are partnered with short chiffon tops. Tank-top or strapless black dresses are cut high to the crotch, occasionally disguised with an overlay of transparent chiffon.

2001 A resolutely feminine chiffon and silk collection in neutral hues.

A ballet-wrap cardigan is partnered with a button-through skirt rendered lively by the introduction of transparent orange godets. The colour orange also appears in flirty knee-length skirts and simple A-line dresses, alongside periwinkle blue, chocolate brown and Ferretti's hallmark nude chiffon. Bias-cut silk-satin shifts, some with collars and sleeves, fall just below the knee.

2007 Subtle embellishment and muted prints feature in a collection that includes princess-line trench coats and feathered evening wear.

A dress of dove-grey chiffon pleated and ruched into concentric circles, with the focus on the hip, provides a light delicate touch in a collection that includes romantic dresses and ladylike ultra-feminine tailoring. Shapes are clean and simple. A metallic silk-satin is used for both cocktail dresses and daywear, for button-through dresses and for high-waisted princess-line coats, which have a 1960s feel. Other coats have a dropped shoulder that balloons into bell-shaped sleeves from a series of pin-tucks, a design feature that recurs through the collection. Mohair in pea green and purple is constructed into just-below-the-knee sheath dresses and full-skirted trench coats. Feathers are incorporated into cocktail and evening wear to introduce an airy lightness.

ALEXANDER McQUEEN

www.alexandermcqueen.com

The iconoclastic designer Alexander McQueen (1969–2010) – who tragically took his own life at the height of his global success – reconstituted perceptions of bodily form and beauty through eloquent and theatrical layers of culture. His dark imagination was bolstered by widely admired technical skills of cut and construction, which gave his less extravagant output a refined wearability.

McQueen left school at sixteen and took up an apprenticeship in Savile Row with bespoke tailors Anderson & Sheppard and then with Gieves & Hawkes. His next employment was with theatrical costumiers Angels & Bermans, where he was introduced to the historical methods of cut and make. He worked briefly with Koji Tatsuno and then Romeo Gigli, before being accepted on the Master's of Arts in fashion at Central Saint Martins College of Art & Design. His graduate collection was bought by the stylist Isabella Blow. In 1996, McQueen replaced John Galliano (see p.172) as head designer at Givenchy (see p.132), and in 2000 the Gucci Group took over the majority shareholding of McQueen's own label, retaining the designer as director.

McQueen's achievements were recognized by numerous awards, including British Designer of the Year in 1996, 1997, 2001 and 2003, and International Designer of the Year from the Council of Fashion Designers of America in 2003. The label is now under the creative direction of Sarah Burton, who was appointed in 2011 to design the wedding dress of Prince William's bride Catherine Middleton.

◀ **McQueen's posthumous A/W 10/11 collection references Byzantine art and religion.**

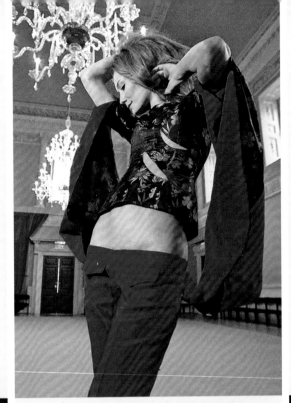

1995

The 'Highland Rape' scene uses the most recognized tartan – Royal Stewart.

Notorious for its ambiguous presentation of 'tartaned', dishevelled and violently disrobed models – allegedly as a metaphorical indictment of the English subjugation of Scotland – the 'Highland Rape' collection was successfully controversial. Tartan is sculpted into bodices and tailored into flared or pencil mid-calf skirts. Low-rise trousers are partnered with cropped chiffon tops with high tartan collars.

1998

Elements of bondage appear in this wide-ranging collection.

A perforated-leather sheath dress features in a collection that makes unfettered play with transparency and perforation, and with tailored or metal-cast exoskeletons. There are sartorial experiments that reveal exquisite cutting techniques: the revers that never stops until it has draped and reversed back up to the waist, or the rigid geometry of intercut fabrics that sit with the precision of a falling shadow.

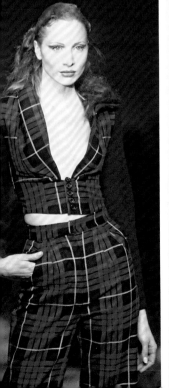

1996

With the 'bumster' – a designer act of sartorial daring that escalated to a global phenomenon – McQueen exhibited his creative authority.

Although antecedents of McQueen's low-rise trousers are seen in ranges dating back to 1992, it is only in the context of his S/S 96 collection, 'The Hunger', that they take a greater significance. Taking the graphic clarity of exotic plumage in a contained palette of red, black, inky navy, white and silver grey, garments are formed into new constructions with an incisive slash, chop or flash of the designer's shears. Satin, brocade, lace, leather, metallic tulle and linen are interlinked in a range of outfits – feathered, tufted and occasionally be-tailed with magpie panache or geisha fragility. A skull-encasing oval mask in metallic voile resonates with the delicate transparency of devoré feather prints. There is a suggestion of the threat of predation in the dress with a claw-wielding leopard printed in sinister chiaroscuro or from the dresses overlaid with a trapper's mist net.

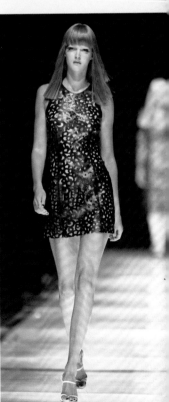

1999

Amid allusions of quasi-surgical bondage – bridles, girdles, cages and halters – Alexander McQueen presents a core collection of formal outfits.

From the frock coat and capri pants in candy-stripe satin to the bias-cut wrap dress in elaborate white linen drawn-thread work, there is an undercurrent of craft in the textile components of the range. Upmarket leno canvas is used for coarse satin-stitch florals, glossy white-on-white embroidered peacocks adorn a flimsy negligee coat and loose-weave raffia tapestry is crudely patterned in skirts and tops. Perennials of crisp *tailleur* are refreshed by the choice of materials. Flouncy lace-ruffled cascades are used to create trains for asymmetrical blouses, skirts and trousers, while saddlery straps are employed as heavy counterpoints. Elsewhere, Spanish lace fans are translated into winged corsets or rigid crinolines of perforated and segmented blonde wood. Spray-painting robot arms violate the virginal white, petticoated dress strapped to a defenceless model on a turntable. Closing the show, she finally escapes.

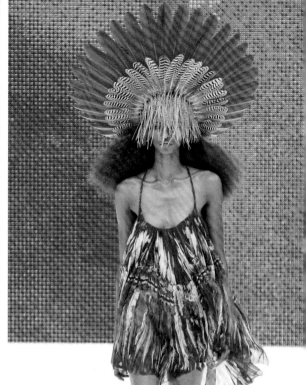

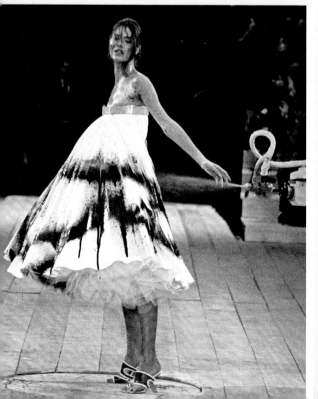

2003

In a catwalk narrative that places the Aztec, the buccaneer and the conquistador in confrontation, the Sun King is summoned by a feathered headpiece.

Considered to evidence commercial influence arising from the investment of the Gucci Group, the pyrotechnics usually associated with McQueen are reduced to a flow of covetable and wearable outfits, ranging from multi-frilled rainbow-hued evening dresses to leather corsets worn with billowing blouses. Buckskin and tan leather are teamed with ecru lace and draped chiffon, accessorized with coin- and key-laden thongs and broad belts. Arrays of covered buttons signal historical references, while loose ruffled knits and brocade suggest decadent piracy. The skull scarf is a must-have piece, and the gathered and layered lace cuff adds a flourish. Black lace mantillas are fashioned into capes and see-through dresses, accessorized with leather, rosaries and raven feathers. Jumpsuits are rolled down to the waist and worn with ruffled tops, while brightly coloured satin playsuits feature cascades of vibrant plumes.

2009

Celebrating animals, vegetables and minerals from the primitive past, 'Natural Distinction, Unnatural Selection' is the title for the spring/summer collection.

A tanned crocodile-skin basque, strapped and buckled at the back and worn over a billowing floral-print dress, is faced with plain satin. Elsewhere, wood-grain, skeletal and kaleidoscopic crystalline images appear at the centre front of dresses or cigarette-trousered suits. Some dresses trap pressed flowers between layers of voile, while others are encrusted with 3D rosebuds. A skinny-legged suit partnered with a butterfly-print frock coat recalls the dusty scales of the butterfly in a fabric composed of a mosaic of multicoloured zip fasteners. Massive looped and ombré-dyed fringes suggest the mobility of soft plumage across a cocktail dress. Laser-cut saddlery leather is crafted into robust ceremonial corsets that confine at the waist the fullness of delicate floral prints. As a finale, in a hymn to the mineral, faceted multicoloured crystals are emblazoned across the entire surface of hourglass dresses and skintight bodysuits.

2010

A spectacular launch as a live-stream Internet event.

With the drama and production values of an apocalyptic blockbuster, McQueen presents a futuristic collection.

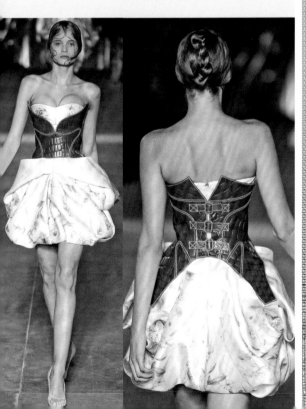

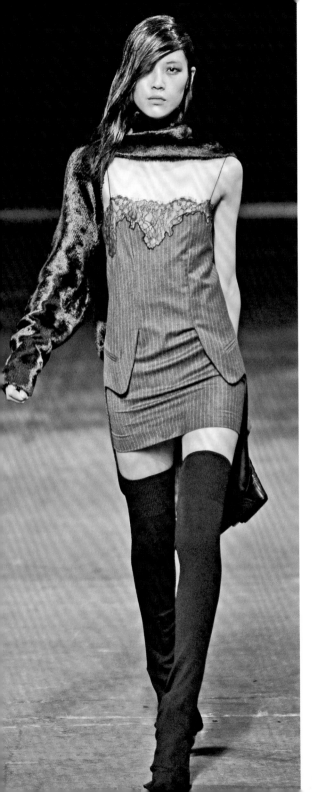

ALEXANDER WANG

www.alexanderwang.com

Archetypal New York designer Alexander Wang (1984–) offers a designer label at affordable prices. Born in San Francisco, Chinese-American Wang moved to New York at eighteen to try his hand at designing clothes. After just one year of studying design at Parsons The New School for Design and interning at *Teen Vogue*, Wang launched his label in 2007. His signature style – M.O.D. (model off duty) – describes a louche, relaxed look underpinned by sportswear influences that define urban understated cool. The T by Alexander Wang label comprises variations on the basic fashion T-shirt, focusing on detailing such as oversized necklines and armholes and carefully placed mini patch pockets. More recently, Wang has partnered slouchy layers of jersey with elements of strong tailoring to produce a sophisticated, more polished look.

Exemplary exponent of khakis and the white T-shirt, Wang was the natural choice to collaborate with US brand Gap in their GAP Design Editions initiative in which Gap, in partnership with the Council of Fashion Designers of America (CFDA)/*Vogue* Fashion Fund winners, brings emerging US design talent to the stores. Following the 'T' collection, the designer introduced his first full menswear collection in 2010, comprising basics such as zip-up hooded sweaters, tank tops and classic shirts.

In 2008, Wang won the CFDA/*Vogue* Fashion Fund, followed by the Swarovski Womenswear Designer of the Year in 2009, and, in 2010, Wang was the recipient of the Swarovski Accessory Designer of the Year Award.

◄ **Evening 'playwear' 2010 made from men's suiting, lace-edged lingerie and dancers' warm-ups.**

2009

Wang confers daytime dressing on performance sportswear with this relaxed collection.

To better recall the heat of South Beach Miami, models shimmer with sprayed water and faux perspiration beads on the catwalk for the S/S 09 collection. Florid-toned fabrics are shown alongside simpler neutral colours in cambric, ecru and grey marl jersey, together with sheer-black mesh and leathers. Dresses and swimwear make reference to the twisted motif of a knotted crop top. The collection's theme of holiday pursuits is reinforced by the insouciant mixture of poolside elements with gym and street attire.

2008

Shirt tail out, shorts, cropped jacket – it's 1984, again.

Wang tempts his theoretical muse, the M.O.D., with a cropped jacket worn over shirt and shorts: a supercasual and cool mid 1980s rehash of post-punk, easy summer dressing. Frayed denim sawn-offs, drop-waist shift dresses, pedal pushers and *Miami Vice* concertina-sleeved jackets are playfully reinterpreted. Nothing is complicated: fastenings can be poppered and black socks are optional.

2010

The sculpted lines of the 'combat uniforms' of the all-American halfback are recalled in Wang's sports daywear.

Mixed metaphors are the common currency throughout Wang's output. His witty ability to dissect the conventions of a pre-existing wardrobe in order to rearrange and rekindle its eloquence is well evidenced in this spring/summer collection drawn from the classics of American football. The forty outfits explore the re-proportioning of the details and cloths from both contemporary and vintage campus football clothing. Khaki drill, fleece-backed sweatshirt material, and stitched and laced tan leather are contrasted with sports mesh and underwear jersey. Wang leads the emphasis from casual daywear to a dressier evening feel by introducing non-sportswear fabrics.

ANNA SUI

www.annasui.com

Anna Sui (1964–) started out in fashion when punk was still a defining New York movement and vintage clothes were being rediscovered as an important source of inspiration for designers. Sui took punk's rock appeal and mixed it with a romantic nostalgia derived from elements of past style to create a contemporary version of boho style. In 2006, *Fortune* magazine estimated the collective value of Anna Sui's fashion empire at more than US $400 million.

Born in Detroit, Michigan, Sui decided from an early age that she wanted to be a fashion designer. She made her own clothes and went on to pursue a degree at Parsons The New School for Design in New York, where she met fashion photographer Steven Meisel. On graduating, Sui worked for a variety of sportswear companies, while also designing clothing that retailed in such New York stores as Macy's and Bloomingdales. With the encouragement of model friends Naomi Campbell and Linda Evangelista, Sui launched her first catwalk show in 1991, which was followed by the opening of her first shop in New York City's SoHo district.

In 2004, the designer launched a more youthful version of her fashion line, called Dolly Girl by Anna Sui. A children's line, known as Anna Sui Mini, debuted in early 2009 and Anna Sui shoes premiered on the catwalk in the A/W 09/10 collection. Also in 2009, Sui won the Council of Fashion Designers of America Geoffrey Beene Lifetime Achievement Award, the same year that the designer collaborated with Target to produce a line inspired by the cult US television programme *Gossip Girl*.

◄ **A powder-blue maxi-dress with lace panels appears in an eclectic S/S 11 collection.**

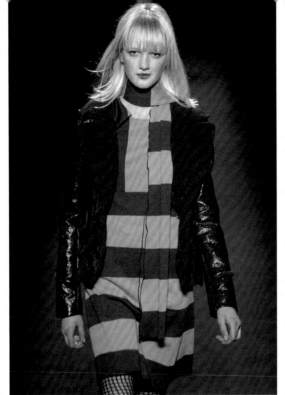

1992 The first runway show combines vintage fabrics with retro styling.

Outsize gingham checks cut on the cross form a figure-hugging bodice atop a tulip-shaped skirt cropped at mid-thigh. Alongside the bra top worn with an open shirt and matching mid-calf skirt, the outfits show the Sui signature of sweet with sexy, a combination that references vintage fashion with post-punk edginess. Idiosyncratic accessories include the steeple straw hats and bold necklaces.

2008 Kaleidoscopic colours, textures and patterns are lavishly embellished.

Art deco is the inspiration for the printed velvet cropped jacket worn over a three-quarter-length tunic in a 1920s print with a large floppy collar. The chiffon tunic is printed in panels of florals and checks, and worn over a flirty skirt edged in a paisley print. This multi-layering and juxtaposition of colour and texture permeates a collection that draws on many sources, from Renaissance costume to 1920s flapper style.

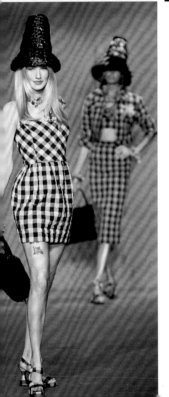

2001 Wide bands of colour on sweater dresses and windowpane checks colour-matched to dyed shearling feature in a range that veers from the demure to the eccentric.

Broad horizontal stripes in apple green and khaki appear on a knitted dress worn beneath a khaki patent-leather jacket lined in purple-dyed shearling that turns back to form the lapels. Similar stripes feature on knitted two-piece suits in black and white, with round piped pockets on the simple jackets. Varying scales of windowpane check are deployed throughout the collection, forming two- or three-piece trouser and skirt suits, all in shades of orange and brown and worn with stylized floral prints, sometimes placed under suede jackets and coats with shearling lining dyed to match the dresses. Sweet 1960s-inspired shifts in pink, pistachio green and apricot have fluted hems and collars embellished with appliquéd flowers and worn with a matching floral corsage. Quirky accessories include a string of two-dimensional felt flowers worn suspended from the neck.

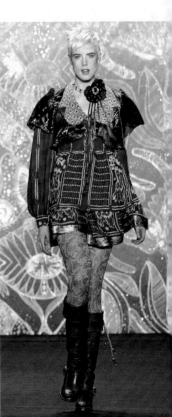

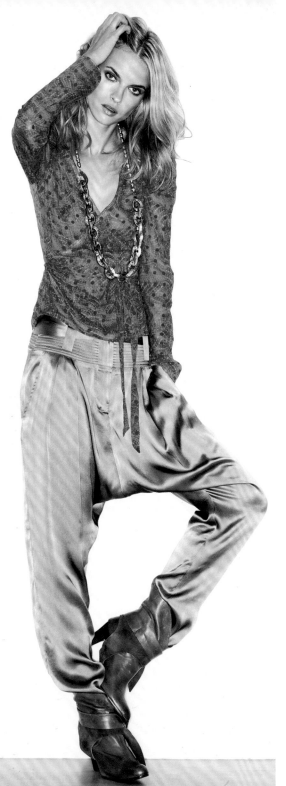

ANTIK BATIK

www.antikbatik.fr

Drawing on a true bohemian sensitivity, Italian-born Gabriella Cortese (1965–) launched the Antik Batik line in 1992, inspired by the elegance of her Hungarian grandmother and her own taste for the richness of Russian avant-garde paintings. Leaving home in Turin for Paris at eighteen to study French language and literature in the early 1980s, Cortese later travelled to Tibet and Bali, India and Peru. She returned to Paris with a stock of *pareos* (sarongs), sandals and scarves to sell to acquaintances. Cortese enriched the range with the introduction of specific fabrics that were embellished by various craft means to her own designs. She then extended the range to include other garments.

Initially in partnership with her travelling companion Christophe Sauvat, Cortese developed the idea into a wholesale business, and Cortese and Sauvat opened their first Antik Batik boutique in Paris in 1999. The bohemian eclecticism of Antik Batik was launched and its distribution expanded through numerous retailers, yet it has always retained an ethical handmade approach. Now a brand with global celebrity, Antik Batik continues to work closely with the village ateliers Cortese has nurtured around the globe. She employs hundreds of skilled handworkers in India, Bali and Peru to produce garments that have the refinement of Left Bank chic and the character of crafted heirlooms.

The Antik Batik collections offer versatile separates rich in detail, pattern and colour. The vitality of the line lies in its ability to gratify transcultural appetites. For these reasons, the label has a covetable client base including Cameron Diaz, Hilary Duff, Eva Herzigová, Vanessa Paradis and Carla Bruni-Sarkozy.

◄ **Hippie de luxe style for 2010 with heavy satin sarouel pants and a patterned voile blouse.**

2009 Cummerbund belts constrain light decorative summer fabrics.

The waist of an off-the-shoulder button-through gypsy dress is emphasized by an embossed belt. This recurrent punctuation is used with patterned maillots, with dolman-sleeved cotton knits, or with a tiered and frilled strapless dress in floral chiffon. Large-scale prints are left loose in volumes of delicate cloth: an empire-yoked full-length kaftan and a chiffon djellaba, printed with feathery roundels.

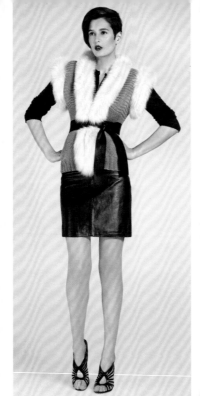

2010 A collection that transposes and hybridizes cultures on a global scale; the span of influences runs from the remote Andes to urban retro deco.

Affirming the ethical artisanal methods and her long-term support of production sources, Cortese uses her campaign collaboration with photographer Thierry Le Gouès – made and shot in a Peruvian location – to highlight the origin of her products. The photographs were sold in a Parisian gallery to fund aid work after disastrous flooding in Peru. The embroideries, forms and colours of the Alto Plano are evident in the range, although this influence is not exclusive. Other trends can be traced back to the beaded embroideries of the glittering 1920s or the fauvist colours of Sonia Delaunay. At the de luxe end, the line presents feminine and rock touches in equal measure, with graphic Mongolian lamb capes and black leather trousers.

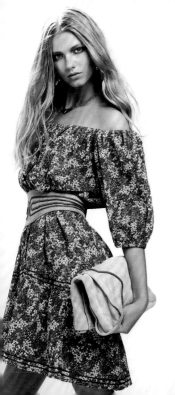

2009 Using dark tones, Cortese maintains the hand-selected feel of eclectic artisanal production.

A fur-trimmed rib-knitted gilet sets the tone of self-indulgence, reinforced by a black cashmere sweater and leather miniskirt worn with heeled sandals. The framing of the face using directional detailing is a recurrent mechanism in the autumn/winter collection: a deeply frilled V-panel on a charcoal knee-length jersey dress leads the eye – by way of a high collar – to the head. In the same way, a black wide-sleeved kurta tunic concentrates the vision by the application of sequins running in several parallel bands.

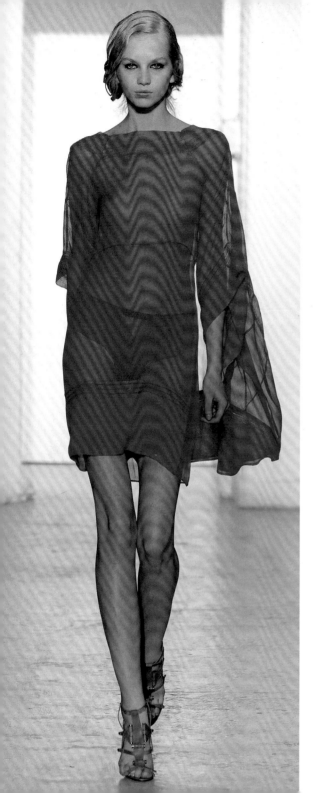

ANTONIO BERARDI

www.antonioberardi.com

The Antonio Berardi label merges Italian and English traditions and craftsmanship to seductive effect, and is favoured by celebrities who find his hybrid heritage a heady fashion mix. Born of Sicilian parents in provincial England, Antonio Berardi (1968–) incorporates the essence of his Mediterranean roots in the event dresses in his collection. He studied at Central Saint Martins College of Art & Design, while at the same time working as an assistant to John Galliano (see p.172), who became something of a mentor. Berardi's graduation show in 1994 attracted buyers from high-end fashion stores in the United Kingdom, and the designer launched his first professional collection the following season.

Although a member of the group of iconoclastic designers in London during the 1990s that included Alexander McQueen (see p.38) and Hussein Chalayan (see p.154), Berardi tended towards feminine clothes that had an element of finely constructed tailoring rather than sensationalist statement pieces. In 1999, he moved from the London catwalks to Milan, and in the following year Extè appointed Berardi as their head designer, also manufacturing his own-name collection. After several years showing in Milan and Paris, Berardi returned to the London catwalks in September 2009.

The designer is an expert at variations on the knee-length hourglass look, the result of a judicious use of innovative materials. Berardi is one of few international designers who operates with complete autonomy.

◄ **A sheer, kimono-sleeved dress frames tailored lingerie in Berardi's S/S 09 collection.**

1997

A black and white dress from the 'Voodoo' autumn/winter collection.

The crisply tailored dress is rendered sinister by the use of fallen and bloodstained feathers pinned to the neckline. Elsewhere in the collection, fiery red leather is fashioned into sheath dresses split to the thigh and skintight trouser suits. Transparent chiffon evening gowns are draped around the waist with embroidered flowers and accessorized with candleholders as crowns.

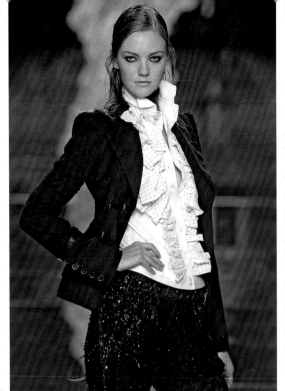

2009

A red carpet homage in dress form to the corsetière.

The bold body-sculpted corset dress with *trompe l'oeil* black lace panelling, endorsed by film actress Gwyneth Paltrow, was chosen by Lucy Yeomans, editor of British *Harper's Bazaar*, as 'dress of the year'. It was the standout piece in a collection that combined the seduction of lingerie with the precision of sartorial construction, including diaphanous dresses in fuchsia pink and slick satin.

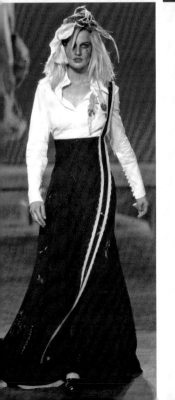

2005

Severe tailoring in a predominantly monochrome colour palette incorporates military and historical details referencing 17th-century Cavaliers.

A sharp-shouldered jacket with a nipped-in waist over a double-ruffled shirt with a high collar is both a contemporary version of the tuxedo and a historical pastiche when worn with beaded bloomers that reference galligaskins (breeches), which are worn over straight-legged trousers. Elsewhere in the collection, dropped shoulder seams expand into huge layered lace sleeves, while coat collars with overlapping tabs lend a military feel. Massive ruffs continue the historical theme, and frilly pale print dresses recall Restoration poet Robert Herrick's 'sweet disorder of the dress'. The 1970s dandy style is also evident in long narrow trousers and skinny jackets worn with shirts that flourish an outsize bow, tied at one side of the collar, and with extreme piped lapels. Frequently featured is the device of quartering the skirt and introducing a different fabric in the top left-hand corner.

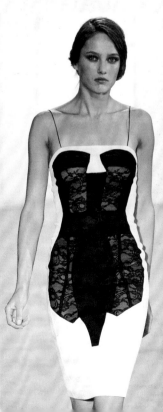

ARMANI

www.armani.com

Eschewing trends and gently segueing from season to season, Giorgio Armani (1934–) continues to evolve his signature minimalism that acknowledges the mood of the time. The Italian-born designer revolutionized menswear in the 1980s by challenging the traditional techniques of English tailoring. Deconstructing the jacket by removing rigid interlinings and facings and extending and dropping the shoulders, Armani provided a loose fluid look at odds with the then formal man's suit. He also redefined female fashion using unstructured tailoring and softly textured fabrics that draped and wrapped around the body in shades of taupe, beige and navy. Armani's use of unpressed linen for summer permitted a naturally crumpled look in blazers, loose drawstring trousers and dirndl skirts.

Crossing disciplines from medicine to fashion, Armani first worked as a menswear buyer for a Milanese department store, before going on to work for the Cerruti group during the 1960s. The designer established his own label in 1975, and is now the sole shareholder of a business estimated at US $7 billion. Internationally known lines and collections include Giorgio Armani, Emporio Armani, Armani Jeans and Armani Exchange. Frequently seen on the red carpet is Armani Privé, the most recent addition to the couture collection. It is painstakingly made by hand in exquisite fabrics for celebrities such as Jennifer Lopez, Kristin Scott Thomas and Queen Rania of Jordan. The brand also encompasses Armani housewares and furnishings, sunglasses and scent. One of his latest ventures is a chain of hotels, with one in Dubai and another in Milan.

◄ **S/S 09 features Armani's well-known unstructured contemporary Italian men's tailoring.**

2002 The characteristic Armani style is sustained through the use of luxurious soft supple fabrics and a pared-down silhouette.

Oversized trousers featuring double front pleats extended to form broad loops for a wide self-fabric belt are loosely pulled in at the ankle and worn with a form-fitting diagonal-knitted top. Jackets in softest leather or wool crepe are fitted and draped around the body. They have the unmistakable Armani moulding on the shoulder and resolutely minimal tailoring details. Pattern is provided through texture rather than print, in a colour palette confined to navy and black, shell pink, ice blue and taupe. Sequinned horizontal and diagonal bands of black and white stripes appear on equally understated evening wear.

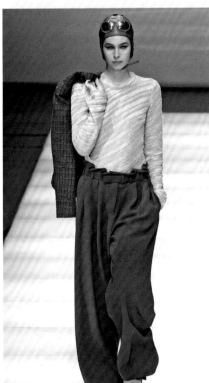

1980 Richard Gere appears in American Gigolo (1980) wearing an Armani-designed wardrobe.

The film noir proved a successful showcase for Armani's luxurious soft-tailored and understated glamour, resulting in the menswear line achieving global acclaim. The film fetishized the notion of abundance and choice in an era when the narcissistic gym culture and the cult of the body were juxtaposed with rampant consumerism. In an iconic scene, Gere toys with the best permutations in his array of Armani garments; one by one the same narrow-collared shirt is coordinated with its perfect micro-patterned tie.

2010 Inspired by the moon, pearlized tailoring and dresses are shown for Armani Privé.

A bespoke evening dress of parabolic curves fashioned into asymmetrical frills in palest azure blue is one of a collection of dresses and suits in a nearly monochrome colour palette. Elsewhere, collarless jackets in silver quilted lamé with double puff sleeves have a futuristic edge, the binding at the centre front extending to form the folds of science fiction foliage on the shoulder. Oversized moon-shaped buttons feature on curvy jackets and one-shouldered goddess-type sheaths shimmer in aquatint satin.

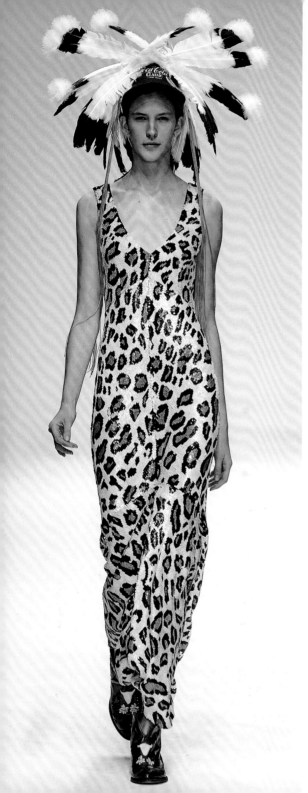

ASHISH

www.ashish.co.uk

Sharing a decorative compulsion with his stylistic forebears of the 1970s and 1980s – Kenzo, Kansai and Krizia – Ashish has cornered the 21st-century glitz market with his hand-sequinned patterning on all manner of garments. Ashish Gupta (1973–) was born and grew up in New Delhi, has a studio base in London and has workshops for his artisan production in India. On leaving Central Saint Martins College of Art & Design in 2000 with a Master's degree, Gupta began producing his hallmark embroidered clothes for private clients and friends. By the following year, he had landed his first retail order from Browns Focus. Just three years later, he produced his debut Ashish runway show within the schedule of London Fashion Week.

Season on season, the iconography that Gupta subjects to sequin saturation evolves – but with undimmed exuberance. Travelling in the span of his collections from polychrome images of microbiology and African cloth, to Nike's Swoosh and Disney characters, and eventually to tweed and Memphis-style abstract prints rendered into sequin graphics, Ashish maintains a frenetic handwriting. The designer has gained the New Generation Award on three occasions and has collaborated with British high street retailer Topshop on six diffusion collections to date.

In later collections, Gupta has added menswear, denim elements and accessories to his catwalk vocabulary, and there is a sense of the label maturing into a new sophistication, retaining the use of paillettes but with fewer jokes in order to retain its retinue of celebrities, which includes Madonna, Marina Diamandis, M.I.A., Paloma Faith, Sarah Jessica Parker and Tori Amos.

◄ **Leopard-print sequins and feathered headdresses create an irrepressibly ornamental S/S 11 look.**

2005 Technicoloured embellishment is used in simple garments with complex printed fabrics.

The proliferation of loosely connected patterning – some African inspired and some more kimono in style – gives the collection a chaotic rigour that is held in check by the general wearability of the garment form, which includes a version of the classic trench coat and the all-in-one playsuit. The addition of tie-dyed tights alongside the complex sequin print is a further challenge to non-extrovert wearability. Gold shoes add to the general joie de vivre of the collection.

2010 The oversized tweed coat and pull-on hat are juxtaposed with lavish sequinned embroidery.

Combining mannish tweeds and chunky knits with his hallmark graphic stitchery, Ashish explores a cross-cultural approach in this collection. *Trompe l'oeil* cricket sweater cable-knits in paillettes compete with gigantic cross-stitch and kilim motifs or monster Bargello patterns – rendered sparkling by hand processes. The implication is that it is not necessary to wear wall-to-wall sequins to benefit from their impact; Ashish garments can work as separates away from the showy requirements of the red carpet.

2010 A collection transcendently eclectic in its references features this slashed and knotted body-con dress.

Recalling the body-conscious bandage dresses of the 1980s, Ashish adds sarongs, shorts, clamdiggers and T-shirt shifts to the spring-summer mix, all of which are exploited as canvases for comprehensive patterning. Roosts of flamingos and garlands of hibiscus vie for attention with lightly humoured text and arbitrary advertising slogans. The graphic frivolity extends through the collection with references to comic and pop art, and includes the tourist maps and picture postcard imagery of the traveller. To stem the visual puns, a few garments, including denim biker jackets, have been made startling by the addition of spiked studs.

AZZEDINE ALAÏA

Dubbed 'King of Cling' by the fashion press in the 1980s, Tunisian-born designer Azzedine Alaïa (1940–) was instrumental in putting stretch into mainstream fashion. The signature Alaïa look emerged in 1985 with the iconic side-laced dress, sculpted to fit like a second skin. Although his clothes appear to follow the line of the body, they actually create their own shape, the infrastructure inventing curves where there are none and flattening those that are superfluous.

The designer studied sculpture at the Ecole des Beaux-Arts in Tunis before moving to Paris in the 1950s, where he undertook a brief apprenticeship at Christian Dior (see p.92), followed by two seasons at couture house Guy Laroche, where he honed his tailoring skills. Alaïa introduced his first ready-to-wear collection of body-conscious clothes in 1980 and continued to work privately for individual customers until the middle of the decade. In 1987, he developed long-sleeved scoop-neck dresses accessorized with black opaque tights, instigating an enduring fashion staple. Styled with slicked-back hair and red lipstick, the overtly sexy silhouette represented the glamazon of the era.

Alaïa experiments with fabrics, such as a velvetlike specialty viscose-chenille yarn that produces fabric with the density of a woven cloth, while remaining pliable. In 1994, he showed dresses in 'houpette', a stretchy fabric that moulds to the body. In 1995, he made clothes out of 'relax', an anti-stress fabric with carbon-dipped fibres that repel electromagnetic waves.

◄ **An aggressively female and feline leopard-print knitted dress in A/W 91/92 haute couture.**

1986 Model and actress Grace Jones wears the iconic side-fastening dress.

The Lycra stretch dress is cut on the spiral with criss-cross seaming that lengthens the leg and supports the bosom and bottom, resulting in the much copied form-fitting dress that defined the gym-honed body. Named Best Designer of the Year in 1985 by the French Ministry of Culture, Alaïa continued to offer his skintight shape with the Mermaid dress in 1986, created from green acetate knit with a spiral zipper set in a curved seam.

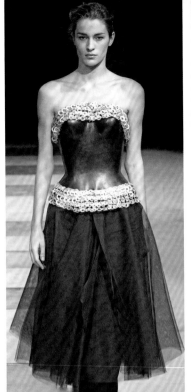

2007 Emphasis is on the midriff, defined by corset belts and panels of pleating, to create a feminine triangular-shaped silhouette.

A high-waisted skirt meets a cropped tailored jacket to create an angular silhouette, the pleated midriff of the skirt forming a corsetlike suppression of the fabric, which then incorporates godets to form a rigid A-line skirt. The same effect creates the fullness at the back of the jacket, neatly tailored at the front with princess-line seams. An identical suit in grey is different only in the details, with the yoke and outer sleeve seaming picked out with braid. Other skirt suits are created from perforated doily-edged felted wool, with bertha collars and matching stiffly frilled skirts. Frothier frills appear in all-white skirts attached to clinging single-jersey bodices. Pleats are also seen in knitted cropped cardigans with matching skirts.

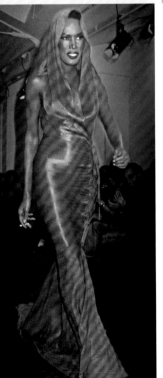

2003 Haute couture pieces in fringed and moulded leather and chiffon for spring/summer.

Rows of chain-link decoration define the edges of a seamless moulded leather torso, the hourglass shape emphasized by the fullness of the pleated and tucked silk-tulle skirt. Daywear includes a black leather tailored jacket, partnered with a double-fringed leather miniskirt, and a woollen narrow-legged trouser suit enlivened with asymmetrical fringing along the hem of the jacket. Printed crocodile skin is worked into a bolero with a cross-over front, in a version of the ballet cardigan, and matched to a mid-calf tutu.

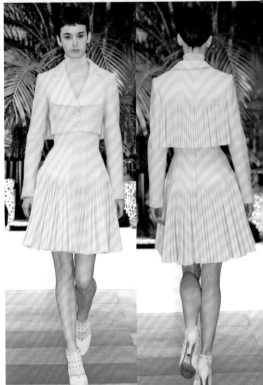

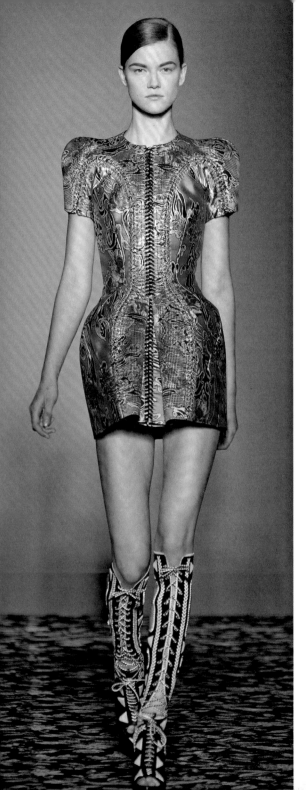

BALENCIAGA

www.balenciaga.com

From 1937 to 1967, Cristóbal Balenciaga (1895–1972) reigned supreme as the 'couturier's couturier'. One of the most revered fashion houses, Balenciaga had a sophisticated and dedicated clientele who reputedly went into mourning when the couturier closed the doors of his salon without warning in 1968. Starting in a small atelier in San Sebastian, Spain before opening his Parisian couture house on the avenue George V in 1937, Balenciaga only developed his resolutely personal style after World War II, with radical experiments in cut and structure that referenced the work of artists such as Francisco de Goya and Francisco de Zurbarán.

The theatricality of Balenciaga's clothes was leavened by an austere architectural quality: collars were cut to stand away from the neck, sleeves shortened to bracelet length and heavily textured fabrics were moulded to skim the body, resulting in a serene simple line with minimal unobtrusive seaming. During the 1950s, he created a new silhouette by broadening the shoulders and relinquishing the waist, ultimately producing the influential chemise or sack dress in 1957.

On his death in 1972, the house lay dormant until 1986 when the Jacques Bogart company acquired the rights. Designer Michel Goma was replaced in 1992 by Josephus Thimister; Nicolas Ghesquière joined Balenciaga as a licence designer, eventually becoming head designer in 1997. In 2001, the Gucci Group secured the house, the same year that Ghesquière launched the Lariat, a motorcycle-inspired riveted and tasselled handbag that became an immediate best-seller in a period dominated by an obsession with accessories.

◀ **A carapace of opulent brocade is formed into armour-like dresses for the S/S 08 collection.**

1951
Removed from the hourglass shape, Balenciaga offers a simplicity of form.

A strapless dress has strict vertical monochrome stripes overlaid with delicate filigree embroidery, the result of a unique collaboration with the embroiderers of the House of Lesage. Continually developing and refining fabrics, Balenciaga worked alongside the Swiss textile house of Abraham to develop silk gazar, a material to which Balenciaga's dresses are inextricably linked. During this post-World War II period, the couturier consolidated Balenciaga's reputation as a luxury brand, thereby generating a level of international fame to equal Dior and Chanel.

1938
Balenciaga references his country of birth in this collection.

Sculptural in its severity, a dress with draping at the waist is matched to a flowing cloak decorated with white binding and bows resonant of the matador's cape. Balenciaga interpreted numerous historical styles throughout his career. His renowned Infanta gown was inspired by the costumes worn by Infanta Maria Margarita in portraits by baroque artist Diego Rodriguez de Silva y Velázquez.

1959
The cantilevered skirt cut shorter at the front before sweeping to the ground at the back is a signature feature of Balenciaga's designs.

Inspired by the lines and potential for movement inherent in the Spanish flamenco dress, Balenciaga uses a cantilevered skirt in this vibrant pink cocktail dress. The skirt is gathered on to a boned form-fitting bodice with a sweetheart neckline, and then falls in a deep flounce lined with layers of pink feathers. The cantilevered cut was hailed for its accommodating fit, creating a slimmer silhouette on a curvier form. During this decade, formal entertaining included the cocktail party, and by the late 1950s the etiquette that decreed uncovered arms before eight o'clock in the evening unseemly was no longer adhered to, resulting in sleeveless and décolleté garments, usually worn with a pair of elbow-length gloves and a cocktail hat. The green dress is by Givenchy.

1998 **Nicolas Ghesquière constructs minimally cut, predominantly geometric fabric and leather pieces to drape and fall around the body.**

Supple black leather – draped around the body and ruched at the neck with studs along one shoulder – features in a collection confined to sombre black with the emphasis on cut. Basic geometric forms, such as the square, are manipulated into off-the-shoulder tops or gently gathered into a blouson waistline, suspended from narrow straps and constructed in wool, suede and leather. Billowing floor-length dresses with no apparent darts or seams have a monastic quality, emphasized by the leather coif headwear. Wool crêpe coats are detail-free with concealed fastenings, flowing to the ankle and simply tied with an obi-style cummerbund. A severe black suit, caught once at the front of the jacket, opens to reveal a narrow skirt with just a flick of a fishtail.

1995 **By Josephus Thimister, artistic director from 1991 to 1997.**

Modern opulence is the signature look of Belgium-born Thimister, evidenced here in a floor-length gown of violet crêpe. The bodice is draped from a gently gathered shoulder seam across the body to form a waterfall frill, caught in with a belt.

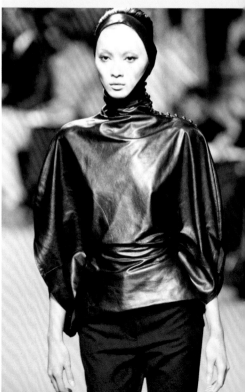

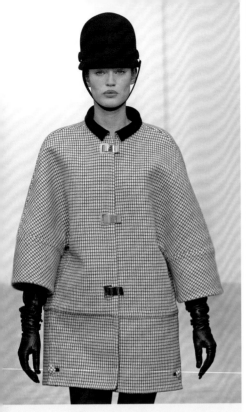

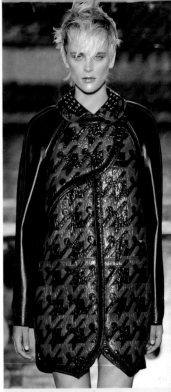

An uncompromisingly modern collection of unique textures and surfaces.

Bonded wool jersey is overprinted in Lastex in various textures from dot and dash to honeycomb, forming layers of bright pastel colour – mint green, turquoise and orange – offset by grey. The fabric creates its own futuristic cocoon-like silhouette, independent of the body beneath and caught in at the waist with a belt to form an undulating peplum. The narrow raspberry-pink trousers have a turquoise turn-up. Fragile knits form a contrast with delicate star-shaped motifs on a miniskirt and contrast sweater in the spring/summer collection.

2006 **The Balenciaga archives are referenced with coats and jackets with stand-away collars, three-quarter sleeves and outsize details.**

A 1950s-inspired cocoon coat in finely checked tweed is cut on the cross with an outside seam on the dolman sleeves and a stand-away collar – a style favoured by Balenciaga to frame the face and elongate the neck. A domed hat and platform shoes lengthen the torso. The jacket, seen also in outsize windowpane checks, adheres to the same silhouette and is worn with a miniskirt of rigid box pleats. Elsewhere, taffeta coat dresses swing from caped shoulders. The top-heavy silhouette becomes long, lean and narrow, with skinny low-rise trousers worn below fitted jackets with cap sleeves, pulled in at the high waist with a leather bow, or checked dresses with bias-cut inserts. Simple white sheath dresses are accessorized with a twist of pink scarf.

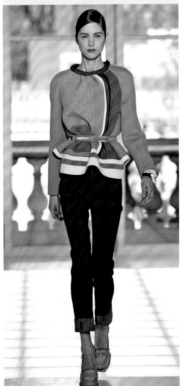

2011 **Rockabilly style with iridescence: fluorescent lace and black leather.**

Oversized houndstooth in red and black crackle-treated leather forms a futuristic exoskeleton coat with raglan sleeves and a riveted Peter Pan collar for autumn/winter. The houndstooth is also degraded into soft tweed, as well as into an all-over print to form simple sequinned dresses. Moulded panels or sleeveless printed lace shirts in fluorescent colours are mixed with skirts and trousers with asymmetrical front fastenings.

BALMAIN

www.balmain.com

Notorious for its £1,000 jeans, the French fashion house Balmain is renowned for being one of the most expensive labels in fashion. So influential and desirable did the brand become under the creative direction of Christophe Decarnin that it gave rise to the term 'Balmania'. His signature pieces excited the interest of both his clients and the fashion press in equal measure.

The original fashion house was founded in 1945 by Pierre Alexandre Claudius Balmain (1914–82), who together with Christian Dior (see p.92), Balenciaga (see p.56) and Givenchy (see p.132) formed the post-war nexus of the revived French couture industry. During the 1950s, Balmain designed simple elegant clothes, specializing in dress and jacket combinations and draped and pleated evening wear for European royalty and Hollywood stars such as Ava Gardner and Katharine Hepburn. On Balmain's death, his assistant, Danish designer Erik Mortensen, took over until 1990, followed by Danish designer Margit Brandt. Two years later, Oscar de la Renta (see p.236) joined the house where he remained until 2002; he was replaced by Laurent Mercier in 2003. However, the house fell into financial hard times and was forced to file for bankruptcy.

Investors revived Balmain in 2005 and brought in French designer Christophe Decarnin, previously with Paco Rabanne. According to Balmain's owner, French businessman Alain Hivelin, the commercial and critical success of the label is due solely to the creative genius of Decarnin. The brand enters a new era, however, with the appointment of French-born Olivier Rousteing as overall creative director.

◀ **An ultra-short mini-dress studded with Swarovski crystals is seamed with black leather for 2009.**

1954

Purporting to dress women for everyday living, Pierre Balmain designed luxurious gowns for grand social occasions, as well as understated tailored daywear worn by socialites.

A lavish off-the-shoulder ball gown mounted on a boned bodice and a many tiered skirt is delineated with narrow black ribbons that create a vertical row of tiny black bows down the centre front. The dress shows Balmain's participation in the voluptuous 'New Look' of the era, captured in the typical 1950s pose where the shoulders arch forward to create a 'hairpin' silhouette. The couturier's opulent evening gowns obeyed the fashion strictures for full-on formality for certain occasions, which required a décolletage and elbow-length gloves, as well as perfect make-up and important pieces of jewelry. Flourishing in the golden age of couture, by 1956 Balmain had 600 employees and twelve couture workrooms under the auspices of his renowned directrice Ginette Spanier. Rather than being groundbreaking, Balmain's sophisticated wearable couture remained firmly in the context of mainstream fashion.

1961

Epitomizing Parisian glamour at its zenith, a Pierre Balmain evening gown photographed by John French at the Trocadéro against a backdrop of the Eiffel Tower.

Posed in front of an iconic French landmark, and updating the 1950s hourglass figure, this draped evening gown is sculpted around the bosom into a sweetheart line, with the gathered skirt held in at the waist with a defining broad black velvet band. The almost louche sensual pose, in which the garment is allowed to follow the lines of the body, is in keeping with the more relaxed social codes of the era, as is the tousled bouffant hair and seductive velvet ribbon around the throat in place of fine jewelry. The haute couture system underwent a reappraisal in the developing ready-to-wear market and youth-led fashions of the 1960s. However, Balmain continued to offer luxurious fabrics and the traditions of the atelier to his conservative clientele of socialites and European royalty, rather than supplying the iconoclastic and space-age modernism and futuristic materials of his fellow couturiers Ungaro and Courrèges.

1993 Haute couture by Oscar de la Renta for autumn/winter.

The first US designer to front a French couture fashion house, De la Renta continued to propound the label's traditional qualities of beautifully crafted minimal simplicity, in keeping with the wishes of the label's clientele at a time when grunge fashion walked the catwalks of ready-to-wear. A Donegal tweed suit has a calf-length pencil skirt that partners a neat double-breasted jacket with patch pockets and wide lapels.

2006 Christophe Decarnin elevates the couture house to cult status.

Black lace over a white silk taffeta dress provides a contrast in texture, the lantern sleeves burgeoning from the elbow-length lace. Understated stylish luxury is evident in cropped brocade dresses and drapey metallic trousers falling from the hip, worn with simple knitted silk T-shirts with shoulder embellishment. The shoulders are also given emphasis with black guipure lace boleros worn over vest tops and narrow trousers.

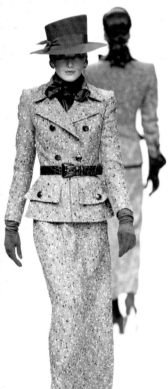

2003 Haute couture by Oscar de la Renta for spring/summer uses his signature ruffles to evoke the Venetian carnival: a masquerade of Pierrot masks and hooded sirens.

Clever cutting takes the V-necked bodice of a jumpsuit into a ruff of stiffened taffeta, at the same time forming cap sleeves. The waist of the black all-in-one is defined by a twist of sugar-pink silk-satin. Ruffs are also worked in gazar, extending around the back of the neck to form an entirely circular collar before decreasing in size as they follow the line of a black silk top to the waist, leaving the back bare. Flat-fronted side-fastening trousers in palest lilac and a twisted belt in purple complete the look. Elsewhere, double ruffles appear in red as a bolero over black; the trousers are form-fitting with a centre-front seam defining the leg. Pink satin is also fashioned into ruffled tops, worn with split narrow skirts in cream. Deep frills in black are placed diagonally across the body of a cream trouser suit, and also form an upturned 'U' travelling from hem to waist and back again.

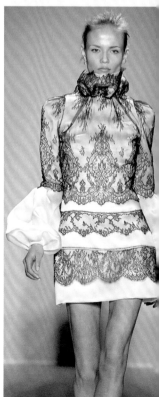

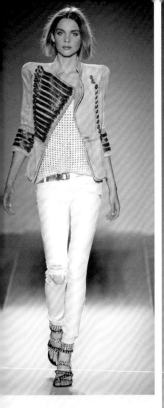

2010 Exaggerated shoulders, military detailing and fierce shoes.

With a plunging neckline, a metallic sequined dress has a draped skirt open to the hips and is secured with a three-buckled belt.

2011 Signifying the subversive era of punk and rock chick fashion.

A stenciled text on cropped shorts studded with rivets and safety pins is partnered with a faux-stained ragged vest and ripped tights.

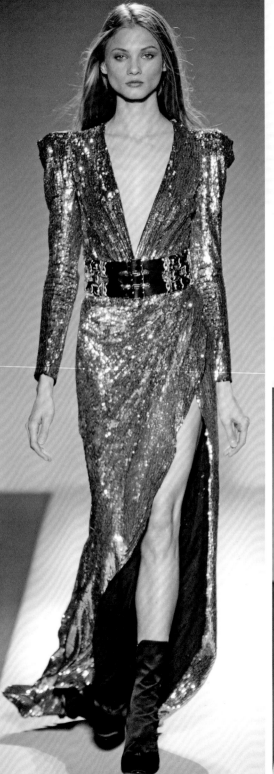

2009 The world's most exclusive purveyor of rock chick style.

Raising the price benchmark, these bleached and ripped skinny jeans cost £1,000 a pair. They are partnered with a drapey T-shirt under a military-style jacket with Swarovski crystal-embellished frogging and epaulettes that inspired a plethora of mass market copies. Extended, round-moulded shoulders appear throughout this collection of tailored jackets and figure-hugging dresses cropped at mid-thigh.

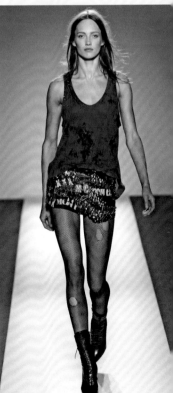

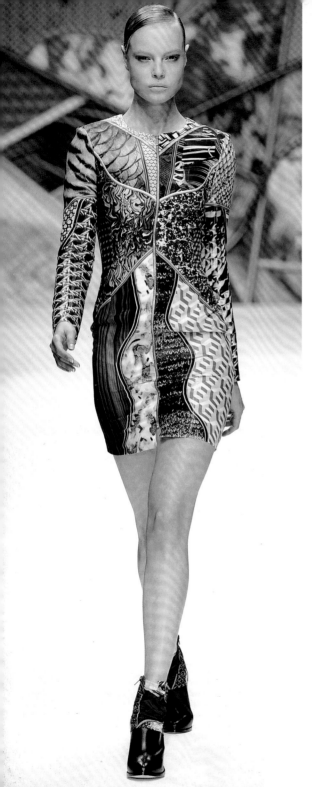

BASSO &
BROOKE

www.bassoandbrooke.com

One of the first labels to embrace and fully exploit the techniques of digital printing, Basso & Brooke continues to deliver a kaleidoscopic mix of pattern and colour. Brazilian-born Bruno Basso (1978–) and Englishman Christopher Brooke (1974–) released their first collection under the label for London Fashion Week in 2005. The duo met when Basso moved to London to study visual anthropology after a three-year stint as an advertising art director in his native Brazil. Two weeks after his arrival he met Brooke, an English fashion graduate from Kingston who went on to gain a Master's degree from Central Saint Martins College of Art & Design. Basso is the master printmaker; Brooke designs the pieces that carry the prints. In 2004, they were the inaugural winners of Fashion Fringe, a competition to search out emerging talent.

The look of the label has developed over the years as complex pioneering techniques, such as printing on sequins and a process that results in a high 3D shine, have been exploited. The resulting collages of images from a myriad of sources, all rendered in polychromatic explosions of texture, are displayed in garments simple in shape and construction. Basso & Brooke's innovative use of the digital printing process has resulted in the Metropolitan Museum of Modern Art acquiring a Swarovski crystal-embellished garment in 2005. In May 2009, Michelle Obama wore a piece from their S/S 09 collection at an informal evening of poetry, music and the spoken word at the White House.

◀ **A multicoloured digital
patchwork of Asiatic
print motifs adorns a
sheath dress for S/S 10.**

2005

Subversive prints of sexual imagery flow across tasteful dresses.

Basso & Brooke's capsule collection, which secured £100,000 and the Fashion Fringe Award in 2004, hinged upon the 1980s-inspired garment forms redefined into edginess. This was achieved by Basso's superimposed flourishes of bawdy imagery, digitally printed and engineered to the dress and jacket shapes designed by Brooke. Digital print remains the duo's hallmark technique.

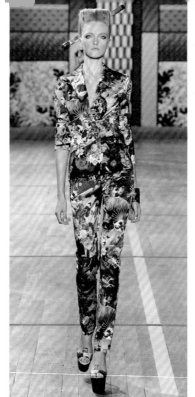

2010

A neo-pop recollection of Jeff Koons, this striped blazer dress with meandering swirls is cinched below notched revers over a bra top.

Designing few variations in silhouette beyond the mid-thigh waisted cocktail dress (with a little drape at the hip), Brooke offers his graphic partner Basso a largely stable canvas on which to place his engineered digital prints. The exception to this is the layered interplay of blazers and bras in occasional outfits. The livid glossiness of the neo-pop-based prints is a sign of their subsequent development into a 'high-gloss aqua finish' the following season. The hard-edge hyperrealism of Basso's prints is animated by the fragmenting of pattern into swirls and fissures of vivid rainbow colours across the garments. The saturation of print is leavened by limiting it to panels over sheer base fabrics in a number of the body-conscious styles.

2009

A tailored trouser suit with an obi sash is digitally printed with figurative cornucopia.

Inspired by the Japanese traditions of dress, composition and pattern, the 'High-Tech Romance' spring/summer collection makes a very literal connection to geisha culture through its core accessories. References to *okobo geta* sandals, obi sashes and *kanzashi* hair sticks are evident throughout and are in themselves vehicles for yet more print saturation. The range of juxtaposed motifs runs from hard-edge florals in shades of crimson, turquoise, purple and yellow to direct references to Edo period artist Katsushika Hokusai and the dark tonality of manga.

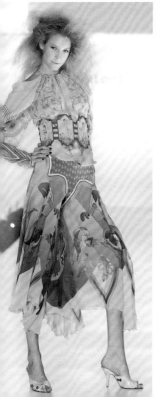

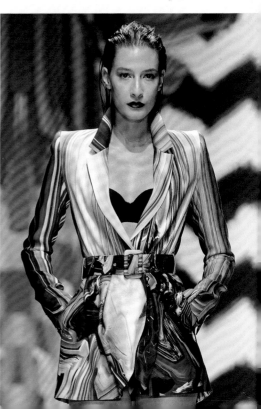

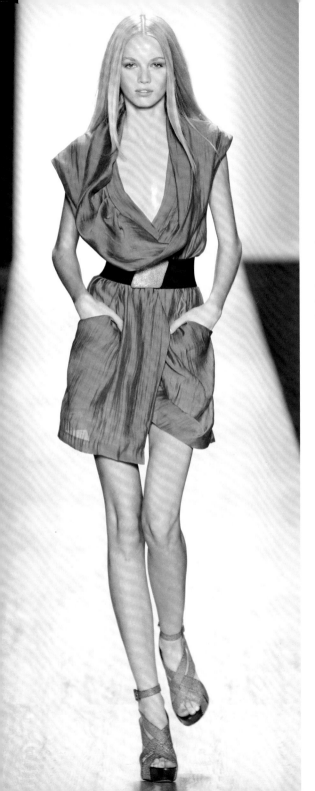

BCBG MAXAZRIA

www.bcbgmaxazriagroup.com

Ruched and draped cocktail, maxi and day dresses in vibrant colours are the components that make the BCBGMAXAZRIA label (named after the French phrase *bon chic, bon genre* – 'good style, good attitude') a red carpet favourite. Californian-based Parisian designer Max Azria (1949–) has built a thriving fashion empire that encompasses numerous apparel, accessories and fragrance lines, starting with the BCBG label in 1989. The first New York catwalk show in 1996 consolidated Azria's success as a designer of affordable pieces with a fashion edge. He debuted the Max Azria Atelier line in 2004, a collection of sophisticated evening dresses in which draping and pleating are used for maximum Hollywood glamour. Azria launched his first ready-to-wear collection, Max Azria, co-designed with his wife Lubov, in February 2006 on the New York catwalk.

Azria is also the designer, chairman and chief executive of BCBGMAXAZRIAGROUP, which, in 1998, acquired the French fashion house Hervé Léger, renowned for body-con bandage dresses. He relaunched the label in 2008, for which he received the Fashion Excellence Award at the thirty-third Annual Dallas Fashion Awards. A young contemporary collection, BCBGeneration, also appeared in 2008. His many awards include California Designer of the Year (1995), Atlanta Designer of the Year (1996), the Fashion Performance Award (1997), the *Hollywood Life* Breakthrough Award (2004) and the Wells Fargo Century Fashion Achievement Award (2007) at the Los Angeles Fashion Awards.

◄ **Draping and the bold use of bright colour are the focal points of the collection for S/S 09.**

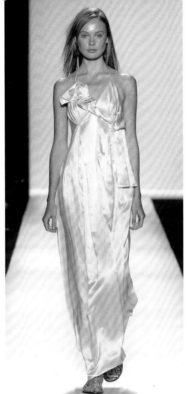

2000
A precisely tailored ready-to-wear collection for autumn/winter featuring pastel tweeds, tan leather, fur and metallic snakeskin.

Metallic threaded tweed gives a tailored wrap coat added urban glamour, the details such as patch pockets and a tie belt defined with topstitching. Gold leather boots inject more glittering allure, as do silver lamé and metallic brocade trouser suits. Decorative stitching also appears over fabrics patchworked together to form knee-length evening dresses and tailored jackets. Coats are cut from softly checked pink and apple-green tweed and mixed with metallic poison-green reptile-skin skirts. Tan leather is shaped into trousers and pinafore dresses with slashed, swirling hems and mid-calf skirts. Evening wear includes pink chiffon dresses worn beneath luxurious white Mongolian lamb full-length coats and sheer nude chiffon tops with a scattering of rhinestone embroidery.

2011
'BCG' is dropped to differentiate this collection from the main line.

An easy-fitting skirt with unpressed pleats in nude silk-satin, accompanied by a floating chiffon top and long scarf, provides subtle glamour in a collection that focuses on finely detailed understatement. Elsewhere, sheer loose slash-necked tops are layered over pink satin ankle-length slip dresses or white swimsuits with provocative cut-outs. Trapezoidal forms feature on the bodices of silk georgette dresses.

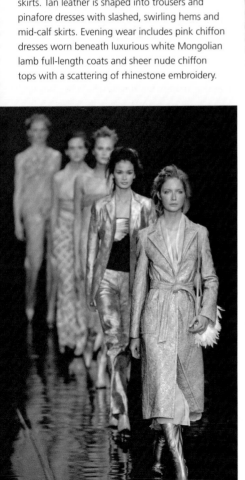

2006
A BCBG Max Azria collection in muted colours of lilac, putty and green for spring/summer.

An ankle-length evening dress in palest leaf green with halter-neck shoestring straps is adorned with a garland of ruched silk-satin across the breasts. Baby-doll tops with a discharge print of abstract leaves are worn with ruched and gathered shorts that are tied with a bow at the hip, or partnered with semi-tailored jackets. Columns of draped and gathered silk georgette are interrupted with jewelled belts on the hip, and oversized off-the-shoulder dresses in soft colours also appear with more intensely hued broad horizontal stripes.

BELLA FREUD

www.bellafreud.co.uk

In 2003, Kate Moss was spotted wearing a black cashmere jumper emblazoned with the slogan 'Ginsberg is God'. This instant fashion must-have, reissued in 2007, was by British designer Bella Freud (1961–) whose knitwear line, introduced in 1990, retains all the idiosyncrasy and wit of her former fashion label. Freud was born into a celebrated European dynasty that included her great-grandfather Sigmund Freud and father, painter Lucien Freud, who designed her logo. Her involvement with avant-garde British fashion began in 1977 when, at the age of sixteen, she was offered a job by Vivienne Westwood at her World's End shop, then called Seditionaries.

Freud subsequently studied fashion in Rome at the Accademia di Costume e di Moda, followed by tailoring at the Istituto Mariotti. She returned to complete her fashion training under Vivienne Westwood (see p.314) from 1980 to 1983 before launching her eponymous collection of tailored knitwear – a clever collaboration of classic meets quirky tailoring with her trademark school uniform and military references. Success and recognition came in October 1991, when she launched a collection at the London Designer Show exhibition for the first time, the very same month she was named Young Innovative Fashion Designer of the Year at the British Fashion Awards. In 2000, Freud became the fashion designer for Jaeger in a bid by the company to reposition itself as a contemporary label.

Freud's knitwear continues to display a punkish irreverence mixed with a Chanel-inspired Parisian chic, often with literary references. In 2010, the designer collaborated on a collection with Susie Bick.

◄ **A plaid blouson from 1996 with caped yoke creates angular volumes over cuffed trousers.**

1997 An eccentric costume pageant that appropriates aspects of culture and heritage.

In a bricolage of random elements of regalia, a knitted dress gains an air of playful eccentricity, from the black and white pompoms to the tiny swagged frills, secured with bows at the hem. The collection includes a tropical white sailor suit and a Spanish riding ensemble. Overlaying the Union Jack, a one-eyed dog features on a skull and crossbones on an intarsia knit. A classic silk brocade cheongsam is paraded alongside an extremely open-knit bodystocking, and faux ermine borders a lordly cape, worn over printed trousers.

2011 The 'English Boy' collection of spring knitwear embraces the style of David Bowie.

With the consummate simplicity of her 2003 success with the Ginsberg sweater, another role model is acknowledged with the 'Star Man' tag on an elongated sweater worn with a 1970s staple: striped socks. The five-piece collection pitches uncomplicated knitted separates with essential graphic flourishes, including a pop art lightning strike, throwaway text and an enigmatic exhortation to recognize the year 1970. Each is left to speak for itself in the orthodox frame of a black crewneck sweater or buttoned cardigan.

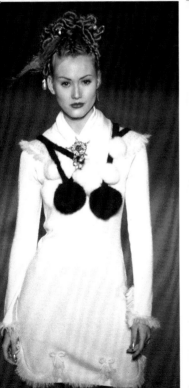

2007 Freud took on the residual iconography of the dormant Biba brand when it was relaunched in 2007.

Star-spangle print hot-pants, a croupier vest in sequins and a newsboy hat in green velvet are combined with the iconic Biba logoed T-shirt in the designer's first of two collections for Barbara Hulanicki's former brand. The collection pivots on a variety of retrospective garment styles, including a ruched bodice seen on a gathered satin jacket with rouleau loop fastenings – a Biba trademark, as are horizontally striped T-shirt dresses. Flared 1970s-shaped mid-calf skirts and dresses in large-scale floral print resonate with vintage glamour. A daisy print gets many outings: in white it is a shirtwaister, A-line from the hip; and in black it is an ankle-length pinafore dress.

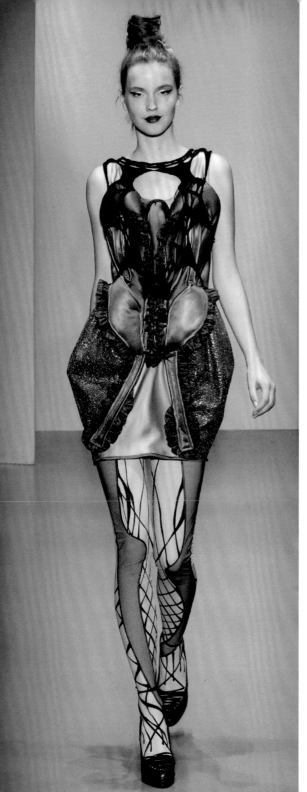

BORA AKSU

www.boraaksu.com

An intricate mix of textures involving handcrafted decorative elements using traditional textile craft techniques is the hallmark of Turkish-born Bora Aksu (1969–). An alumnus of both the Central Saint Martins College of Art & Design BA and MA courses, Aksu won the Topshop New Generation Award immediately on graduation in 2002, allowing him to embark on his own eponymous label in 2003. Notable collaborations include his work with Converse, the Cathy Marston Project – a contemporary dance company – and the Artisan Armour Group, which produced items for such epic films as *Troy* (2004). The creation of dance costumes proved a significant challenge for Aksu because he had to provide clothes that were both practical on stage and that could aid the narrative and character of the dance piece.

Aksu's S/S 05 collection, 'Living Waters', defined his style with its references to the glamour of the 1970s. The singer Tori Amos bought the whole collection for her 'Bee Keeper' world tour. The designer's craft-based aesthetic makes him an ideal collaborator with award-winning ethical clothing label People Tree, for whom he designs capsule collections to raise awareness about fair trade workshops. Founded by Safia Minney, People Tree ensures that collectives in developing countries are given training to produce clothes that use local craft traditions while being commercially viable. Materials and dyes are organic, and the label's policy is to have as little impact on the environment as possible.

Bora Aksu is available in fifteen countries worldwide, and has such celebrity followers as Florence Welch, Pixie Lott, Paloma Faith and Rihanna.

◄ **The 2011 'Ants & Corsets' collection combines carapace-like detailing with frills.**

The 1970s are revisited with sherbert-coloured chiffons and side-knotted headscarves.

Tori Amos wears high-waisted side-zipped hot pants with a crochet-banded top and a hippie headscarf. The handcrafted shoulder bag, in peach over mint green, reappears elsewhere worn with knitted knickers below a revealing draped top in orange crépon. Floating asymmetric layers of orange and lemon chiffon are fashioned into high-waisted dresses, one with caped sleeves and a keyhole opening, another inspired by the master of 1970s draping, the US designer Halston. Wide-legged trousers are cut high at the waist.

2004

Neutral-coloured collaged pattern pieces for spring/summer.

Scoop-fronted trousers, with buttoned flaps on each thigh, are hoisted up on to a cowhide belt, like cowboy's chaps, and worn below a sleeveless jacket with an asymmetrical zip. Elsewhere, sleeveless jackets constructed from straps twisted around the torso have elements of corsetry with bands of satin boning. Pink candy-stripe provides prettiness and is worked into fringe-hemmed dresses worn underneath waterfall coats.

2008

Ruffles, waterfall frills, lace and flounces in a highly crafted and complex collection of voluminous dresses for autumn/winter.

A caped jacket with billowing sleeves is bound in textured patent leather at the cuffs and neck, and falls open over a voluminous layered skirt, worn with black jewelled tights for gothic glamour. Waterfall frills are integral to the collection, cascading in a torrent of bound chiffon from neck to hem, from either side of the hips to a point, or providing volume beneath a light-as-air chiffon dress. Circular frills form undulating skirts on little black dresses. When not black, colours are Biba-esque: muted plum, dusty pink, ginger and khaki. Silk-satin bibs and belts are combined to provide definition to a soft floating silhouette; a circular padded braid is coiled around the neck and hips, attached by a row of buttoned tabs.

BOTTEGA VENETA

www.bottegaveneta.com

Understated elegance and technical virtuosity are the defining characteristics of luxury goods label Bottega Veneta (meaning 'Venetian atelier') under the current creative direction of Tomas Maier. The label was founded in 1966 by Michele Taddei and Renzo Zengiaro in the Veneto region of north-east Italy. In response to the excesses of logo-mania at that time, the company underplayed the notion of overt status dressing with the slogan 'When your own initials are enough'. Recognizable not by a logo or a signature print but by the distinctive construction process of hand weaving strips of leather called *intrecciato*, the label's handbags exemplified stealth luxury.

Bottega Veneta's fortunes declined, and by the 1990s the brand abandoned its understated ethos and attempted unsuccessfully to purvey a more trend-driven aesthetic. To get the label back on track, British designer Giles Deacon (see p.130) and fashion stylist Katie Grand fronted the brand in 1998, resulting in a more fashion-led profile. When the company was acquired by the Gucci Group in 2001, Tom Ford appropriated Deacon to work with him on Gucci womenswear (see p.136), replacing him at Bottega Veneta with Tomas Maier. Maier, with experience at Sonia Rykiel (see p.280) and Hermès (see p.146), set about returning the brand to its original identity. Bottega Veneta presented its first women's ready-to-wear show in 2005 and its first men's show in 2006. The brand includes fine jewelry, eyewear, fragrance, accessories, luggage and furniture.

◀ **Sports luxe, origami draping and minimal detailing by Tomas Maier for S/S 10.**

2000 The *intrecciato* weaving technique is used by Giles Deacon.

Bringing a slightly subversive yet high-fashion aesthetic to this two-piece suit, Deacon uses the label's unique weaving technique, more customarily used for handbags. The fitted jacket with narrow lapels and a single-button fastening is worn with a matching pencil skirt and ribbed knit. A wide floppy-brimmed hat and wrist warmers bring a modern edge to the collection.

2011 Understated elegance in black, putty and ecru from Tomas Maier.

A bi-coloured dress, with satin patch pockets, cascades to the ground in a swirl of slithery silk jersey from an empire-line waist. Daywear in the spring/summer collection includes knee-length trapeze-line dresses in black and loosely fitting silk-satin trouser suits. Cropped to the knee all-in-ones with frayed edges and loose horizontal pockets caught in the hip seam provide a more edgy glamour.

2005 Richly hued silk-velvet dominates an autumn/winter collection by Tomas Maier for both men and women, alongside flat tweeds, leather and red fox fur.

A burnt-orange blouson is worn with matching wide-legged trousers loosely gathered at the ankle – a sporty element in a collection devoted to double-breasted princess-line coats, sharp fitted trench coats in black, cream or pea-green leather and fluid jersey dresses with wrap tops in pea green and orange. The iconic 'Cabat' *intrecciato*-weave handbag, a square-shaped basket of supersoft skins incorporating a numbered plaque inside the interior pouch rather than exhibiting a logo, appears throughout the collection. Variations of this bag are still a hallmark of the brand, as is the understated promotion. Manufacture of the bags continues to take place in Verona, Italy, where the flexibility of the skins is tested. The weaving technique remains a trade secret and traditional methods are used: leather cutters use scalpels sharpened on stone rods to carve out the bag's shape.

BURBERRY

www.burberry.com

Since his appointment as creative director at Burberry in 2001, British designer Christopher Bailey (1971–) has transformed one of Britain's oldest clothing manufacturers into one of the most celebrated international fashion labels. By bringing Burberry into the 21st century, Bailey has accomplished what many British brands covet: a renaissance of a heritage brand that retains its quintessential Britishness and has a modern fashion relevance.

Following his graduation from the Royal College of Art in 1994, the Yorkshire-born designer worked for Donna Karan (see p.114) and Tom Ford at Gucci (see p.136) before being chosen by the then chief executive Rose Marie Bravo to design for Burberry. Bailey is responsible for the company's overall image, including all advertising, corporate art direction, store design and visuals, as well as the design of all Burberry collections and product lines. As creative director, he oversees some sixty different men's and women's collections each year, including the Prorsum, Brit, London and Sport labels, plus childrenswear, denim, underwear, fragrances, cosmetics, homeware and all the accessories (bags, shoes, eyewear and jewelry). He is also responsible for the design of the shops: 119 retail stores, 253 concessions, 47 outlets and 81 franchise stores worldwide.

In 2004, Bailey was awarded an honorary fellowship from London's Royal College of Art. And in 2009, he was named Designer of the Year at the British Fashion Awards and was appointed Member of the Order of the British Empire in the Queen's Birthday Honours List for his services to the British fashion industry.

◀ **The trench is reworked for 2010: shortened to mid-thigh with ruching replacing epaulettes.**

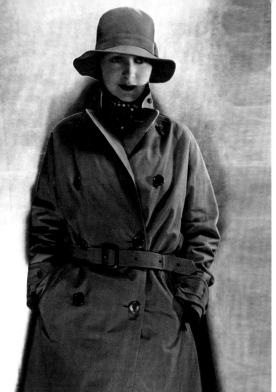

1970 **A revival of the brand in the 1970s brought the label to a younger, more fashion-aware customer through a series of advertisements in upmarket magazines.**

The black, tan and red pattern known as Haymarket check or the Burberry classic check was first used as a lining for the trench coat in 1924. The core function of the lining was to identify the outer gaberdine as that of the Burberry patent quality. It was not until 1967 that the 'Burberry Check', now a registered trademark, was widely used independently of the coat for accessories such as umbrellas, scarves and luggage. Priced at the top end of the market, the coat was advertised in high-end fashion magazines, such as *Queen Magazine*, with a series of aristocratic celebrities modelling the garment. The check was reconfigured several times in the following decades in an attempt to disassociate the distinctive design from a minority downmarket customer base who adopted the check as a trademark in the label-conscious 1990s.

1930 **From its inception, the trench coat, worn here with matching hat, became an invaluable wardrobe staple, and the label became synonymous with the raincoat.**

Burberry was founded in 1856 when Thomas Burberry (1835–1926), a former draper's apprentice, opened his own store in Basingstoke, Hampshire selling outdoor attire. In 1880, Burberry invented gaberdine, a hard-wearing, water-resistant yet breathable fabric, which he patented in 1888. In 1914, Burberry was commissioned by the British War Office to adapt its officer's coat to suit the conditions of contemporary warfare, resulting in the trench coat. Military details remain as style features on the classic fashion trench coat, including epaulettes (to hold the folded hat in place), adjustable straps on the sleeves to stop water running down the arm and capacious pockets. It is also double-breasted for extra warmth and to provide another layer of waterproof fabric on the main part of the body. The trench coat came with a quilted lining that was removable for wear in the warmer seasons.

2003 Intarsia-patterned knits combined with narrow jersey trousers, printed leggings and colour-blocked parkas in Christopher Bailey's first women's line for Prorsum.

Shaped knits with intarsia patterning of coin-sized spots and extended turtle collars alongside classic single-colour V-necked sweaters form the basis for a collection that includes wearable separates and pieces incorporating draped and knotted chiffon, an intimation of a look with the potential for further development by the designer. In addition to the narrow jersey trousers and above-the-knee straight skirts, the emerald-green satin skirt with oversized patch pockets at the front of the thigh is the only reference to the classic trench coat. Shades of green appear throughout the collection, from pale pistachio chiffon to the subdued khaki of the knitwear. An acid-bright yellow parka worn over contrasting royal-blue or purple chiffon dresses adds a significant shot of colour to an otherwise muted palette.

2006 A metallic theme encompassing gleaming satin, glittering sequins and iridescent copper runs through a collection of empire-line dresses and big-buttoned coats.

Paying homage to the fashions of the early 1960s, the collection incorporates cropped hemlines, ingenuous baby-doll dresses and silk ribbons tied in artless bows under the bust. Curved oversized floppy collars appear on wrap dresses and coats. Futuristic shimmer is provided by the use of silk faille, duchesse satin and gold brocade, structured into tulip-shaped miniskirts and coats, some with cuffed sleeves. The trench coat is acknowledged in the double-breasted shirt dresses, incorporating storm flaps on the shoulders. For a softer look, clinging knit lace tops are partnered with flirty skirts and skinny sequinned cardigans, all in shades of brown and yellow ranging from apricot and sand to caramel and cream, colours that are carried through into the menswear in double- or single-breasted suits and the classic off-white trench coat.

2008 Rich autumn colours and luxurious textures in a layered look.

2010 Rugged cropped aviator jackets contrast with pleated chiffon.

'Butcher-boy' caps, scarves and gloves reference the northern England artist L. S. Lowry, further confirmed by the use of traditional fabrics such as Yorkshire-woven wool and speckled Donegal tweed. These are constructed into sharply tailored slim-fitting jackets or traditional duffel coats, worn over paisley-printed shirts and boot-cut trousers in a palette of deep colours: chocolate brown, russet and bronze.

A collection that combines tough with tender: industrial-strength zips in delicate lace dresses; soft sheepskin variations of the aviator jacket, some of them knee-length, banded with leather straps and buckles; military battledress jackets complete with gold buttons worn alongside silk chiffon that is twisted and draped to contour the body. Bailey's signature palette of muted greens and browns is enlivened with tactile surfaces of velvet, fur, chiffon and satin.

BY MALENE BIRGER

www.bymalenebirger.com

With an ultra-feminine direction that encompasses delicately detailed dresses and sophisticated separates underpinned by subtle embellishment, the By Malene Birger label is one of the few Danish fashion brands to achieve global visibility. Designer Malene Birger, the creative force behind the label, graduated from the Danish Design School in Copenhagen in 1989. Birger designed for Jackpot by Carli Gry before becoming head designer for womenswear at Swedish company Marc O'Polo from 1992 to 1997. On her return to Denmark, Birger formed her first company, Day Birger et Mikkelsen, before leaving to freelance for a number of major fashion brands.

Birger's own brand, By Malene Birger, was launched in 2003 in Copenhagen, with major investment from Danish fashion firm IC Companys A/S, and with Birger owning 49 per cent of the company. In 2006, she opened a flagship store on Antonigade in the heart of Copenhagen. In addition, she has her own boutique in Illum, the department store on the city's main shopping thoroughfare. Birger is the recipient of many awards, including *Scanorama*'s Scandinavian Design Award in 2004, and, in 2008, *Costume* magazine in Norway awarded her Best Brand of the Year.

As a Danish UNICEF ambassador, Birger designs a T-shirt and a string shopping bag four times a year, the profit from which is donated to UNICEF. By Malene Birger is sold in more than 950 stores worldwide with franchise stores in Dubai and Kuwait City.

◄ **Broad black and white stripes feature either on the horizontal or the diagonal for S/S 10.**

2005 Consolidating the label with relaxed separates for spring/summer.

A cropped denim biker jacket with a belted collar lends a classic 1950s flavour to printed cotton shorts. The collection also features a crocheted thigh-high kaftan in aqua, accessorized with strings of coloured beads, and a striped burnt-orange chiffon blouse with frilled peplum and gathered sleeves. A lemon chiffon dress with a draped bodice and high waist is embellished with a jewelled collar that extends across the shoulders.

2011 Showing in Copenhagen: luxe sportswear in neutral colours.

Loose-fitting trousers, pleated and gathered at the waist and tied with a broad bow, accompany a cowl-neck silk-crêpe loose top. Breton-striped T-shirts, peg-top trousers and drapey dresses give a sportier edge in a range embracing safari jackets, pompom-edged linen kaftans, pencil skirts and blazers for workwear. Sequins add a dash of glamour on extended T-shirts and waistcoats.

2008 Leopard print and faux leopard fur with signature sequins on loosely tailored coats and jackets contrast with body-defining wrap dresses and pencil skirts.

A fluid leopard-print hooded cape is toughened up with a three-buckled squared-off feature at the waist. Leopard print is also worked into a wrap dress, worn beneath a boyfriend cardigan and with over-the-knee boots, and appears as faux fur in a simple single-breasted knee-length coat with fur buttons. Shots of bright colour – emerald green, purple and bitter lemon – are used as accents in a predominately sombre colour palette, infused into long fringed knitted scarves, bags and a single pencil skirt. Greys and blacks subdue opaque tights, over-the-knee socks and over-the-elbow gloves. Tulip-shaped tops with wide shoulders and narrow hems are worn over knitted leggings in metallic thread, which also appear under a black satin evening dress embellished with square-cut jewels on the bodice. Strapless prom dresses sport pink feathers around the gathered waist.

CALVIN KLEIN

www.calvinklein.com

The label is renowned for its minimalism, restricted colour palette of white, grey, cream, navy and black and restrained understated style. Calvin Klein (1942–), paradoxically, is also the designer who pushed the boundaries of sexual explicitness in selling his products, from jeans to underwear and scent.

Klein studied at New York's Fashion Institute of Technology in the early 1960s, launching his own label in 1968, initially concentrating on coats. By 1971 and the end of the hippie era, Klein tapped in to what the newly emerging professional working woman really wanted from fashion: easy interchangeable pieces such as trousers, drape skirts and silk shirts in luxurious fabrics that could be purchased from a single designer.

In 1980, Calvin Klein became the first label to sell designer jeans, launching the line with a notorious television commercial featuring the young actress Brooke Shields, who asked suggestively of the camera: 'Want to know what comes between me and my Calvins? Nothing.' The advert rapidly propelled the brand ahead of its competitors. This was followed in 1982 by Bruce Weber's homoerotic images of men clad only in Calvin Klein underwear, homage to the gym-honed body of the 1980s. Throughout this decade, Klein eschewed the then fashionable occasion dress, designing instead restrained tightly edited collections comprising his signature slip dresses and simple black tubes of jersey.

In 2002, Calvin Klein was sold to the Phillips-Van Heusen Corporation. The luxurious sensual minimalism of the brand remains under the creative directorship of Brazilian-born Francisco Costa.

◄ **Deceptively simple ingénue dresses in a predominantly neutral colour palette for 2011.**

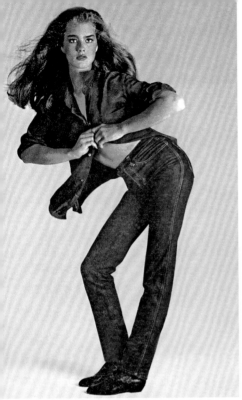

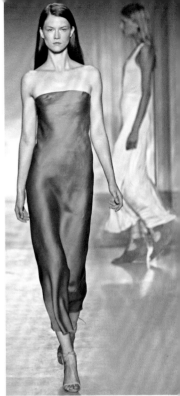

Easy tailoring in neutral shades offers aspirational luxury for the professional urban woman.

A two-piece trouser suit worn with a simple white T-shirt represents exemplary metropolitan style for the confident woman in the workplace, the softness of the tailoring in contrast to the aggressive lines of the power-shouldered trouser suits of the previous decade. Continuing the tradition of the pioneers of understated US style – Claire McCardell and Halston – the Calvin Klein label purveys an all-American pared-down aesthetic associated with the urban elite. It is financially underpinned by mass-market lines for underwear, fragrance and sportswear.

1980 **Brooke Shields models CK-monogrammed blue designer denim, photographed by Richard Avedon for a print advertisement.**

These jeans are identified by a loop-stitched back pocket with copper rivets and a zip fastening. Originally an item of workwear made from hard-wearing indigo-dyed cotton from Nîmes in France (thus denim), blue jeans were of a robust construction, reinforced with rivets and most popularly manufactured by Levi Strauss. Worn by anti-establishment figures such as James Dean and appropriated by the hippie culture in the 1960s, the first 'designer denim' became a high fashion item at the end of the 1970s. Designer jeans were styled specifically for a woman's shape where previously they had been generic in cut and manufacture. They are now invested with various design quirks and logos, in distinctive weights and washes, and are established as a fashion staple.

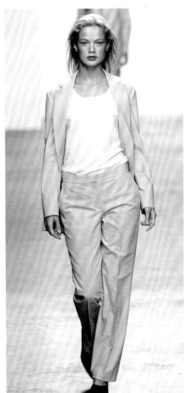

2008 **Signature minimalism in soft tailoring by Francisco Costa.**

A bias-cut silk-satin strapless sheath dress exemplifies the long lean silhouette that prevails throughout a collection of almost ankle-length skirts and dresses that gently acknowledge the waist with a simple seam or belt. Slope-shouldered jackets completely devoid of style lines or decoration partner high-rise narrow trousers and soft white shirts. Pearl-grey silk-satin shirts are tucked into palazzo pants.

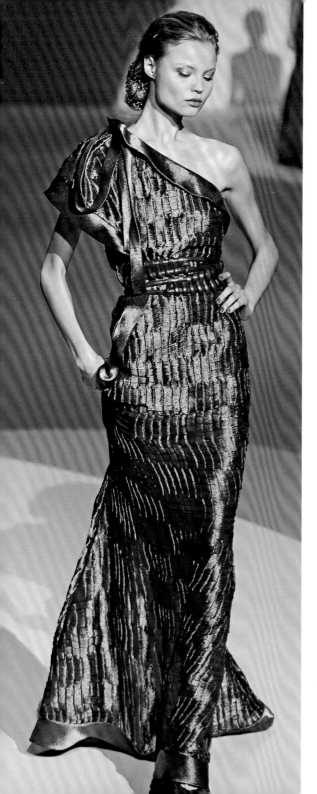

CAROLINA HERRERA

www.carolinaherrera.com

Carolina Herrera (1939–) lends her own inimitable style to a label that reflects her regular appearance on the world's best-dressed women lists. Born Maria Carolina Josefina Pacanins y Niño in Caracas, Venezuela, Herrera had a privileged upbringing, attending her first couture show, that of Cristóbal Balenciaga (see p.56), when she was thirteen. As a socialite in New York in the 1970s, she spent evenings at Studio 54 with friends Bianca Jagger and Andy Warhol. In 1980, encouraged by her friend and *Vogue* editor Diana Vreeland, she went into business and formed Carolina Herrera Ltd, offering elegant meticulously made clothes in luxurious materials that epitomized urban understated glamour.

Herrera launched a fur collection in 1984 and a bridal line in 1987, and opened her flagship store on Madison Avenue in 2000. A more affordable diffusion line followed in the United States, and in 2002 CH Carolina Herrera was launched, which includes fragrances, menswear, handbags and shoes. The designer presented her eponymous scent in 1988, followed by Carolina Herrera for Men in 1991. In 2008, she launched the CH Carolina Herrera line in the United Kingdom, and it has been extended to include ready-to-wear, menswear, childrenswear and home accessories. The company is owned by Puig. Herrera is a recipient of the International Center in New York's Award of Excellence as well as Spain's Gold Medal for Merit in the Fine Arts. She was also awarded the Gold Medal by the Queen Sofía Spanish Institute in 1997.

◄ **A one-shouldered wrap gown in a rugged jacquard weave in the 2010 collection.**

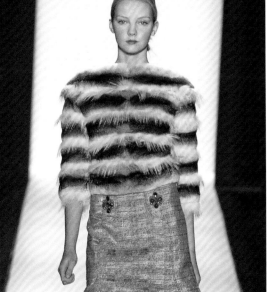
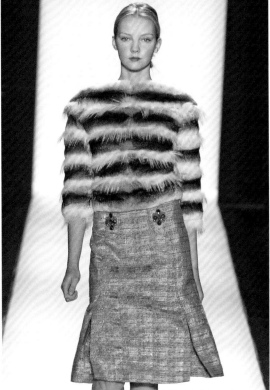

1988 Sharp-shouldered trouser suits epitomize 1980s power dressing.

A wide-legged trouser suit in neutral-coloured tweed has a long-line jacket that finishes exactly in sync with the sleeves. It is immaculately styled with matching accessories: a brown hat, suede heels and gloves. The white earrings pick up on the flash of white beneath the jacket's stand-up collar. A casually carried fur wrap with a striped lining in the same colour as the suit completes the look.

2010 Polished glamour in cocoon-shaped coats, chinchilla and floating chiffon.

Overlapping fins of soft grey silk organza interspersed with beaded cross-hatching segue into godets that float around the hem of the dress to form a fishtail. Daywear comprises wide-legged trousers worn with belted jackets beneath understated wrap coats with fox-fur collars. Sleeveless dresses have such design details as diagonal seaming or vibrant prints.

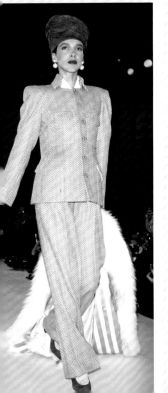

2005 Refined status dressing for autumn/winter combines demure tailoring and soft tweeds. Fur is incorporated in daywear and draped silk-satin in jewel colours for evening wear.

A luxurious chinchilla top worked into horizontal stripes and a gold lamé tweed skirt with two kick-pleats front and back represent high-end fashion for 'ladies who lunch'. The skirt shape also appears in flat tweed in soft pastel colours, partnered with prim fitted jackets. Shirt dresses and wide-legged trousers worn with chiffon print blouses or buttoned-to-the-neck jackets are appropriate for the boardroom. Evening wear comes both short and long; sleeveless knee-length dresses, some with flounced or pleated hems, are fashioned in subtle prints. The ankle-length bell-shaped skirt in conker-brown silk taffeta, billowing out beneath a crisp white shirt, typifies Herrera and is representative of her personal style. Red carpet candidates would favour the floor-length cowl-neck gown in purple satin, the fullness of the skirt pulled up to one hip.

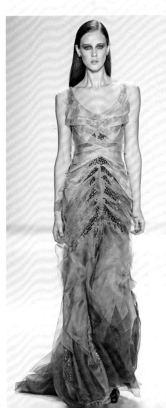

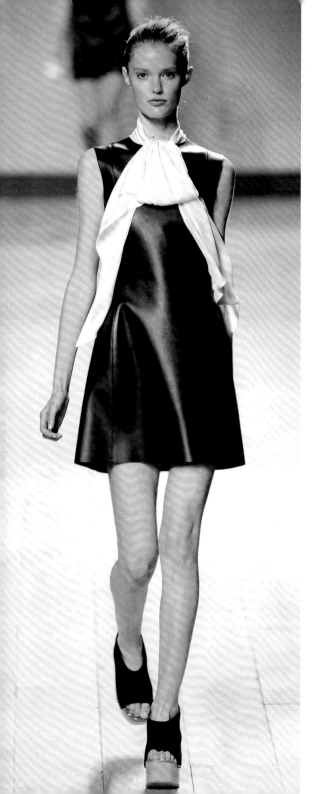

CÉLINE

www.celine.com

British designer Phoebe Philo (see p.244) has successfully repositioned French label Céline as a covetable fashion-led brand after years of sartorial uncertainty. Her appointment in 2008 followed a move to elevate the brand and to impose tighter control. This resulted in the closure of all but one store in the United States, the dropping of less exclusive retailers, the withdrawal of production from China and the restoration of the accent on the name.

Céline was originally founded in 1945 by Céline Vipiana as a purveyor of children's shoes that later expanded into the ready-to-wear women's clothing market. Apart from a brief period of profitability under the creative direction of US designer Michael Kors (see p.216), who left in 2004, the brand remained unfocused and underperforming under the auspices of ex-Burberry (see p.74) designer Roberto Menichetti and Ivana Omazic. In September 2008, following months of discussion with Philo, LVMH, which has owned the brand since 1996, announced the ex-Chloé visionary as the new creative director, starting with the autumn/winter collection in 2009.

Paris-born Philo, a graduate of Central Saint Martins College of Art & Design in 1996, initially worked as design assistant to Stella McCartney (see p.284) at French label Chloé before succeeding her as creative director in 2001. Philo fronted the label for five years before resigning in 2006 to spend more time with her family. Philo's appointment at Céline has turned the brand into one of the most influential fashion houses, the designer favouring a strong minimalist silhouette of wearable womanly clothes in luxurious fabrics.

◀ **Phoebe Philo's first catwalk collection in 2010 offers sportswear-influenced minimalism.**

1998 The debut collection by US designer Michael Kors.

Archetypal elegance from Kors is evident in this mid-calf pencil skirt with vertical hip pockets and trouser-front fastening for easy relaxed dressing. The heavy-gauge sweater of the same colour has a deep ribbed turtleneck and ribbed hem, and is worn beneath a matching three-quarter-length cardigan, putting a luxurious spin on the classic twinset, particularly with the addition of the red fox-fur collar.

2008 Ivana Omazic combines elements of couture with sportswear.

The fullness of the skirt of this burnt-orange empire-line dress is controlled by criss-crossed straps at the waist, creating a triangular silhouette that recurs throughout the collection, an effect emphasized with deep double hems stiffening the skirts. Full-pleated skirts appear with skinny fitted V-necked cardigans and off-the-shoulder trench coats. Draped silk-satin evening dresses are suspended from flat silver torques.

2005 Roberto Menichetti incorporates a 1960s-inspired look with minimum embellishment in one of the two ready-to-wear collections he presented for the label.

A royal-blue scoop-neck silk-jersey top with two-colour sleeves and buttoned teardrop-shaped cut-outs at the back falls loosely around the body. It is partnered with an A-line skirt with Swarovski crystal embellishment, a feature that also appears on the hem of a cropped jacket. A controlled colour palette consists of browns and purples with hits of citrus, turquoise and raspberry pink in silk jersey or taffeta. Balloon-hemmed sheath dresses and skirts feature a one-colour print of lotus flowers, occasionally matched with multidirectional geometric prints and broken horizontal or vertical stripes. Eyelets also appear around the neckline of simple jersey tops. High-waisted knee-length skirts with wide pleats and mannish loose trousers, sometimes cropped below the knee, are worn with two-tone pink jersey jackets.

CHANEL

www.chanel.com

Gabrielle 'Coco' Chanel (1883–1971) was one of the most influential designers of the 20th century; her understated clothes revolutionized women's lives and democratized fashion. She provided garments that epitomized simple relaxed elegance with their provenance in the utilitarian clothing of sport and leisure. With the assistance of her partner 'Boy' Capel, Chanel opened a shop in Deauville, where, from a small atelier, she began making off-the-peg clothes, eventually opening her Parisian couture house in the rue Cambon in 1928. Influenced by the sporting garb of her aristocratic English lover, the Duke of Westminster, she popularized the pocketed three-piece cardigan suit in fluid jersey, the cornerstone of daytime fashion for women in the 1920s and 1930s.

After several years of obscurity following the outbreak of World War II, the house reopened in 1954, specializing in easy-fitting simply tailored two-piece suits, in contrast to the rigid restrictive silhouette of couturiers such as Christian Dior (see p.92), whose work she considered retrograde. Chanel continued to design until her death in 1971. In 1983, Karl Lagerfeld (see p.182) was brought in as artistic director by owners Gerard and Alain Wertheimer to rejuvenate the house and to bring it to the attention of a younger edgier clientele. He did this by introducing subversive elements to classic Chanel pieces: he exaggerated the Chanel logo on the 2.55 bag and subverted the classic bouclé suit with variations of fabric, scale and embellishment. The Parisian fashion house is once again a globally recognized luxury goods brand offering couture, ready-to-wear, handbags, scent and cosmetics.

◄ **A cloqué spencer, with fringed jabot and cuffs, with a peg-top skirt for 2011 ready-to-wear.**

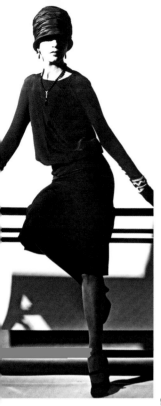

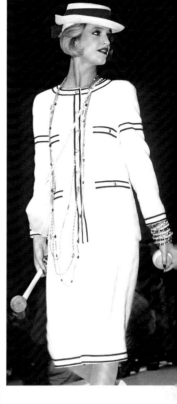

1956 The classic two-piece cardigan suit by Gabrielle 'Coco' Chanel, photographed in the couturier's suite at the Ritz Hotel in Paris.

With the reopening of her fashion house in 1954, Chanel introduced the timeless two-piece textured wool bouclé suit that exemplified mid-century wearable chic in an era preoccupied with the hourglass figure. The easy-fitting edge-to-edge jacket and the gently flared A-line knee-length skirt provided the contemporary woman with an elegant uniform that recognized the demands of modern life. The jacket was cut simply with a narrow torso, created by a high armhole and narrow sleeve. Decoration was limited to matching braid along the edge of the horizontal pockets, cuffs, hem and around the edges of the jacket. The hem of the jacket and the skirt were weighted to ensure an even hemline. The couturier also revolutionized the practice of wearing jewels, discarding the precious for the faux, with the ostentatious costume jewelry she created with Fulco di Verdura.

1926 The archetypal little black dress, a timeless classic of subtle glamour.

The simplicity of cut and ease of wear resulted in the little black dress entering the fashion lexicon of timeless classics. Described by *Vogue* as the 'Model T Ford' – the car that everyone could afford to drive and that came in one colour, black – of the fashion world, it democratized elegance. With lines that were easy to replicate by the ready-to-wear industry, it was the epitome of modern stylish elegance.

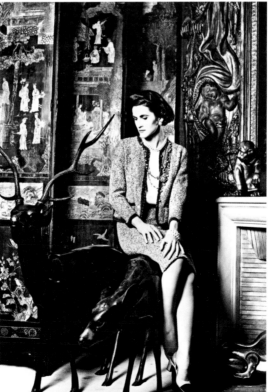

1984 Karl Lagerfeld refreshes the brand but retains some key Chanel details.

With the house almost moribund since Chanel's death in 1971, German-born Karl Lagerfeld was brought in to oversee the ready-to-wear line in 1983, with French designer Hervé Léger responsible for haute couture. Lagerfeld soon assumed total control of the label, subverting the Chanel signature look by replacing wool bouclé with denim and leather and exaggerating classic Chanel accessories such as outsize pearls.

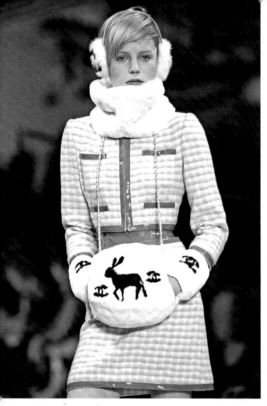

The two-piece suit is unmistakably Chanel, accessorized with the updated iconic 2.55 bag.

Named after the date of its creation – February 1955 – the 2.55 bag has evolved into one of the most significant fashion symbols of the 20th century. The quilted fabric or leather bags are suspended from a long gold chain interlaced with leather, an innovation in that era as it allowed ladies to carry their bag on their arm instead of in their hands. It fastens with a rectangular gold-plated lock. Three flap pockets make up its solid rectangular shape: the first in the shape of a tube for lipstick, the second zippered and the third for papers and letters.

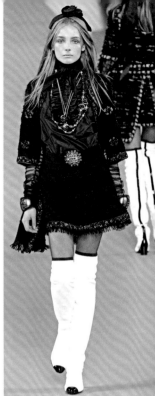

2001 **Cropped jackets and neat A-line skirts are combined with jacquard knits and mini sweater dresses for autumn/winter ready-to-wear.**

Bound in beige patent leather, the cropped boxy jacket has the horizontal pockets of classic Chanel. The chain-strapped muff replaces the shoulder bag, decorated with the interlocking double 'C' of the Chanel logo and the silhouette of a hare – a motif that reappears, together with that of a deer, throughout the collection. The emphasis is on the waist, with gently flared A-line skirts and short jackets, and V-necked tops and skirts. Softly tailored coats with patch pockets adhere to the same silhouette, while tweed or jersey ra-ra skirts are partnered with horizontally striped sweaters. Pink quilted silk-satin and bias-cut tweed are fashioned into fit-and-flare coats, while evening glamour comes from pleated chiffon dresses.

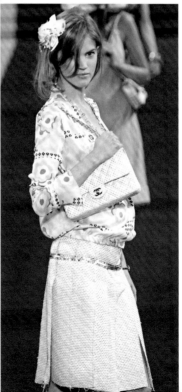

2006 **Appropriation of Chanel's hallmarks for autumn/winter ready-to-wear.**

Over-the-knee white boots with black patent toes recall Chanel's iconic two-tone shoes, as does the textured braid that delineates the edge of the skirt in this two-piece suit. Minimal little black dresses and coats are repeatedly decorated with a single brooch – the Maltese cross, the ancient symbol formerly worn by the Knights Hospitaller. It was first designed for Chanel by Fulco di Verdura, and originally set in a cuff.

2010
Furry trousers, sparkling mohair and icy jewelry for haute couture.

A patchworked sheepskin floor-length coat with an all-round fur trim for him, and a 1960s-inspired red wool dress with a deep band of fur on the hem and cuffs and tied with a tangle of deconstructed braid for her. Shaggy fur boots of yeti-like proportions appear throughout the collection with matching coats or heavily textured knits. Delicate ribbed mohair sweater dresses graduate from white to ice blue.

2011
Metallic tweeds, vivid floral prints and raw-edged textiles for ready-to-wear.

For spring/summer, a jacket of black, white and red windowpane-checked tweed is allowed to fray into fringed cuffs. It has a cut-away front and wide revers, and is worn with neat shorts and a vivid floral-printed blouse. Elsewhere, frayed ribbons are threaded into the lapels of a black leather jacket, with loose tendrils of thread floating from the dress beneath. Evening dresses are of raw-edged chiffon, or formed from alternate layers of jewelry-encrusted laser-cut lace in black and white.

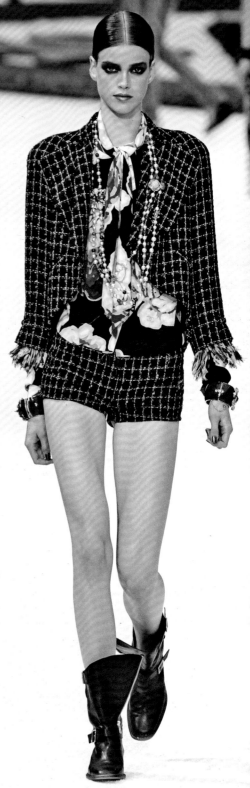

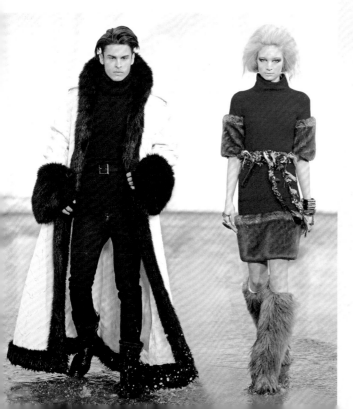

CHLOÉ

www.chloe.com

British designer Hannah MacGibbon brought a minimalist approach to a brand formerly famous for its frills and furbelows. The French prêt-à-porter label Chloé was founded by Gaby Aghion (1921–), a Parisian of Egyptian origin, to produce high-quality clothes without the formality of haute couture. Preceded by a series of designers including Martine Sitbon, Karl Lagerfeld (see p.182), Stella McCartney (see p.284) and Phoebe Philo (see p.244), MacGibbon was appointed as creative director in 2008, followed by Clare Waight Keller from 2011.

Under the auspices of Karl Lagerfeld, who worked for the label from 1959 to 1978 and then from 1992 until 1997, Chloé became one of the most covetable labels of the 1970s, projecting a fresh youthful style through fragile blouses and high-waisted fluid print dresses. While Lagerfeld was at Chanel in the early 1980s, Martine Sitbon introduced a series of masculine tailored suits before he returned to the label in 1992. Stella McCartney then became creative director, bringing the brand an edgy mix of sharp tailored jackets teamed with flirty vintage lingerie. McCartney left in 2001 and her assistant Phoebe Philo replaced her. Philo brought a streetwise edge to the label, introducing the first 'It' bag to the market: the padlocked Chloé 'Paddington'. She more than doubled sales with her witty baby-girl tunic dresses and vertiginous wedge-heeled shoes. See by Chloé, younger and more casual than the main line, was created in 2001. Philo left the label in 2006. Discarding all the frills, prints, hardware-laden bags and chunky clogs of previous collections, the designer brought her stripped-down sophistication to the label.

◄ **A 1970s-themed 2010 collection of streamlined minimalism by Hannah MacGibbon.**

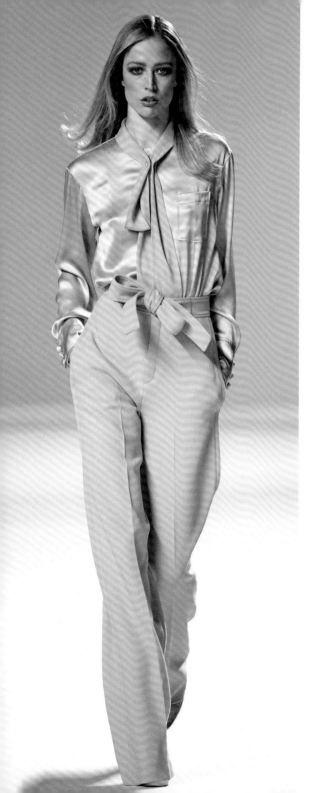

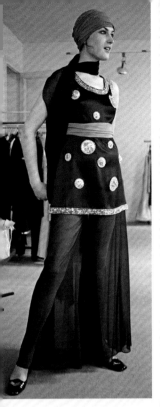

1998 Stella McCartney combines sharp tailoring with elements of lingerie for spring/summer.

A boned silk-satin corset worn over a button-through ankle-length dress resonates with McCartney's signature mix for the label of severe tailoring with sex-fuelled lingerie. Elsewhere in the collection, the corset appears in navy moiré with a shot-silk taffeta skirt, or is partnered with tiny lace bra tops worn beneath tuxedo-style jackets with wide lapels and nipped-in waists. Trousers are high waisted and flat fronted, with width at the hem to balance the sharp shoulders of the jackets, and worn with delicate lace appliquéd chemise-style tops.

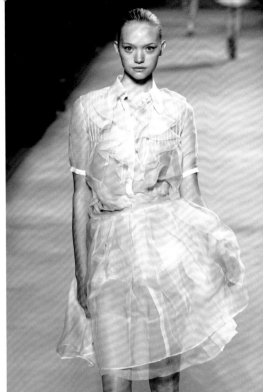

1969 A 1930s-inspired embellished Pierrot outfit by Karl Lagerfeld.

Marking the transition between the 1960s miniskirt and the longer hemline of the 1970s, the Pierrot outfit also references the nostalgia of that era for the 1930s. This is particularly evident in the choice of accessories: a head-hugging turban and a long scarf. The short tunic-style dress with bound armholes, neckline and hemline is worn over a transparent chiffon ankle-length skirt.

2006 A soft mainly unstructured spring/summer collection by Phoebe Philo features vintage-inspired embellishment.

A pin-tucked blouse with a jabot collar and a tiered skirt in organza represent the more structured elements of a collection devoted to easy free-flowing garments that in general bypass the waist. Kaftans show white-on-white embellishment of appliquéd daisies, pin-tucked yokes and rows of tiny pom-poms. Mid-calf smock tops are high waisted with vertical pockets and deep flounced hems, and are as loose-fitting as the A-line dresses with ruffled collars. Various shades of yellow, from egg yolk to chartreuse, provide a sudden hit of colour. A short-sleeved shirt worn with a high-knotted tie offers a contrast to the floaty femininity. One-button pea coats with patch pockets are an intimation of Philo's later pared-down tailoring for Céline.

CHRISTIAN DIOR

www.dior.com

Christian Dior (1905–57) became the most well-known name in fashion between the launch of the 'Corolle' collection, dubbed by journalists as the 'New Look', in 1947 and his sudden death in 1957. Synonymous with a new-found elegance and luxury following the austerity of World War II, the collection was funded by textile magnate Marcel Boussac. Dior's lavish use of fabric for the New Look was in defiance of clothes rationing and portrayed a nostalgic form of femininity. This exaggeratedly female silhouette, with its voluminous crinoline calf-length skirts and waspie belts that constricted the waist, was both influential and short-lived. Every Dior collection that followed introduced a new style: the Princess line, the H line (dropped waist), the A line, the Y line (with emphasis on the shoulders) and finally the Spindle line.

On Dior's death, his assistant, the young Yves Saint Laurent (see p.320), created his first collection for the label in nine weeks. Respecting the traditions of the house, the Trapeze line was widely acclaimed and meticulously crafted, with a younger softer appeal. However, his 1960 Beat Look enraged Boussac and when Saint Laurent was called up to the French army, the Dior management raised no objection. He was replaced by Marc Bohan, who imbued collections with his conservative style until 1989 when Italian designer Gianfranco Ferré took over. In 1996, John Galliano (see p.172) was appointed chief designer, by the chief executive of Dior's new owner LVMH, until his dismissal in 2011.

◄ John Galliano's interpretation of male 19th-century equestrian wear, for S/S 10.

1956

A more accommodating and less exaggerated silhouette by Dior in one of the last collections before his death.

Dior presented his clients with a succession of silhouettes: the Zig Zag (asymmetrical), Vertical and Tulip lines emerged between 1948 and 1953. Between 1954 and 1955 the H, A and Y lines were launched. The H line still had an emphasis on the waist, even though it was comparatively straight from shoulder to hip. This two-piece woollen suit or costume has a collar cut high at the back of the neck to form squared-off revers. The jacket has an extended button band that finishes at the waist. The skirt is pencil-slim and reaches to just below the knees. Decoration is kept to a minimum, with slanted pockets the only design feature.

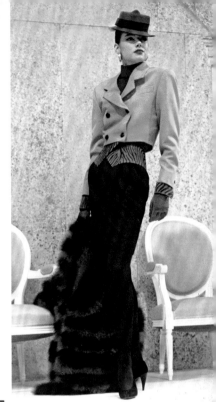

1947

A radical reintroduction of the hourglass figure, photographed here by Willy Maywald.

One of the best-selling items of Dior's New Look, unveiled in 1947 to an appreciative audience, was the *Le Bar* day suit: a mid-calf black wool skirt with deep knife pleats partnered with a pale shantung jacket fitted to the waist with a rounded shoulder line and padding on the hips, which epitomized the new femininity. The suit's infrastructure included a waspie corset and layers of stiffened petticoats to minimize the waist. Dior's New Look became one of fashion's defining moments and consolidated the influence of Paris and the haute couture system.

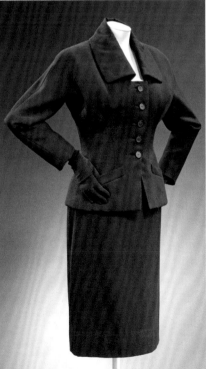

1988

As creative director from 1961 to 1989, Marc Bohan consolidated the reputation of the house.

For his last autumn/winter collection for Dior, Bohan juxtaposes complementary vibrant colours, including orange with royal blue and purple with forest green. The sharply tailored black skirt is partnered with a double-breasted colour-blocked cropped jacket in orange with a high-neck jumper of royal blue worn beneath. The bold use of colour and the broad shoulder line is typical of the period, as is the use of animal print to highlight the waist and cuffs.

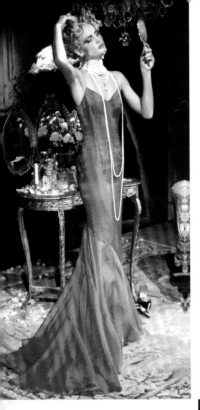

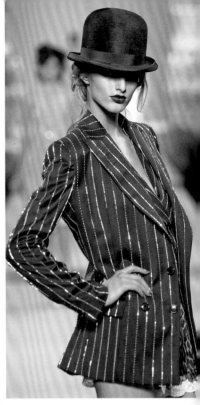

2005 Theatre and fashion collide in a collection of deconstructed dresses swathed in tulle and draped in taffeta.

The couture 'Creation' ensemble by Galliano purports to be a work in progress, with the muslin bodice suggestive of a tailor's form and with all the infrastructure of a couture garment on display, from the ribbon tapes and exposed seams to the tulle undergarment. The displaced bust-pad sits on the hip, and the pincushion, habitually worn by the atelier fitters, becomes an accessory by placing it on the arm. Elsewhere, the lavishness of plumed hats and embellished gowns is combined with mid-calf circular skirts of printed and beaded organdie over nude corsets. Folkloric embroidery appears in a Peruvian-inspired display of vividly coloured tutus.

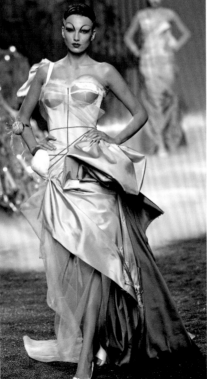

1997 Signature bias-cut romanticism and *fin de siècle* decadence from John Galliano.

On the fiftieth anniversary of the founding of the couture house, John Galliano presented his first haute couture collection at the Grand Hotel in Paris. The ground floor was decorated to replicate Christian Dior's late 1940s showroom on Avenue Montaigne, complete with 791 gilt chairs and 4,000 roses. The eclectic collection, which included Masai-inspired silk evening dresses, allayed fears that the young designer would prove too maverick for the position of creative director of the house.

2008 Galliano's transgendered ready-to-wear collection pays homage to screen icon Marlene Dietrich.

A brown pinstriped double-breasted jacket with a metallic thread worn over a lace-edged leopard-print petticoat juxtaposes masculine and feminine in a collection that channels the androgynous appeal of Dietrich. Her habitual attire of pinstriped three-piece trouser suits, white trenches and an insouciant beret appears in a collection that purveys the Hollywood glamour of the era. A silver ankle-length bias-cut satin slip dress is worn with a silver fox-fur collar. In shades of shell pink, eau de Nil and lilac, satin is worked into draped skirts and jackets, or fishtail-hemmed dresses.

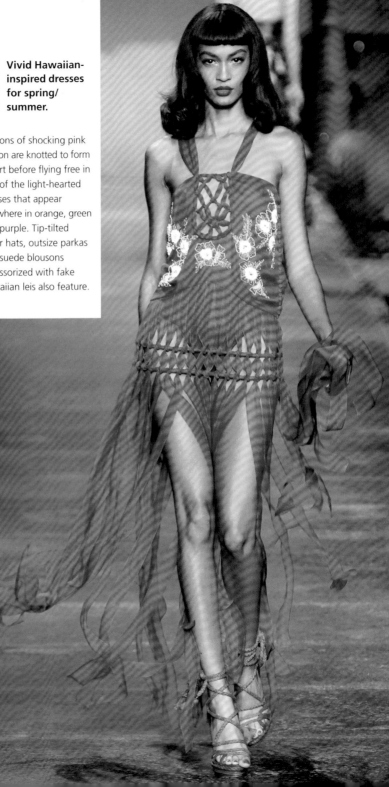

2010 Equestrian adventure and boudoir déshabillé in Galliano's ready-to-wear collection.

Supple leather is worked into a 19th-century-inspired highwayman's frock coat in conker brown, worn with back-laced boots for added swagger. The fragile printed slip dress is later partnered with fine-gauge knitted stockings with ribbon ties and frilled tops, or extended to the ground in a swirl of delicate embroidered chiffon. Off-the-shoulder knits are threaded with silk-taffeta ribbon ending in bows, and worn with tan leather jodhpurs. Jackets with pleated shoulders suggest bondage with three buckled straps across the waist.

2011 Vivid Hawaiian-inspired dresses for spring/summer.

Ribbons of shocking pink chiffon are knotted to form a skirt before flying free in one of the light-hearted dresses that appear elsewhere in orange, green and purple. Tip-tilted sailor hats, outsize parkas and suede blousons accessorized with fake Hawaiian leis also feature.

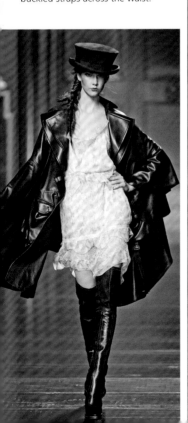

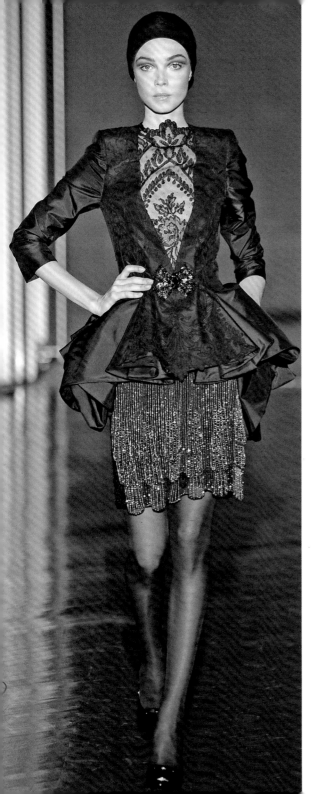

CHRISTIAN LACROIX

www.christian-lacroix.fr

Heralded by the international fashion press as the direct heir to Christian Dior (see p.92) when he opened his couture house in Paris, Christian Lacroix (1951–) reinvigorated the notion of couture with the extravagant sensuality and complex juxtapositions of colour and pattern in his debut collection in 1987. Borrowing from an eclectic sweep of sources, including Catholic iconography, bullfights and the circus, the collection incorporated lavish embellishment, excessive trimmings and a corseted boned silhouette.

Born in Arles, France, Lacroix never completed his studies in 17th-century art history and museum curatorship. Instead, his love of drawing and fashion, combined with fortuitous social connections, led to his position as head designer at the revered house of Jean Patou. While there, he introduced *le pouf*, the bubble or puffball skirt, in 1986, instantly changing the wide-shouldered tapered look of the 1980s into a more recognizably feminine form. Lacroix's success encouraged fashion entrepreneur Jean-Jacques Picart and businessman Bernard Arnault to create the twenty-fourth couture house in Paris, with Lacroix at the helm.

Although enormously influential, the house famously never made a profit. The failure of the first Lacroix scent, a brand of designer jeans and a ready-to-wear line named Bazaar heralded the descent of the label. In 2005, Arnault sold the house to the Falic Group, who filed for voluntary bankruptcy in 2009, resulting in Lacroix losing control of the house that bears his name.

◄ **A jacket with a deep peplum in a collection of luxurious textures for A/W 09/10.**

1986 Lacroix introduced *le pouf*, which became an instant fashion classic.

The puffball skirt brought change to the decade's sharp-shouldered silhouette, disarming power dressing and promoting whimsy and romance. The groundbreaking collection was awarded the *Dé d'Or* (Golden Thimble), a prize given by the international fashion press to the best couture collection of the year. Lacroix designed three collections for the house, reinstating its importance in the fashion hierarchy.

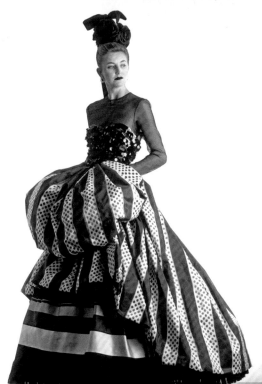

1996 Longer lines and a more restrained haute couture collection.

Borrowing from the Catholic imagery of southern Europe, this bride of Christ wears a severe ankle-length gown fitted to the waist and flared gently at the hem. It is accessorized with a halo/tiara and secularized by the flaunting of an oversized shocking-pink bow at the back and jewels rather than a rosary. Daywear includes tailored suits with customary jewelled embellishment.

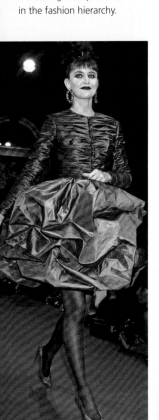

1987 The designer's fashion debut under his own name garnered enormous publicity, not seen since the introduction of Dior's groundbreaking New Look in 1947.

A riot of polka dots and stripes extends over hoops and petticoats to form a polonaise, which incorporates two types of fabric: the horizontally striped underskirt and the swagged and voluminous spotted and striped overskirt. The collection was presented to a horde of anticipatory photographers and fashion press. Drawing inspiration from the vernacular clothes of south-west France and Spain, the sixty garments – with titles such as Sylvéréal, Sansouires, Tamaris and Granada – use all the artisanal virtuosity of the atelier, such as fringing, beading, embroidery and leather work. Opulence is further attained with the use of vibrant colour and extravagant silhouettes, for example a yellow satin balloon skirt with black pompoms, red duchesse satin coats, jackets embroidered with Camargue motifs and pony skin and black Persian skirts.

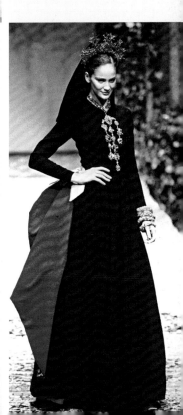

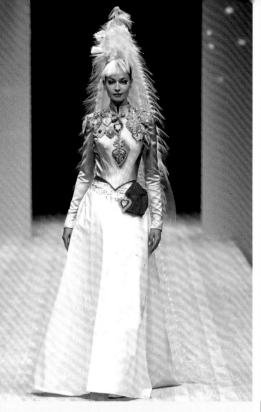

2003

A cornucopia of dazzling colours and textures for haute couture.

For autumn/winter, a slither of pea-green silk-satin is draped around the body to fall into a deep cowl neck at the front. The back is left bare and the side split to the waist to reveal an underskirt of metallic gold lace with a scalloped edge. Broad taffeta ribbon bows form a vertical headpiece worn over a silver skullcap, which also tethers a chiffon paisley-printed shawl on one shoulder and a jewel-encrusted three-quarter-length sleeve on the other. A contrasting corsage in shocking pink is secured in a puff of black fur.

1999

The runway as aisle – the traditional finale of an haute couture show is the wedding dress – using the atelier's skills to the full.

This 18th-century-inspired dress features a 'stomacher', a stiffened triangular section of fabric inserted into the bodice that ends just below the waist, keeping the carriage upright. This style historically includes front lacing, decorated with ribbon bows of decreasing sizes. Here, these are replaced with jewelled hearts pinned to the bodice. The traditional train and veil is substituted for frayed fronds of silk taffeta. Although Lacroix is renowned for his ebullient juxtaposition of brilliant colour – purple, mimosa, orange, pink and emerald green – couture customers frequently have the catwalk designs made in white to wear as a wedding dress. Bridal gowns are of vital importance to the commercial success of haute couture.

2004

Lacroix's version of Pucci's house style of polychromatic pattern.

A slip dress, split to the thigh with the bodice outlined in black and worn with a matching lightweight coat, features the designer's interpretation of Pucci's psychedelic colours, refined for a contemporary market. The patterning is translated into fine knits, shaped to the body and worn with cropped trousers. A scattering of paisley motifs is appliquéd to grey woollen coats and skirt suits, or used simply as lining.

2006 Sharp tailoring, luxurious fabrics and oversized prints for autumn/winter.

Military detailing enriches this sharply tailored mid-thigh skirt suit in faded lilac crêpe. The tabbed neckline, jacket facings and peplum are described in metallic silver thread, while a strip of black mink forms the collar. Fur is also used around the neck of a cropped red jacket, worn with tailored shorts. Overblown paisley motifs appear on a gypsy-inspired midi-dress and ultra-short miniskirts.

2008 An haute couture collection, with the title 'An Angel Passing By'.

Black and gold feathered wings sprout from the shoulders of a lace and brocade dress with a draped chiffon overskirt.

2011 Playing with scale in a collection of youthful menswear.

Too big or too small cropped or slouchy trousers and shrunken or oversized jackets in linen, denim and windowpane checks.

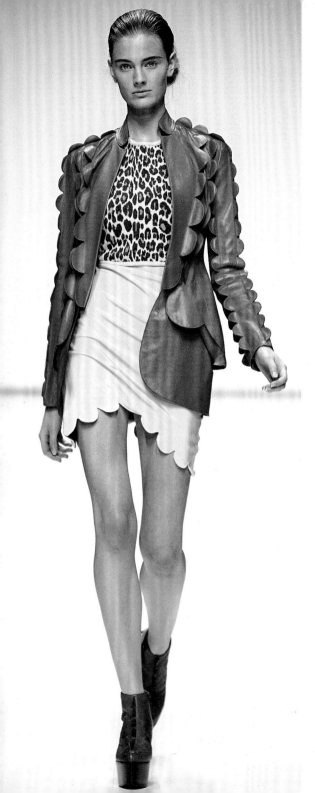

CHRISTOPHER KANE

Scottish-born Christopher Kane's strength as a designer lies in his ability to elicit a demure sexiness using such innocent components as gingham and lace. This was evident in his graduate fashion show from Central Saint Martins College of Art & Design in 2006, which featured a range of tiny body-con dresses of stretch lace. This immediately resulted in a job offer from Donatella Versace (which he declined) and an audience with US *Vogue* editor Anna Wintour.

Kane (1982–) established his own-name label in 2006 with the support of the Topshop New Generation grant. His sister, Tammy Kane, runs the financial side of the business and also assists in the fabric creation and design process. In 2006, Kane was awarded the Young Designer of the Year at the Scottish Fashion Awards.

Although refusing the job offer, Kane is a consultant to the Versace (see p.306) label. He also designs for the younger Versus diffusion line, of which Donatella is creative director, and the first full collection appeared in September 2009. The designer has also produced a range for Topshop; his capsule collection for the British high street clothing store was the most successful of all its young designer collaborations. In addition to designing his own label and consulting at Versace, Kane is also part of Atelier Swarovski, a small group of designers who create special jewelry collections for Swarovski. On 27 November 2007, Kane was awarded New Designer of the Year at the British Fashion Awards.

◀ **In 2009, scale-like circles of red leather form scalloped edges that contour the body.**

2007 Supershort bandage dresses in neon brights set the trend for fluorescent colours.

Metal rings are placed to provide tension from laced rouleau loops on specific areas such as breasts, buttocks and thighs. Recalling the body-sculpted dresses of the 1990s, bands of neon elastic are wrapped around the body and held together with industrial-sized zips. Separates involve thigh-tight patchworked skirts and loose sweaters in knitted lurex. Stretch-lace mini-dresses feature lace frills bursting from the edge of the dress or rippling across the torso in combinations of fuchsia with turquoise and orange with lime.

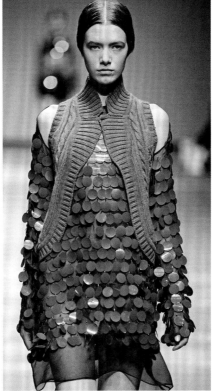

2010 Juxtaposing prim with perverse, pastel tablecloth checks appear with bra-shaped tops.

A soft gingham-type print, a fabric more commonly used on little girls or for kitchen curtains, is accordion-pleated into a flirty skirt attached to a transparent blouse revealing a bra top beneath. Gingham is used throughout the collection in shell pink and black. Demure puff sleeves contrast with thigh-high-split skirts to produce complex pieces that mix toughness with femininity. Scottish cashmere is fashioned into pastel-checked sweaters with raglan sleeves, the seams left open on the shoulders to reveal the blouse beneath.

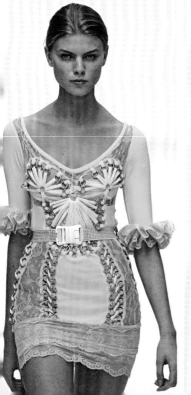

2008 Diverse weights and textures combine in this Aran waistcoat worn over a silk chiffon dress of oversized sequins.

These two materials come together elsewhere, with the paillettes applied directly to a cable-patterned sweater dress, either mid-calf or cropped, and worn with a ragged-edged chiffon skirt. Chunky knits appear throughout the collection, the result of a collaboration between Kane and Scottish yarn and knitwear company Johnstons of Elgin, which manufactures the cashmere elements of the designer's collections. In other pieces, the knit is discarded in favour of hide-and-seek sequins partially obscured by floating fabric panels. Heavily embellished jackets and dresses feature deep-piled scrollwork comprised of impacted pleated chiffon.

COMME DES GARÇONS

www.commedesgarcons.org

Averse to the superficiality of fashion trends, Rei Kawakubo (1942–) explores the eloquence of anti-fashion and deconstructionism to confront the accepted norms of personal adornment in the realms of clothing and cloth. A fine arts and literature graduate of Keio University in Tokyo, Kawakubo initially worked in a PR role with the Asahi Kasei chemical group, leaving to become a freelance stylist in 1967. Six years later, in 1973, she was able to formally establish Comme des Garçons, having first adopted the name in 1969. She moved to Paris in 1980 to open her first boutique and, by the late 1980s, her retail footprint had extended to more than 300 shops, with 25 per cent of them outside Japan.

Asymmetry, exposed construction and 'found' and contorted materials (all used in arbitrary volumes) are signature emblems of Kawakubo's approach. Despite this subversive and revolutionary attitude, which first appeared on the catwalk in 1981, Comme des Garçons has attained international fashion acclaim and global sales, winning for Kawakubo the Mainichi Design Prize in 1983 and 1987, and the Veuve Clicquot Business Woman Award in 1991.

Kawakubo is an avid collaborator, including working with her long-term partner Yohji Yamamoto (see p.318). The three-storey concept boutique – 10 Corso Como Tokyo – opened in 2002, the result of a partnership with gallery owner and publisher Carla Sozzani. This art, design and fashion experience shows thirteen Comme des Garçons lines alongside forty other guest labels.

◄ **For 2009, a pearl-laden dress is suppressed and sheathed with an overdress of chiffon.**

1983 A counterpoint to trend-led fashion is asserted through amorphous forms.

The ingenious interleaving of strip-cut panels from overlapping layers of wool jersey endows this sombre garment with aspects of a topological puzzle. This balanced symmetry is far from dominant in the rest of the collection, which heralds a radical confrontation with Western silhouettes. Kawakubo creates dramatic and irregular sculptural forms, producing a composition of colours and materials in motion.

2011 A monochrome collection playfully explores the concepts of displacement and the repositioning of traditional garment forms.

Buy one, get one free: joined sculpted leather and jersey pieces represent Kawakubo's surreal vision. Core garments – military coats, blazers, bikers and parkas – are erratically placed around the body, with sleeves and collars trailing behind. Sleeves are ubiquitous: falling from the hips, parked in redundant tiers at the shoulder or clustered and mismatched at the spine. A coat is constructed from two separate jackets – one long, one short – worn over billowing striped trousers or a folded jodhpur-shaped skirt. Outfits evolve gradually, but there are several repetitive accessory anchor points: deep boldly buckled empire-line belts, harness-strapped leather bras and feathered cloche hats. Other constants are a leather shift dress and strict shades of grey.

1997 Misshapen padding and stand-off volumes of pleated organza disguise the female body.

The distortion of the figure is matched by high coloration throughout the collection. Visual gravity is continually re-centred by the creation of extravagant curvy growths of either densely swaddled padding or of delicate self-supporting garment structures, manipulated from lightweight materials such as paper taffeta and organza. The intensity of the colour palette – red, electric blue, inky black, lime, chocolate, sky, gold and orange – reinforces the solidity of the irregular forms, like soft masses of oil paint squeezed from the tube.

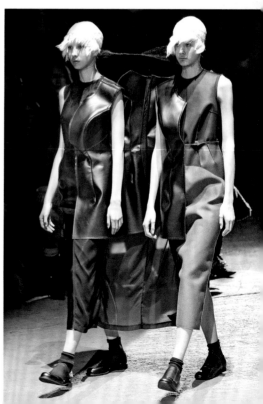

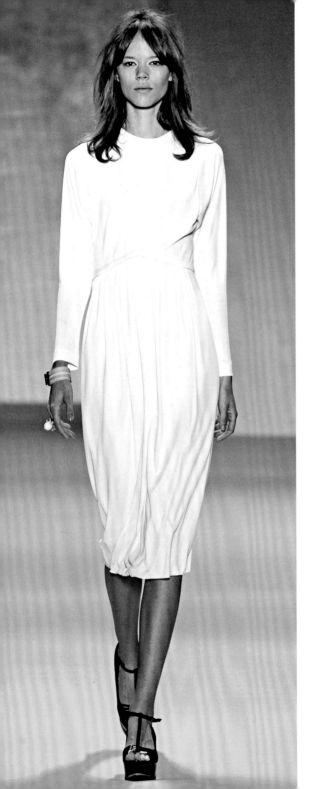

DEREK LAM

www.dereklam.com

Contemporary luxury is the defining ambition of New York–based Derek Lam (1967–). Aiming at refinement and elegance, Lam analyses the core features of a particular garment, such as the trench coat, and redefines its components into a new product.

Born in San Francisco, the child of Chinese immigrants, Lam began his fashion career in 1990 after graduating from Parsons The New School for Design. Following twelve years with Michael Kors (see p.216) as vice president of design for the KORS Michael Kors line, Lam went into partnership with Jan-Hendrik Schlottmann to found Derek Lam International LLC in 2002. Lam launched his own label in 2003.

A handbag line introduced in 2006 includes the designer's signature urban clutches and ram's head hardware. Also in 2006, Lam was appointed as creative director of the luxury lifestyle label Tod's, home of the iconic hand-stitched Gommino loafer and the D-bag. His capsule collection, a pared-down edit of fifteen pieces, put a modern inflection on the heritage brand. The business was established in 1908 by Filippo Della Valle as a small cobblers and was renamed Tod's in the late 1970s – the name was selected from a Boston telephone book because it was pronounceable in every language – by his son Diego Della Valle. In 2007, shoes and eyewear ranges were added, and the European luxury goods group Labelux acquired a controlling stake in the brand in 2008.

Lam has received numerous awards, including the Council of Fashion Designers of America (CFDA) Swarovski's Perry Ellis Award for Womenswear in 2005, the CFDA/*Vogue* Fashion Fund in 2005 and, in 2007, the CFDA Accessory Designer of the Year.

◄ **S/S 11 focuses on shape and fit, juxtaposing minimalism with 1970s-inspired stretch fabrics.**

2004
A collection of multidirectional floral prints, demure dresses and cashmere knits.

A strapless white and silver damask dress with a sweetheart neckline embellished with black embroidery around the empire-line waist exemplifies a collection of demure sexiness, also seen in midriff-baring black bra tops with gathered mid-calf skirts falling from the hips. Modest V-necks in lemon and pale blue are worn over floral print A-line skirts. Equally decorous, sheaths feature rose prints, with necklines scooped and gathered. Mid-calf silk-satin trenches appear in raspberry pink or are cropped to above the knee in ice blue.

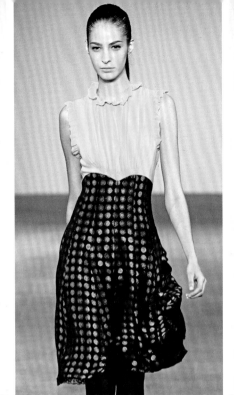

2010
From eclectic sources of inspiration come bold blocks of colour and lively florals.

This oversized easy wrap coat with a curved tulip hem has its revers caught into one of the parallel seams that runs from shoulder to hem, one of many playful tailoring details that appear throughout the collection. Another is an all-over star-print dress with asymmetrical hem and cowl collar, the neckline filled with a faux scarf in a contrasting colour that picks up the seamed piping of the dress. Shorts in bright primary colours are partnered with floral-print blouses, and tan suede is used for raglan-sleeved T-shirts and A-line skirts.

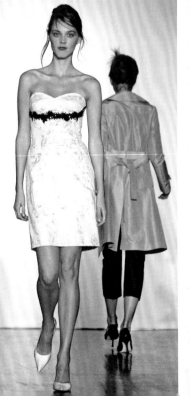

2006
Upmarket luxury with sharp silhouettes, fur accessories and bold hits of jade green and yellow for autumn/winter.

A finely gathered sleeveless bodice in golden yellow with tiny ruffles on the neck and armholes is affixed with a high-waisted heart-shaped seam to a printed spotted skirt, forming a princess line, with the fullness of the pleats released on the hip. Elsewhere, frilled and pleated chiffon tops are tucked into wide-legged trousers or layered over leggings beneath edge-to-edge jackets. Coats and jackets have caped sleeves; the latter worn over pencil skirts and cropped leggings. Lam's reworking of classic pieces includes trench coats in jade-green satin or cropped at hip length into jackets with vertical pockets and tie belts.

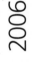

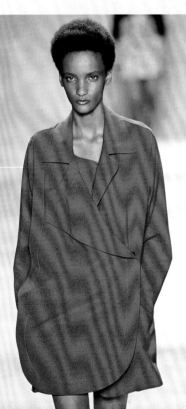

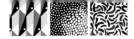

DIANE VON FURSTENBERG

www.dvf.com

The iconic wrap dress designed by Diane von Furstenberg (1946–) first appeared in 1972 – a statement piece for the sexually liberated women of the era. Designed to define the body, the dress wrapped in front and tied at the waist, and was made from drip-dry cotton jersey in her signature twig and splatter prints. The cut was so flattering to the body's curves that by 1976 some five million garments had been sold.

Born Diane Michelle Simone Halfin in Brussels, Belgium, the designer entered the fashion world as an assistant to a photographer and film-maker's agent in Paris. In 1969, she married Egon von Furstenberg and moved to New York, where she realized that women needed practical flattering clothes for the professional opportunities that were becoming available to them. After building up a fashion empire worth US $150 million under the Von Furstenberg label, the designer sold her original dress company in 1978, but lost control of her label to licensees in the 1980s.

In the 1990s, the wrap dress once again achieved cult status with vintage pieces being sought by fashion's cognoscenti. Von Furstenberg and her daughter-in-law Alexandra relaunched the business, and by 1997 the dress was back in production, this time in silk jersey with a new range of colours and prints. Its combination of elegance and allure still had fashion cachet and it has become a wardrobe staple for a new generation of women. Von Furstenberg is president of the Council of Fashion Designers of America.

◄ **A final show (A/W 10/11) by creative director Nathan Jenden presents vivid silk dresses.**

2003 Multicoloured floral prints, capri pants and full skirts recall 1950s style.

The button-through shirt dress piped in vivid primary red features in a collection with the title 'Once Upon a Time'. A 1950s look is referenced with pedal pushers and capri pants teamed with form-following bustiers. Mid-calf full skirts flare over frothy net petticoats, caught in at the waist with a wide belt or cummerbund. Neat cropped jackets are worn with wide-legged trousers or over the designer's signature wrap dresses, which come in a sleeveless printed chiffon version for evening.

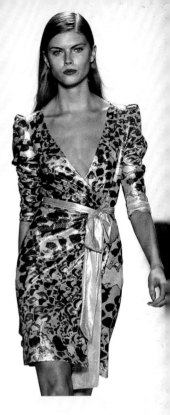

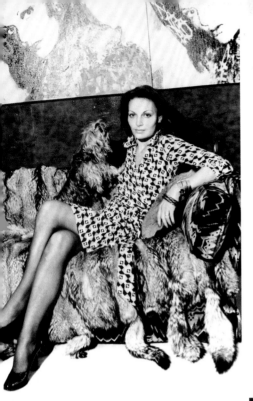

1973 Von Furstenberg models her design. The slogan, 'Feel like a woman, wear a dress!' appeared on every tag and is the company's registered trademark.

A global fashion empire was built on a simple wrap dress that spawned a million copies. Inspired by the appearance of Julie Nixon Eisenhower wearing her wrap top and skirt on television, Von Furstenberg decided to combine the two pieces into one. Unassuming, low maintenance, simple in construction and inherently sexy, the dress arrived on the New York scene just as the fashion world was ready to relinquish the kaftans and fringed maxi-skirts of the hippie style. The Diane von Furstenberg Studio produced easy-to-wear cotton and silk knit dresses in the designer's signature geometric prints from 1970 to 1977. In 1974, the designer introduced snake and leopard prints. Tops and long dresses were then added to the collection.

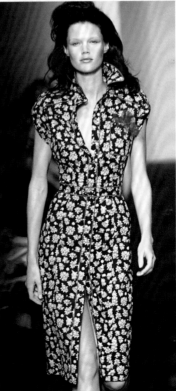

2007 Retro print designs feature graphic images on 1960s-inspired shapes.

Dresses in chrome yellow and black snake-effect print with gathered sleeves and tied with a lamé bow provide contemporary versions of the veteran designer's hallmark wrap dress, and also appear in fuchsia pink and black. Fuchsia pink continues to be a theme throughout the collection, appearing in leggings worn with off-the-shoulder black tops and as a flash of colour on a black sleeveless dress.

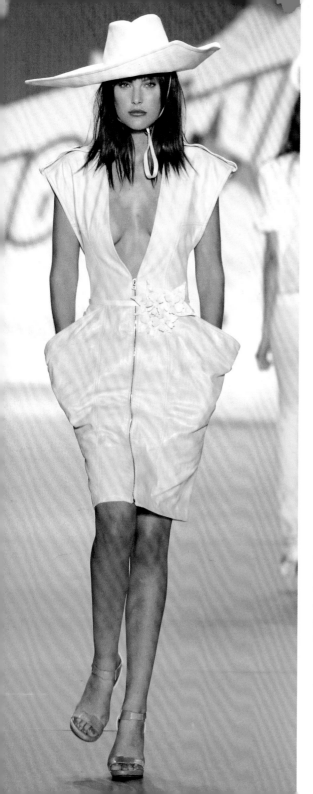

DIESEL

www.diesel.com

Only The Brave – the holding company of denim mega-brand Diesel – has more than 300 stores in eighty countries and has an estimated value of US $1.8 billion. As far back as 1997, Ernst & Young nominated founder and chairman Renzo Rosso (1955–) as Entrepreneur of the Year, and, in 2005, the German edition of *GQ* magazine named him Man of the Year.

Having grown up on a farm in northern Italy, Rosso became a student at Padua's technical college at the age of fifteen. On graduation, he joined a local denim company, Moltex, eventually securing himself a share of the business. Together with his former boss Adriano Goldschmied, Rosso launched the Genius Group in 1978, linking up with avant-garde designers and brands of the time, such as Katharine Hamnett and Martin Guy. At the beginning of the 1980s, Rosso began designing and selling jeans and casual wear under the Diesel label and opened a retail outlet in 1982. In 1985, he bought out Diesel from the Genius Group and pushed the turnover to US $130 million within five years. He introduced Diesel Kid in 1984 and Diesel Female in 1989, and the retail presence of Diesel extended to more than thirty countries.

DieselStyleLab was established in 1998 to offer a strong fashion impact, but the line was withdrawn in 2009. Sophia Kokosalaki (see p.282), whose label was acquired by the group in 2007, is the creative director of the directional offshoot Diesel Black Gold womenswear line, manufactured by Staff International, which also produces Vivienne Westwood's Red label (see p.314), under licence, as well as the Martin Margiela (see p.208) line.

◀ **A plunging zip-front dress with overstated pockets in primrose leather for 2008.**

2000 Layered separates of futuristic sportswear in a neutral palette.

A carapace-like cape anchors a hooded knit top worn over flared trousers in a collection of interchangeable units comprising apron-fronted miniskirts, layered tanks and sleeveless zip-fronted jackets. Both men and women sport wide-legged cropped trousers, with parka variations. Ultra-fine knits form off-the-shoulder sweaters, and Space Age stretchy tunic tops are zipped to the throat.

2010 Stonewashed double denim, neon nylon and leather, studs and chains for 1970s-inspired rock chicks and biker boys.

Double-denim shorts and a zip-front top with chain-effect fringing across the yoke and shoulders appear next to second-skin low-rise jeans and waistcoats with studded seams and skinny jersey dresses with studded hoods for rock chick chic. Black leather and denim are combined in jackets with a denim body and black leather sleeves and worn with matching minis. Elsewhere, surprisingly preppy layers of parkas over cropped cardigans and checked skirts appear, alongside chinos, lumberjackets and flannel mini-dresses. Oversized off-the-shoulder T-shirts with neon abstract prints recall the 1980s. Men predominantly wear parkas, in all shades of leather, partnered with sleeveless neon gilets.

2006 A playful subversion of militaria for men and women for the spring/ summer season.

A satin bomber jacket worn with white trousers suggests an off-duty uniform in a collection obsessed with all things military. Chinos, khakis, gold braid, fringed epaulettes, medals, forage caps, mess dress and fatigues appear; style lines and details are uniformly recognizable in their origin, but sharpened in interpretation. Details and colours are shared across the genders, but a counterpoint vein of womenswear evolves in satins and silks, with 'GI Jane' flaunting her cleavage in black bra and marabou and tilting a jaunty cap.

DOLCE & GABBANA

www.dolcegabbana.com

With a heady mix of corset-inspired dresses, see-through lingerie and the liberal use of leopard-skin prints juxtaposed with severe tailoring, Domenico Dolce (1958–) and Stefano Gabbana (1962–) reference a style that is rooted in their Sicilian heritage. The design duo convey a sultry sensuality inspired by strong iconic Italian women such as Sophia Loren, Monica Bellucci and, by adoption, Madonna. All three have appeared in advertising campaigns and been seen wearing the label on the red carpet. Dolce & Gabbana showed its first womenswear collection in 1985, followed by lingerie and swimwear in 1989 and menswear in 1990. During the early 1990s, perfume, scarves, ties and men's underwear all successfully went into production. In 1994, the company launched a diffusion clothing line, D&G, riding on the back of the successful publicity Madonna created when, in 1993, she wore D&G clothes on her 'Girlie Show World Tour'.

In 1995, the first eyewear and sunglasses collection appeared. The long-term collaboration with Madonna continues, and she designed three sunglasses for the S/S 10 range. In 2000, the designers launched D&G Time, a watch collection that is produced and distributed by Binda. Further collaboration came with the design of the Motorola RAZR V3i in December 2005, and Scarlet Johansson fronts a cosmetic line that was introduced in 2009. The brand's continuing success and expansion are evidenced by the perennial counterfeit trade in bogus Dolce & Gabbana goods.

◄ **A stiff organza dress and beaded jacket bring couture detailing to ready-to-wear in 2009.**

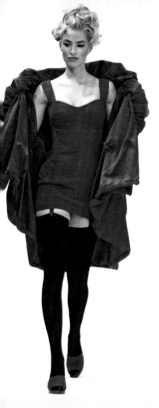

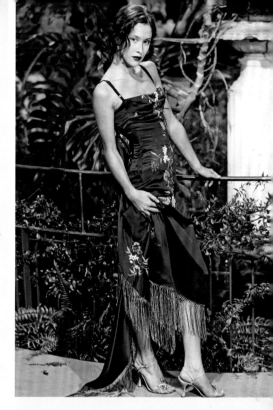

1996

Little black dresses, both long and short, alongside authoritative tailoring and leopard-skin beachwear.

A skinny-fitting shirt over a matching leopard-skin bikini and floaty headscarf represent flirtatious seduction, seen elsewhere in a diaphanous ground-grazing kaftan and an ankle-length sheath dress split to the waist. White and red two-piece suits with pencil skirts and wrapped and tied jackets imply a heady glamour when worn with a brown suede fedora. Minimal double-breasted trouser suits with mother-of-pearl buttons and tailored button-through dresses provide a contrast to a leopard-skin-printed coat worn over matching chiffon palazzo trousers.

1992

Teetering on the verge of 1950s boudoir and burlesque wear.

In a collection that makes no secret of exploiting titillation, a flyaway opera cape frames a scarlet corseted mini-dress. The raunchy tone is broadcast in a déshabillé campaign shot by Steven Meisel, featuring cleavage-enhancing styles. The clichéd vocabulary of seductive lingerie – from baby-doll negligees to beaded bra tops with opera gloves – is occasionally spelt out in sequins, shouting 'LOVE', 'SEX' or 'SUGARBABY'.

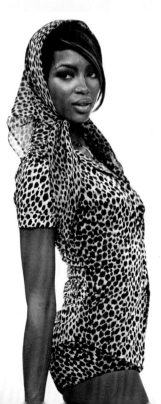

1998

A romantic flower-strewn collection includes lingerie detailing, fringed piano shawls and lavish oriental embroidery on metallic fabrics.

A corseted boned dress in conker-brown silk-satin has adjustable bra straps and a fringed hem, with 3D textile and embroidered flowers across the torso. Gold and old rose piano shawls – some embroidered and fringed, others left plain or printed in vivid colours – also feature and are married with long-line print dresses. Tubular metallic mid-calf dresses with bra-shaped tops are worn beneath loose jacquard-weave coats or topped with transparent chiffon overblouses. Silver bustiers are worn with tight black skirts, the silhouette softened with transparent black tulle embroidered with flowers, forming a train from the hips. An embroidered oyster satin coat with black turn-back cuffs has a dyed fur collar of old gold and a swag of textile flowers.

Dolce & Gabbana honours *La dolce vita* **(1960) with a partial re-enactment, complete with a mini Trevi fountain.**

A V-necked cashmere sweater and skimpy floral-printed boxer shorts are thrown together with cool post-modern insouciance. Although some outfits echo Italian actor Marcello Mastroianni's sharp suits and shades, the dominant formula is a mash-up of the casual modishness expressed by the 1960s Roman paparazzi in Federico Fellini's epoch-defining film. Garment styles are unerringly specific: hipster jeans, bomber jackets, blazers and reefers, camel Crombies and leather safari jackets. The mixing avoids rules of coordination, instead adhering to the principles of non-conformism: the wolf pup T-shirt print is neat with a tailored jacket and broad belt.

1999 **A collection of contrasts: miniskirts and maxi-coats in utilitarian nylon and lavish embroidery.**

A brief beaded miniskirt worn low on the hips is partnered with a shaggy dyed fur top, which features elsewhere over heavily patterned narrow trousers. Both outfits are accessorized with a broad jewelled belt, which is also seen around a black corset dress and a tartan miniskirt. Maxi-coats in buttercup yellow and fuchsia with three-quarter sleeves and small neat collars also appear in jade-green PVC, worn over Chinese embroidered cropped trousers in royal blue. Nylon coats are lavishly embellished with floral stitchwork.

2006 **Military detailing from the Napoleonic Second French Empire of gilded** *passementerie.*

An empire-line silk-velvet dress in dark forest green embellished with a gold tasselled cord and a chiffon frill is accessorized with a matching reticule, a small handbag first used in the 18th century. Equally elegant, falling from a ruffled collar, is a pale blue chiffon halter-neck dress, bound at the breast with a gilded embroidered panel. These ultra-feminine elements are offset by masculine-inspired militaria: frock coats with tabbed fastenings and cropped jackets with gilt buttons and epaulettes, all layered with waistcoats and shirts.

2009 — Volumes of fabric, from massive sleeve heads to crinolines.

A monochrome screen print of film icon and blonde bombshell Marilyn Monroe features on the voluminous skirt of an evening dress. Elsewhere in the collection, the emphasis is on the shoulders: marking them with fur, tailoring them into wide curves or outlining them with outsize ruffles. The wide shoulder is offset by knee-length pencil skirts and broad waist-nipping belts. Gloves are morphed into hats and scarves.

2010 — Underwear as outerwear: leopard skin, black lace and red rose prints define the label's signature style.

Epitomizing the sensual glamour of the label, the micro-length quilted floral skirt, hemmed in scalloped lace, is worn below a red leopard-print top with off-the-shoulder puffed sleeves and black lace insertions – just exposing the floral bra beneath. Red leopard-print chiffon is also worked into bandeau-topped mini-dresses, split-fronted sheath dresses and frilled skating dresses with ruffled gypsy necklines. Stretch-satin body-conscious pencil skirts with mismatched long-line bra tops also appear in plain black with added lace and fringing.

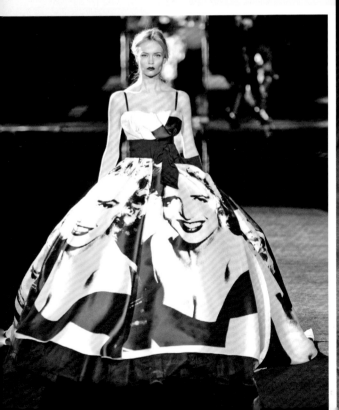

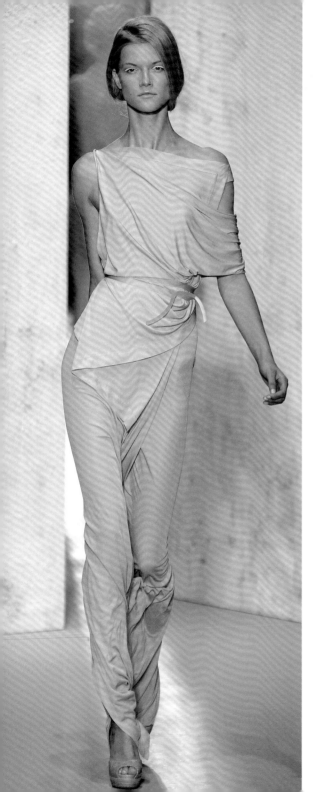

DONNA KARAN

www.donnakaran.com

Renowned for her 'seven easy pieces', US designer Donna Karan (1948–) has kept her finger on the pulse of what the urban professional woman wants since the inauguration of her label in 1984. The aspirational capsule wardrobe in supple stretch fabrics included the body, an all-in-one bodysuit that ensured a smooth contour beneath the softly wrapped skirt. Worn with dense opaque tights, the pieces were warmly welcomed by women who adopted them as a uniform for late 20th-century life.

Karan initially studied at Parsons The New School for Design, followed by a period working for fellow US designer Anne Klein, before launching her eponymous brand with her then husband Stephan Weiss and the Takihyo Corporation. The longevity of the brand is because of Karan's own approach to fashion; she creates problem-solving clothes such as the 'cold shoulder' dress, which obscures both the décolletage and arms, leaving the shoulders bare and providing evening glamour without excessive nudity. Ageless and classless, the brand also invests in the development of exclusive fabrics, with Karan committed to investigating experimental fibres and the latest technology in a bid to sustain the label's identity.

The diffusion line DKNY was launched in 1988. In 1997, Karan resigned as chief executive, but continues to act as chairperson and input on the Donna Karan line. She has been recognized seven times by the Council of Fashion Designers of America, including a Lifetime Achievement Award in 2004. In 2002, Peter Speliopoulos, formerly with Cerruti, was appointed creative director of the brand, which is now owned by LVMH.

◀ **Draped jersey dresses for 2010 are inspired by the elements: water, air, earth and fire.**

A black, white and grey debut collection by Peter Speliopoulos references Audrey Hepburn.

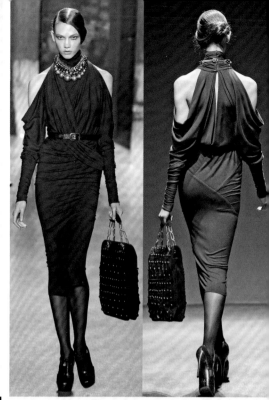

The two-piece grey tweed suit has all the hallmarks of 1950s styling: the stand-away collar that bares the neck and the two-seam sleeves cut on the bias for a close fit. Modernity is introduced to the autumn/winter collection in the futuristic silver oval belt, which is seen elsewhere in the show on second-skin catsuits or as cut-outs on the hip of white jersey knee-length dresses. Winter white coats have piped black leather seams running from the hip up to the raglan sleeves, ending in a neat stand-up collar.

1996 **Casual glamour in a mainly white collection for spring/summer.**

A minimal wool wrap coat with dropped shoulder seams and vertical pockets has a relaxed line in keeping with other pieces in the collection: midriff-skimming tops and edge-to-edge jackets. Karan's signature look of understated sexiness is evident in the single-button silk-jersey shirts with maxi-skirts, hung from the hips and showing a flash of bare midriff, and clinging ankle-length dresses with slashed shoulders.

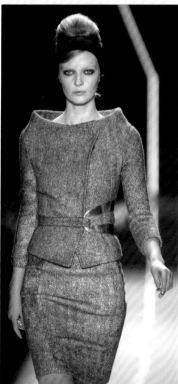

2009 **Empowering the working woman's wardrobe with the strong-shouldered long lean lines of the 1980s in luxurious fabrics.**

A halter-neck dress with a wrapped crossover bodice has sleeves that are open at the shoulder before extending over the wrist to form tight-fitting cuffs. Body-conscious clinging jersey is also used for close-fitting turtleneck dresses and tops, draped across broad shoulders and worn over calf-length pencil skirts in shades of brick red, rust and tobacco brown. Flannel and barathea jackets are cinched with simple leather buckled belts and worn over carrot-leg trousers (gathered into the waistband and narrow at the ankle). Vicuña is worked into a wrapped and belted overcoat, accessorized with leopard-skin-print arm warmers. Evening gowns feature folded satin taffeta, arranged in points along the top of the bodice and fanned out over the skirt.

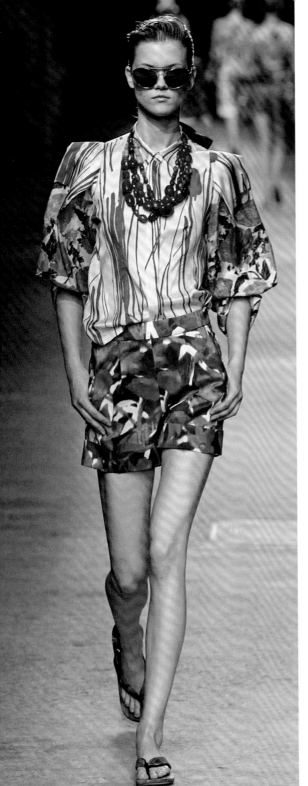

DRIES VAN NOTEN

www.driesvannoten.be

Luxurious layering in an eclectic array of colour, texture and print defines the romantic sensibility of Belgium designer Dries Van Noten (1958–). Following the family tradition – his grandfather was a tailor and his father a fashion retailer – Van Noten enrolled at Antwerp's Royal Academy of Fine Arts in 1976. He graduated in 1980, and began his career in 1986 with the launch of his first menswear collection as one of the avant-garde Antwerp Six collective at London's Fashion Week. In the same year, he opened a small boutique in Antwerp, and, in 1992, the designer presented his first men's collection in Paris, followed by a women's line one year later.

Van Noten's initial success as a master of high-end boho glamour was somewhat diminished during the long period of minimalist fashion in the early 1990s. However, since the beginning of the 21st century the label's combination of lavish materials once again has fashion appeal. These include jacquard weaves, printed velvets, complex knits and embroidered and over-dyed fabrics in a subtle colour palette configured into loose, wrapped and draped layers. In 2008, Van Noten won the International Award from the Council of Fashion Designers of America.

Continuing to live and work in Antwerp, Van Noten has five boutiques, and the brand is sold in more than 500 stores worldwide. Dries Van Noten is a privately owned company and does not advertise. The designer creates four collections a year: men's and women's for summer and winter.

◀ **Multicoloured florals on easy-fitting blouses, sarong skirts and floating dresses in 2008.**

1996
Sari silks and Indian-influenced tailoring in rich spice colours.

A loosely fitted double-breasted blouse is simply tied at the waist over an ankle-grazing wrap skirt of Indian-inspired block prints. Colours and textures are layered throughout, from richly embellished sari skirts worn over silk-satin trousers, gathered at the ankle, and topped with plain white Nehru jackets, to patterned sweaters that confine billowing knee-length silk blouses over wide-legged trousers.

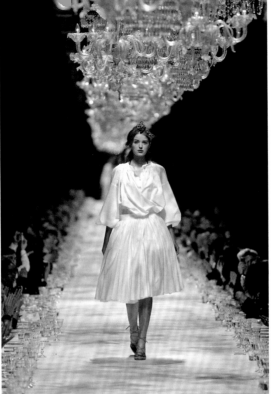

2010
A predominantly navy and camel collection of form-fitting striped and checked menswear.

The collegiate striped double-breasted blazer is enlivened by the braided and fringed persimmon scarf, which provides a note of colour in an otherwise sombre autumn/winter collection. Van Noten's propensity to mix print is confined here to playing off stripes against checks: a jacket of stripes has checked sleeves, and striped sleeves are given a checked body. In a similar vein, sleeveless trench coats are worn over checked shirts. The trench is also shown with contrast binding around the edges and on the pockets.

2005
Celebrating the fiftieth collection of the Dries Van Noten label, the show starts with pure white before incorporating the designer's signature embellishment.

A pleated peasant-inspired blouse fastened with a single button is loosely tucked into the unrestrained waistline of a full gathered skirt, promoting an easy, almost déshabillé appearance all in white. Variations of the blouse include a gauzy see-through version worn over a two-tiered skirt and a neater style worn under a side-fastening waistcoat. Big shirts in crisp cotton or faded vintage-looking printed florals are loosely drawn around the body, with sleeves billowing from a dropped shoulder line. They simply cross over at the waist and are worn over bra tops and partnered with gathered printed skirts. The bra is also exposed when worn under empire-line see-through soft print dresses, which are allowed to fall open to the waist. The colour palette and print definition intensify as the spring/summer collection continues, until the familiar mismatched prints appear.

ELEY KISHIMOTO

www.eleykishimoto.com

The business and marital partnership of Wakako Kishimoto (1965–) and Mark Eley (1968–) has established one of the most enduring and recognizable of London's creative brands over the last two decades. The two trained separately in the design of textiles for fashion: Kishimoto specialized in making printed garment collections at Central Saint Martins College of Art & Design and Eley designed woven fabrics for fashion while studying at the University of Brighton.

Their joint career began by providing print ideas for labels such as Louis Vuitton (see p.190), Alexander McQueen (see p.38) and Alber Elbaz (see p.34). They launched their own womenswear label in 1996. Their list of clients and collaborators is diverse, and ranges from design direction for Cacharel in 2008 to working with the Architectural Association and Volkswagen. Collaborations with Converse to produce trainers and Kimono Breath on a range of yukata robes used the trademark Flash design.

Rooted in decorative textiles, the womenswear label fits readily into a British outlook of capricious non-conformism, yet there is a Japanese sensitivity in the way in which pattern with pattern is given dominance in the relationship of garment form to ornamented surface. This decorative approach has also been used in a range of products, such as motorcycle helmets for Ruby, wallpaper, jewelry for Vendome, Ben Wilson chairs and G-Wiz electric cars. A Japanese licensing partnership in 2007 has consolidated the brand.

◄ **A hallmark bold repeat print appears on a demure summer smock for S/S 10.**

2002 Painters Paul Klee and Wassily Kandinsky provide print inspiration.

A geometric-printed skirt in a fauve-inspired palette is colour-matched to a wide-lapelled jacket and worn with an outsize red beret and printed tights. Within an eclectic stream of thrift-shop-style and misshapen pieces, the collection retains the authoritative stamp of strong prints, and explores the dramatic effects available when pattern, form and colour freely intermingle.

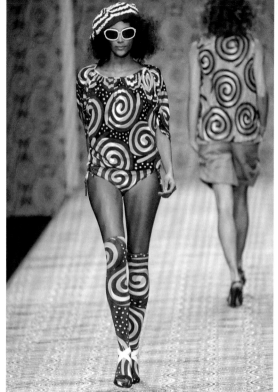

2008 Subtle references to Pierrot, mime and commedia dell'arte characters.

A cummerbund-seamed shift dress in a painterly bias check evokes images of the harlequin, a recurring motif in the collection. The wide ruffled Peter Pan collar and frilled circular yoke enter and exit; the white mime glove and circus-sized polka dots and buttons come and go – all hinting at theatrical detailing within accessible styles. Pantaloons and patterned clown shorts also make an entrance.

2005 Unsurprisingly, the Eley Kishimoto style displays a Japanese disinhibition in the mixture of patterns and colours when clothing the figure.

A loosely gathered smock top, pants and over-the-knee socks place the most pattern possible in the smallest area. An Afro-Caribbean theme forms part of the 'local' collection, which was launched simultaneously with Eley Kishimoto's Ellesse collaboration. Using a printed catwalk and juxtaposing exhibitionist teenage street fashion in Tokyo with Edo period court dress boldly reaffirms the Eley Kishimoto core value of pattern on pattern. The range of sources is broad and is used to play out consequences: what happens to an African print when you introduce an image of suburban London architecture; or what happens when you place an obi round a beach robe? Elsewhere, there are calmer moments that reveal a refined elegance: the bias-cut bodice of a print dress becomes ribbons of interwoven straps that form a halter 'necklace'.

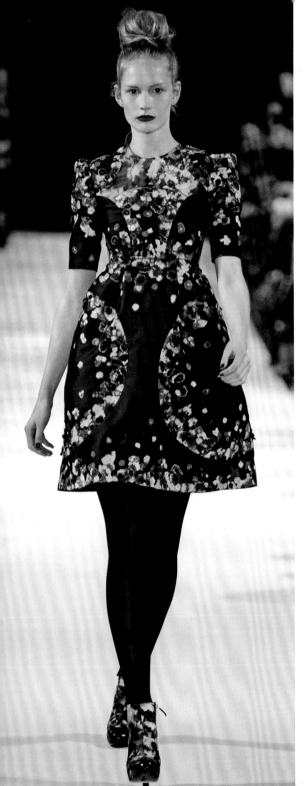

ERDEM

www.erdem.co.uk

Redefining print for the 21st century, Canadian-born designer Erdem Moralioglu (1977–) creates one-of-a-kind pieces of demi-couture worn by powerful women in the public eye such as Michelle Obama and Samantha Cameron, as well as by celebrities including Julianne Moore. Erdem's riotous prints have an eye-stopping impact that is all the more striking for being contained within the framework of a controlled and austere silhouette.

Moralioglu studied fashion design at Ryerson University in Canada before moving to London in 2000. Following a brief internship at Vivienne Westwood (see p.314), the designer secured a British Council scholarship to study for a Master's degree at the Royal College of Art. Graduating in 2003, the designer worked with Diane von Furstenberg (see p.106) in New York.

Aware of a gap in the market for feminine yet fashion-led clothes, Moralioglu launched his label in 2005, working out of a small studio in London's Shoreditch. The designer's signature graphic prints are the result of a painstaking series of processes. He scans, digitally manipulates and distorts an original piece of artwork, which is then worked on by hand to change the scale and impart a painterly quality. The whole process is enhanced by the judicious use of a radiant colour palette. Moralioglu limits his collections to simple pieces such as dresses, tops and skirts that emphasize his control of pattern and colour. He won the Fashion Fringe Award in 2005. In 2010, he was awarded the British Fashion Council/*Vogue* Designer Fashion Fund of £200,000 to support the future development of the brand.

◀ **3,000 flowers and 100 Swarovski crystals are attached by hand to the 'Narcisse' print for 2009.**

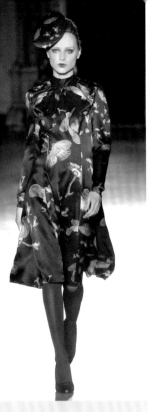

2008

A bold palette of citron yellows, rich amethyst and chlorophyll greens is combined with a series of print processes and a dramatic simplicity of cut.

A strapless ball gown features a profusion of digitally printed flowers embellished with Swarovski crystals along the petal-shaped hem of the skirt. The piece heralds a collection that deploys couture attention to detail and sources luxurious fabrics. Duchesse satin from the silk mill Taroni in Como is worked into quilted funnel-neck coats of gleaming yellow. French lace maker Sophie Hallette supplies the lace for the feminine reworking of the classic trench coat and for a series of evening and cocktail dresses in which it cascades from the neckline in a froth of tiered fabric. Box pleats are used throughout the collection: on double-breasted high-waisted coats, providing a neat carved look reminiscent of Givenchy in the 1960s; and to create the fullness of the balloon-shaped skirts of the ball gowns. The figurative prints are rendered abstract by the use of filters.

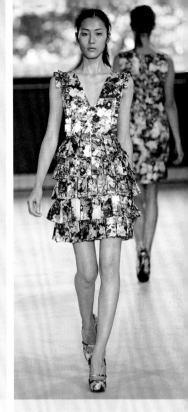

2006

A strong, assertive botanical print: the beginning of 'the Erdem woman'.

The most assured pieces in Erdem's first collection for A/W 06/07 feature prints of birds, butterflies and bold stripes, indicating the future trajectory of the label. Disparate components make up the range and include severely tailored elements such as cowl-neck dresses and pinafores in a sombre colour palette of grey and black. The introduction of yellow is the only intrusion of bright colour.

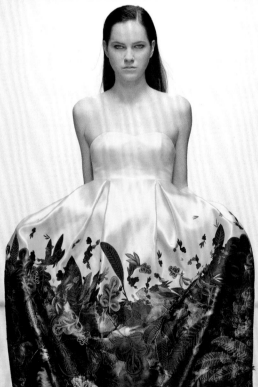

2010

Ultra-feminine frills and floral prints feature on demure dresses.

Box pleats are scaled down to define the seams of a fitted bodice and to create a many-layered skirt of frilled tiers. The print is reminiscent of vintage seed packets featuring violas and pansies, and is carefully engineered to provide a lighter zone above the waist. Shoes also carry the same print. Elsewhere in the collection, guipure lace is cut and appliquéd on to vibrant jewel-coloured silk-satin.

ETRO

www.etro.it

The bohemian flamboyance of the Etro label hinges on the bold fusion of saturated colour with uninhibited pattern and texture. Founded by Gimmo Etro (1940–) in 1968, the original business focused on the supply of highly embellished and luxurious cashmere, silk, linen and cotton cloths to the designers and couturiers of Milan. Emphatically Eastern in inspiration and coloration, the label adopted the paisley motif as a symbol in 1981, subsequently introducing men's and women's accessories in its hallmark cloths, and later branching out to include a range of leather goods and homeware.

The Etro label was made more visible in 1983 by the opening of its first dedicated store, followed by the first ready-to-wear collections on the catwalk in 1994. In classic Italian dynastic mode, the design direction remains in the hands of the founder's offspring: Veronica, who trained in London at Central Saint Martins College of Art & Design, and Kean take responsibility for the womenswear and menswear lines respectively, while Jacopo deals with textiles and finance, leaving Ippolito to run the accessories and home divisions.

Extrovert in intention, the label locates its many shops and concessions in the glitzier retail venues around the world: Rodeo Drive in Beverly Hills, the Forum at Caesars in Las Vegas, Madison Avenue in New York and many other capitals such as Dubai, Moscow and Rome where visible extravagance resonates. The decorative overstatement of its catwalk collections places Etro at the margin of cutting-edge fashion while representing de luxe hippie style.

◀ **In 2010, delicate printed fabrics produce a modern hippie look of relaxed femininity.**

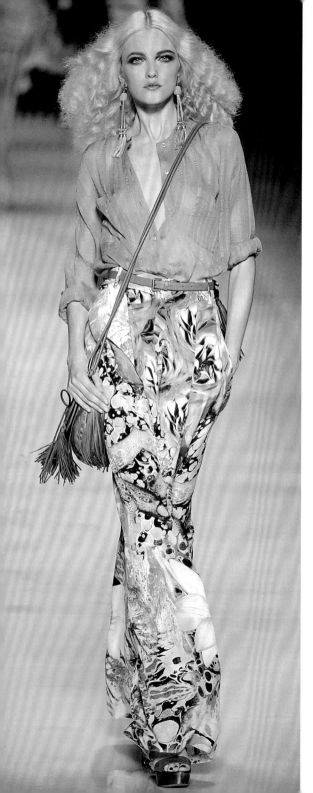

1997 A collection that represents the textile riches of the route from Samarkand to Shanghai.

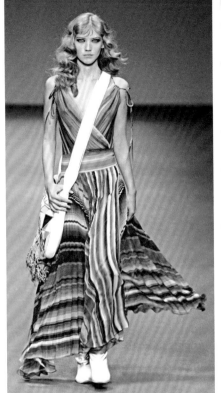

Evoking travels on the Silk Road, this outfit recalls the pagodas and stylized florals of the East. Silks, velvets, satins, furs and brocades are harnessed to an eclectic range of garment forms throughout. Diverse dress cultures come together: massive Uzbekistan-style hats in Mongolian lamb are worn with the demure cheongsam of Chinese Kashgar; or the cropped choli of northern India is teamed with a rich satin wrap skirt. Elsewhere, black satin creates an enveloping djellaba concealing the opulence and luxury of cashmere dresses.

2006 Matisse-inspired cut-outs in Mediterranean colours and paisley prints dominate the collection.

The signature paisley motif is diffused across the fluted panels of this free-floating ankle-length chiffon dress with a deep border of aubergine. The luxurious femininity of the collection includes flowing printed silk chiffon dresses, the bodice occasionally bound with twisted and knotted chiffon threaded with oversized beads. Cerulean-blue Matisse-like cut-outs decorate the borders of pure white skirts and jackets. Matisse is also referenced in black line drawings patchworked with paisley to form knee-length shirt dresses.

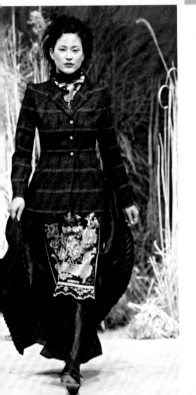

2004 The Etro look reconciles geographical diversity of inspiration by the use of a coordinated colour palette.

An extravagant rainbow-striped and sunray-pleated maxi-skirt and wrap-over top feature in a collection that explores expressions of femininity, such as chintz-patterned gathered skirts and shortened embellished kaftan-style tops. Sherbet-pink and turquoise wide-legged hipster trousers appear with flared smock tops and striped blazers. The signature paisley print features on simply shaped knee-length coats in glossy satin and is also patchworked on to black chiffon evening dresses. These elements are brought together through the unifying application of colours of spice market vibrancy across prints that are sheer and floaty or fitted and flimsy.

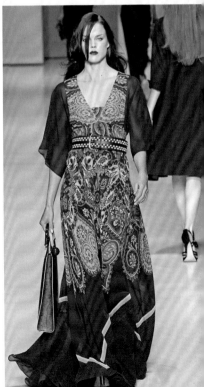

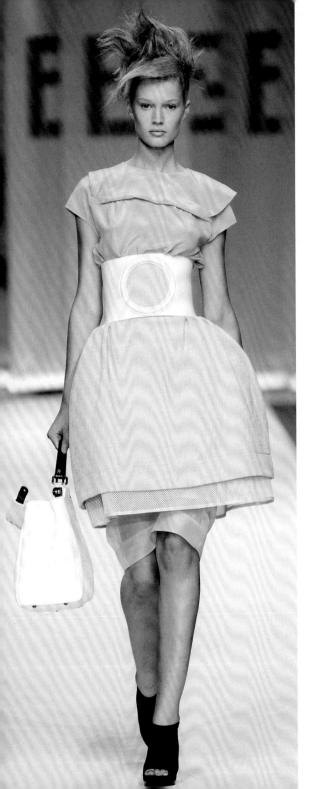

FENDI

www.fendi.com

Founded by Edoardo (d.1954) and Adele (1897–1978) Fendi, the house opened its first shop in Rome in 1925 specializing in fur and leather goods. Courting the luxury market, the label grew in recognition during the 1930s and 1940s, resulting in the couple's five daughters sharing the management of the company. Their name was launched as a fashion label in 1955.

In 1965, the Fendi sisters appointed Karl Lagerfeld (see p.182) as creative consultant. Lagerfeld modified the traditional processes of the fur and leather trades to liberate the ways in which these materials were fabricated, enabling them to become as versatile as other cloths. In 1969, the label put forward a ready-to-wear fur collection that exploited this modern experimental outlook. In the same vein, pelts and skins were modified in novel ways, such as printing, for use in the Fendi bag, which became softer in construction. In 1977, Fendi launched a prêt-à-porter collection expanding into menswear, accessories and home furnishing. Fendi has ridden out the general outcry against the fur trade, despite Naomi Campbell being fired as spokesperson for People for the Ethical Treatment of Animals (PETA) for modelling Fendi furs in 1997, the same year that the granddaughter of the founders, Silvia Venturini Fendi, designed the famed Fendi baguette bag.

In 1999, LVMH and Prada bought a 51 per cent stake in the business. By 2007, Prada and the Fendi family, led by chairman Carla Fendi, had sold their shares to LVMH, although Carla and Silvia Fendi remain involved. Fendi has over 160 boutiques in more than twenty-five countries.

◄ **Contrasts in material and finish dramatize Lagerfeld's 2009 layered look with cinched waist.**

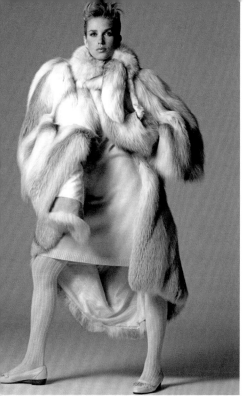

2000 A menagerie of skins, furs and special effects in shades of brown for autumn/winter.

A patent-leather quilted biker jacket with matching jeans and boots is cinched at the waist with a gold belt and accessorized with a fur shrug and oversized fur bag. Fendi's ability to deliver a virtuosic confection is evident in a collection that refers to the glamour of the 1970s and 1980s with flared A-line skirts and a mainly brown palette. Tone-on-tone banded panels reinforce bold lines and intricately worked striped pelts are drawn into dramatic confluent chevrons. Printed furs and fabrics fragment the silhouette with their blocked and chopped patterns.

1980 Fendi cries wolf without inhibition in an era when luxury meant excess. Lagerfeld later defends his use of fur to PETA.

Maximum glamour in the form of an oversized wrap fur coat epitomizes the ostentatious excesses of the 1980s when more was more. With its fashion currency rising from its relationship with Karl Lagerfeld from the mid 1960s, the label has expanded its global client base through a respect for materials and an instinct for star-laden marketing and endorsements by such luminaries as Claudia Cardinale, Sophia Loren, Catherine Deneuve, Diana Ross and Sarah Jessica Parker. In 1985, the brand celebrated sixty years of Fendi and twenty years of Lagerfeld, with diversification into jeans, accessories and home furnishing, an exhibition at the National Gallery of Modern Art in Rome and the launch of its first fragrance.

2011 A vivid scarlet patent-leather bag features a clasp with the Fendi logo.

The interlocking double 'F' logo on this shoulder bag was introduced in 1965 by Karl Lagerfeld. It is the unmistakable mark of the ubiquitous must-have 'It' bag, the most famous being the Fendi baguette, so called because it is carried under the arm like its namesake, the French loaf. The impractically small bag is produced in limited numbers each season in 600 different materials, often intensely embellished.

GARETH PUGH

www.garethpugh.net

The rubberoid excrescences in British designer Gareth Pugh's gothic graduate collection at Central Saint Martins College of Art & Design in 2003 gained him the visibility and notoriety he craved. Pugh (1981–) has since continued his shock and awe approach, but a level of sustainable sales arising from the publicity has been harder and slower to attain.

The English National Youth Theatre gave Pugh an early chance to feed his taste for the spectacular and illusory by appointing him costume designer when he was just fourteen. Later, as an undergraduate, Pugh held an internship with Rick Owens at the furrier Revillon in Paris and met Owen's wife, fashion consultant Michele Lamy, who became his backer in autumn 2006. Until that point Pugh had subsisted on the peripheral benefits of fashion press acclaim: *Dazed & Confused* used his sculptural 'inflatable creatable' installation in an international exhibition; he appeared in the reality television series *The Fashion House*; and he collaborated on various projects with a number of magazines including *Arena Homme+*, *Self Service*, *Cent* and *i-D*. He was eventually invited to participate in a joint show in 2005 with Fashion East in London.

Pugh's first solo show in autumn 2006 followed a course of modulated extremism and included elements of sophisticated wearability. In 2008, Pugh was given the ANDAM Award, fashion's largest international prize. With this injection of funds, Pugh was able to begin to show in Paris from the S/S 09 season.

◄ **Discarding the bulbous and embracing elegance for A/W 10/11, Pugh shows his creative maturity.**

2006 This show-opening outfit of inflated jacket, clinging vinyl trousers, metal-effect breastplate and ballooning pompadour presages a complex menagerie of styles.

The brief range of thirteen outfits revealed by Pugh for A/W 06/07 would normally be marginalized by the phrase 'capsule collection'. However, in terms of exposure, his work attracted wide coverage – both positive and negative. The showy theatricality of the experimental circus Pugh created depended on maximizing the variety of extravagant styles with a few common materials forming the linking narrative. Tulle ruffs recur alongside tight black PVC and harlequin check in gold lamé and black velvet. The inflatable components are limited to oversized Puffa jackets and the surreal balloon-monster black rabbit that closes the show. The unearthly impact is reinforced by white Pierrot make-up, the complex sculpted matt coiffures and the occasional steepled hat, all set in opposition to the Doc Marten boots that anchor the confections to the catwalk.

2008 A compilation of Pugh's monochromatic visual language, the A/W 08/09 collection is an assembly line for the designer's notoriously dark imagination.

The undulating crinoline skirt and extended shoulder pieces contrive to hybridize kendo armour with the ridged scales of an invertebrate creature. The addition of horizontally ridged tights and the antennae-like plaits emerging from the forehead confirm this. Ridged zips appear throughout the collection and sit alongside the fur of monkeys. Among the extensive catalogue of materials lie safety pins, black suede, ponies' tails, bleak black leather and grey ecclesiastical flannel. With apocalyptic overtones, the Pugh chimerical female is offered a choice of silhouette: big or enormous shoulders; a fitted waist then straight down; or a fitted waist then wide like a crinoline. There is an implication of masochism in the repetitive assemblages of fabric components with an abundance of safety pins, zips and the restrictive use of leather.

GIAMBATTISTA VALLI

www.giambattistavalli.com

Focusing on short cocktail wear that is often restrained in colour and shape, the Giambattista Valli (1966–) brand was launched in 2005 with a demure and retro-couture feel in sepia-toned neutrals. Valli grew up in Rome and attended the European Institute of Design in 1984, with a sojourn studying illustration at Central Saint Martins College of Art & Design in 1987. The following year Roberto Capucci took him on in a PR role before promoting him to his design staff, where Valli gained insight into the technical aspects of manipulating volume, texture and colour. Valli moved to Fendi (see p.124) in 1990, becoming senior designer on the Fendissime line. His next appointment, in 1995, was at Krizia as senior designer of the women's ready-to-wear line, before joining Ungaro (see p.294) as art director for prêt-à-porter in 1997. In 2001, his role at Ungaro was extended to accessories and the Ungaro Fever label.

Under his own label, Valli continues the refined cocktail look that he established at Ungaro. Latterly, he has shown sophisticated tailored daywear, with tweed or printed illusions of tweed replacing the fluffier components of the statement gowns. There is often an interplay of texture – feathers, fringes or fur set off against sheer plains or occasionally animal-skin prints.

Valli has produced outerwear collections for Moncler and fur ranges with Ciwi Furs. In 2010, the Mariella Burani Fashion Group, which manufactured his collections, went into liquidation, forcing Valli to seek new partnerships.

◀ **Draped and swathed silk chiffon features in contrast to animal prints for S/S 11.**

2005 Signature balloon skirts appear alongside ribbon and bow detailing.

Nude-coloured ostrich feathers are fashioned into a frou-frou cocktail dress that is tied up with a black satin ribbon across the breasts to form a big bow with streamers to the hem and below. Elsewhere in the autumn/winter collection, ribbons adorn the waist of an ombréd chiffon dress and are used to belt a fur coat. A neutral colour palette is enlivened with shots of fuchsia and orange.

2010 Architectural shapes are inspired by 1960s tailoring.

A black chiffon dress gathered into a white bib-fronted yoke provides an element of restraint alongside form-fitting evening skirts with exaggerated fishtail hems of frilled ruffles. Ruffles are also graduated from waist to hem on a skirt partnered with a raglan-sleeved top in grey tweed, the two textures separated by a nude satin ribbon. Cocoon-shaped coats and jackets feature in nude wool.

2008 Changing scales and proportions with playful frills, luxurious fabrics and rich embellishment are interspersed with unadorned monochrome severity of cut.

Exaggerating the proportions of the occasion dress, Valli adds volume with a balloon-shaped skirt in a digital print of overblown roses in red and pink. This is one of a series of dresses that also incorporates a red-dyed fur shrug, garlands of appliquéd roses and jewelled embellishment. Elsewhere, layers of horizontal circular frills undulate from neck to hem on simple knee-length dresses; in contrast, unadorned sleeveless shifts are allowed to gently curve into a narrow hemline. Other dresses in nude silk chiffon have frills excised from the body of the dress, Chinese-lantern style, and are embellished with fur shrugs dyed to match. The tucked and pleated tulip skirt shape appears throughout, in high and low waistlines, in soft wool, brocade and silk-satin, and is partnered with fur capes or bouclé jackets. Cocktail dresses are festooned with fabric rosettes, ruffles and embroidery.

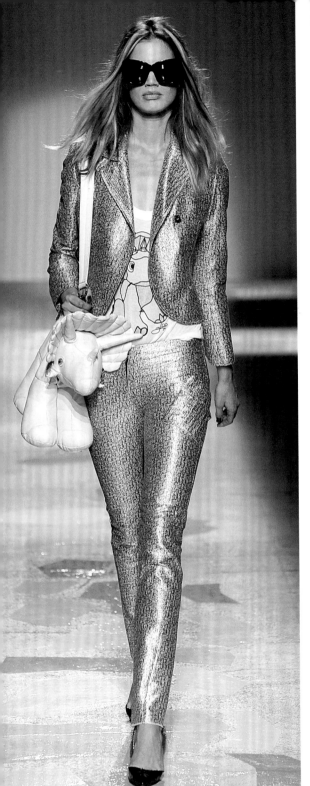

GILES DEACON

Leavened by a wit and toughness, Giles Deacon's label has a fetishistic edge that also plays with stereotypes, qualities that British-born Deacon (1969–) is now bringing to the couture house Ungaro (see p.294) as creative director. His appointment restored credibility to a label damaged by the selection of actress Lindsay Lohan as creative adviser.

Deacon spent his childhood in a remote part of the Lake District in England, a background that reflects his imperturbable yet idiosyncratic approach to fashion, which has been refined by his time with companies such as Jean-Charles de Castelbajac and Bottega Veneta (see p.72). The designer habitually incorporates references to popular culture in his collections, such as cartoon prom dresses in acid-bright colours. His prints feature meticulously observed unusual subject matter such as large-scale bees and wood-effect gorillas produced in collaboration with print designer Rory Crichton.

A graduate of Central Saint Martins College of Art & Design, Deacon launched his own label in 2004. A self-confessed team player, he forged a close relationship with British stylist Katie Grand while still at college. She adds a global flourish to his work and is at the heart of his creative team. He became British Fashion Council Designer of the Year in 2006, and in 2009 gained the prestigious French ANDAM Award, allowing him to show in Paris. He has worked on several collaborations with such companies as Mulberry (see p.226), Converse and, since 2007, the British high street chain New Look.

◄ **Severe tailoring is offset by playful cartoon prints and a toy accessory for S/S 10.**

2004 — Distinctive print motifs applied to 1970s-inspired silhouettes.

The gibbon motif encapsulates Deacon's irreverent approach in this second show of his own label, which moved on from the more chaotic menagerie of the first. Woven by Stephen Walters & Sons, the patterned brocade appears throughout the collection on jackets partnered with striped skirts and pencil-skirt suits. Diaphanous kaftans sport wood-grain print.

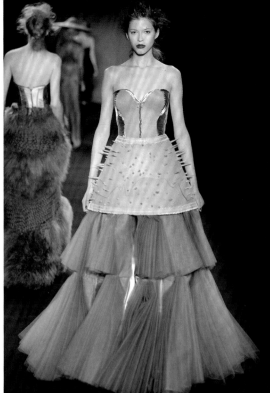

2010 — The A/W 10/11 collection is imbued with grown-up allure.

An orange shift dress with laser-cut frills worn beneath a belted cardigan marks the evolution of the label. Elsewhere, fly-front jackets and coats are constructed for maximum wearability in a refined colour palette of browns and oranges. Yellow of egg-yolk intensity appears in a colour-blocked dress, with a teardrop cut-out motif at the neckline. The whole is a subtle subversion of ladylike chic.

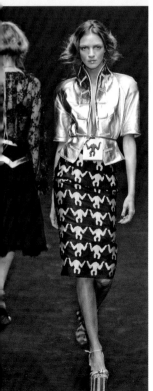

2009 — Hard and soft textures are finely adjusted in this contoured bodice extending to a rigid carapace-like skirt that is juxtaposed with floating panels of pleated chiffon.

Providing a gothic touch to the essentially traditional sweetheart neckline, shaped bodice and crinoline, the overskirt is studded with jewelled stalagmites. This theme recurs throughout the collection, also appearing on stiff leather A-line skirts and simple sheath dresses with eroded edges. Oversized wrist warmers, knitted from excessively chunky yarns, are attached to silk-satin blouses and are occasionally pierced with bone-coloured claws, adding an abject edge to the collection. Dresses and blouses are pulled together with safety pins, and neon colour is applied on T-shirts with the randomness of the abstract expressionists. As always, incorporated into the collection is an element of print; here, it portrays fishing flies, complete with hooks. Garments are accessorized with over-the-knee front-zipped boots in satin or suede and large circular hats.

GIVENCHY

www.givenchy.com

Renowned for dressing two of the major fashion icons of the 20th century – Jacqueline Kennedy and Audrey Hepburn – Hubert de Givenchy (1927–) promoted a contemporary look in 1957 with his influential knee-length sack or chemise dress that skimmed the body and was to set the style for the following decade. Born in Beauvais, France, Givenchy was associated with several Parisian couturiers such as Jacques Fath, Robert Piguet, Lucien Lelong (where he worked alongside Pierre Balmain, see p.60, and Christian Dior, see p.92) and, finally, Elsa Schiaparelli, before opening the house of Givenchy in 1952.

As one of the most influential couturiers of the era, Givenchy gained international recognition with his costume designs for Audrey Hepburn in the films *Funny Face* (1957) and *Breakfast at Tiffany's* (1961) and with his designs for Jackie Kennedy, the model of chic for a generation of women. In 1988, Givenchy sold his business to LVMH, and the designer retired from fashion design in 1995. His successor, appointed by head of LVMH Bernard Arnault, was John Galliano (see p.172), the first British designer to front a French couture house. He was followed by Alexander McQueen (see p.38) in 1996, whose work received a mixed reception, and, from 2001 to 2004, Julien Macdonald (see p.180) took the helm. Italian-born Riccardo Tisci has been creative director of Givenchy women's ready-to-wear and haute couture since 2005, and in May 2008 he was named as menswear and accessories designer of the men's division. Previously with Ruffo Research, Tisci brings a darkly romantic edge to the Givenchy label.

◄ **A 1961 design classic: the simple black dress on Audrey Hepburn in *Breakfast at Tiffany's*.**

1953 In contrast to the embellished clothes of the period, separates were a novel notion and emphasized the silhouette.

Model Suzy Parker celebrates the hourglass figure with a printed mid-calf skirt in old rose, matched to a black silk-taffeta quilted and cropped A-line jacket with raglan shoulders and bracelet sleeves. Bettina Graziani, Hubert's model and muse, inspired a narrowly cut top with ballooning sleeves caught into a cuff at the wrist – the Bettina blouse. In an era when fashion was dominated by the Parisian couturiers, Givenchy's understated unostentatious outfits offered an alternative to the theatricality of Dior and the cerebral clothes of Balenciaga. This led to Givenchy's eager embrace of modernity towards the end of the decade, when the designer relinquished the hourglass silhouette for the waistless sack dress.

1969 The bikini is updated by Givenchy for a youth-led market.

First popularized in 1946 by couturier Jacques Heim, the bikini reappears here in crisp white with undulating surfaces of circular frills. The sculptural design adds illusory curvature to the archetypal straight-sided 1960s model. The designer also proposed the feminine and demure skirted one-piece swimsuit, often knife-pleated and attached to a tank top, and accessorized with an oversized straw sun hat for beachside glamour.

1961 Influencing a generation of women, Jacqueline Kennedy, America's first lady, favoured Givenchy.

The designer's streamlined suits in solid blocks of bright colour stood for a clean-cut unfussy glamour as evidenced in this tweed skirt suit worn by Jackie Kennedy. It was designed by Givenchy for Chez Ninon, a small dress salon selling custom-made copies of the best of Paris. The designer always incorporated into Jackie's clothes an element of exaggerated detail, for example a single large flat bow or an oversized button or two that could be seen from a distance. Partnering the suit is a beret-style hat by milliner Roy Halston Frowick.

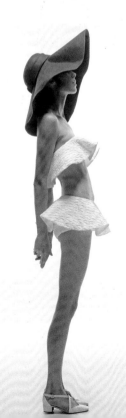

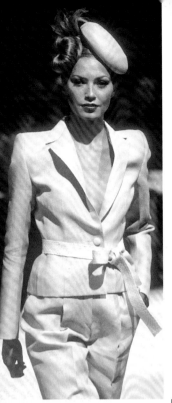

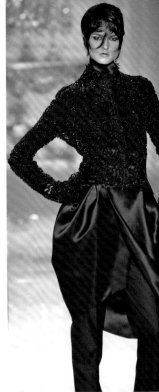

British designer Alexander McQueen's first haute couture collection for Givenchy was considered disrespectful to the traditions of the house's founder.

An appropriation of 19th-century military uniform segues into a cheerleader costume – complete with white trousers and a plumed hat – in a collection that engages with other female archetypes – the Valkyrie, Horned Goddess, angel and Amazon, the latter in an asymmetrical sheath dress that exposes one breast. McQueen's dark vision is relinquished for this debut collection, although his preoccupation with the feral is evident in the details among the immaculate tailoring and draped dresses. Silk-satin in old gold, with hints of pewter and pale green, is draped into a strapless dress, worn with a horned headdress – the work of McQueen collaborator, jeweller Simon Costin. The contours of a white satin coat are emphasized by a double row of buttons from hem to breast, where the revers extend into two points at the shoulder like devil's horns.

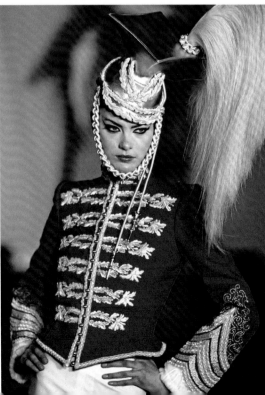

1996 **John Galliano's first haute couture collection for the house.**

A neatly tailored trouser suit – a cropped jacket softened by a ribbon bow at the waist and pleat-front trousers with vertical pockets – channels the understated feminine tailoring of the label. Elsewhere, Galliano indulges in full-blown historical romanticism and pastiche in a series of 18th-century-inspired dresses in broad grey and white stripes and in a lavishly fringed and frilled flapper dress in blush pink.

2001 **Debut haute couture collection by Julien Macdonald.**

A duchesse satin tulip-shaped skirt over narrow trousers and with a beaded lace jacket represents Macdonald's edgier approach to interpreting the Givenchy style. Predominantly in black, the collection uses luxurious textures – leather, lace, mink and velvet – for full-length gowns with sweeping trains, high-waisted skirts and coats with matching pinstriped trousers.

2008 A mix of modern goth and dancewear by Riccardo Tisci.

Origami pleats and folds in paper white oscillate around the body in this haute couture evening dress – a technique also seen on a tailored coat in palest green, the folds interspersed with a froth of ostrich feathers. A vermilion dress has a Tudor ruff and puffed sleeves; otherwise black is used for dresses and fluted skirts with undulating hems. Ruffled white underskirts show and feathers form the skirt of a wrap top.

2010 Riccardo Tisci for Givenchy ready-to-wear exploits Nordic stitches and neoprene.

For autumn/winter, high-waisted trousers are left unzipped to the hips to disclose a waspie bodice that subverts the traditional Fair Isle design to form a *trompe l'oeil* lacing effect. It is worn over a laser-cut lace top in a juxtaposition of tough and tender. The same unzipped apron front is used on neoprene trousers over lace body stockings and knee-length skirts, worn with knits featuring curlicues of complex Fair Isle patterns, in cream, red and black that replicate ruffles of fabric.

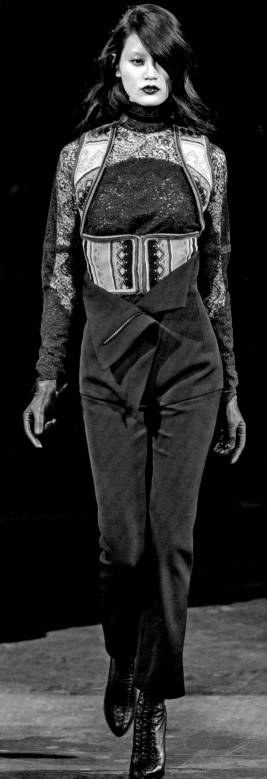

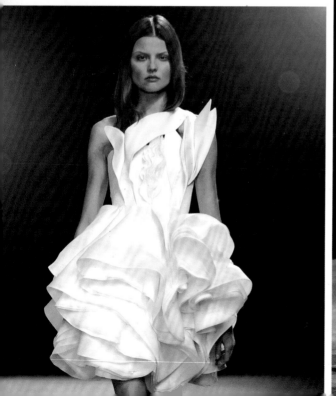

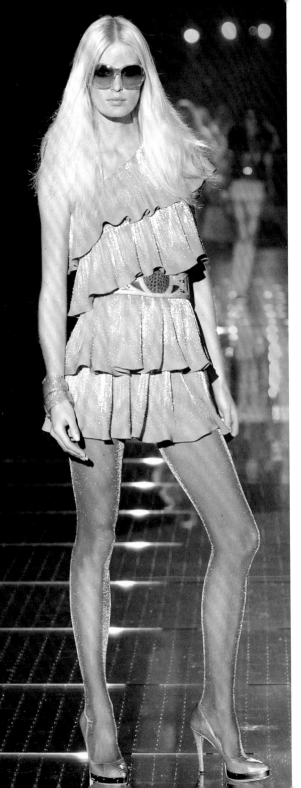

GUCCI

www.gucci.com

When Tom Ford took control of Gucci in 1994 he both reflected and shaped the culture of the 1990s. Under his creative direction, the brand entered the fashion stratosphere to become the most coveted label of the era.

The house of Gucci was founded by Guccio Gucci (1881–1953) as a leather goods workshop in Florence in 1921. The Italian luxury label thrived after World War II, when the double-G motif became internationally recognized. Over-expansion of licensing agreements during the 1980s caused a temporary downfall, and internal conflicts within the family-owned company also took their toll. The US retail executive Dawn Mello was appointed in 1989 to reposition the brand, and she subsequently hired Tom Ford as Gucci's chief ready-to-wear designer. In 1994, Ford was promoted to creative director, where he established a relationship between sex and fashion that was imbued with a knowing, sophisticated glamour. On the strength of Ford's collections, Gucci went public in October 1995 and Domenico De Sole was appointed chief executive. The company entered into a strategic alliance with PPR, creating the Gucci Group and acquiring among others Yves Saint Laurent (see p.320), Stella McCartney (see p.284), Alexander McQueen (see p.38) and Balenciaga (see p.56). Ford retired from women's fashion in 2004, largely because of business disputes with PPR.

Frida Giannini, formerly accessories designer for Gucci, was appointed creative director in 2006. Initially, she brought a hippie de luxe mood, more femininity and less sexual abrasiveness to the label, before reclaiming some of the hard-edged glamour of the Ford years.

◄ **Frida Giannini's debut A/W 06/07 collection as creative director of Gucci ready-to-wear.**

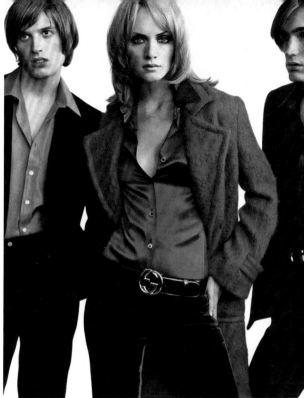

1971 Tailored hotpants and knee-length boots epitomize 1970s Gucci glamour, accessorized with a tote bag featuring the distinctive double-G motif on canvas.

Aldo Gucci, son of founder Guccio Gucci, produced the bamboo-handled handbag in 1957. Celebrity endorsement – and thus elevation to status bag, alongside the Chanel 2.55 and Hermès Kelly bag – came in the form of the patronage of the United States's first lady, when Gucci designed a bag carried by Jacqueline Kennedy Onassis, the 'Jackie bag', which was relaunched in 2008. The scarcity of leather after World War II led Gucci to develop its trademark red and green striped webbing, derived from the saddle girth; it also bedecked the front of the iconic suede moccasin loafer with a miniature horse's snaffle. These were the signature elements that defined the label for the next four decades until US designer Tom Ford, previously with Perry Ellis, was invited to rebrand the company in 1992. Accessories now account for 80 per cent of the Gucci turnover.

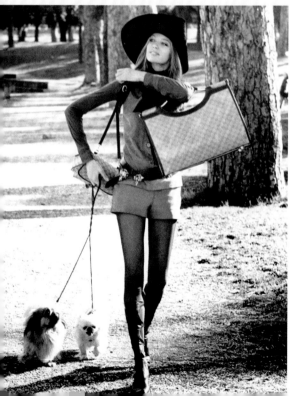

1995 Ford's tightly edited breakthrough collection reinvented Gucci style and resurrected the double-G logo as an icon for the 1990s and beyond, now appearing on all Gucci products.

Last seen on the dance floor of Studio 54, tight on the thigh hip-hugging satin or velvet trousers with boot-cut legs and disco satin shirts in peacock blue and lemon reappeared. Sharp-shouldered skinny blazers in high-gloss silk velvet are worn with unbuttoned shirts, their 1970s-inspired collars spread open over the jacket lapels. Luxurious glossy mohair provides loosely cut knee-length wrap coats in pale turquoise and burnt orange, while more structured tailored coats feature easy patch pockets. Minimally detailed knee-length leather coats in brown or black are worn over scoop-neck mini sweater dresses or black V-necked sweaters and trousers. Insouciant glamour is supplied by a bright red sweater dress caught on the hips with a narrow belt displaying 'G' for Gucci, and worn beneath a dyed orange fur three-quarter-length coat. All are accessorized with the Gucci loafer featuring the horse's snaffle.

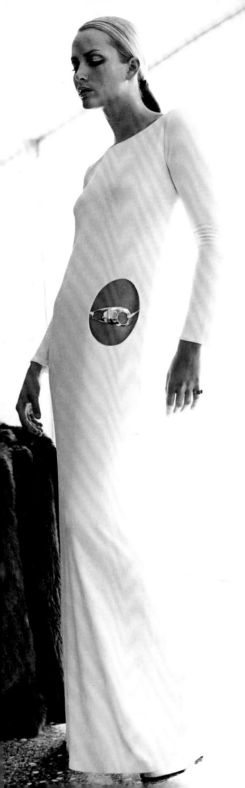

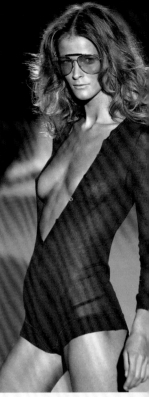

1996 The dress that consolidated Ford's reputation for high-octane glamour.

An homage to Halston allies fashion and overt sexuality. A white columnar dress in rayon jersey with a cut-out at the hip combines classical simplicity with contemporary form.

2001 An autumn/winter collection of severe tailoring is offset by fur and lace elements.

An edge-to-edge fur coat validates a collection comprising matt black trouser suits with minimal detailing, apart from oversized zips up the front of trousers or around the waist.

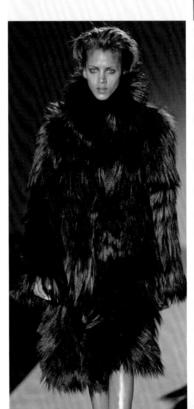

2002 Trousers and tops are discarded to reveal underwear as outerwear.

Sheer knitted silk jersey exemplifies Ford's association with overt sexuality and transgressive glamour for the gym-honed body. It is seen elsewhere in the collection in skinny cardigans pulled tight across the body and worn with cropped shorts with underwear fastenings or wide-legged trousers with drawstring tops. Mid-calf A-line skirts provide a more casual, understated look.

2003

A collection of long lean boot-cut trousers, military-inspired coats and fur hats.

A reworked trench coat with a 1970s vibe – as evidenced in the waist seam, skirted hem and outsize lapels – is worn over head-to-toe black. Other coats express a more military feel, being double-breasted and decorated with pairs of brass buttons. Second-skin fine cashmere turtleneck or polo-collared sweaters are lent a faintly sinister edge when worn with black-belted trousers, tightly wound silk bandanas around the neck and winter shades. Pinstriped worsted in shades of blue is worked into two-buttoned suits.

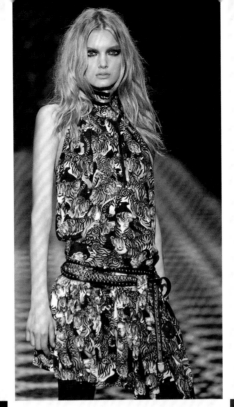

2011

Urban safari glamour, using pale suede and leather, and jewel-like silk for evenings.

A tulip-shaped skirt in duchesse satin, draped to the front and worn with a smoothly wrapped and knotted top, is secured with a stiffened broad gold belt. It sets the template for more of the same in such jewel colours as burnt orange, turquoise and emerald green. Broad belts feature throughout the collection, some in leather interlocking circles over safari-style shirts and tight leather trousers. String-coloured macramé mini-dresses appear with oversized bags – Giannini always sends out a fully accessorized collection.

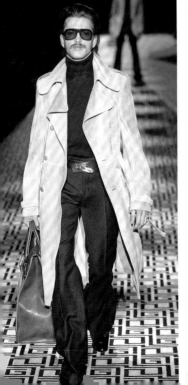

2008

Referencing 1970s hippie de luxe with colourful Russian-inspired folkloric prints and handcrafted embroideries.

An all-over print of tigers is worked into a halter-neck mini-dress with a ribbon-edged opening at the neck, fastened with brass buttons. A metallic-studded belt is bound twice, low on the hips over a broad fringed sash that falls to the hem, a recurring motif throughout the collection, over short jacquard-patterned skirts and narrow trousers. With further reference to the 1970s, the Afghan coat appears, shortened into a jacket edged in Mongolian lamb, with panels and pockets embroidered in turquoise and black. The favourite hippie print – paisley – is worked into massive fringed scarves, chiffon blouses and silk-crêpe mini-dresses.

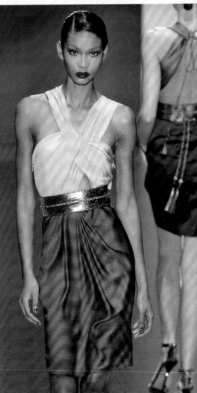

GUESS

www.guess.com

An expression of the *dolce vita* sex appeal, the American dream and ingenious publicity, Guess was founded in 1981 by the Moroccan-born Marciano brothers: Paul, Georges, Armand and Maurice. From its inception, the brand was based on innovatively cut and dyed denim, and it continues to develop new washes and treatments, experimenting with colours rather than indigo, and using different types of denim, such as ringspun.

In 1981, its first product, stocked by Bloomingdale's, the three-zip Marilyn stonewash jean, sold out in three hours. By the end of 1982, the Marcianos had sold some US $12 million worth of jeans. Occasionally problematic partnerships with other producers (Jordache) led to huge expansion: Guess has more than 1,000 outlets worldwide and had a revenue of US $2.1 billion in 2009. The company has several branded trademarks and now markets accessories, cosmetics, childrenswear, menswear and the premium ranges By Marciano and G by Guess.

The Guess look is sexy, relaxed and closely tied to post-war popular culture: jeans are cut tight, hemlines are short and youth is paramount. Its instantly recognizable style is attributed to Paul Marciano, who took the decision to photograph models in black and white, combining typically American scenes with provocative poses. Guess advertising made global names of Carla Bruni, Anna Nicole Smith and Claudia Schiffer. Guess has also placed its products in prominent films, for example *Back to the Future* (1985). Accused of being dated, the company reinvented itself in the 2000s, recruiting Paris Hilton as a model in 2004 and relaunching several lines.

◄ **Implicitly advocating the 'live fast, die young' lifestyle, Guess offers rock chick style for 2011.**

1992 A halter top, tied over a plunging bra, is partnered with sprayed-on pants, epitomizing the overtly sexual appeal of the controversial press advertisements.

In homage to renowned shots of Marilyn Monroe in striped capri pants by the photographer Nahum Baron in 1954, Guess re-enacts the poses with Anna Nicole Smith. The blonde convictions of the Guess brand have endured over decades of aggressive expansion, driven by award-winning campaigns that harness filmic and starlet overtones. By using contemporary sex symbols to mirror and intensify the power and notoriety of their cinematic precursors, the brand sends out a simple yet powerful message: wear Guess, get attention. Anna Nicole Smith also becomes Deborah Kerr rolling in the surf in her chambray button-through dress and exposed stocking tops. And as Jayne Mansfield, Smith becomes a décolleté moll embroiled in the shady underworld of the fight game; elsewhere she relives *La Dolce Vita* (1960) in a plunging strapless number. Guess also has Smith perform as an evening gowned diva.

2003 Since the 1980s, Guess has taken the iconography of the blonde bombshell through every permutation to invest its principal jeans line with retail seduction.

Guess models take up the mantle of Brigitte Bardot as the sultry protagonist in the impersonation advertising campaign of 2003. The look is blonde Bardot in the mid 1960s, but the cut of the jean is of its own time. The magazine advertisements faintly reference relevant films or noted publicity stills. Garment styles are explicitly seductive: a bandeau top worn with a choker, stilettos and skintight jeans; or fishnets with a lace-up pelmet miniskirt in frayed denim and a star-blazoned athletic singlet; or the loose-laced black basque worn under a satin track blouson. The message is permissive and underwear becomes outerwear, as camisoles, cropped and knotted vests and visible bras. Slightly more demure is a tight denim jumpsuit, with tabbed half sleeves and a press-stud fastening at the centre front; Vespa scooters add overtones of a Fellini film.

HALSTON

www.halston.com

The proponent of luxurious minimalism, and referencing the design innovators Claire McCardell and Bonnie Cashin, Roy Halston Frowick (1932–90) launched his eponymous womenswear label in 1968. Initially a milliner for New York department store Bergdorf Goodman (and designer of Jacqueline Kennedy's famous pillbox hat), Halston continues to be associated with the disco scene of the notorious Studio 54 set of the 1970s. He created silk kaftans and fluid jersey evening wear for his celebrity friends Bianca Jagger, Lauren Bacall, Anjelica Huston and Babe Paley. Halston went on to develop an understated easy-to-wear yet sophisticated look constructed from pliable fabrics such as silk and wool jersey and, his favourite fabric, an expensive artificial fibre called ultrasuede. He used a neutral subdued palette of natural colours. One of the most influential of his generation of US designers, Halston was dubbed 'the best designer in America' by *Newsweek* in 1972.

In 1973, Halston sold his name to Norton Simon Industries. Since his death in 1990, the label has had no fewer than eight separate owners and six designers. It was revived in 2008 by Harvey Weinstein, Tamara Mellon and stylist Rachel Zoe. They installed former Versace designer Italian Marco Zanini as creative director, and he showed his first collection for A/W 08/09. Net-a-Porter signed on to sell pieces immediately following the show. In July 2008, British designer Marios Schwab (see p.202) became responsible for the main line, while *Sex and the City* star Sarah Jessica Parker was made president and chief creative officer of the archive-inspired Halston Heritage line.

◄ **Exponent of 1970s disco glamour, Halston pared down the silhouette and used luxurious fabrics.**

2008 Streamlined casual wear offers a coordinated simplicity.

Under the relaunched Halston label, the first collection by creative director Marco Zanini references the simplified lines and minimal detailing of the original Halston look. Zanini limits the colour palette to shades of brown, mocha and coffee, with a hallmark shot of bright orange. The collection includes coats, tunics and trousers as well as fit-and-flare evening wear.

2011 Definition is achieved by skilled draping rather than cut.

Apparently a single piece of jersey – without darts and with minimal seams – the excess width of the garment is pulled up from the hips to define the waist. The vivid red dress with asymmetric shoulders is secured with an outsize metal pin. The spring/summer collection incorporates minimal construction techniques and is suffused with abstract designs printed on sequins to provide a luxurious shimmering surface.

2009 The apogee of the Halston signature look: evening wear in fluid draped silk jersey in a single strident colour resulting in easy luxurious glamour.

The columnar dress is extended into a piece of fabric the length of the body and thrown over the shoulder to form an asymmetric neckline, a recurring feature in this collection by Marios Schwab. The designer revisits the Halston archive, including iconic pieces from the 1970s: floating unstructured jet-set silk kaftans, asymmetric-shouldered dresses and halter-neck jumpsuits in a single blast of vivid colour such as orange, yellow, turquoise and lapis-lazuli blue. A small element of black and white African-inspired print provides an uncharacteristic excursion into pattern. Construction adheres to the Halston principle of less is more. Lacking in buttons, zips and plackets, functionality is provided by drawstrings, drape and stretch. The all-in-one, seemingly without fastenings of any kind, gracefully assumes the contours of the body in a slither of saxe-blue jersey.

HELMUT LANG

www.helmutlang.com

The minimalism of the Helmut Lang label is expressed principally through sharp and careful cutting to create basic elegant silhouettes using high-quality fabrics that often incorporate innovative technical characteristics. Lang (1956–) was drawn into fashion from a background in economics then art, setting up a made-to-measure atelier in 1977 in Vienna, and two years later opening the boutique Bou Bou Lang. From 1984 to 1986, he developed women's ready-to-wear collections, which led to a government-sponsored launch of the Helmut Lang label in Paris in 1986. Lang's sobriety of concept achieved great success and resonated with the radical intellectual approach to design of that period.

In the 1980s, the label's base was re-established in Vienna, where the refinement of deconstructive principles was favoured by an international client base in the creative industries. Urbane, confident and modernist in outlook, the Lang approach mixes elegant forms in neutral-coloured luxury fabrics with edgier synthetics. In the 1990s, the label branched out into eyewear, underwear, denim and fragrances.

At the end of the 1990s, a partnership with the Prada Group was formed, which led to the 51 per cent acquisition of the Helmut Lang company by Prada in 2004. A year later, Lang left his own brand and, by 2006, Prada had sold on their acquisition to Link Theory in Japan. Link Theory, under the umbrella of the Fast Retailing Company, has relaunched the Helmut Lang label, now designed by Michael and Nicole Colovos.

◀ **A simple shift from the first Lang show in 2008 designed by Michael and Nicole Colovos.**

Lang adds deconstruction to his basic modernist catalogue.

Stark black and white print is fractured by a wrapped overskirt worn with black shorts to represent a collection defined by intelligent futurism. Elsewhere, opaque black coats lose their sleeves to curved confections of sheer white and burnt-orange voile. A blouson becomes a heavily zipped but fragmented transparent blouse, and white plastic zips are split and recombined with pearlized eyelet lace into cocktail dressing. The lean look and the spartan colour palette are deployed democratically across lines for both women and men.

1997 **Renouncing all traces of affectation by embellishment, the Lang design philosophy strikes a modernist note of pragmatic minimalism.**

A severe black linear silhouette of slender trousers and a crewneck sweater are made cocoonlike by a rectangular duvet wrap of padded satin. Quiet touches of relative levity are expressed in the collection by the occasional introduction of synthetic finishes and fibres alongside the luxury classics. Sculptural flourishes include an extension of cloth to embrace an upper arm or a wrap of ecru jersey as a cummerbund over a pure white blouse. The use of colour is similarly contained and rational: black is mixed with black, white with white, and occasionally white is offset by a black contrasting trim. Less often a pallid blue, taupe, camel or pink appears. As a climactic effect, a blood-red full ciré skirt features.

2005 **Maritime frames of reference appear throughout the collection.**

A furled white spinnaker as a blouse is one of the many allusions to sailing that form the theme of the spring/summer collection and is referenced throughout, from accessories to materials. Rope-soled or nail-edged shoes are threaded and tie at the ankle below cuffed capri pants. Ropes and lanyards hang alongside curved seams, and the life-jacket waist strap is integrated into a blouson jacket.

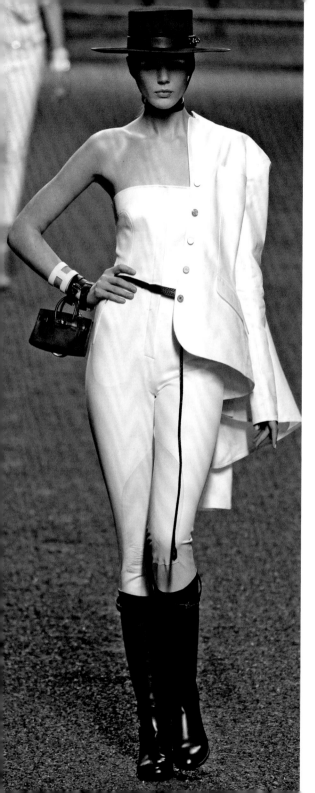

HERMÈS

www.hermes.com

Exemplifying meticulous craftsmanship and the creator of iconic luxury handbags, Hermès is one of the oldest family-owned companies in France. Thierry Hermès (1801–78) first opened a workshop in Paris in 1837, supplying horse harnesses for carriages. The bespoke craft skills of the saddle makers are naturally affiliated to the making of fine handbags, and Hermès has elevated these artisan skills to high art in its Parisian atelier. Emile-Maurice Hermès, Thierry's successor, purchased the building at 24 rue du Faubourg Saint-Honoré in Paris, which still houses the flagship store as well as the workshops. The company was controlled by Jean-Louis Dumas-Hermès, the fifth generation chairman, until 2006, when Patrick Thomas became the first non-family member to helm the company.

The company produced its first bag in 1892: the *Haut à Courroies*, designed to transport riding gear. Another key moment in the company's history was when Emile-Maurice obtained exclusive rights to use a zip – nicknamed the Hermès fastener – on leather goods and clothing, with one appearing on the label's first leather garment: a zippered golfing jacket for Edward, Prince of Wales. In 1922, the first leather handbags were introduced, and, in 1923, the Bolide bag was the first in history to feature a zip. Other classic bags followed, including the much coveted Birkin bag in 1984.

Hermès's first women's collection of couture clothing was shown in Paris in 1929. From 1956, ready-to-wear collections have been designed by various practitioners, including Belgian designer Martin Margiela (see p.208) from 1998 to 2003 and Jean Paul Gaultier (see p.164) from 2003 until 2010, when Christophe Lemaire took over.

◄ **The equestrian-inspired final show by Jean Paul Gaultier for Hermès, a collection for S/S 11.**

1937 Capitalizing on the importance of accessories in the 1930s, Hermès extended its range beyond handbags to include hand-stitched gauntlet gloves.

At the turn of the 20th century, the horse and carrriage gave way to the automobile as the major means of transport, and Emile-Maurice Hermès anticipated that the company would need to diversify from its equestrian roots into manufacturing luxury leather goods such as trunks and overnight cases. During the 1930s, this led to Hermès producing some of its most recognized accessories, including handbags, gloves and printed silk scarves, which were to become design classics. In 1930, the *Plume* bag appeared, a more practical and pliable version of the horse-blanket bag and the first that could double as both a day bag and an overnight tote. In 1935, the leather *sac à dépêches* was created, later renamed the Kelly bag. The 1930s also witnessed the entrance of Hermès into the US market, by offering its products in the Neiman Marcus department store in New York.

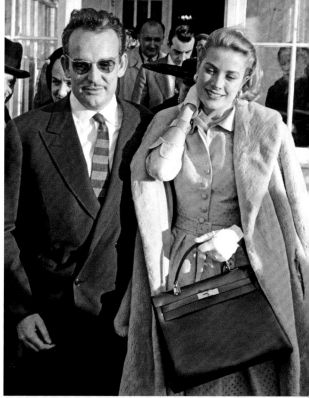

1956 Grace Kelly was photographed for *Life* magazine in 1956, hiding her pregnancy with a classic Hermès bag, after which the *sac à dépêches* became known as the Kelly bag.

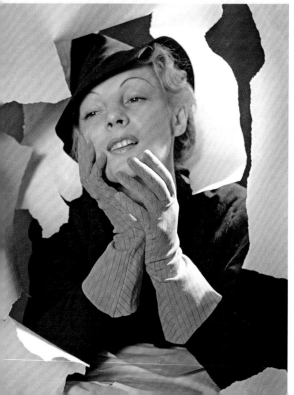

Now a design classic, the Kelly bag is a collector's item, handed down from mother to daughter and with a waiting list for the latest design. Taking eighteen hours to construct, each Kelly bag is the work of one person, and each bag is stamped with the name of the craftsperson and the date. The bag requires more than 2,600 saddle stitches in double rows, all effected by hand. The handle is constructed from five separate pieces of leather and is shaped by hand using a special knife. The bevelled edges of the leather are subsequently smoothed away with sandpaper and dyed to match the bag. The clasp and the four metal feet on the base are riveted to the skin and four holes punctured to secure the bag's locking belt hardware. It is then ironed to get rid of the crinkles in the calfskin, and the final stage is to stamp the 'Hermès Paris' name on each bag.

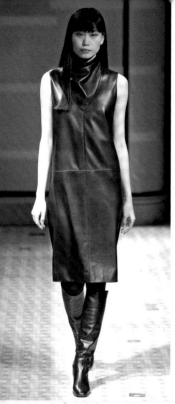

A neatly tailored French navy shorts suit, accessorized with a scaled-up Kelly bag, is in marked contrast to a collection that elsewhere celebrates the haute hippie, with printed chiffon kaftans and off-the-shoulder frilled tops worn with cropped capri pants. These feature military detailing and – together with the oversized pirate hats with undulating brims – bring a buccaneer edge to the collection. A Hermès printed scarf is tied loosely around a cropped top with midriff-baring trousers.

2002

An all-black collection by Belgian designer Martin Margiela.

A sleeveless leather dress quartered with seams is differentiated from the norm by a triangular insert at the neck, forming a faux scarf. The collection's sombre palette is emphasized by minimal tailoring details on cocoon coats, easy-fit trousers and edge-to-edge cape-sleeved jackets. Sleeveless jackets are tucked into wide-legged trousers. Knitwear includes sweater dresses and floor-length off-the-shoulder evening wear.

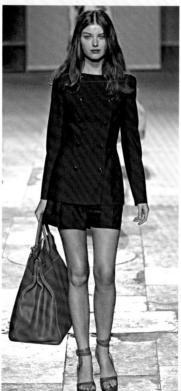

2006

An enduring status symbol, the square Hermès silk scarf is knotted and looped at the back of the head, the ends left free, peasant style.

The iconic Hermès silk scarf was introduced in 1928, and in 1937 a dedicated scarf factory was established in Lyon. The first squares featured a print of white-wigged ladies playing a popular period game and were named *Jeu des Omnibus et Dames Blanches*. The modern Hermès scarf measures 90 centimetres (35.4 in) square, weighs 65 grams (2.3 oz) and is woven from the silk of 250 mulberry moth cocoons. All scarves are hand-printed using multiple silk screens – generally up to thirty, with one for each colour on the scarf, although forty-three is the highest number of screens used to date. Two scarf collections are released each year, along with reprints of older designs and limited editions. Since 1937, Hermès has produced more than 25,000 unique designs.

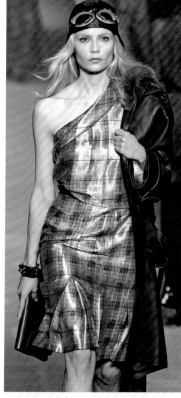

2008 The collection features the Hermès signature burnt orange.

Rich renaissance patterning is worked into an across the body bag accessorizing a luxurious suede coat with extended leather lapels and turned-back cuffs. It is cinched at the waist with a tasselled and plaited leather belt. An outsize paisley shawl is tucked into the neckline; the same print is also used for knee-length dresses and scarf skirts. Spicy colours such as turmeric and paprika add to the orange tones.

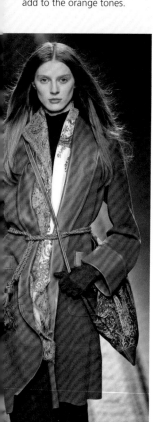

2009 1920s-inspired aviator glamour with soft brown leather and fur flying jackets.

A silk-satin printed plaid in muted tones is worked into a one-shouldered dress, caught at the waist with a narrow belt. The fur-trimmed leather coat features a matching lining.

2010 Top-to-toe black leather recalls a city-suited businessman, complete with brolly and bowler.

A belted tweed jacket is layered over a second jacket in leather, with matching loosely cut leather trousers in a collection of masculine tailoring softened with leopard-print chiffon.

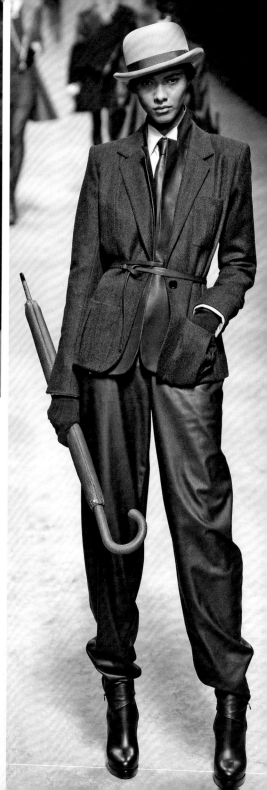

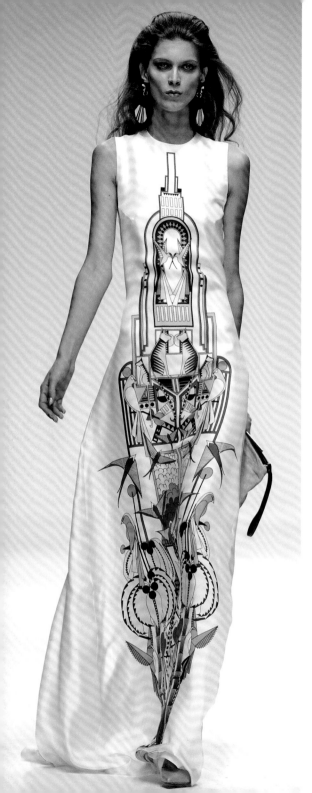

HOLLY FULTON

www.hollyfulton.com

With her distinctive highly embellished womenswear and jewelry, Edinburgh-born designer Holly Fulton (1977–) references 'Odeon' style – 1930s Hollywood glamour juxtaposed with motifs from art deco, cubism and the Bauhaus. Integrating vibrant colour and bold graphic lines with sculptural textures, the designer produces a synthesis of texture, surface and form. The pared-down streamlined garments – short shift-type dresses and straight-legged trousers – provide a base for Fulton's obsessive preoccupation with surface detail. She uses couture techniques, contemporary materials such as Perspex and plastic and engineered digital prints to create *trompe l'oeil* and 3D effects on her garments and jewelry designs, adding motifs from 1960s pop art and the 1980s Italian design collective Memphis.

Graduating with a degree in fashion design from Edinburgh College of Art in 1999, Fulton worked for Scottish design house Queene and Belle and the jeweller Joseph Bonnar before moving to London to study fashion womenswear at London's Royal College of Art, graduating in 2007. Fulton was then appointed accessories designer at Parisian couture house Lanvin (see p.184) under creative director Alber Elbaz (see p.34), where she used strong graphic imagery and pop art colours to create outsize statement pieces of jewelry.

Fulton received the Swarovski Emerging Talent Award for accessories in 2009. She was also awarded Young Designer of the Year at the Scottish Fashion Awards and Next Young Designer at the *Elle* Style Awards in 2010.

◀ **A print of New York City's Chrysler Building features on a 2011 full-length shift dress.**

2007 Fulton's Royal College of Art postgraduate collection.

All eleven outfits incorporate lasered components. From simple coloured tiles of perforated acrylic sheet, jewel-like panels are constructed across the surfaces of garments, following the principles of saturated geometric decoration. Plastic cascades of baubles and paillettes adorn the neck and shoulders, while tubes of clear and tinted silicone are coarsely knitted into sturdy slip dresses.

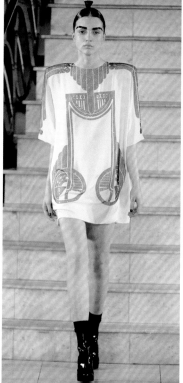

2011 Ancient Egyptian symbols in turquoise blue and orange are grounded in black for the spring/summer collection.

A futuristic print is shaped into a simple swimsuit with high-cut legs worn beneath a feathery jacket in black. Feathers also intercede on a skirt between horizontal stripes of printed New York skyline, worn with a 1980s Memphis-inspired crazy-paving print top. Patent yellow skating dresses are punched with Egyptian-inspired hieroglyphics, while skirts display perforated patterns of 1930s cocktail glasses complete with cherry. Jewelled and patterned shift dresses sometimes have buckled shoulder straps. Wrap skirts and dresses feature a softer, more flowing look, with an all-over multidirectional print of the venerated Egyptian bird the Sacred Ibis. Vests or silk halter-neck tops feature jewelled collars that are attached by rings.

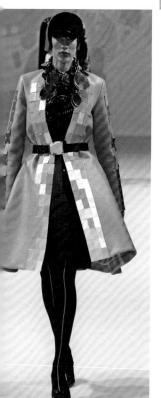

2009 Art deco–inspired pieces showcase innovative jewelled embellishment in futuristic materials.

A power-shouldered tunic dress represents a collection of simple garment shapes with complex decoration, some of which evokes imagery from the German expressionist film of 1927 *Metropolis*, directed by Fritz Lang and set in a future urban dystopia. A yellow batwing top with geometric forms on the edge-to-edge front is worn with black leather boots and trousers combined. Elsewhere, an orange pleated bloomer skirt falls from a black leather bodice with buckled shoulder straps.

HUGO BOSS

www.hugoboss.com

Hugo Boss is a high-profile fashion empire founded on the manufacture of men's suits. With shops in 103 countries, more than 5,000 retail outlets and an annual turnover of more than half a billion dollars, the label has extended into high-end ready-to-wear for both men and women. The company was established by Hugo Boss (1885–1948) in 1923 in Metzingen, Germany to manufacture work clothes and uniforms up to and including World War II. The company expanded into menswear in 1953, with a successful mid range of clothing for men in the 1960s that offered a ready-to-wear Cardin-inspired look using Italian fabrics in fashionable colours. Early success was predicated on the production of small batches of garments in upmarket styles at affordable prices.

In 1993, businessman Dr Peter Littman reorganized the firm and its image, discarding the old logo in favour of three new ones: Boss, the high-end sophisticated collection; Hugo, for the younger man; and the bespoke Baldessarini, named after the designer. The 1990s also saw the launch of the label's first collection for women and the implementation of Boss Orange and Boss Black, now designed by Graeme Black. Sporty and golf-inspired clothes for men came under the label Boss Green. With the extension of the avant-garde Hugo line to include directional clothes for women, the Hugo Boss brand covers all bases. In December 2001, Baldessarini stepped down as Hugo Boss chief executive and was succeeded by Dr Bruno Salzer. As well as being involved in sports sponsorship, the brand has established an annual international art award, the Hugo Boss Prize, in conjunction with the Guggenheim Museum.

◄ **High-end menswear for A/W 09/10 from the Hugo by Hugo Boss collection.**

2004
A mix of utilitarian styling and lustrous fabrics for a spring/summer collection.

A pearlized-lilac leather bomber jacket partners a glossy pearl-grey pinstriped skirt. The pinstriped fabric is also used for slim-line men's suits with a single-button jacket and for shorts suits in womenswear. Ribbon ties are threaded through low-rise trousers, worn with cropped petticoat tops. Evening wear includes an empire-line dress in black leather with a shoestring tie around the natural waistline. A princess-line cocktail dress incorporates icy circular frills set into the seams.

1989
The yuppie suit conforms to the traditional 20th-century man's silhouette of broad shoulders and narrow hips.

Alongside British label Paul Smith, Hugo Boss epitomized the popular conception of the yuppie, the young aspiring professional of the 1980s, satirized by Tom Wolfe in his book *The Bonfire of the Vanities* (1987). The yuppie suit was styled by businessmen rather than tailors, comprising a double-breasted jacket and pleat-front trousers. The overcoat reflects the easy oversized silhouette of the suits. During the 1980s, Hugo Boss engaged in an early example of product placement when the label appeared in the two most stylishly influential television shows of the decade: *Miami Vice* and *LA Law*. The strategy of subcontracting and the use of high-quality materials enable the brand to maintain visibility in a competitive market.

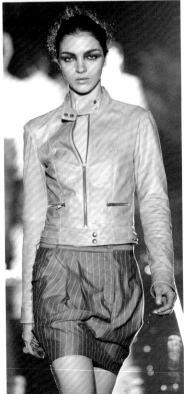

2011
Soft tailoring for suits, shirtwaisters and ultra-feminine chiffon dresses.

A neatly tailored trouser suit gently resonates with 1980s detailing: the pushed-up sleeves, peg-top trousers and short waiter's jacket. The inspiration is confirmed elsewhere by a businesslike black skirt with a deep peplum providing fullness on the hips, worn with a crisp white shirt, and by a batwing-sleeved royal-blue taffeta goddess gown. Oversized chunks of faux coral enliven checked sundresses and scarlet evening wear.

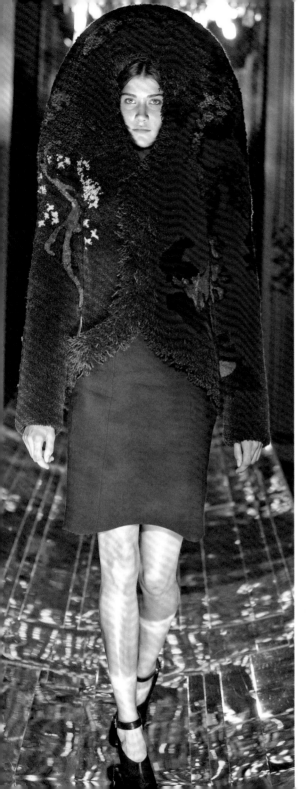

HUSSEIN CHALAYAN

www.husseinchalayan.com

Within the litany of seasonal catwalk shows, there are few designers who can perennially command the attention of the media primarily for the haunting metaphysical character of their designs. Turkish-Cypriot Hussein Chalayan (1970–) has demonstrated an ability to pose multilayered questions about the relationship between humanity and materiality in his work. Fourteen international museums and galleries – across eight countries and three continents – have shown exhibitions of his work, including the Venice Biennale in 2005.

The artistic and cultural resonances of Chalayan's work do not obscure the fact that his output is commercially viable. From the outset of his career in 1993, on graduation from Central Saint Martins College of Art & Design in London, Chalayan has formed commercial bonds with a number of companies in the development of his labels. From 1998 to 2001, he fronted the New York knitwear company TSE. This was followed by connections to British high street store Marks and Spencer and Italian manufacturing company Gibo. In 2001, he was appointed fashion director at the luxury jeweller's Asprey. He began his own menswear line in 2002 in an exclusive deal with online retailer yoox.com. He was a recipient of the Design Star Honoree Award from the Fashion Group International in 2007. Chalayan has added the creative direction of Puma sportswear to his sphere of interests, and collaborated with Swarovski, the Falke legwear line and New York denim label J Brand in 2009.

◄ **The rise and fall of the evolved collar in 2005: upsized for boleros and extended to dress hems.**

1997 Almost flying: parachute lines and flight attendant suits.

Chalayan adds parachute connotations to a conservative shift dress in a collection that offers many urbane business wear variants. Brown suits with skirts or trousers are uniformly cabin crew compatible, unless gently punctuated with inserts reflecting the wing geometry of paper planes or kites. In the same vein, a V-panel of transparent net gives an edgier impact to the bodice of a long jersey shift dress.

2010 From the mariachi frills of Mexico to the sou'westers of Maine.

A hyperreal twister dress makes the conceptual literal. The 'Mirage' collection investigates the fruits of a diagonal trawl across the United States and Mexico. Nantucket oilskin headwear accessorizes enlarged Boston club blazers. Shaker bonnets attached to crisp white shirts under tailored jackets make innocent hoodies. A slick cape over a sandy camel blazer echoes Arizona and frilled crochet colour signals sunny Tijuana.

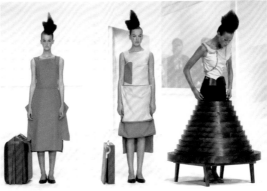

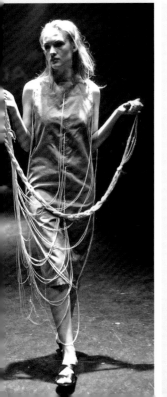

2000 Turning tableaux into gentle rhetoric: in the midst of considered and commercial pieces, messages on the plight of the refugee are imparted by ingenious transformations.

Chalayan is set apart from other designers by a willingness to demonstrate his reckless imaginative virtuosity. Here, he creates a furnished room set that metamorphoses into wearable garments and luggage, signifying the insecurities of the displaced. To plant this spectacle in the midst of a commercial presentation is indicative of a serious desire to add content and values to artefacts that interact with the human form. As a consequence, the 'Afterwords' collection has a complex narrative. Scenes are set that embrace all generations, and garment genres or types are introduced on uniformly styled models. Transforming shapes recur in orthodox form: the wooden skirt is mirrored in the black petticoated prom dress; a chair's loose cover has the same final profile as a black evening gown and the waterfall-pleated cocktail dress. Some styles are witty: the calf-length shearling coat is patch-pocketed with trompe l'oeil mittens.

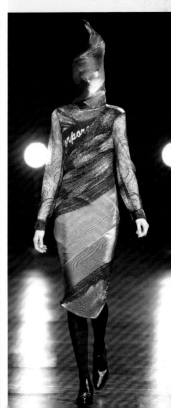

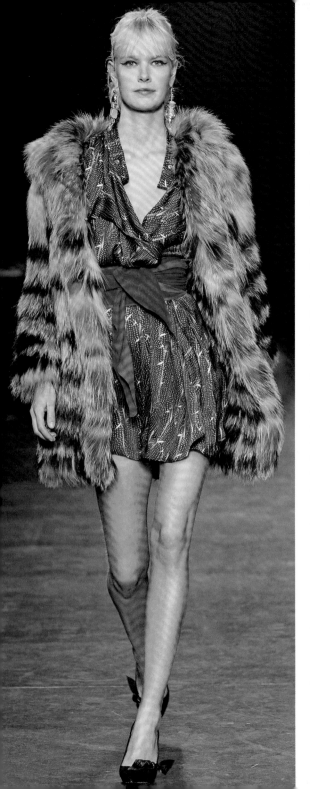

ISABEL MARANT

www.isabelmarant.tm.fr

Contemporary yet classic, combining grunge with glamour, the Paris-born designer Isabel Marant (1967–) offers an uncomplicated Left Bank chic with her laid-back tailoring and bohemian details. The designer launched her accessories line in 1989, and her reputation for effortlessly hip clothes has spread from her native France to Europe and the United States, with the opening of a store in New York in 2011. With a signature style that includes strong-shouldered jackets with craft embellishments and flirty feminine pieces, she works with her fabric suppliers to create and then age materials unique to her label, preferring to use fabrics with an aged patina in keeping with the hippie de luxe look of the clothes. Tracksuit-style slouchy trousers, elegant tweed and velvet jackets and casually belted draped chiffon dresses with dropped waistlines exude a relaxed and individual style. An exponent of the summer boot, Marant sees the cuffed pirate version, often embellished with fringes and chains, as an essential component of her louche look.

Reworking retro fabrics and vintage pieces such as army jackets, Marant started selling her home-made creations in Les Halles. In 1987, she enrolled at Studio Berçot, which was followed by an apprenticeship at Michel Klein. Marant has been designing under her own name since 1994, when her offbeat aesthetic was at odds with the minimalism of mainstream fashion. Her main boutique is in an old Parisian artist's studio. The diffusion line Etoile is a more affordable range.

◄ **For 2005, a fur is worn with a printed silk shirt dress, cinched with a red suede cummerbund.**

1997 The collection shows baroque prints in a long lean silhouette.

An asymmetric lurex jacquard-knitted top and a split-to-the-thigh maxi-skirt provide contrast in a collection that mostly features slim-fitting trouser suits in either white or, with reference to the blaxploitation films of the 1970s, copper satin, accessorized with Afro hair. Elsewhere, a paisley pattern provides the motif for see-through black lace tops and dresses in this spring/summer collection.

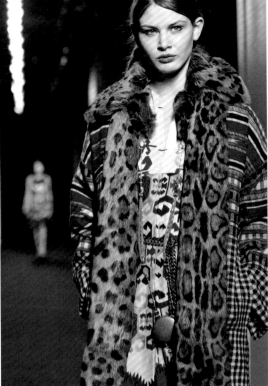

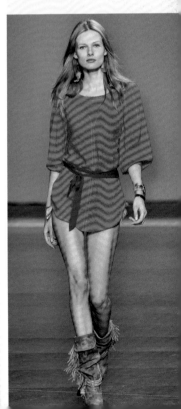

2010 High-end festival wear and summer dressing from Isabel Marant.

Draped and frilled mini-dresses in pink, turquoise and silver lamé are worn with Marant's signature fringed boots, often with lamé ribbon scarves wound several times around the neck. Striped and sequinned knits appear under vintage-inspired edge-to-edge jackets in bejewelled tweed, embellished with buttons and fringing. Big-shouldered jackets are partnered with pelmet brocade skirts and racer-back vests.

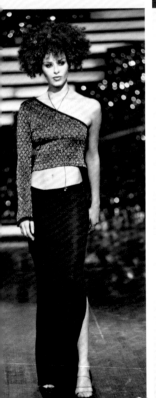

2005 Unstructured tailoring and feminine floating chiffon combined with colourful textured tweed is offset with boho-style touches such as embroidery.

Leopard-skin printed fur lines this tweed edge-to-edge coat, which is bordered with outsize black and white checks and worn over an ikat-inspired print dress. The print dress is a key feature of this texture-rich collection, worn beneath double-breasted sheepskin jackets that are cropped, to the knee or shaped into a bolero. The vibrant orange/red of the dress is picked up elsewhere in colour-blocked skirts in silk-satin and easy wrap dresses. It also provides a flash of colour beneath floating knee-length grey chiffon dresses. Feminine detailing is continued throughout the collection on hip-length chiffon tops with self-colour embroidery and miniature pompom fringing. Accessories include beanie hats and heavy bronze medallions. Cropped loose-fitting trousers in cream or grey are worn with matching knits and accessorized with thin plaited belts embellished with tassels.

ISSEY MIYAKE

www.isseymiyake.com

The dominant preoccupation throughout Issey Miyake's work is a sensitivity to the relationship between innovative fabrics and novel garment forms. This connection dramatizes the movement of the body within soft architectural exoskeletons of textiles. In 2005, the designer (1938–) was recognized as an artist of international stature, honoured with the Praemium Imperiale Award for Sculpture and inducted into a peer group of global creatives of the calibre of Anthony Caro, Frank Gehry and Federico Fellini. This was a fitting recognition for the Hiroshima-born protagonist of a stable of associated brand lines. Miyake has drawn influence from his Japanese origins, but having studied and worked in both Europe and the United States, he has assimilated many aspects of global culture.

After four decades in the industry, Miyake has produced key concepts that have formed permanent fashion landmarks: the Pleats Please line, the 1980 cast-acrylic flared torso-as-bustier and the radical technology of the A-POC (A Piece of Cloth) construct your own garment concept. In some collections there are elements of a sober playfulness, but the central characteristic of the Miyake identity is a respect and appetite for enduring quality in wearable artefacts. Since his retirement in 1997, Miyake has restricted his role within the company to research projects. In 2010, the brand celebrated the delivery of the eightieth womenswear and the fiftieth menswear collections, under the direction of Naoki Takizawa until 2007, when Dai Fujiwara took over.

◄ **A 2010 collection of parabolas, vectored coils and textured circular swags.**

1989 Thermal pleating defines 3D forms in prefabricated polyester pieces.

The experiments of the 1980s led to the launch in 1993 of Pleats Please. Just as Mariano Fortuny at the beginning of the 20th century looked to classic Hellenic dress – the chiton and himation – to define his Delphos gown in patented silk pleats, likewise Miyake adopted the philosophy of letting the behaviour of his own patented fabrics determine the variety of perennial forms in his garment collection.

2006 A moulded leather cuirass gives an Amazon tone to army surplus.

An eclectic flow of military references underlies the collection designed by Naoki Takizawa. A wide range of variations on the greatcoat, fatigues and trench is explored in raw-edged hide, in shearling and in quilted parachute silks. The colour palette leans towards re-enactment tones of tan, navy, indigo, arctic white, khaki, grey and parade red. Much strapping, lacing and webbing features.

1999 A-POC technology pre-constructs garment permutations on 'A Piece of Cloth' in such a way that customized units are liberated for immediate wear by simply using scissors.

In a mid-catwalk demonstration, Miyake technicians reveal the versatility and immediacy of long-term research into embedding clothing envelopes in the continual production of fabric rolls. Meandering chains of warp threads are cross-linked and partnered in complex digitally controlled sequences in such a way that the fabric, or layers of fabric, can be cut without losing the integrity of the structure, thus releasing a variety of garment compartments to independent life – usually with short fringes at the perimeter. The virtuosity of the technology allows this early version to incorporate a complete wardrobe of multi-size clothes: dresses, camisoles, skirts, leggings, socks and hats – all freshly cut from a single fabric roll. To reinforce the quasi-scientific nature of the range, other lines exploit modernist materials: A-POC supported by heat-reflective Tyvek and by transparent PVC.

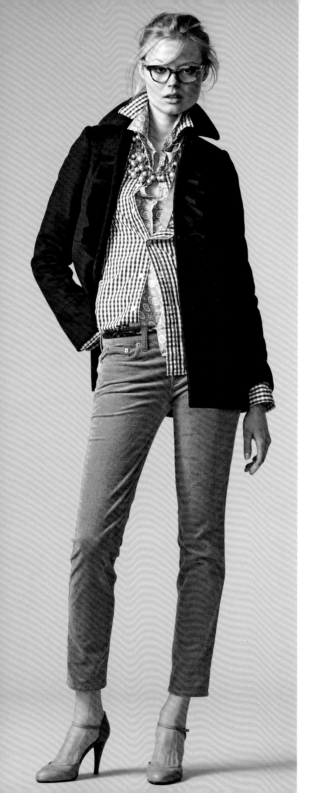

J.CREW

www.jcrew.com

Founded by the Cinader family, the US style institution J.Crew began life as a mail order catalogue company in 1983. Six years later, the brand opened its first store in New York City. Today, customers can shop online or at any one of the 244 stores in the United States.

In 2003, Millard 'Mickey' Drexler, previously credited with building Gap, joined J.Crew as chairman and chief executive, and he continues to develop the brand's women's, men's and children's (crewcuts) collections. J.Crew also produces the J.Crew collection, a higher end line of limited edition creations. In 2006, a denim-focused line of casual wear was introduced for younger women under the name Madewell – a revival of the US denim label founded in 1937 – for which *Vogue* cover girl Alexa Chung cut her teeth as a designer with a capsule collection in 2010.

Under the creative direction of Jenna Lyons, appointed in 2007, the brand has evolved from its early associations with the 'preppy' look of rollneck sweaters, checked shirts and chinos into a label with a core proposition that combines well-made fashionable clothes in quality fabrics, unexpected colours and attention to detail. Michelle Obama is a visible ambassador for the company, as are Sarah Jessica Parker, Rachel Bilson and Oprah Winfrey. Currently, the UK-based shopping website net-a-porter.com is the only outlet outside the United States carrying J.Crew clothes.

The J.Crew Group continues its retail expansion with a series of new speciality boutiques including the men's suiting shop, the J.Crew bridal boutique on New York City's Madison Avenue and a new crewcuts location in New York's Tribeca neighbourhood.

◄ **Layered casual wear with skinny pants, checked shirts and pea coats for 2009.**

2009 Boyfriend blazers, vintage detailing and a muted palette of cool greens and nudes.

A crisp white blazer cinched at the waist with a tan leather belt is worn over a butter-yellow print shirt and cropped gathered mini, in a collection that juxtaposes ingénue appeal with boyfriend borrowed jeans and jackets. Denim adds a harder edge to the more overtly feminine elements, as a shirt with jacquard tailored shorts hung from the hips, and cut-off shorts worn with a white-on-white fringed vest top and a cardigan of broad horizontal stripes. A nude pink vest with ruffled bib front partners khaki drawstring trousers.

2011 The J.Crew Madewell line combines tomboy pieces with insouciant easy dressing.

A cropped printed tunic with three-quarter sleeves features in a collection of uncomplicated pieces: airy loose-stitched knits, crisp tailored shorts, cuffed trousers and variations of the striped breton T-shirt, oversized or worn under a nude silk jacket. Coral, khaki and camel are the predominant colours, worked into a broadly striped cardigan, a sleeveless blouse with safari pockets and a softly tailored velvet jacket. Accessories include two-tone correspondent shoes in tan and cream, khaki peep-toed wedges and across the body bags.

2010 A collection by Frank Muytjens for J.Crew of subdued natural hues and dark-dyed denim for autumn/winter.

A long-line suit with a single-breasted jacket and narrow trousers has a relaxed informality when partnered with a navy knitted cardigan, button-down shirt and brown suede shoes. Layering is a feature of the collection, seen in a rust-coloured military-style jacket with drawstring waist, epaulettes and double pockets worn over a cream country cardigan with leather buttons and flat-fronted trousers in charcoal grey or chocolate brown matched to a narrow tie and griege shirt. More casual is the Fair Isle sweater worn with dark-dyed narrow jeans with turn-ups, partnered with a navy donkey jacket and a robust saxe-blue zip-fronted quilted coat.

JASON WU

www.jasonwustudio.com

The instant exposure experienced by Jason Wu (1982–) when Michelle Obama wore his white one-shouldered silk-chiffon gown with Swarovski crystals to the Inaugural Ball in 2009 placed the young designer in every national newspaper. Prior to this springboard, Wu had been designing his own collections for only two years and had built up a client list of celebrities attuned to his look, which ranges from the flirty and floaty to the serene and classic. Taiwan-born Wu entered the design profession at a very young age – at just fourteen he produced freelance clothing designs for dolls for Integrity Toys under the lines Jason Wu Dolls and later Fashion Royalty. At the age of sixteen, he became creative director of the company. He then went on to further his education, studying sculpture in Tokyo and fashion at Parsons The New School for Design, before interning at Narciso Rodriguez (see p.228). He launched his first full-scale clothes collection under his own name with his earnings from his doll design work in 2006, winning the Fashion Group International's Rising Star Award in 2008.

Based in New York, Wu extended the reach of his label in 2010 by adding another collection to his range, putting a more refined palette into play with greater emphasis on dark neutrals. For A/W 10/11, he collaborated with cashmere brand TSE to create a capsule collection of thirteen looks, including cashmere sweaters, flannel blazers and chiffon dresses. Wu sought to expand the company's core cashmere identity into other sympathetic materials. He used special washing techniques to refine the handle of both the cashmere and chiffon pieces.

◄ **Ultra-feminine, the vibrantly coloured 2011 waterfall wrap dress emphasizes the waist.**

2009
A one-shouldered mid-length draped dress in pastel green for Wu's resort collection.

In a small collection of demure styles, Wu shows the skills that led to his global exposure as the First Lady's designer of choice. The dress shown here was revisited and lengthened in crystal-clad white for Michelle Obama's ball gown for the Inaugural Ball. Wu uses exposed shoulders to suggest athleticism and vigour and delicate fabrics to reveal movement. The collection ranges from layered daywear – a duster coat over shorts or a long slim cardigan with a floaty patterned dress – to cocktail and goddess gowns.

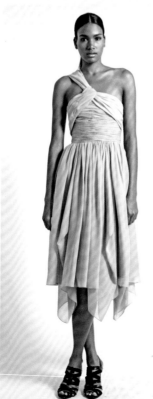

2006
Wu uses a palette of boudoir shades for his debut collection.

A simple panelled and fitted beige shift dress is rendered edgy with the addition of a wolf-fur shrug and black lace banding. Elsewhere in the collection, lingerie and corsetry detailing are combined with fur, creating clean lines and fuss-free elegance. Materials include tulle, silk and cashmere. The use of lace and fur suggests feminine intimacy, while adding texture.

2011
A cruise collection celebrates Gallic-inspired gamine charm with polka-dot chiffon, pussycat bows, breton tops and boaters.

Reworking his successful adoption of the shorts suit, Wu adds the flourish of a chiffon jabot to evoke Parisian chic. A monochrome print of a gauzy floral appears throughout the range to thematic effect, both graphically and in the suggestion of flimsy materiality. The floating belted layered shift moves beneath a hooded anorak and is topped with a thin-brimmed boater; later it recurs as the fabric of a trailing bias-cut evening gown. A subtle recollection of classic Chanel arises from the broad gauzy edging to a low-slung coarse-silk blazer over shorts. Horizontal pleats of overlaid voile are delicately caught in seams of skirts and bodices, and radial pleats disappear into round necklines.

JEAN PAUL GAULTIER

www.jeanpaulgaultier.com

Quintessential Frenchman and irreverent designer Jean Paul Gaultier (1952–) is a self-taught prodigy, progressing from enfant terrible to global brand status in a career spanning four decades. He was recruited as design assistant to Pierre Cardin (see p.246) at seventeen on the strength of an unsolicited portfolio of sketches. In 1971, Gaultier worked briefly at Jacques Esterel before moving to Jean Patou, where he remained for three years. By 1976, Gaultier had attained sufficient profile to launch his own label with the company Mayagor, while continuing to provide designs for swimwear, leather and fur collections for other labels. From 1978 to 1981, Gaultier's label was backed by the Japanese conglomerate Kashiyama, which continues to produce it under licence in Japan and the Far East. The Italian groups Gibo and Equator supported his woven and knitted manufacturing respectively.

The longevity of Gaultier's impact arises from his willingness to absorb influences from evolving youth culture and from his affinity with cross-branding exercises, for example his creation of Madonna's wardrobe for her 'Blond Ambition' tour in 1990 and Kylie Minogue's wardrobe for her world tour in 2008.

Since 1997, Gaultier has delivered a couture collection, for which he received the International Award from the Council of Fashion Directors of America in 2000. Hermès (see p.146) has financed 35 per cent of Gaultier's company since 1999, and Gaultier took responsibility for the creative direction at Hermès until his resignation in 2010.

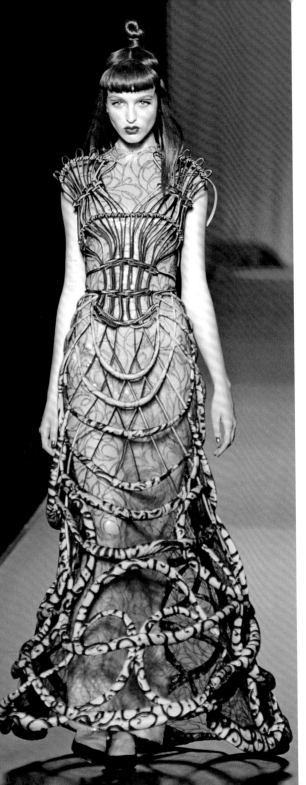

◄ A neon-bright acid-green gown from the 2008 haute couture line has Medusa-like coils.

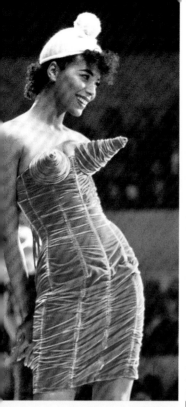

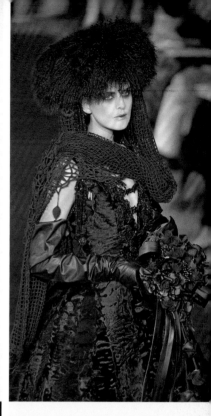

1985 Gaultier tears apart dress conventions to fuse disruptive visions of gender, famously placing men in skirts.

Constructed from tartan cloth, the ankle-length skirt from the iconoclastic men in skirts collection, 'Et Dieu créa l'Homme', has enough associations with the male Scottish kilt to render it more easily acceptable as masculine attire, especially when worn with a matching shirt and rugged knit cardigan. Male dress has been bifurcated since the 16th century, since when designers have continually attempted to make the male skirt fashionable. Transgressing social codes, Gaultier frequently introduces the skirt into his menswear collections as a means of injecting novelty into male attire, most famously the sarong seen on footballer David Beckham in the mid 1990s.

1984 A seamed corset dress in orange rayon velvet has torpedo-shaped bra cups and back lacing.

By the mid 1980s, Gaultier's ability to maximize editorial publicity for his provocative concoctions and theatrical presentations placed him brightly in the firmament of avant-garde design. Fascinated as a child by his grandmother's salmon-pink lace-up corset, the designer frequently fetishizes the garment, most famously with the exaggerated conical breasts on the corset worn by Madonna. Promulgating the concept of underwear as outerwear, the designer eroticizes the female body, constantly returning for inspiration to the boudoir.

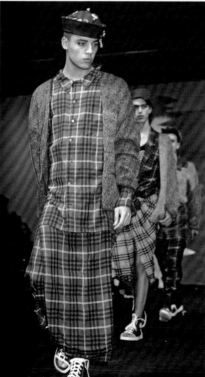

1997 The avant-garde bride in mournful black brocade with a crocheted lace mantilla for a train.

With designs as sumptuous and decadent as the gowns and costumes depicted in the paintings of Giovanni Boldini, Gaultier launched his first haute couture collection to wide acclaim. The gothic opulence encompasses tsarist Russia and Fabergé, the consumptive decay of Thomas Mann's Venice and of the Hanoverian monarchy of Spain. In embracing the labour-intensive methods of the couture atelier – crochet *passementerie*, encrusted embroidery, exotic decorative furs – the salon is a place of excess.

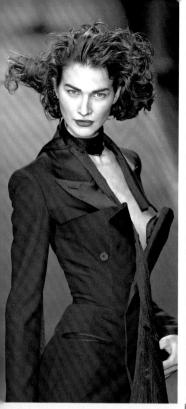

2003
Haute couture all-in-one bodysuits beneath bustier dresses for autumn/winter.

A printed all-encompassing – including head, hands and heels – bodysuit gives the impression of a full-body tattoo. It forms part of a series that uses multicoloured patchworked leather and – as evidence of Gaultier's lurid playfulness – a bodysuit featuring a red heart at the centre of a map of veins and arteries. Second-skin suits also appear under tailored skirt suits, the jacket morphing into a dress, in leather and tweed. Luxurious wrap coats, oversized parkas and sable-lined crocodile-skin cloaks provide volume.

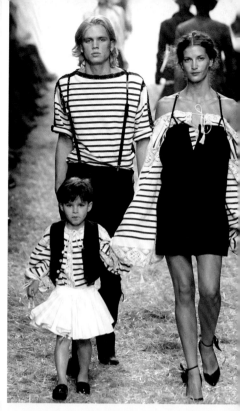

2001
Rebelling against traditional couture using technical brilliance.

The tailoring of haute couture is subverted by leaving breasts and back exposed. A two-piece double-breasted trouser suit in sombre black has a tight-waisted jacket with a horizontal open seam across the breasts, which extends to form a third revers. Elsewhere vertical seams along the line of the body are left open to expose the conical cups of a bra beneath, or feature cut-outs at the back.

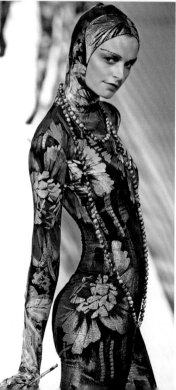

2006
The collection celebrates rustic charm, with romantic frills and black lace bustiers offset against androgynous tailoring.

A striped breton jersey T-shirt is a Gaultier staple, and a garment closely associated with the designer's personal wardrobe. Family friendly, it is reworked into a gathered overdress for the woman, and worn with a white pleated skirt by the boy. Rustic references abound throughout the ready-to-wear collection: dungarees, blousons teamed with cropped waistcoats, corn-dolly dresses, off-the-shoulder smocks and dresses with drawstring necklines decorated with Eastern European folkloric embroidery. A woman's three-piece striped suit gives a masculine edge to the romantic rural style. As ringmasters of the circus, men wear all-white trousers and frock coats, or striped trousers and braces with knee-high black boots.

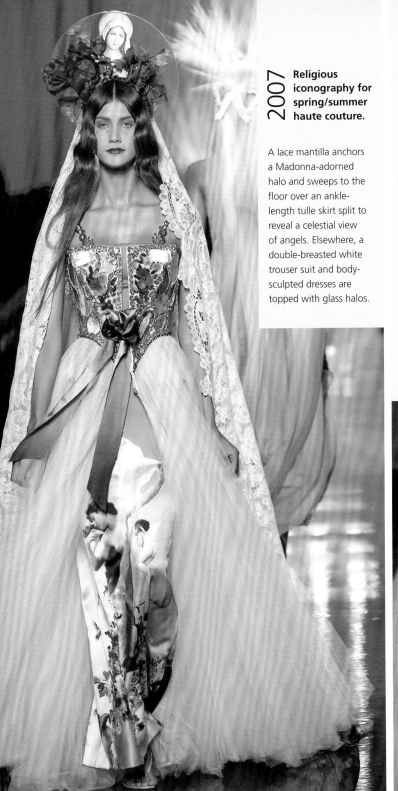

A lace mantilla anchors a Madonna-adorned halo and sweeps to the floor over an ankle-length tulle skirt split to reveal a celestial view of angels. Elsewhere, a double-breasted white trouser suit and body-sculpted dresses are topped with glass halos.

Leather strips are plaited and woven over a crinoline cage to form a corset and worked into circular bra cups – a return to Gaultier's fetishization of the corset. In a similar vein, dresses relying solely on ribbons criss-crossing the body eventually float free. Gaucho-inspired trousers, oversized beaded sombreros and embroidered fringed shawls exemplify Mexican exoticism, hybridizing Frida Kahlo and Carmen Miranda, particularly when accessorized with hats fashioned into sprouting palm trees.

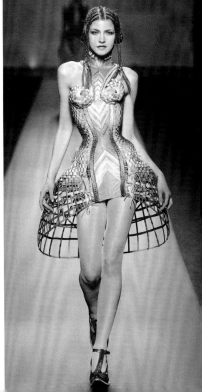

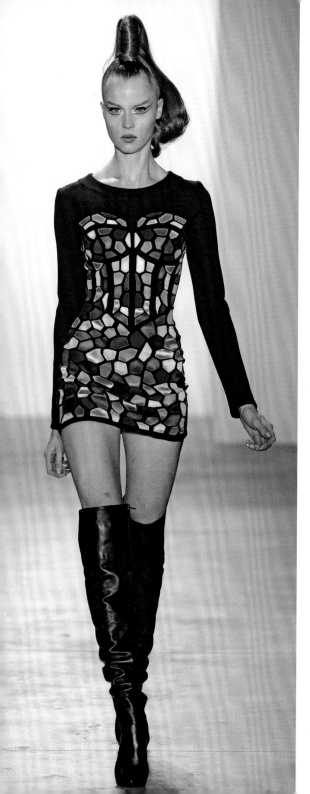

JEREMY SCOTT

www.jeremyscott.com

Courting pop-biz patronage, Jeremy Scott (1976–) uses graphic irony from popular culture in his unpredictable catwalk collections. Pushing an Americana-based eclecticism, Scott uses his whimsical approach to entice support from the professional stylists of an array of 'look at me' clients, such as Björk, Kanye West, Lindsay Lohan, Kylie Minogue and Lady Gaga. He also designed the airline stewardess outfit for Britney Spears's 'Toxic' video.

Born in the United States, Scott is from Kansas City, Missouri, and now resides in Los Angeles. Rejected by the Fashion Institute of Technology, he went to study fashion in New York at the Pratt Institute. Moving to Paris on graduation, Scott gained work and support from veteran designer Karl Lagerfeld (see p.182), who regarded the youthful art director as the touchstone of an edgy and young street style. Scott began his own catwalk career in Paris in 1997, subsequently showing collections in New York, London, Los Angeles and Moscow.

His avant-garde output, which includes humourous and idiosyncratic prints, lends itself to high-visibility collaborations, for example, he has a long-term line with Adidas called Jeremy Scott for Adidas. The winged high-tops, a mix of 1980s basketball shoe with removable metallic leather flaps and JS lace jewels, became an instant best-seller. Scott has also undertaken several short-term alliances with Swarovski, Christian Louboutin and Stephen Jones.

◀ **A 2010 sweater dress has a quilted appliqué of stained glass and a bejewelled bustier.**

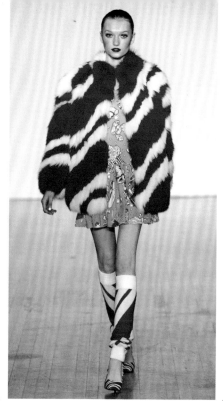

1998 Scott's earliest signed Paris collection evokes images of the decadent Venice Carnival.

Playing between the implicit seductive hedonism of the masked odalisque in filmy gold and the operatic drama of the black silhouette, this dress has a structured black bodice and a flounced cowl and sleeves of lamé. With a colour palette restricted to black and gold, the sculpted pieces in the collection include a lamé trouser slashed at the knee, a one-sleeved fur jacket, three-quarter-length fitted jackets with winged shoulders, split and fringed harem pants and a form-fitting jacket that is divorced from its peplum.

2009 A demure shirtwaister has a telephone print, flounced skirt and bow at the neck.

Expanding gradually from subtle suggestions of Disney in red, black and white, the Minnie and Mickey Mouse conceit is made explicit in this collection with a coat of white cartoon gloves over red dungaree shorts with big buttons. Elsewhere, the mice are referenced in refined commercial pieces: a frilled sweetheart panel sits lightly on a body-hugging knit dress or a simple polka-dot frill is attached to a boat neck. The colour palette is eventually allowed to extend to other primaries, while giant eyelets replace polka dots.

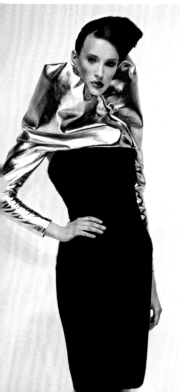

2006 A candy-striped fur jacket is worn over a cartoon-print dress of food products: fries, pizza, popcorn, pretzels and Oreos.

Scott explores every surreal transposition of food to clothing that he can find the means to fabricate. Under the slogan 'Eat the Rich', the liveries of McDonald's and Snickers – and other brands – are ruthlessly appropriated, reappearing in this collection as a giant 'fries in a box' sweater dress and 'Hamburglar' tote, or as a Jeremy snack-bar hoodie dress. Spaghetti with meatballs finds expression as a ball gown of intertwined spaghetti-like threads. A pizza becomes an enveloping quilted kimono in shades of cheese, salami and olive. The feast concludes with ball gown games based around the notion of inappropriately placed ice-cream cones.

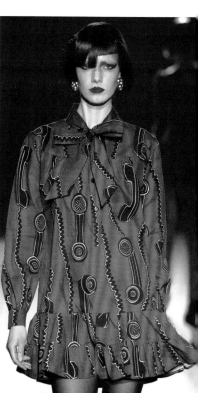

JIL SANDER

www.jilsander.com

The Jil Sander identity focuses on minimalist austerity of line and quality materials in noble fibres. The brand aims to invest wearers with a strong sense of independence and power, liberating them from any necessity to follow trends.

As a graduate from the School of Textiles in Krefeld near Hamburg, Jil Sander (1943–) joined the exchange programme at the University of California in 1963, before embarking on a career in fashion journalism. Sander began to work as a freelance fashion designer in 1968, opening her first Jil Sander boutique in the same year, followed by Jil Sander Moden in Hamburg a year later. The designer's first womenswear range was launched in 1973, and in 1978 she established Jil Sander as a limited liability company (GmbH). With the Lancaster Group in 1979, Sander launched a range of cosmetics and fragrances – PURE woman and PURE man.

Sander's fastidious attention to quality and detail ensured that the ready-to-wear label remained in the luxe category for three decades. However, this led to a crisis when the Jil Sander philosophy was compromised by the Prada Group management, under chief executive Patrizio Bertelli, when it took over Jil Sander AG. Sander resigned in 2000 in frustration at the imposition of cost constraints to her line, returning to the fold in 2003 for two collections and then finally withdrawing from involvement in her own label, leaving Raf Simons to be appointed in 2005 as creative director.

In 2009, Jil Sander began designing collections for Uniqlo under the brand name +J – well distanced in the marketplace from her eponymous label.

◄ **The S/S 10 collection by Raf Simons reduces Sander's standards to strategic remnants.**

1990 Jil Sander harnesses luxury fabrics to androgynous minimalism.

The Jil Sander label came to signify luxury by clarity and economy of statement at the beginning of the 1990s, when the company went public, exploiting its visibility and reputation in the market. Disavowing decorative effect in this autumn/winter collection, the core values of the brand were subtlety, intelligence and restraint, affording the Sander woman independence and authority.

2010 Raf Simons adds an undercurrent of subversion to tailoring etiquette.

A dolman-sleeved sombre tweed dress, cropped across the shoulders, has added chiffon straps. Subtle traditional cloths such as wool are leavened by playful cutting to create a lighter tone. A Prince of Wales check is kept severe in a fly-front jumpsuit except for the addition of a transparent yoke; or a youthful romper suit is made city sharp with revers, in a collection of subtle understatement.

2000 Pure white linen, lawn and leather lie at the heart of this spring/summer collection that concludes the working relationship between Sander and Prada.

A boat-necked tunic top with brief shorts in delicate lawn are cycled in and out of a collection that proposes varied levels of opacity and hemline. Sheer linen sweaters in black, white or teal are worn over shorts, culottes and skirts or under brief duster jackets. Folded white panels recall an unfurling foresail, while an easy drawstring at the waist speaks of seaboard life. Elsewhere, shirtwaisters composed of layers of sheer fabric become discreet daywear and a strong three-colour floral print is kept calm and pastel by showing the reverse fabric. As the range progresses to evening and cocktail wear, dominated by shifts and slips, the flower is styled into a studded metallic embroidery motif across the bodice or yoke of multilayered organza in black or pale copper. Slots, draped flaps and round bias frills are used to defuse the austerity of silhouette.

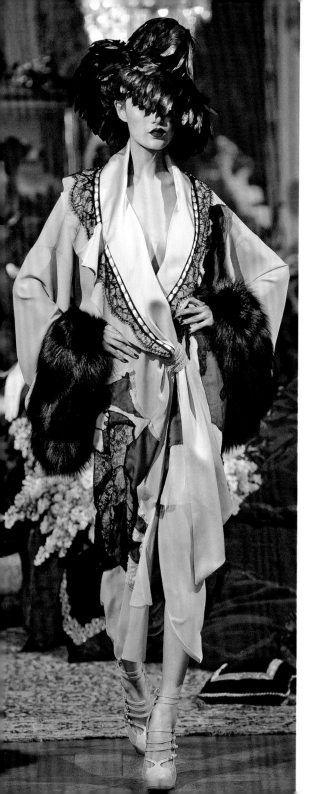

JOHN GALLIANO

www.johngalliano.com

John Galliano (1960–) is an English eccentric whose wild imagination, romanticism and innovation led to his appointment in 1995 as the first British designer to head a French haute couture house. Galliano rejuvenated the Givenchy label and brought couture to the attention of a younger edgier clientele.

Born in Gibraltar, Galliano moved with his family to London in 1966, where he went on to study at Central Saint Martins College of Art & Design. Inspired by the French Revolution, Galliano's final degree show in 1984, 'Les Incroyables', had all the hallmarks that would come to identify his unique aesthetic: idiosyncratic tailoring, a persuasive narrative and a strong vision perfectly executed down to the smallest detail.

Galliano launched his own label in 1985 and presented his first commercial collection, 'The Ludic Game', at London Fashion Week. In 1988, Galliano was awarded Designer of the Year for the 'Blanche Dubois' collection, but although he enjoyed the adulation of the fashion press, financial backing for the designer continued to be a problem. Five years later, Anna Wintour, editor-in-chief of US *Vogue*, secured a backer for him and also provided socialite Sao Schlumberger's decadent villa as the venue for his next show. The 'Princess Lucretia' collection was restricted to seventeen pieces, all black. Following his years as design director of Givenchy (see p.132), Galliano moved to Dior (see p.92) in 1996, where he remained as creative director until his dismissal in 2011.

◀ **An intimate salon show of twenty looks epitomizes 1930s glamour for 2011.**

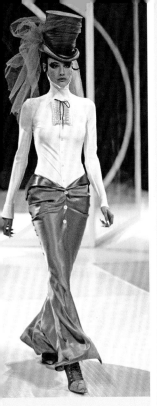

2004

Galliano's first menswear range is kaleidoscopic in its inspiration.

Spray-on long johns, in Galliano's signature bespoke print (designed for him by Central Saint Martins graduates Stephanie Nash and Anthony Michael) appear amid the apparel of myriad male stereotypes: the jock, pimp, boxer, cowboy, city slicker, gangster and hustler. These bruised and bloodied protagonists of masculine physicality are juxtaposed with flashes of traditionally feminine clothing, such as the pink suspender belt and formal black tie and tuxedo partnered with a frilled floral overskirt, socks and shoes on display.

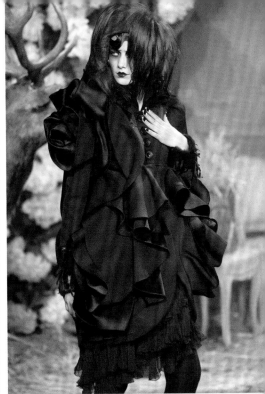

2000

A bricolage of influences from burlesque to bondage.

The high-boned collar, ribboned stock, draped skirt front and top hat recall the severe silhouette of an Edwardian riding habit. This is in contrast to the abundant use of tulle in a collection of frothy layers of petticoats under prom dresses and full circle skirts in pale pink and lilac gingham. The Scottish kilt is interpreted in pink tulle, worn with a gingham busboy jacket with puffed sleeves.

2007

Evidence of Galliano's preoccupation with asymmetry and shifts in traditional tailoring conventions for autumn/winter.

A waterfall of circular frills cascades from the empire-line waist of the redingote-style jacket to form a lavish many skirted peplum to the knee, the dramatic impact of the piece enhanced by the ruffled petals of an oversized rose attached to one shoulder. Other ruffles are whorled into a rose focal point, the sleeves cuffed in a deep band of red fox fur. Eclecticism and a narrative romanticism provide the underlying aesthetic of a collection that incorporates exaggerated Edwardian gigot sleeves, the loose lines, tulip-shaped skirts and rich reflective fabrics of the Poiret era, and the frilled chiffon flapper dresses from the 1920s, alongside Galliano's signature intricate bias-cut slip dresses.

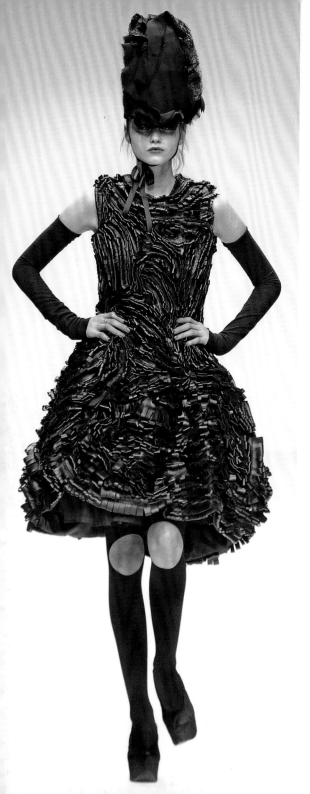

JOHN ROCHA

www.johnrocha.ie

With a relish for exploring texture with craft-based embellishment alongside contemporary innovations such as laser cutting, Ireland-based designer John Rocha (1953–) creates collections that resonate with eloquent detail. Born in Hong Kong of Chinese and Portuguese descent, Rocha came to London in the 1960s and studied fashion at Croydon College. His graduation show included the use of Irish handwoven wool and inspired him to visit Ireland. He eventually moved to Dublin, where he works with his wife and business partner Odette. Having worked for twenty-five years in fashion design since the inception of his label in the 1980s, Rocha runs his design practice – Three Moon Design – out of Dublin's Ely Place.

Lines include John Rocha, John Rocha Jeans, Rocha John Rocha and John Rocha Jewellery. His diffusion range produces four collections a year for 'Designers at Debenhams', as well as homeware and accessories for the British high street department store. He has worked on residential property schemes in Liverpool and Birmingham, hotel interiors, private jet interiors, costumes for film sets and even multimedia theatre. Collaborations include cut-crystal stemware and vases for Waterford Crystal.

Rocha continues to show ready-to-wear womenswear and menswear twice annually at London Fashion Week. In 1993, Rocha was named Designer of the Year at the British Fashion Awards. He was appointed a CBE in 2002 for his long-standing contribution to the fashion industry. The John Rocha lifestyle boutique opened on London's Dover Street in 2006.

◄ **A highly textured 2010 collection in matt black creates 3D patterning from strands of leather.**

1997
Red, black and white in various materials: leather, wool and chiffon.

Rocha rarely uses a multidirectional all-over print, preferring instead to handcraft the design in a one-off engineered piece, as seen here in this trapeze-line dress with printed tachist (from the French 'to stain, spot or blot') design. Elsewhere, long trailing medieval sleeves appear on fine-gauge knits and devoré tops that are layered beneath severely tailored coats for autumn/winter.

2007
Fragility and frou-frou in an Edwardian-inspired display of summer linens in ecru, cream, pale pink and nearly black.

A crêpe de Chine all-in-one in palest shell pink has a gently bloused bodice that is gathered in to a hand-knitted collar (matching the beanie hat). Sleeves are ruched at the elbow creating deep pleated cuffs, a technique that also appears on the waist of cropped linen jackets. Rows of frills are offset against each other on the centre front of jackets, which are worn over narrow trousers with pockets on the thigh, giving the impression of early 20th-century jodhpurs. A linen hip-length jacket is given volume at the hem with rows of deep lace-edged frills. It is lined with ruched silk-satin and toughened up with trench coat features such as storm flaps. Cropped trench-style jackets in brown linen are partnered with easy-fitting pocketed shorts.

2002
Circles—incorporated into the pattern piece, printed or appliquéd—appear throughout the collection.

A demure mid-calf pinafore dress with circular insets of laser-cut lace frayed around the edges is worn over a thick-knit turtleneck sweater. A contrast in texture is provided by chunky knitted oversized collars, which anchor fragile chiffon form-fitting tops, and by heavy ribbed waistbands on halter-neck bodices that are frilled and frayed. Ankle-length black knitted cardigan coats over white chiffon dresses continue the monochrome theme that runs through the collection. White or black oversized trouser suits are belted low or simply wrapped.

JOHN SMEDLEY

www.johnsmedley.com

The timeless style of the John Smedley brand is ironically a clear expression of modernism, given that the British-based company is more than 225 years old. Beloved of the mods and preferred by the preppy, the fine-gauge sea-island cotton and pure merino lambswool knits – particularly the Isis, Leander or Orion polo shirts, not to mention the Sirius cardigan – have been wardrobe staples for decades.

The essential John Smedley product has several defining characteristics, which are at the heart of the brand philosophy. Only natural fibres are used for the yarns, and the company is able to trace the provenance and thus assure the quality of this core ingredient, which is fashioned – entirely without cut seams – into garments that will endure both physically and fashionably. The fineness of the knitted structure, with stitches at a density of less than one per millimetre, demands a high level of skill at every stage of production to avoid compromising the quality. The company, therefore, eschews the use of external manufacturers, using only their own machinery and personnel, and invests in innovative technology to marry with the classic methods of the last century.

Womenswear enjoys overtones of classic sportswear, which has been developed into a new aspect of production: garments that have no seams at all, using the most advanced machinery available from Japan. Recently, the company has introduced a childrenswear range and sells to more than thirty countries.

◀ **A crewneck sweater in merino lambswool for 2009 has multicoloured geometric patterning.**

2007

The renaissance of vintage detailing and styling from the company archive is a constant aspect of range development.

The John Smedley three-button polo shirt derived from the Isis tennis shirt of 1932 has had innumerable reincarnations since its first launch. With a short placket and crisp white collar balancing the deep rib in white at the waist, the rugby striped body and cap sleeves are styled with a petticoated circular skirt in multilayered organdie, in a manner recalling 1950s cheerleader sportiness. Sea-island cotton is the spring and summer seasonal hallmark of Smedley's luxury label, which is able to reprise its own brand characteristics as part of market evolution. The company's core identity lies in fine-gauge knitwear, which lends itself to casual modernity.

1930

During the 1930s, knitted swimwear evolved from products based on underwear.

With a panel disguising the built-in knickers, a one-piece maillot reveals its antecedents in finely knitted underwear. Paralleling the initiative of US companies, such as Jantzen, to recognize the development of sportswear and the natural female figure, John Smedley cuts the front bodice into welted panels: four to divide and form the breast shape and two below, allowing close fit through the body. In this period, Lastex was combined with wool to encourage a modicum of gravity-defying stability in a wet environment.

2010

The versatility of 21st-century production equipment allows maximum coloration.

The Iggy cardigan, with boyfriend-style exaggeration in sizing, is invested with an elaborate stripe – amounting to fourteen shades of merino wool, each requiring a separate yarn feeder in production. Forming a signature piece in a collection that evidences the prodigious technical ability of the company, the style can be worn with a variety of pieces from leggings (produced seamlessly) to simple solid-shade tops. Garments display shoulder emphasis, either from integrated pleating or from short gathered sleeves.

JONATHAN SAUNDERS

www.jonathan-saunders.com

Scottish designer Jonathan Saunders's virtuosity with colour and his appreciation of tone enables him to integrate pattern into convincing three-dimensional form. This results in collections that epitomize modern femininity, from his signature colour-blocked ankle-length dresses to his carefully crafted prints that are engineered to fit the body.

Initially studying product design at Glasgow School of Art, Saunders (1977–) switched to textiles before going on to study for a postgraduate degree in print for fashion at Central Saint Martins College of Art & Design. He was at the forefront of a print revival when he introduced his collection of vibrant zigzag prints in his graduation show in 2002. Immediate recognition followed when he collaborated with Alexander McQueen (see p.38) on a bird of paradise feather print for the designer's S/S 03 collection. Saunders was also enlisted as a consultant for fashion houses Chloé (see p.90) and Pucci (see p.260) when it was under the direction of Christian Lacroix (see p.96).

Saunders continued to show regularly at London Fashion Week until 2008, when he moved his collections to New York, returning to London in 2010. He has produced several successful collections for British store Topshop and US store Target, and in 2009 was signed up as creative director at Pollini. Saunders was named Designer of the Year at the Scottish Fashion Awards in 2005 and British Designer of the Year at the *Elle* Style Awards in 2008.

◄ Graphic zigzags and plumage-inspired metallic prints feature for A/W 09/10.

2003 Prints that are specifically engineered to fit the garment offer colour-blocked patterning of vibrant hues that provides extra impact when juxtaposed with black.

Solid circles, perforated at the edge, and geometric forms such as trapeziums and parallelograms etched with narrow white lines are used with mathematical precision to animate this tiered knee-length dress. The asymmetric caped collar appears frequently throughout the collection; when partnered with narrow trousers in a single, strong colour, the emphasis is always on the upper silhouette. Billowing ankle-length kaftans and shorter versions to the waist are worn with thin jersey rollneck jumpers and coloured tights, further adding to the rainbow mix of carefully controlled colour. Saunders places his richly coloured prints on to garment forms with the bold confidence of a surface pattern specialist. This lack of inhibition allows printed geometry on an aggressive scale and powerful coloration. Elsewhere in the collection, the dynamic is contained by the use of mirror imaging to frame the decoration to the body.

2005 Saunders frames the body by investigating colour and pattern and by using the principles of Euclidean geometry to construct prints.

The controlled yet innovative use of shades and tones of colour is evident in this tunic top worn over a swirling maxi-skirt, and throughout the collection. Saxe-blue with lavender and orange or turquoise with mustard and brown are frequently ombré-printed to diffuse the borders between one colour and another, or emphasized with the introduction of black. Unequivocally abstract print is inspired by Bauhaus designer Oskar Schlemmer, a proponent of using geometry to change the shape of the human body and creator of the stage work *Triadic Ballet* (1922). Intrinsic to the balance and line of the body, the print element is engineered to fit each pattern piece using traditional craft techniques rather than being merely decorative. Menswear includes polo shirts, V-necked sweaters, shorts and printed T-shirts worn with loose cardigan jackets.

JULIEN MACDONALD

www.julienmacdonald.com

Barely there knits and uber-glamourous evening wear are the hallmarks of Welsh designer Julien Macdonald (1972–). Beloved of celebrities in need of reinvention, his show-stopping garments often appear on the red carpet, garnering the designer pages of publicity from the paparazzi.

Macdonald reinvented the sweater dress in his postgraduate collection from London's Royal College of Art in 1996. The cleverly structured dresses knitted on a hand frame attracted the attention of Karl Lagerfeld (see p.182), who commissioned him to produce knitwear for Chanel (see p.86). The following year, the designer set up his own company, which he launched at London Fashion Week. In 2001, Macdonald was appointed creative director at Givenchy (see p.132). His all-black first collection in July 2001 marked a departure from his previous style and received a mixed reception, although his ready-to-wear collections for the label were more successful. Macdonald designs a diffusion range, Star, for British store Debenhams, which was launched in 2004. Macdonald has robustly defended his decision to use fur in his designs, particularly chinchilla, sable, fox and mink.

Private investor Jamey Hargreaves is chief executive of the label, with Macdonald the creative director. In August 2004, Macdonald was awarded an Honorary Fellowship by the University of Wales in recognition of his contribution to UK fashion, and in June 2006 the designer was awarded an OBE for services to fashion.

◄ **Antique lace and chiffon evinces a newly romantic aesthetic for Macdonald in 2011.**

1999 Macdonald grabs the spotlight with his signature risqué knits.

Macdonald leaves most of the yarn floating freely except where it is clustered geometrically or condensed into seam lines with tuck stitches. The collection explores the versatility of knitwear for autumn/winter in a number of ways: the heavy tiered and fringed fir-tree coat; the snow-spangled sheath; the flimsy icicled halter dress; and the frosty mantle of heat-pressed spaghetti plastic.

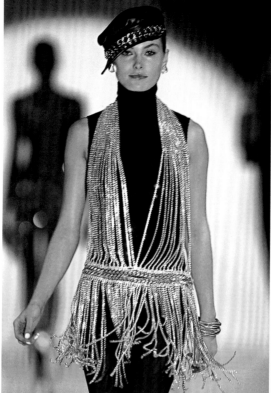

2004 Ladylike modesty imbues a collection of tweed and silk-satin.

A bias-cut nude satin skirt partnered with a double-breasted tweed jacket reflects a new sobriety in Macdonald's more customary red carpet oeuvre. Pussycat bows, pencil skirts and pinafore-shaped tops provide ballast to the shimmering one-shouldered evening wear that is split to the waist and thigh. Fur is used as an accessory and in chevron-dyed stripes on a coat for the autumn/winter season.

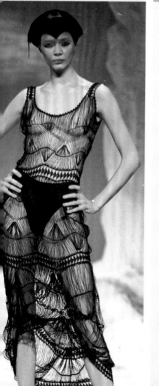

2001 Tough glamour combines black leather and sharp tailoring with leopard-skin print spaghetti-strapped slip dresses, diamond fringes, fur stoles and feathers.

Resolutely attention-grabbing, this dress is composed of strands of diamonds poured around the neck, which are caught in at the waist and then fall in a fringe. It is only one component of a glitzy collection that includes an all-in-one zip-front skintight jumpsuit with tattoolike embroidery over the hips and shoulder. Severely tailored pieces – for example, a royal-blue version of a sharp-shouldered tuxedo – vie for attention with lavishly embellished jackets worn over turtleneck black sweaters and knickers. Leopard print appears on a trouser suit and on slip dresses with asymmetrical hems. As ever, fur is integral to the label, with knee-length wrap coats, mink berets and the old-fashioned notion of the fur stole partnered with pencil-skirt suits. Pearly kings and queens appear in black and white embellished trouser suits, and black leather caps add an edge of toughness.

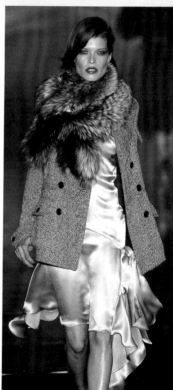

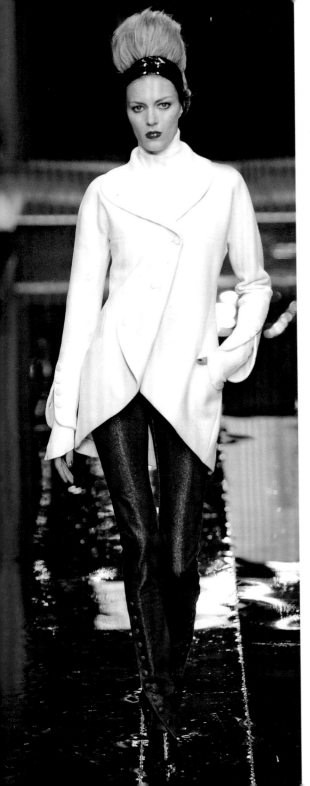

KARL LAGERFELD

www.karllagerfeld.com

One of the most recognized names in contemporary fashion design, Karl Lagerfeld (1938–) was born in Germany of a plutocratic family. He moved to Paris in 1952, where, after winning a competition set by the International Wool Secretariat, he began his fashion career. Lagerfeld first worked for Pierre Balmain (see p.60) from 1955 to 1957, before moving to the house of Patou for five years. He then began a long association with Chloé (see p.90), and from 1965 he also began designing furs for Fendi (see p.124), for whom he created the 'double F' logo. Today, Lagerfeld is the creative director of Fendi.

In 1982, Lagerfeld was appointed to rejuvenate the house of Chanel (see p.86). One of his first moves was to deconstruct the classic 2.55 handbag, moving the logo from inside to outside the bag, placing a defiant huge 'double C' on the front to signal the 1980s era of ostentatious conspicuous consumption. While continuing to design for Chanel, Lagerfeld established his own design business in 1984 and resumed designing for Chloé in 1992 until 1997. Dubbed 'Kaiser Karl' by the press, Lagerfeld has gained a reputation for a ferocious work ethic.

Current licences include menswear, ties, scarves, shoes (Charles Jourdan), sunglasses, watches, jewelry, furs (Revillon), interior fabrics, wallpapers and carpets. Collaborations include a jeans line with Diesel (see p.108) and a clothing line with international Swedish fashion brand H&M in 2004.

◀ **A collection of razor-sharp tailoring with futuristic frock coats for A/W 10/11.**

1985 Fireworks explode on the gathered skirt and bodice of an evening dress.

Together with fellow couturier Christian Lacroix, Lagerfeld enjoyed the upsurge in demand for bespoke clothing that occurred during a period renowned for its conspicuous consumption. It was a time when popular interest in fashion reached new levels through television dramas such as *Dynasty* and *Dallas*. Lagerfeld's influence expanded, coinciding with a newly burgeoning global marketplace for fashion.

2009 A graphic collection for spring/summer emphasizes the midriff with corset belts, and exploits the circle motif to create design solutions.

The handle of a bag is cut to describe a pair of spectacles and is held over the model's face, thus touting the unmistakable Lagerfeld visage on a tote. The image also replicates the designer's signature white shirt and tie, but the model wears floating silk tulle sleeves incorporating embroidered jewelry. All appear with a zip-fronted duchesse satin knee-length skirt with rows of laced panels either side of the high waist, a device that also appears in black at the midriff of a starkly tailored white shirt. The waist continues to be a zone of interest, with asymmetrical peplum-shaped and double-buckled belts in black over tailored white cotton and printed dresses. Elsewhere, a navy pinafore dress is worn over a cropped white top, exposing a strip of flesh.

2006 Elongated silhouettes in a sombre-hued collection for men and women for autumn/winter.

A mid-calf evening dress of wrapped and draped black silk jersey has an asymmetrical shoulder strap, and is accessorized with gloves embellished with silk tulle frills – a recurring feature in the collection, occasionally expressed as rows of fur and feathers on separate wrist warmers. Elsewhere, lengths hit the ankle, and cuffs extend over the hands in a series of all-enveloping narrow coats in black wool, with equally concealing knitted dresses. Baggy-topped boots accompany tie-dyed tights, worn under a greige jersey dress with satin pockets and wrist warmers.

LANVIN

www.lanvin.com

Known for her exquisite *robes de style*, characterized by their full skirts and featuring an adaptation of the 18th-century pannier, Jeanne Lanvin (1867–1946) established France's oldest continuing couture house in 1889 when she was just twenty-two years old. Lanvin initially opened a milliner's boutique on the rue du Faubourg St Honoré in Paris, and joined the country's Syndicat de la Couture in 1909. The signature Lanvin *robes de style* were introduced in the 1920s, and over the following two decades they were repeated in a variety of fabrics such as silk taffeta, velvet, metallic lace, organdie and chiffon. The pastel-coloured gowns were embellished with appliqué, beadwork and embroidery in one of the three ateliers owned by the house. Collections also included tea gowns, dinner pyjamas, dolman wraps, hooded capes and zouave bloomer suits. Lanvin had her own dye works where she developed Lanvin Blue, inspired by stained glass.

In 1895, Lanvin married her first husband, Count Emilio di Pietro, an Italian nobleman, and two years later gave birth to her only daughter, Marguerite Marie Blanche. The brand's signature scent, Arpège, in a bottle featuring Paul Iribe's gold image of Lanvin and her daughter, was introduced in 1927 and continues to be a best-seller. On Lanvin's death in 1946, her daughter continued to oversee the business. Designer Antonio del Castillo was appointed in 1950, succeeded by, among others, Jules-François Crahay, Dominique Morlotti, Ocimar Versolato and Cristina Ortiz. In 2001, Shaw-Lan Wang, a Taiwanese publishing magnate bought a controlling interest in the house and appointed Moroccan-born Alber Elbaz as artistic director (see p.34).

◀ **A toga gown among a 2008 ready-to-wear collection of sumptuous satins by Alber Elbaz.**

The 18th-century silhouette with pannier is interpreted by Lanvin for her *robe de style*.

The broad-skirted dress in silk organdie has a scalloped hem animated by stylized flower motifs, embroidered on each panel to match those on the tubular bodice, which bypasses the waist in keeping with the androgynous styles of the day and the era of the flapper. A chemisette is inserted into the deep 'V' of the face-framing organdie bertha collar. Lanvin appropriated historical and cultural decorative traditions and combined them with contemporary craft techniques and materials to form her distinctive aesthetic.

1939 The 'Cyclone' evening dress by Jeanne Lanvin worn by her daughter the Comtesse Jean de Polignac.

The turned-back tops and ruched bra cups of the dress emphasize the hourglass figure, as do the seamed close-fitting bodice and the gathered and stiffened double-tiered duchesse satin skirt – the lower tier falling to the ankle. The waist seam is hidden by a narrow belt, with braided edges, culminating in an external pocket of lavish jewelled embroidery. The same encrusted jewelry is worked into a halter-neck tie that also forms a garland across the upper part of the bodice. In a revival of nostalgia and full-blown romanticism at the end of the 1930s, the natural waist was reinstated, following a decade of the bias-cut silk gown.

1957 A Lanvin evening gown photographed in the theatre of King Louis XV at Versailles.

Representing the requisite glamour for the formal 1950s social occasion, this full-length gown by Antonio del Castillo has a wrapped chiffon bodice and panels of printed brocade falling from an empire waist. Del Castillo was invited by Lanvin's daughter to design for her mother's firm in Paris, with hopes of relaunching the firm's name. From 1950 to 1962, the house of Lanvin-Castillo was known for elegant clothes, slender silhouettes, long-flowing skirts in rich luxurious fabrics and elaborate embroideries.

1996 The debut collection of Brazilian-born Ocimar Versolato, who designed for the label until 1998.

A slim-fitting coat dress in a metallic jacquard weave represents the severe silhouette that occurs throughout the collection in day dresses, two-piece suits and coats and tailored double-breasted trouser suits with wide-legged trousers – most accessorized with foulard scarves. In contrast, a scallop-edged lace miniskirt is worn with a satin zip-fronted jacket. For evening, lilac and palest grey chiffons are whipped around near-naked bodies, and a chiffon ball gown in Lanvin Blue pays homage to the founder of the house.

2008 Lucas Ossendrijver's collection for Lanvin Homme eschews the matching two-piece suit.

Playing with proportion and scale, Ossendrijver layers a cropped collarless white shirt over a jersey T-shirt. They are worn under a pinstripe jacket and with easy-fitting trousers for a modern take on traditional tailoring. Elsewhere, white shorts are partnered with studded shirts, and mushroom-coloured nylon coats with toning shirts and jersey trousers. Pyjama-style jackets and shirts are worn over pleated trousers, and vertically striped blazers in broad royal-blue and black bands complete the 'schoolboy on vacation' look.

2005 Exemplifying understated feminine glamour, a ready-to-wear collection designed by Alber Elbaz.

The blouse has cuffed and gathered raglan sleeves extending into a turned-back pleated collar, forming a circular yoke and held in place with rows of stitching. It is worn with a skirt tight to the hip before flaring out into gentle gathers. Elsewhere, airy trench coats, ribbon-bound pleats and jewel-like embellishments are seen. Silk faille and gazar are laundered to soften them into a feminine silhouette of airy skirts and fitted jackets, tied at the waist with a single bow in shades of bright pink or inky blue. Goddess dresses are made from Fortuny-like pleated silks, defined around the breast and hips with ribbons. Ribbon-threaded pearls form accessories.

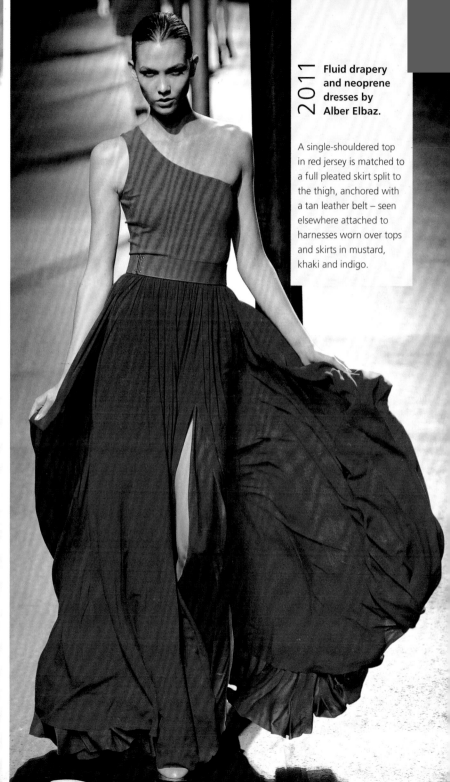

2011 Fluid drapery and neoprene dresses by Alber Elbaz.

A single-shouldered top in red jersey is matched to a full pleated skirt split to the thigh, anchored with a tan leather belt – seen elsewhere attached to harnesses worn over tops and skirts in mustard, khaki and indigo.

2009 Elbaz offers minimal seaming, bold jewelry and unfinished edges.

For the autumn/winter collection, a seamless dress in nude is shaped to the body by the application of drapes and tucks on the hip. The technique is also used on raw-edged skirts and zipped wrap coats in black. Inside-out seams with unfinished edges feature on cream and grey satin jumpsuits, draped dresses and unlined felted coats, the hems and lapels of which are left unfinished.

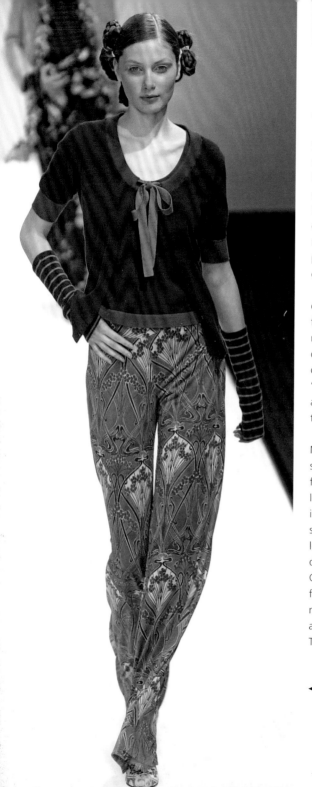

LIBERTY

www.liberty.co.uk

Since 1875, London store Liberty has been a luxury emporium at the forefront of the decorative arts. A long heritage of collaboration with the avant-garde designers of the day – Christopher Dresser in the 19th century, Robert Stewart in the 1950s and, under the direction of creative consultant Yasmin Sewell in 2009, a global mix of cutting-edge fashion designers – has secured a place for the company as a forward-looking exponent of contemporary design.

Founded by Arthur Lasenby Liberty (1843–1917), on London's Regent Street, the oriental emporium sold furniture, textiles and dresses inspired by the aesthetic movement, a reaction against the mass production of the Industrial Revolution. By the late 1870s, the company was known as Liberty & Co, purveyor of 'artistic' dress and interiors in the art nouveau style, a design movement with which the company continues to be associated.

The mock Tudor store was built in 1925 on Great Marlborough Street, designed as a series of interlocking shops rather than one big department store. During the following decades, Liberty consolidated its role as the leading store for quality decorative textiles. However, it was the post–World War II decision to return the store to its roots in the Arts and Crafts Movement that led to collaborations with innovative and iconoclastic designers such as Lucienne Day, Jacqueline Groag and Colleen Farr, who were responsible for the fashion fabrics. No longer in family ownership, the company is majority owned by MWB Group Holdings Plc. In 2005, a new brand, Liberty of London, was launched with Tamara Salman as design director.

◄ **Using the Liberty textile archives for art nouveau–patterned trousers for 2001.**

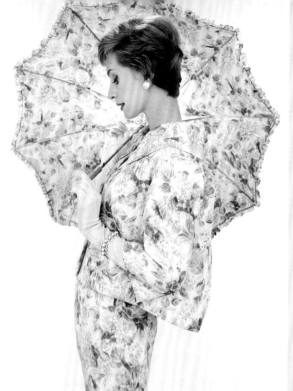

2008

A collection by Japanese designer Junya Watanabe subverts Liberty heritage prints with experimental draping, braided jackets and cap-sleeved baby doll dresses.

A cross-draped dress with puffball skirt in muted tones of Tana Lawn is edged with gold lace around the halter neck – one of many pieces using Liberty print designs. Traditionally, Tana Lawn, a fine soft 100 per cent cotton fabric with a very high thread count, was used exclusively for childrenswear such as formal smocked dresses and blouses. The small-scale, multidirectional all-over floral print was then appropriated by designers such as Mary Quant, Tuffin & Foale and Gerald McCann for the 'dolly bird' dresses of the 1960s, when fashion was youth-led and the style was for mini-dresses with very little shaping, and later in the decade for the smock tops of flower power. At the time, Liberty was the sole retailer to offer printed textiles by the yard to the home dressmaker that would also appear at the same time on the catwalk of the ready-to-wear collections by designers such as Yves Saint Laurent.

1958

A floral-printed 'costume' from the Liberty's Original range, sold alongside fashion by the Incorporated Society of London Fashion Designers and replicas of French couture.

Representing feminine formality and the sway-backed silhouette of the 1950s, this cropped jacket with bracelet sleeves is partnered with a narrow pencil skirt in an all-over floral print. Full-on grooming and matching accessories were a prerequisite of the era, seen here in the frilled parasol, long gloves, pearl button earrings and bracelet. The store provided the total look, showcased during a 'walk around the store' fashion show when customers could enjoy afternoon tea while the clothes were modelled around them. Alongside in-house design, the Liberty buyer bought original couture models, together with the toiles, which would be copied in Liberty's own workrooms. The newly emerging fashionable teenager was catered for by Young Liberty, a range of such garments as dirndl skirts, slacks (some featuring Robert Stewart's furnishing designs), beachwear and oversized mohair sweaters.

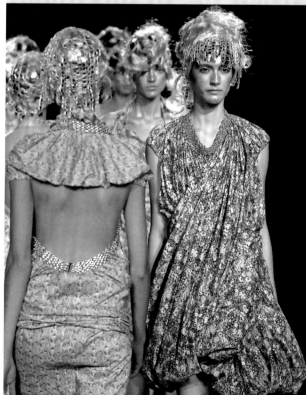

LOUIS VUITTON

www.louisvuitton.com

Louis Vuitton, a brand synonymous with first-class travel, the luxury goods market and a high-profile fashion label, was founded when Vuitton (1821–92) began his career as a box maker in the 19th century. He was appointed as *layetier*, or expert luggage packer, to Eugénie de Montijo, the wife of Napoleon III, propelling him into servicing the European *haut monde*. He opened his own store in 1854, the Maison Louis Vuitton on rue Neuve des Capucines in Paris, where he began to design his own luggage collection.

On Vuitton's death in 1892, the company's management passed on to his son George. In 1896, the legendary Monogram Canvas was launched, and throughout the following century many distinguished bags followed: in 1901 the Steamer bag, the Valise bag in 1923, the Keepall in 1924 (the forerunner of weekend totes), the Car bag in 1925 and the Noé bag in 1932. In 1987, the company merged with the champagne group Moët Hennessy, run by Bernard Arnault, to form one of the world's most powerful luxury goods conglomerates. Patrick Louis Vuitton, the founder's great-grandson, is president of the company.

In 1997, Louis Vuitton expanded to include ready-to-wear women's clothing. Marc Jacobs (see p.196) was appointed to oversee the brand, bringing an edgy commercial eye to the label and signing up Stephen Sprouse to design the Graffiti bag in 2001. In 2003, Japanese designer Takashi Murakami created the Eye Love bag range, which generated US $300 million in sales.

◄ **A lavish celebration of boudoir kitsch and chinoiserie by Marc Jacobs for S/S 11.**

1938 An advertisement for a collection of Louis Vuitton matching luggage – cabin trunk, hat box and valise – shows the signature Monogram design first introduced in 1896.

As the popularity and accessibility of travel increased during the latter part of the 19th century, fashionable luggage was much in demand. In response, Louis Vuitton created the flat-topped cabin trunk, replacing the humpback trunks (domed to allow water to run down the sides) that had been used previously. Vuitton introduced canvas to the outside of the wooden trunk, which was then coated with shellac to render it waterproof, adding staves, trim and hardware. It was designed for easier stacking and mobility, and it became the foundation for the success of the company. Other luggage makers began to copy the designer's style and, in 1888, Vuitton attempted to protect his designs by creating the Damier checkerboard pattern on canvas, bearing a logo that read *marque L.Vuitton déposée* (or 'L. Vuitton trademark'). From 1901, the company began to add other smaller pieces of luggage to the range.

1968 Style icon Audrey Hepburn carries a Louis Vuitton bag. Hepburn popularized the brand following product placement in Stanley Donen's Hollywood spy caper *Charade* (1963).

In 1959, the classic logo-print canvas was used to create small handbags to complement the items of luggage – the Steamer bag from 1901, the Keepall (similar to a duffel bag) from 1924, both of which provided the blueprint for all the totes and travel bags that followed, and the Noé bag, designed in 1932 to hold five bottles of champagne – previously manufactured by the company. During the 1960s, logomania had yet to reach its 1980s zenith. However, following early examples of celebrity endorsement, wealthy trendsetters were already eager to acquire certain status symbols – the Gucci loafer, the Hermès headscarf and Kelly bag and the Vuitton handbag. The bag was identified by its *griffe* (a French word meaning 'claw' or 'talon' and used to define a prestigious label), consisting of intersecting 'LV' initials and a curved beige diamond with quatrefoils and its negative, a beige circle with a four-leaved flower inset.

1998 The debut collection of US designer Marc Jacobs.

An understated oversized white shirt worn over an easy-fitting below-the-knee skirt exemplifies Jacobs's subtle approach to designing for an acknowledged status label, the first ready-to-wear collection by Louis Vuitton in the company's 144-year history. Restricting the LV monogram to white on white for a single across the body bag, the collection comprised fine cashmere knits and rubberized coats in white, black and pearl grey.

2004 Tartan and tweed feature in a gothic Highlander collection.

Accessorized with a fur scarf indented with the LV quatrefoil, the windowpane-checked tweed coat has sleeves cut on the bias for a perfect fit, a nipped-in waist and two patch pockets on the hip, a silhouette replicated in fur-lined red tartan. Elsewhere, tartan is twisted into an off-the-shoulder top worn with a black satin basque. Velvet knickerbockers are partnered with a lace-edged lemon sweater or a cropped multi-buttoned jacket in saxe blue.

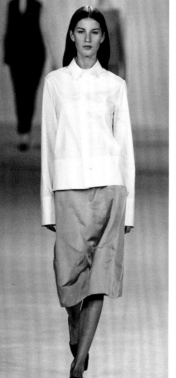

2001 The brand is revamped by spray-painting graffiti over the Louis Vuitton canvas to lend street cool to a status item, creating a must-have for the new millennium.

Once a subversive activity, graffiti was elevated into an art form by practitioners such as Keith Haring and Jean-Michel Basquiat, inspiring New York designer Stephen Sprouse to incorporate the tags and stencils and other visual ephemera of urban life and street culture into his first fashion collection in 1984. In 2001, he was invited by Marc Jacobs to bring his underground approach to the design of a handbag; the result was the iconic Graffiti bag, spawning a million copies. Graffiti also appears on over-the-elbow gloves in a collection that sustained Jacobs's reputation for exploring eclectic sources of inspiration. He presents 1950s-style full skirts with an oversized graphic rose print; two-piece skirt and trouser suits in khaki and cream with military detailing; and sporty unadorned cropped shorts with a plain turtleneck. A camel skirt with a drawstring hem is partnered with a shocking-pink top.

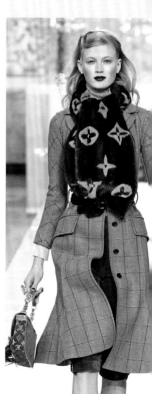

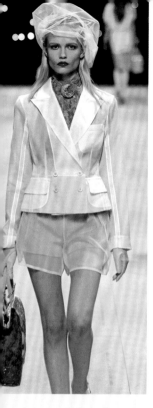

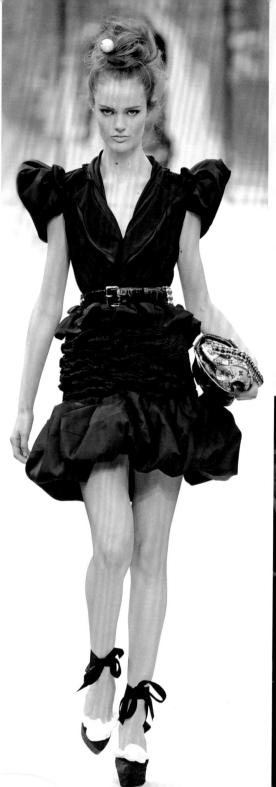

2009 Ruched and frilled cocktail dresses are styled with velvet and ribbon.

Navy and black silk-satin is worked into ruched pleats and tucks for a form-fitting dress with a puffed hem and exaggerated shoulders.

2010 Ladylike decorum in full skirts and fitted knits by Marc Jacobs.

A mid-calf swirling A-line skirt and fitted sequin-encrusted textured knit introduce the hourglass figure to the catwalk.

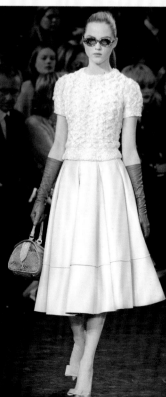

2008 An eclectic and playful collection in rainbow colours for spring/summer.

Silk organdie is carved into a crisp double-breasted jacket with bound seams delineating the construction, worn over an equally transparent skirt, pink shorts and a turquoise top (laser cut into the LV quatrefoil). Naughty night nurses in black lace masks and marbled-silk strapless dresses beneath plastic coats open a diverse collection, which includes lamé knits, pencil skirts and gazar trench coats.

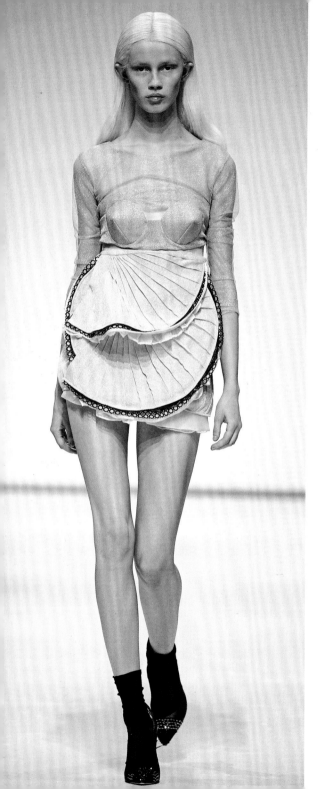

LOUISE GOLDIN

www.louisegoldin.com

Complex structures and complex fabrication are employed by Louise Goldin (1979–), who has a stitch-defying ability to make knitwear look entirely unlike any sweater you have ever owned. London-born Goldin is at the leading edge of contemporary knitwear design, spearheading the current revival in this fashion genre. After seven years at Central Saint Martins College of Art & Design, Goldin had acquired an experimental approach to the knitting process that was evident in her graduate collection in 2005. She then consolidated her technical and creative expertise as head designer at Tereza Santos in Brazil for two years, before returning to London to launch her debut collection in 2007, which was bought in its entirety by London store Selfridges.

In 2008, Goldin made her first solo appearance at London Fashion Week. She excels at exploiting the properties of fine- and heavy-gauge knitted fabrics, fashioning futuristic, multilayered pieces by draping and pleating. She uses computer-aided knitting techniques to create braids and edgings as well as garment pieces. With a forty-piece capsule range for Scottish cashmere and knitwear manufacturer Ballantyne in 2010, the first of two collections, the designer has allied the traditional craft expertise of the company with her signature thigh-skimming body-con knit dresses and sheer diamond-panelled tops. Goldin has also collaborated with British store Topshop on a futuristic studded-shoe collection. In 2010, she was awarded the Fashion Forward prize from the British Fashion Council for brand investment.

◀ **Applying Bauhaus-style geometry to the human form in pastel-coloured knitted fabrics for S/S 10.**

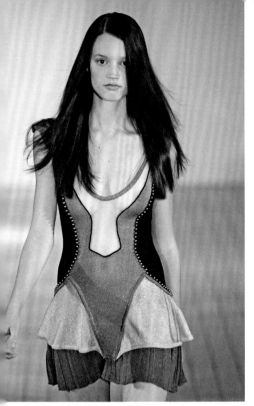

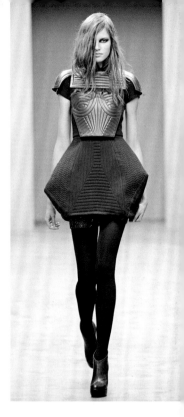

2008
A polychrome machine knit of gored panels makes a short flared vest dress.

Displaying a technical virtuosity of painstaking complexity, Goldin exploits the knitting equivalent of tapestry – among other methods – to inlay vivid colour and patterning with longitudinal yarns. The rich colour palette includes clashing hues, such as scarlet and magenta. The use of patterns, textures and striped panels creates a look that is animated yet fragmented. The space-cadet feel of the collection is reinforced further by accessories: transparent plastic belts and coloured latex headbands.

2007
Fitted and panelled for a frilled Wonder Woman, this is Goldin's take on 'sport luxe': defiantly body conscious and emphatically athletic.

The core of the spring/summer collection is made from sheer knitted jersey, often with a more robust and graphic exoskeleton of lashed and twisted macramé nets and knitted panels. In other pieces within the range, Goldin finds a softer aspect where frills and pleats lend femininity to the look. Layers of differing weights and elasticity are interwoven, rarely departing from the contours of the body and giving an impression of bound harnesses to contain the musculature. Other garments reference competitive sport attire, including the ingenious, zonally elasticated leggings with areas of open work. The choice of pink and black for the geometric patterning also implies an association with art deco style.

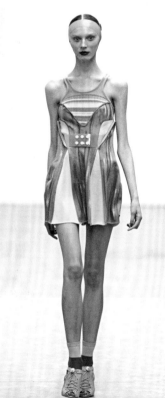

2010
Raygun Gothic precedents are apparent in Goldin's sombre vision.

Goldin boldly engineers black and navy jersey into complex quilted dress forms that are more akin to neoprene dive-wear than to the cocktail dresses they create in her autumn/winter collection. With a dark colour palette, interspersed with almost hidden shots of brightness, the garments are evocative of the sci-fi genre – *Metropolis* (1927) meets *Fahrenheit 451* (1966). Goldin has created a type of futuristic martial art uniform.

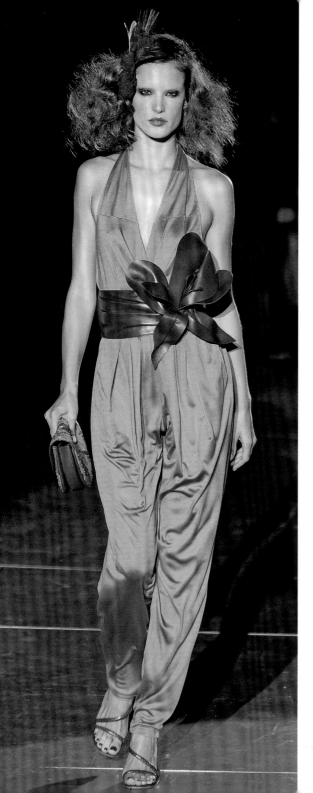

MARC JACOBS

www.marcjacobs.com

New York–born designer Marc Jacobs (1963–) hit the headlines with his groundbreaking grunge collection in 1992 for US sportswear company Perry Ellis. Although commercially unsuccessful, the vintage-inspired flower-strewn dresses partnered with combat boots and silk shirts printed to look like flannel were enormously influential and presaged the decline of the mature over-groomed look of the 1980s. The collection confirmed Jacobs as a visionary designer, and accelerated his desire to start his own label, Marc Jacobs International Company LP, in 1993.

Jacobs launched his first collection in 1986, following his sojourn at Parsons The New School for Design. With an irreverent approach and referencing multiple sources, the designer was the youngest recipient of the Council of Fashion Designers of America Perry Ellis Award for new fashion talent in 1987. In 1997, LVMH appointed Jacobs as its artistic director for its first ready-to-wear range. Under Jacob's aegis, Louis Vuitton (see p.190) marketed a series of iconic handbags, among them the graffiti bag in 2001, a collaboration between Jacobs and New York artist and designer Stephen Sprouse.

The Marc by Marc Jacobs line was launched in 2001 and includes the designer's retro-chic signature detailing, vintage-inspired dresses and quirky oversized buttons. His accessories line features bags, shoes and timepieces. In 2007, a childrenswear range was introduced. In 2010, Jacobs was listed in *Time* magazine's 100 most influential people in the world.

◀ **Revisiting the 1970s in 2011 with draped jersey jumpsuits adorned with outsize corsages.**

2001

Marc by Marc Jacobs popularized the schoolboy belt and the use of coloured denim.

A much-copied striped stretch belt fastened with plastic buckles shaped like either apples or pears recurs throughout a collection that includes this sleeveless turquoise denim jacket and frilled jersey skirt. Easy-to-wear separates in clear bright colours – for example, a candy-striped blouse worn with narrow knee-length shorts or low-rise cropped jeans worn with simple tops – give a youthful edge. Jackets, vests and print skirts are layered with contrasting bands of colour, while horizontally striped dresses are pulled in at the waist with a stretch belt.

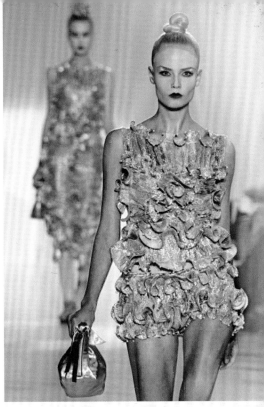

1992

The groundbreaking grunge collection introduces craft-based fashion.

Deep leather fringing and striped off-the-shoulder knits feature in a collection that puts faux humble fabrics such as flannel and denim with cowboy boots, pompom-fringed ankle-length skirts and hand-painted garments. Button-through dresses worn over shorts and 1950s-inspired gingham tiered skirts are partnered with denim jackets that are knotted at the waist and accessorized with a Stetson.

2010

A multiplicity of pleated ruffles appears in a collection of layered chiffon dresses, military tailoring and underwear as outerwear.

The dress is composed almost entirely of shell-like pleated frills in a rainbow of soft pastels interspersed with pearls. This technique is repeated elsewhere in equally iridescent full-length dresses or all-in-one playsuits. Boudoir-inspired underwear as outerwear appears: a blue satin bra is worn over a flesh-coloured shirt primly buttoned to the neck and tucked inside what appear to be high-waisted tights, over which stretch knickers with an elasticized front panel are pulled. Plain-knit knickers are partnered with a neat cropped cardigan edged with a circular frill. Extended tights are also evident at the waistline of the mid-calf lurex tweed skirt with rose-pink and turquoise satin inserts defining the hips.

MARCHESA

www.marchesa.com

With exquisitely embellished gowns, figure-hugging shapes and luxurious materials, Marchesa, named after the infamous *fin de siècle* socialite and femme fatale Marchesa Luisa Casati, successfully channels its namesake's decadent style to a modern audience.

British-born Georgina Chapman (1976–) and Keren Craig (1976–) launched their high-end fashion label in 2004. The design duo met while studying at Chelsea College of Art & Design in London. Chapman, a 2001 graduate of Wimbledon College of Art, began her career as a theatrical costume designer before moving into high fashion. Craig graduated from Brighton College of Art in 2000 with a specialist interest in print and embroidery design, particularly vintage and Asian textiles. Together the designers have created a series of dramatic grown-up glamorous gowns featuring a deft manipulation of opulent fabrics that have graced many of Hollywood's top events. The designers' vocabulary of ornamentation is extensive, ranging from chiffon-gathered roses to tiered pompoms of tulle and from laser-cut waterfalls of organdie to heavy perforated lace.

Chapman's marriage to Hollywood mogul Harvey Weinstein has given Marchesa access to some of the most well-known faces in Hollywood, including stars such as Scarlett Johansson, Anne Hathaway and Sienna Miller. In 2004, the less expensive line, Marchesa Notte, was introduced, and the label also offers a range of handbags and bridal wear. Based in New York, the Marchesa label is available in Neiman Marcus and Bergdorf Goodman in the United States, and Harrods in London.

◄ **Art nouveau scrolls of appliquéd black braid decorate this 2011 strapless evening gown.**

The meticulous hand work and dramatic effects of the label are favoured by stylist Rachel Zoe for celebrity clients.

A scarlet strapless gown introduces pinwheel pleating, an effect that creates additional volume on circular frills, and a technique employed throughout a collection of frilled and flounced evening wear. Artfully manipulated layers of organza build up degrees of opacity with tiers of circular frills from a strapless bodice. Elsewhere, black filigree embroidery provides an armature for the bodice of a full-skirted white dress. Ostrich feathers are combined with textile roses on a strapless sheath, while sequined tuxedo jackets are layered over beaded dresses. One-shouldered gowns in smoke grey and palest green fall from a high waist to pool in a circle of fabric around the feet.

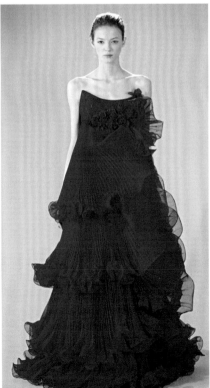

2007 **Romantic evening wear in black, white, pink and palest lime for the label's debut New York show.**

Pale pink gazar is worked into rosettes of ruched fabric to form the bodice of a short cocktail dress. This signature device occurs throughout the spring/ summer collection, either as a single unfurling rose in bright pink, forming a short silk-taffeta cape over a layered skirt, or in miniature, creating a bandeau bodice on a full-length goddess gown in pale grey chiffon. Redolent of the 1980s are strapless minis with puffball skirts, and all-in-ones in stretch black satin with shoulder decoration.

2011 *Fin de siècle*–inspired red carpet glamour is assured and exquisite with intricate decoration.

Layers of outsize circular frills in laser-cut lace cascade around the body in a froth of fragile texture. Elsewhere, silk-satin is worked into a figure of eight on a strapless dress to define the breast and hips. A spider's web of jet-black beads decorates a transparent lace jumpsuit, caught at the ankle with delicate buttoned cuffs and worn beneath a crisp black cropped jacket. The same weblike effect appears in rhinestones over cream silk chiffon. A hand-painted bodice on an ivory tulle gown explodes into a fan of millefeuille layers.

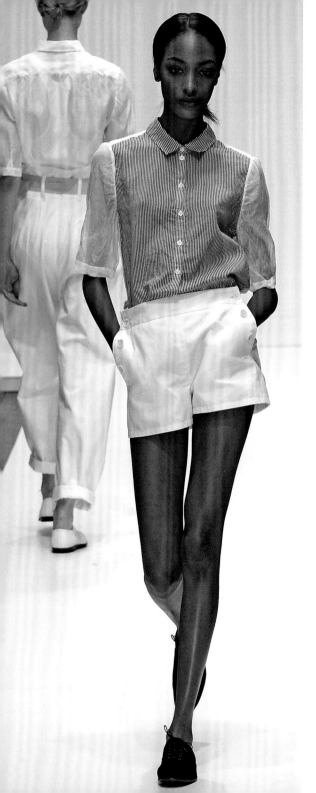

MARGARET HOWELL

www.margarethowell.co.uk

Quintessentially British brand Margaret Howell champions longevity, meticulous workmanship and traditional fabrics such as Harris tweed, Irish linen, poplin, cashmere and sea-island cotton. These materials are worked into pieces of masculine-inspired tailoring for women – herringbone-tweed jackets, V-necked sweaters and double-pleat-front trousers – which are leavened by a frilled collar to a shirt or a transparent mid-calf chiffon dress. A self-confessed fashion outsider, Howell (1946–) also designs standard British basics for men, such as the duffel coat.

The label was launched to immediate acclaim from a kitchen table with Howell's then husband Paul Renshaw in south-east London in 1972. She went on to open her first menswear shop in partnership with retail entrepreneur Joseph Ettedgui on London's South Molton Street in 1977. This was followed by the first wholly owned Margaret Howell shop in St Christopher's Place in 1980, and subsequently by a period of expansion that brought stand-alone stores in Manhattan and Tokyo.

On the couple's divorce in 1987, Renshaw left the company, which was then reorganized in 1990 with the help of Sam Sugure and Richard Craig (who remains as managing director). The opening of the flagship store on London's Wigmore Street in 2002 allowed the designer to showcase mid-century modern design, including furniture by Ernest Race and Ercol, and to hold occasional exhibitions. In 2007, Howell was awarded a CBE for her services to the fashion industry.

◀ **High-waisted shorts and an organdie blouse in a 2009 collection of understated essentials.**

2001 A strictly edited autumn/winter collection with military styling.

Without subversion or irony, Howell promulgates a clean-cut minimal silhouette in heritage fabrics, using precise workmanship, seen in this narrow mid-calf skirt and matching two-buttoned jacket. The white belt is matched to the white shearling edge-to-edge jacket. Elsewhere, a classic trench in black gaberdine is buttoned up to the neck. Shirts with epaulettes and peaked caps lend a military air throughout.

2011 The classic white shirt, raincoat, jeans, chinos and white T-shirt are the staple pieces for this spring/summer collection.

An unadorned double-breasted coat, featuring horn buttons and without any extraneous decoration, exemplifies a collection of spare, perfectly proportioned separates. Sail-white shirts are cropped to above the waist and worn with rolled-up denim and tan loafers. A hip-length canvas duffel coat with a frogged fastening of rope is worn over a simply cut white bikini and white knee-length flared skirt. Linen knits skim the body, with deep ribs at the waist and cuff, or feature polo collars in sea-island cotton in pearly, early morning colours, and are worn with short knife-pleated skirts. Nautical blue and white striped men's shirting is worked into an easy-fitting knee-length dress with horizontal pockets at the hip and a slashed neckline.

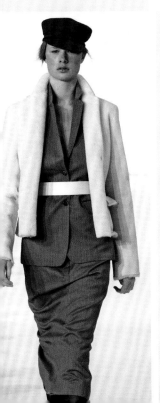

2008 Marked by restraint and clarity, classic men's leisurewear for the spring/summer season.

Apple-green cotton trousers and a merino wool V-necked sweater stand out in a collection that otherwise concentrates on all shades of blue: from French workman-inspired cotton suits to butcher's stripe shirts and turquoise or navy tailored shorts. Loose knits of sea-island cotton stripes are worn with white chinos and merino wool cardigans. Parkas accompany loose shirts over shorts. Suits are easy-fitting in black with a two-button jacket, or cut more narrowly, with a longer line jacket and three buttons in a lightweight glossy mohair.

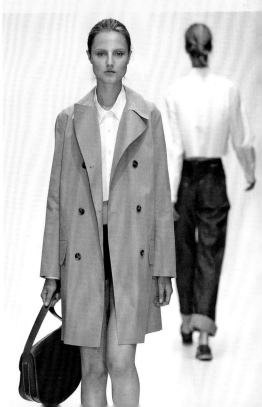

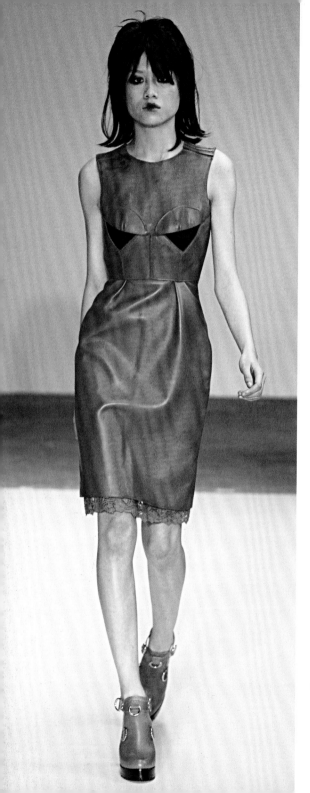

MARIOS SCHWAB

www.mariosschwab.com

Drawing on a range of cultural influences, the half-Greek, half-Austrian designer almost single-handedly revived the 1980s body-con trend with his short tight sculptural dresses on the launch of his own label in 2005. A graduate of ESMOD International Fashion School in Berlin, Marios Schwab (1978–) moved to London to study for his Master's at Central Saint Martins College of Art & Design in 2003.

Swarovski drew Schwab in as a collaborator in its 'Runway Rocks' show in 2008, and Schwab has used Swarovski crystals in subsequent ranges, including his debut collection for the glamorous US brand Halston (see p.142) during New York Fashion Week in 2010. Schwab fused elements of his own design code with the Halston back catalogue of draped silk-jersey elegance. Presented in the round as a mirrored tableau and endorsed by Swarovski and by Halston president and chief creative officer Sarah Jessica Parker, the launch also anticipated the release of the biopic *Ultrasuede – In Search of Halston* at Tribeca Film Festival in March 2010.

In the case of both Halston and his own label, Schwab has developed relationships with jewelry designers and accessory producers to complete the visual impact of his bondage-referenced look. This is evident in the leather pendant chokers by Ileana Makri and silver accessories by Jacqueline Rabun. He has also worked with Berlin eyewear specialists Mykita. Schwab was awarded Best New Designer at the British Fashion Awards in 2006 and the Swiss Textiles Award in 2007.

◀ **Leather and lingerie, lace and tattoos: a biker, goth and boudoir cocktail for 2011.**

2006

The key theme is lingerie: brief slip dresses with hardware from the corsetière.

Anatomical architecture is defined with metallic inserts and parallel topstitching. The collection adheres strictly to a red, white and black palette. Corsetry details are brought to the surface to formal and decorative advantage. There are other cross-currents – Hellenic drapery, belts and braces – that are rendered in harmony with the core theme by the use of metallic finishes. Each embellishment – be it a lace insert or a curve of metal – is strategically placed for seduction by its definition or suggestion of the female form.

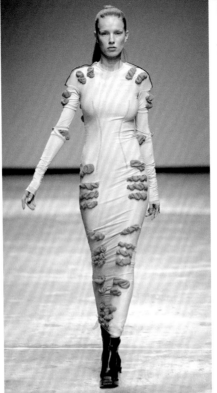

2010

Elements of Tyrolean traditional dress are embedded in bodice details in the collection.

Vernacular dress is rendered modern with the re-proportioning of the dirndl and refined use of colour. The plunging square-necked bodice (*mieder*) is evoked in the white-on-white pleated binding attached to a demure short draped dress. In charcoal and dark navy, a long-sleeved short-cropped jacket with a sweetheart neckline is a suggestion of a loden predecessor. The play of simple geometrical relationships between layers concludes with baroque flourishes of crystal ornamentation.

2008

A body-con take on jersey layering that plays with the ideas of perforation and exposure for autumn/winter.

Schwab explores the possibilities afforded by creating apertures between layers: he uses the Tudor method of slashing fabric to pull through the material beneath, or forms a laser-cut filigree of baroque motifs as a stencil over a contrasting layer. A long jersey sheath dress is attacked with shears and the pockets of jeans worn beneath it in a pragmatic solution. Elsewhere in the collection, a monumental dress of all-over crystals has a knee-viewing window carved out of it, and a dramatic double-breasted maxi-coat comes in three variations: mint condition, distressed with eroded metallic film, and cropped to bolero length.

MARK FAST

www.markfast.net

New-blood designer Mark Fast (1980–) obtained blanket media coverage during London Fashion Week 2009 by clothing a few big models in a little knitted fabric. He was quickly propelled to the head of every press article, each announcing the technical bravura of his curve-clinging dresses.

Fast had exited Central Saint Martins College of Art & Design with a Master's degree in fashion in 2008, showing a knitwear collection that was rightfully acknowledged for its painstaking technical virtuosity. Complex structures, virtually without seams, had been grown by fractional evolutions into constricting elastic garment forms. In this way, Fast was able to take to its apogee the body-conscious lacy experimentation of a generation of designers. The 'Fast look' was made rapidly available to the mass market through a diffusion line with Topshop under the New Generation scheme in 2010.

The Canadian-born designer has now formed a marriage made in heaven with the Italian ready-to-wear brand Pinko. With an ability to respect the artisanal elements of Fast's creativity within industrial processes, Pinko – founded in the 1980s by Pietro Negra and Cristina Rubini – has realized a collection of fifty pieces with a range of bags, jewelry and shoes to complement the 1980s-inspired disco exuberance of the glitzy look. Pinko has a worldwide chain of 100 retail outlets and has an established policy of developing new talent in the anticipation of melding creativity with robust business strategies. Other Fast collaborations include three seasons of knitwear for Bora Aksu (see p.70) and working on the S/S 10 line for Christian Louboutin.

◀ **In 2011, Fast describes a metamorphosis from taut chrysalis to winged butterfly.**

2008
Layering open knits and overlapping colours retains decorum within the clinging form.

Nine all-knit outfits form Fast's student debut at London Fashion Week. The core phenomenon was the organic development of elasticated forms from fragmented knitting, which was able to envelop the figure closely without recourse to cutting or much seaming. The laciness is essentially a decorative by-product of the painstaking method employed by the designer. By using inky-saturated hues in the cellular knits, the garments reveal moiré colour effects that add a sombre richness to the mildly gothic ambience.

2011
Italian ready-to-wear label Pinko signs up Mark Fast to design an S/S 11 collection.

A hooded and crystal-loaded jersey dress from the Pinko by Mark Fast label is ideal for 1980s-style clubbing. Signed up for a two-year collaboration to produce a capsule collection of fifty pieces, Fast uses manufacturing techniques that are less artisanal than those of his own label. Fabrics catch the light and the spotlight: jersey panne velvet, floaty lamé and glazed metallic jersey are shaped into the flimsy attire of the dance floor. Pieces are accessorized with heeled and gilded ankle boots, masses of crystal and rocky bracelets.

2010
Like a Tudor slashed sleeve, the openwork overlayer in taupe and nude reveals the white base layer.

The virtuosity of the soft architectural processes of Fast's knitted fabrication is extended to new effect. Alongside his well-exercised method of fractional knitting, a system of producing narrow panels with heavy corded yarns inlaid to form a series of selvedge loops is introduced in this collection. These loops are then chained together to link the meandering narrow strips as they describe the female form, creating a decorative effect akin to faggoting. Another feature is the encasing of large faceted square crystals within pocketed strips of ribbing that are then used within the structure of the knits as cuff or collar detailing.

MARNI

www.marni.com

Idiosyncratic colour combinations, strong layered graphic prints in refined relationships with each other and craft-based detailing are characteristic of the Italian label Marni. The resulting interplay of pieces generally includes a key garment that anchors the silhouette at an hourglass waist. The Marni label is an offshoot of the Milanese Ciwi Furs company, founded by Primo Castiglioni in 1970. It had become a leading name in the sector by the 1980s, with Castiglioni's son Gianni inheriting the role of chief executive. At the height of the anti-fur PETA campaign, Gianni's wife Consuelo initiated a move away from the company's sole focus on manufacturing furs and leather and proposed a diversified brand – Marni – in which fur should be no more than a component of the ready-to-wear range, used in the same manner as other luxury cloths.

Consuelo Castiglioni launched the first Marni collection in 1994. The successful range was defined by the trade press as hippie de luxe, customers being more youthful and less status-conscious than the bourgeois clientele of the classic fur trade. The bohemian chic label has become a major trendsetter, particularly with much copied pieces of statement jewelry combining resin and textiles. Consuelo is part Chilean, part Swiss and Italian by marriage; in consequence, she has infused the collections with global multicultural inspiration.

The eclectic Marni label became an independent line in 1999 and has now evolved as an internationally known company with a range of ancillary collections: accessories, handbags and eyewear, with menswear and childrenswear launched in 2007.

◄ **Cycling gear transmuted by graphic bold prints for an eccentric S/S 11 collection.**

1999 A soft layered silhouette and signature quirky detailing.

A skirt of cherry-printed silk is partnered with a demure cap-sleeved T-shirt worn under a sheer organdie printed tank top, a look that recurs throughout a collection of many-layered pieces. Silk trousers are worn beneath a calf-length skirt and with a chiffon vest under a bright turquoise jacket. Oversized T-shirts and loosely wrapped skirts suggest an ingénue sensibility, at odds with the sturdy sandals and shoes.

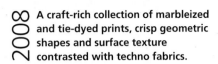

2008 A craft-rich collection of marbleized and tie-dyed prints, crisp geometric shapes and surface texture contrasted with techno fabrics.

An easy-fitting shift dress with a dropped shoulder line and wide sleeves provides a canvas for a marbleized print overlaid with fragmented circular forms in bright turquoise and mustard. Elsewhere, vertically tie-dyed sleeveless shifts accommodate jewelled bodices or are left plain, relying for effect on the print. Shapes are kept simple – boxy edge-to-edge jackets and cropped flared shorts with unadorned T-shirts. Tunics are formed from glossy techno fabrics, while a knee-length dress – wide at the shoulders and narrow at the hem – represents the label's customary ebullient use of print. The renowned statement jewelry is evident: chunks of geometric resin form quirky necklaces, and wide cuffs appear in raspberry-pink and lime-green stripes.

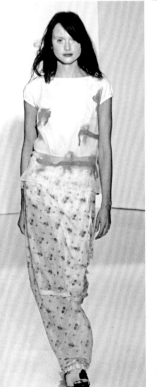

2005 A draped evening gown among a collection of cropped jackets and loosely cut coats.

The asymmetrical neckline of this pale jade evening dress is accessorized with an equally off-centre resin necklace of conjoined circles in orange and brown. Other jewelry is softer: textile corsages adorn cropped jackets and cloth flowers are strung into waist-length necklaces or are tucked into a narrow leather belt. A vintage-inspired floral print in soft chalky tones of green, mushroom and white forms a flowing coat worn over wide cropped trousers and a royal-blue wrap top, layering textures and colours.

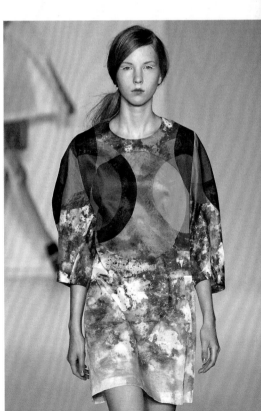

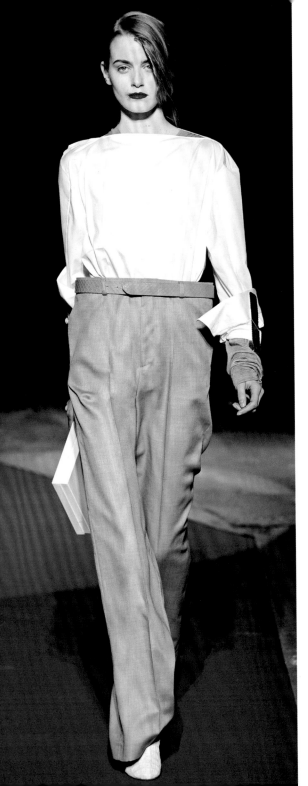

MARTIN MARGIELA

www.maisonmartinmargiela.com

Iconoclast and maverick fashion designer Martin Margiela (1957–) challenges the traditional notion of fashion as a commercial commodity by deconstructing couture techniques, displaying the infrastructure of a garment and exposing the seams, all with scrupulous attention to detail. By cutting coarse linen into a bodice that resembles a dressmaker's mannequin or by reworking knitted socks into a sweater, Margiela subverts the rational approach to garment construction by pushing the boundaries between performance, art installation and fashion with his avant-garde style, which nevertheless includes timeless refined clothes often obscured by his experiments in deconstruction.

The Belgian-born designer studied at Antwerp's Royal Academy of Fine Arts alongside the experimental fashion collective the Antwerp Six. A freelance designer for five years following his graduation in 1979, Margiela then worked for Jean Paul Gaultier (see p.164) until 1987. He launched his own label in 1988.

The seventy-strong group that makes up the Maison Martin Margiela collective eschews publicity. Communication with the Paris headquarters is strictly via email, respecting the ethos of the publicity-shy Margiela who has always refused to be interviewed or photographed. Despite his revolutionary approach to design, Margiela was hired in 1997 by the traditional luxury house Hermès (see p.146) to energize the label. The Margiela brand was acquired by Diesel (see p.108) in 2002, after which Martin Margiela left the company.

◀ **Classic tailoring is subverted by a resolutely anonymous team for A/W 10/11.**

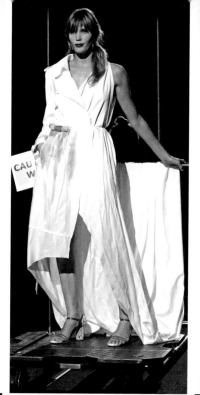

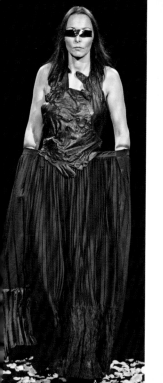

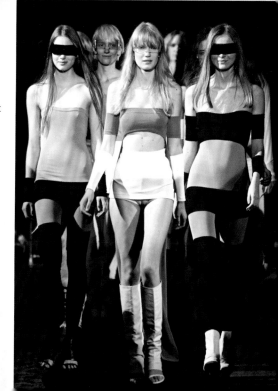

2001 Margiela questions the techniques and logic of garment construction.

Leather gloves are reassembled into a close-fitting bodice that anchors an extended waistband incorporating horizontal pockets, before falling in pleated folds to the ground. This design conceit occurs elsewhere in the spring/summer collection and reappraises the proportions of the body. Playful distortion of scale includes oversized jackets and deconstructed trench coats with dropped shoulder lines.

2008 Models wearing body-sculpted jersey in broad horizontal stripes of nude and black appear as disjointed figures against a black backdrop.

Cut across the top of the thigh to reveal the crotch beneath and aligned to matching armlets, stretch jersey forms horizontal stripes across the body. Elements of bondage – tightly wound collars, open-toed knee-high boots and ripped and shredded trousers – are further reinforced with spectacles that have the appearance of a blindfold, by the company Incognito. Nude-coloured jersey dresses are cropped to the top of the thigh. Futuristic wing-shaped shoulders on tops and jackets are sculpted in boiled wool and satin, sometimes draped in chiffon to soften the angles and mixed with second-skin trousers with a diffused stripe down the front. A *trompe l'oeil* light and shadow effect is achieved with a scattering of sequins on jackets and skirts.

2006 Margiela consistently rejects the notion of fashionability and short-lived trends.

A single-sleeved white silk trench coat segues into an ankle-length halter-neck evening dress with a patch of diffused colour on the hip, formed from a half belt of melting coloured ice. Elsewhere, jewelry of tinted ice cubes bleeds colour on to garments: a turquoise necklace stains the bodice of a column of wrapped white silk, and pink earrings drip on to a halter neck. One-shouldered raspberry-pink dresses have displaced collars and are buttoned off-centre. The concept of positive and negative is exploited with coin-sized prints on dresses worn with tights made in the opposing pattern.

MATTHEW WILLIAMSON

www.matthewwilliamson.com

The juxtaposition of ebullient colour and assured print design is integral to Matthew Williamson (1971–), who first appeared on the London fashion scene in 1997 with his 'Electric Angels' collection. This was a kaleidoscope of neon-bright garments modelled by Kate Moss, Jade Jagger and Helena Christensen, among others. Williamson's fluid, unstructured clothes in magenta, orange, lilac and turquoise were an immediate hit in an era of monochrome minimalism, garnering huge publicity in the fashion press. A-list models and actresses continue to be associated with the label, and Williamson and his friend and muse Sienna Miller virtually created the boho trend of 2003.

Aware from an early age that he wanted to be a fashion designer, Williamson was one of the youngest graduates to study at Central Saint Martins College of Art & Design. Following two years' working for British high street chain Monsoon gaining valuable experience in business management, he was ready to launch his own label. With the support of Joseph Velosa, Williamson established his luxury fashion house in 1997.

His aesthetic has successfully translated to the high street with a long-running diffusion line, Butterfly, for British store Debenhams and a high-profile co-branding exercise with Swedish company H&M. The award-winning London flagship store opened in 2004. There are stand-alone Matthew Williamson stores in New York and Dubai. Williamson has also collaborated with jewelry house Bulgari on a collection of handbags.

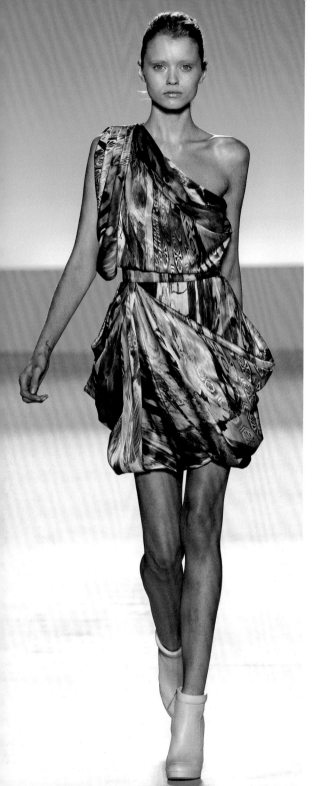

◀ **A short toga cocktail dress in a marbled print defines Williamson's 2010 refined modern elegance.**

1997 A debut collection of fluorescent colour-blocked womenswear.

The two-coloured dress relies for its impact on the juxtaposition of colour taken from opposing ends of the colour spectrum. The turquoise cowl-neck bodice is attached to an empire-line bias-cut skirt of a flirty above-the-knee length in bright pink. It is one of only eleven outfits in Williamson's first collection, titled 'Electric Angels', which appeared on the runway for just seven minutes.

2004 Espoused by celebrity muse Sienna Miller, the peacock-print dress.

The peacock print appears throughout this spring/ summer collection: on maxi-skirts, on crisp cotton jackets, on short kaftans and on floating panels of silk chiffon that define Williamson's signature look. Rolled-up jeans have pockets edged with miniature pom-poms and are accessorized with bejewelled sandals. The all-white ensembles are accented with narrow pink fluorescent belts.

2002 Printed chiffon and sequinned evening wear is combined with preppy stripes and separates for the first catwalk show in New York.

A multicoloured ombré-striped sweater introduces knit to the Williamson stable of print and pattern. The collection combines elements of preppy style, as seen in the turquoise kilt and shrunken striped blazer, with Williamson's signature boho look evident in the embroidered coat dress. Drawstring-neck mohair jumpers, the ends decorated with cheerleader pompoms, are partnered with narrow jeans. Oversized 1980s-inspired velour jumpers with knitted double-ribbed waistbands fall off the shoulder. Shades of the designer's favourite pink are often partnered with bright turquoise. Evening wear includes Williamson's customary shards of printed chiffon, strung into handkerchief points and draped sari-like around the body. Sophisticated columnar dresses fall straight from the bodice to the ground and are edged in a jagged border of embroidered beadwork.

MAX MARA

www.maxmara.com

With an understated ethos, meticulous production values and luxurious fabrics, the Italian Max Mara label represents the enduring values of high-quality fashion. The double-breasted coat in camel-coloured beaver wool and cashmere, named the 101801, is considered a cult item and the perfect example of the classic winter coat. The house of Max Mara was officially established in 1951 by Italian-born Achille Maramotti (1927–2005). Fashion was a family passion passed down from his great-grandmother Marina Rinaldi, who in the late 19th century operated a luxury fashion house in the heart of Reggio Emilia. Maramotti's entrepreneurial vision was to foresee the importance of high-quality mass-produced ready-to-wear clothes that were well designed without being subject to seasonal changes. The very first collection, a camel coat and a geranium-red suit, incorporated the ideals of future production.

Recognized designers such as Karl Lagerfeld (see p.182), Jean-Charles de Castelbajac and Narciso Rodriguez (see p.228) were invited to design for the label, but their contributions remained anonymous, thus retaining a strictly edited consistent look for the label. Max Mara has thirty-five different lines altogether, although Max Mara womenswear remains the core of the company. Other lines include Sportmax, Sportmax Code, Weekend Max Mara (a casual line that is less expensive than the main label), S Max Mara, Max Mara Studio, Max Mara Elegante and one of the few successful fashion-led labels for the 'plus size' woman, Marina Rinaldi. The founder died in 2005, and the company remains family owned, with his son Luigi Maramotti now chairman.

◀ **Pared-down colour blocking for pieces in clean graphic shapes for spring/summer 2011.**

1996 Clean-cut fresh spring/summer separates in pale linens and cottons.

A crisp unadorned shell top and cropped skirt feature in a collection with a mid-1960s Jackie Kennedy style: suits with A-line skirts and simple buttoned jackets with bracelet-length sleeves in lilac or cream. Pocketed button-through shirt dresses with rolled-up sleeves have a sporty feel. Narrow trousers and bandeau tops under sheer chiffon; and camel-coloured wide trousers with a lilac fitted shirt are more formal.

2010 Investment pieces in cashmere: luxurious coats and suits.

The classic camel coat is inextricably linked to the Max Mara label, specifically the 101801 coat, created by designer Anna Marie Beretta for the company in 1981. The coat has since been a constant symbol for the Italian brand. This version for autumn/winter is wrapped rather than buttoned, but still retains the wide raglan sleeves, topstitched collar and generous cut of the original design.

2006 A predominantly natural palette with hits of stronger colour features in a loose easy collection of long-line sweater dresses, wide-legged trousers and simple knits.

A deep cowled neckline, originating in the broad ribbed hem of the sweater, extends into a hood and is worn over high-waisted wide-legged trousers and flat patent brogues. The look exemplifies an understated sporty ease. Elsewhere, pull-on body-skimming sweater dresses in fine horizontal stripes have vest tops or drawstring necklines. Strapless columnar dresses are tailored from bright blocks of colour – emerald green, raspberry pink and cobalt blue. In a collection devoted to pared-down minimalism, sprays of brightly coloured embroidered flowers are the only decoration – across the hem and shoulder of a sweater or forming a diagonal stripe across a calf-length white shift. All-in-one jumpsuits are either rugged and workmanlike in grey linen or are pulled up like extended trousers to above the breasts, one in cobalt blue with frilled suspenders as shoulder straps, another in brown and beige.

MEADHAM KIRCHHOFF

www.meadhamkirchhoff.com

An aesthetic that veers between neo-gothic androgyny and romantic excess is evident in the fashion output of design partnership Meadham Kirchhoff. Just when the fashion press had got used to their sombre palette, sculptural hard-edged leather and mannish references, the Central Saint Martins College of Art & Design graduates began to present collections that were saccharine sweet but that had overtones of animate dolls in a schlock horror film. Fondant-coloured dresses steeped in Miss Havisham–style decayed glamour were juxtaposed with graffiti bomber jackets, outsize printed T-shirts and slouchy socks. Collections inspired by the Arabian nights, with draped and layered veils decorated with fringes, tassels and bobbles in intense colours and topped with a tiara, had overtones of a psychedelic bride, styled for the seraglio rather than the streets.

This transition from a male to female vocabulary in the women's collection reflects the partners' backgrounds: Edward Meadham (1979–) trained in womenswear and French-born Benjamin Kirchhoff (1978–) took the menswear route. Their first joint venture in 2002 was a menswear line, Benjamin Kirchhoff, and it was not until they showed in 2006 that they adopted the united branding for their womenswear label.

For S/S 10, Meadham Kirchhoff's monochrome distressed look was distilled into a capsule collection of T-shirts, skirts, dresses and jackets for British high street store Topshop. The designers are known for the unpredictable nature of their output.

◄ **Austere luxury in 2008, strictly neutral in tone and volume, exploits contrasting surfaces.**

2007

Colour and texture blocking for spring/ summer: ciré, satin, tulle, net and denim are given the blue-black, sloe-black, royal-blue and marigold jigsaw treatment.

The multitextured and polychrome body-sculpted mini-dress could be seen as a compendium of the ingredients that are interspersed throughout the spring/summer collection. Hems are constant at mid-thigh – give or take the occasional flap or bow – while the waist fluctuates between natural, not at all and empire. Vertical asymmetry ebbs and flows. High-waisted shirt dresses have bows at their backs, and hooded and ruffled ciré cagoules take a similar A-line. Robust riveted denim tops, skirts and dresses are frayed and fitted close to the body, which is exposed at the shoulder blades. In other garments, apertures are virtual, using elastic warp-knit net alongside ciré and matt jersey to define the body. Tan leather shoes with ribbon lacing recall Western denim and rodeo style, as do the blue-black and yellow patches and ruffled appendages.

2011

A florid and many layered collection that channels film and music references such as Daisy Chainsaw's *Pink Flower* video and Dario Argento's horror film *Suspiria* (1977).

Glittery pieces – tops with sawn-off sleeves or crudely blanket-stitched into raised seams – are interleaved with gauzy pin-tucked panels and lace-inserted chiffon flounces in the saturated shades of a hothouse flower. The collection establishes a narrative from the outset: a full-blown crowned princess doll meanders through a technicoloured garden in a dreamy confection with dagged neck and cuffs and an exquisite lace and silk-crêpe gown, which is knife-pleated from the waist and gathered by pin-tucks and ribbons on the sleeve. Her coarse leggings and the tiny ballerina and mirror atop her coronet, by Nasir Mazhar, disrupt her regal progress. Elsewhere, doll-like prettiness is suppressed beneath khaki coveralls. A colourful outburst of graffiti slogans – 'Babies!' 'Bunnies!' – is followed by the black and white colour codes of domestic servitude. Heavily embroidered footwear features throughout.

Meadham Kirchhoff | 215

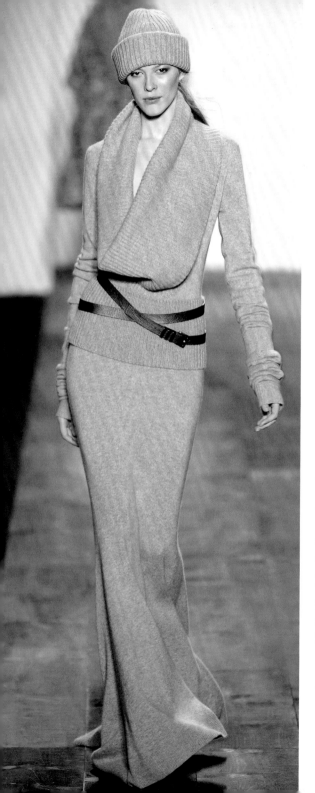

MICHAEL KORS

www.michaelkors.com

Exponent of luxurious sportswear, Michael Kors (1959–) has continually provided the essential American wardrobe since the inception of his label in 1981. His restrained, unpretentious yet sophisticated style has sustained his success and, in March 2009, Michelle Obama chose a Michael Kors black shift dress for her first official portrait. In a soft neutral palette, his shirt dresses, turtleneck oversized sweaters and oversized knits in such sumptuous fabrics as silk, cashmere and suede are in keeping with fashion's contemporary minimalism.

Kors was born Karl Anderson, on Long Island, New York. Following early design experience, he went on to study at the Fashion Institute of Technology in New York City. Named the first ever women's ready-to-wear designer and creative director for the French fashion house Céline (see p.84) in 1997, he reinvigorated the brand with understated elegant clothes and a range of accessories. Kors left Céline in October 2003 to concentrate on his own brand, having launched a menswear line in 2002.

In addition to the Michael Kors runway collection, the MICHAEL Michael Kors and KORS Michael Kors lines were launched in 2004. KORS is considered the mid-tier line, between the runway and MICHAEL collections. The MICHAEL line includes women's handbags and shoes as well as women's ready-to-wear apparel. The KORS line focuses on footwear and jeans. In 2010, Kors was the youngest recipient of the Geoffrey Beene Lifetime Achievement Award from the Council of Fashion Directors of America.

◄ **Sportswear luxe in fur, cashmere and mohair in camel, cream and grey for A/W 10/11.**

1994 Flying under the colours of classic US sportswear, Kors has a close affinity with swimwear.

In a licensing agreement with Trulo Swimwear of Tel Aviv, Kors brought the simplified easy feel of his main line to bear on the designer-led mass retail market of beachwear, rooted in his own expertise drawn from direct customer liaison. The emphasis on textiles is a reflection of the central ethos of his overall collection: simple styles from good cloth. His swimwear favours the high-cut maillot over the two-piece, using sculptural lines to define the natural figure with sympathetic detailing: a curving stripe or a laced neck opening, for example.

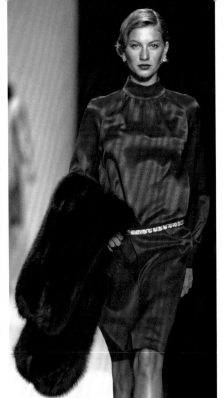

2008 Crisp silhouettes and luxurious fabrics suggest summer at Palm Beach with the 1950s jet set.

His and hers tennis whites: hers with a lemon yoke and shoulder straps, his hooded top and shorts worn beneath a classic navy blazer in cashmere, a colour combination that also features on chunky cricket sweaters. Broad horizontal stripes in lemon, lime and orange appear on jersey dresses, both long and short, or cropped high and worn with skintight jersey shorts, all accessorized with matching stripy sun hats. Wide-legged trousers, figure-hugging sweaters defined with a narrow belt and crisp shirts have a more formal appeal.

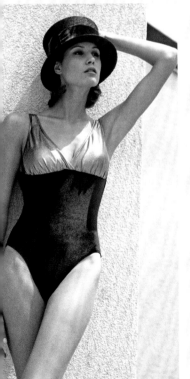

2000 Minimalist unadorned luxurious glamour with glittering metallic fabrics and feather and fur additions.

A ruby-coloured silk-satin dress, accessorized with a black mink stole, is gently gathered into a high neckline and caught low at the waist with a rhinestone belt. An exercise in high-end stealth wealth, elongated cashmere sweater dresses also appear, clinging to the ankle and with a silk cravat tucked into the neckline. Neat knits partnered with patterned and printed A-line skirts are embellished with multiple rows of pearls or feather collars. Glittering lengths of gold or silver lamé form minimalist figure-contouring shifts, or a pencil skirt worn with a plain gold top. White bias-cut silk-satin dresses have shoestring straps and cowl necks.

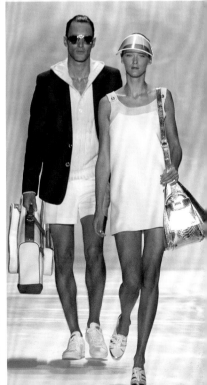

MISSONI

www.missoni.com

The unmistakable handwriting of Italian company Missoni lies in its exclusively designed textiles: the brand is synonymous with the polychromatic warp-knitted stripes that have dominated its ranges for almost half a century. One of the first labels to release knitwear from its frumpy handcraft image and place it at the forefront of 1970s glamour, the company was founded in 1953 by Ottavio 'Tai' (1921–) and Rosita Missoni (1931–) with a small workshop of three knitting machines in the basement of their home in Gallarate, Italy, producing branded garments for La Rinascente stores in Milan.

The business prospered with the support of legendary editor Anna Piaggi, then at the magazine *Arianna*. On a trip to New York, Rosita met the French stylist Emmanuelle Khanh, whose avant-garde approach led to collaboration and a radical new collection for the first runway show in 1966. Fame was assured when, in 1967, Missoni was invited to show at the Pitti Palace in Florence. Unwittingly or otherwise, during the show the fine knitted fabrics appeared transparent under the lights and caused a sensation.

The company's reputation continued to strengthen and, in 1969, the couple built a factory attached to their house at Sumirago. In 1970, Bloomingdale's of New York opened a concession in its store, and, in 1976, Missoni opened its first Milan boutique. Stores worldwide followed.

The Missoni label enjoyed a renaissance with the timely introduction of Angela Missoni as creative director in 1997. She emphasized the use of printed fabrics in the fashion line, while Rosita Missoni concentrated on the interiors label.

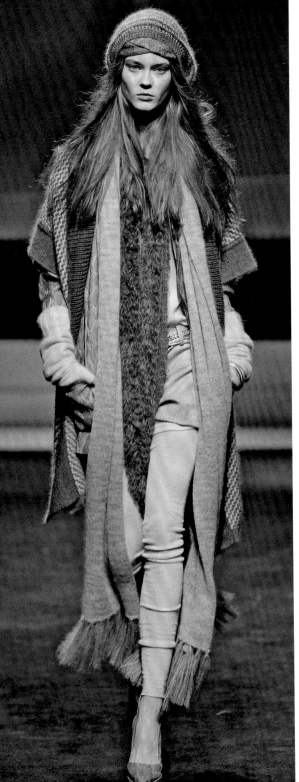

◄ **Missoni returns to its roots with luxurious knits and interplay of pattern for 2009.**

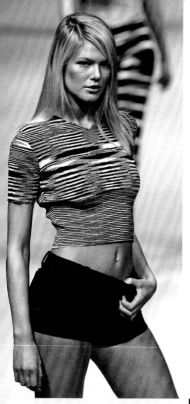

2003

Celebrating fifty years of its hallmark striped and zigzag knits, Missoni stages a retrospective show.

A rainbow-coloured halter-neck top and striped trousers are partnered with an oversized headscarf in the label's signature flame pattern, inspired by the angular art of the Italian futurists. Missoni was the first to create constructed knitted jackets, pioneer the use of knitted furs and produce a knitted tweed-effect fabric that had all the substance of a woven cloth. Tai Missoni upheld the Bauhaus doctrine that there should be no division between the creative disciplines of architecture, fine arts and industrial design, resulting in a sustained coherence between design, technology and the sources of inspiration.

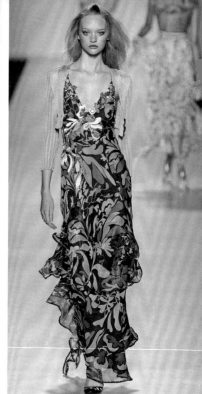

1996

The versatility of knitted structures is used to the full in this spring/ summer collection.

A midriff-baring top features the label's hallmark technique of space dyeing, this time in monochrome, which includes 'calm' periods of geometric reconstruction and 'storms' of more irregular patterning. The technique is also used for a zip-fronted jumpsuit and in combination with intarsia for neatly fitting sweaters. Prints include splashy oversized florals in chintz – glossy trouser suits with a 1970s look and halter-neck full-length ball gowns. The collection predates the retirement of Rosita Missoni, after which the label refocused.

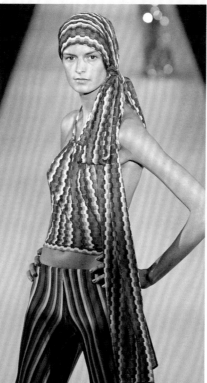

2005

Floral prints are added to Missoni's signature patterning for an ingénue edge.

A shrunken silk-knit cardigan accessorizes an ankle-skimming dress of floral-printed silk chiffon: one of a series of lightly frilled 1930s-style evening dresses in a collection that espouses full-on femininity. The label's signature stitches are retained but used with a lighter hand – a raschel knit is worked into a ballet-wrap top, worn with a lemon frilled skirt, and the chevron flame pattern forms a jacket or 1970s-inspired flares, rendered haute hippie with crocheted chokers and a see-through chiffon top.

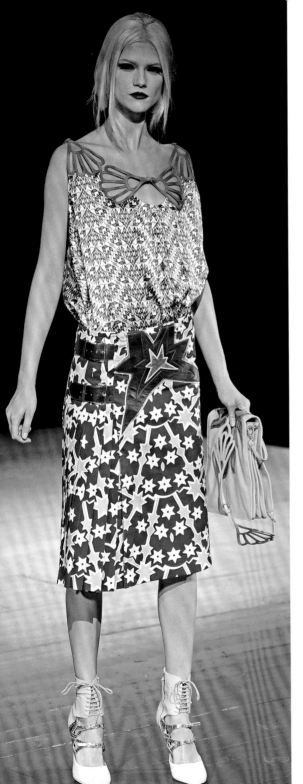

MIU MIU

www.miumiu.com

Avant-garde label Miu Miu is known for its playful detailing and experiments with embellishment and texture, for example, the use of mirrored fragments and unique fabric blends. Miuccia Prada (1949–) created Miu Miu, the secondary 'little sister' line to Prada (see p.250) in 1992, the label a childhood diminutive of her name. It was intended to engage with a younger, more adventurous demographic.

The initial collection of bohemian craft-inspired patchwork and crocheted garments, saddlebags, sheepskin jackets, clogs and boots instantly distanced the line from the more sophisticated and elegant Prada label. This was reinforced by the photographic campaigns featuring young style icons such as Chloë Sevigny, shot by cutting-edge photographers including Corinne Day and Juergen Teller. Combining primness with a covert sexuality, the designer subverts the conservative with fetishistic details, such as socks with dresses and sculptural shoes. Miu Miu proved so successful that the Prada empire grew in size and scope during the 1990s. The first Miu Miu stores, in Paris and Milan, were joined by another in New York's SoHo in 1996, since when forty more have been established.

Initially, both labels showed in Milan, but in 2006 Miu Miu moved to Paris to highlight the contrasting aesthetic of the two labels. An unprecedented fashion coup occurred in 2010, when a Miu Miu dress appeared on the front cover of the August edition of three leading magazines. British *Vogue* and *Elle* and US magazine *W* all featured the orange and lilac mini-dress with appliquéd leather flowers on the bodice, ensuring the garment was a key piece for autumn/winter.

◄ **For S/S 11, a star-spangled kilt with Roy Lichtenstein appliqué has a glam-rock edge.**

1996
A subversion of fashion's ladylike codes given an innocent edge.

A classic kilt with unpressed pleats in vivid orange-red is worn with a blush-pink blouse buttoned to the neck. The demure impact exemplifies a collection of edgy understated faux geekiness, which Juergen Teller photographed in a groundbreaking advertising campaign. The straight-laced simplicity continues with little jacquard topcoats over calf-length slips trimmed with ribbon bows or over mannish trousers and plain stiff shirts.

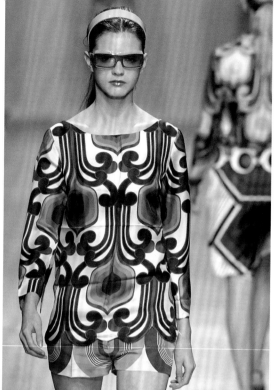

2010
A 1960s flower-inspired collection of graphic frills and petal edges.

A stand-away bell dress in laminated wool has moulded overlapping frills at the hem, below a line of encrusted daisies in felt and metal. The separate high collar in narrow nude fabric is tied in a bouquet-like bow. It is a recurrent flourish throughout the softly sculpted autumn/winter collection, as is the 3D daisy motif, which appears in guipure, or as clustered jewels across a shoe or bag.

2005
A nostalgic collage for spring/summer incorporates jewelry as embellishment on beaded necklines and belts, abstract 1970s-inspired prints and quirky colourways.

Cartoon-scale retro geometry, reminiscent of early 1970s interiors or bric-a-brac, features on a loose-fitting tunic top and mismatched shorts. The recollection is sustained in edge-to-edge jackets, knee-length shorts and demure A-line coats. Wallpaper prints – the stark patterns repeating only once or twice – are engineered to form bodices in a series of halter-neck slips and sleeveless shifts. The muted colour palette of mustard, khaki and brown is accented sporadically with jewel tones of purple, gold and emerald for a simply cut A-line coat, button-through dress or pencil skirt in Thai silk taffeta. Suede is worked into a colour-blocked shift dress of pale mint green, tan and navy, worn with a decorative belt of coloured discs. A softer silhouette is provided by a loose straight skirt in royal blue, hung from the hips beneath a grey polo shirt, and an empire-line waffle-knit sweater dress.

MOSCHINO

www.moschino.it

The provocative and irreverent Italian Franco Moschino (1950–94), dubbed the 'bad boy of fashion' by the press, viewed the fashion industry with a subversive eye at the same time as exploiting the very codes he wished to satirize.

In 1991, Moschino designed a red trouser suit with the text 'waist of money' embroidered around the waistline. With wit and visual puns – his advertising campaign for 1988/89 featured a dress and hat adorned with miniature teddy bears – the designer habitually used fashion as a springboard for his ideas.

Born in a small village in Lombardy, Moschino went to the Accademia di Belle Arti in Milan in 1967. He graduated in 1971 and spent several years working as an illustrator for Gianni Versace (see p.306). In 1977, he was appointed designer at Italian company Cadette, before leaving to launch his own label in 1983, which he showed in Milan. In 1986, the designer produced his first menswear collection, followed in 1988 by the ironically titled Cheap and Chic range, which, although less expensive then his main line, retailed at the high end of the market.

On the designer's untimely death in 1994, at the age of forty-four, friend and long-time collaborator Rossella Jardini, who had been with the label since 1981, took over. She adopted a slightly more reserved approach while continuing to include the *trompe l'oeil* effects and surreal touches that identify the label. Moschino is part of the Aeffe fashion group; in 2008, the flagship store opened in New York selling the main line, Moschino Cheap and Chic, Love Moschino and Moschino Uomo.

◄ **A 1980s-inspired 2010 collection of chain-link prints, pussycat bows and gilt jewelry.**

1996
Heart shapes and flowers, Mughal and flamenco: a cultural mix of autumn wardrobe versatility.

Creating a negative space heart form, described by the dipping waistband centred below the round shoulder lines, the lacy twinset frames a heart-shaped pendant and chain – a recurrent accessory. Low-key romantic femininity is expressed in a variety of chic confections: from the little black flounced dress, swooping to a red rose in the small of the back, to the carpet-print leather trench coat and the grey flannel spencer worn over a daisy broderie anglaise wrap skirt. Patterned silks come in the form of kameez tunics and salwar trousers.

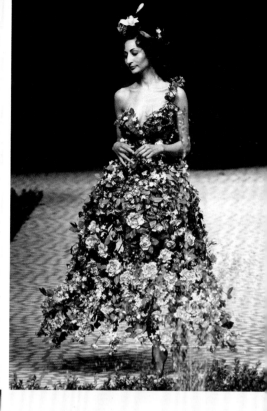

1988
Seemingly random accoutrements recollect Moschino levity.

In an era commonly associated with excess and ostentation, Moschino employed surrealism and a juxtaposition of lavish colour and texture for effect. He created garments from unexpected sources, for example the iconic teddy-bear coat (reintroduced for A/W 11/12 as a removable collar), knives and forks as frogging and later, in 1994, a dress with a skirt made from size 36C bras.

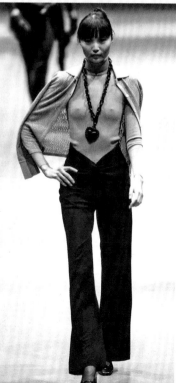

1997
With an extravagant diversity of sources, the collection draws on disparate geographic themes to enigmatic effect.

In a virtuoso floral conclusion to illuminate the transitory character of beauty, the rose in abundance recalls the small headdress posy of the severe show-opening outfit in black. Decorative textiles are invested with narrative importance, from the triptych of printed gowns that unite to form the image of the Taj Mahal, to the cellophane-wrapped, inverted blooming bouquet as bustier dress. East and West meet in loud textile tricks: a trouser suit and Stetson are camouflaged as a brick wall; devotional images of the Buddha are printed on tablets that are blanket-stitched into a sturdy kimono. Photographic prints of horticultural workers are mixed with florals in garment forms from Tokyo, Texas or any tourist zone in-between.

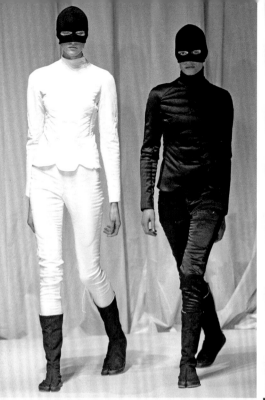

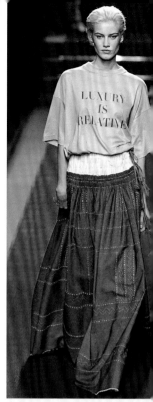

A Spanish influence and signature black, white and red spots and stripes for spring/summer.

Colourful magazine covers are collaged together into a print for a flamenco-inspired evening dress, worked into outsize frilled shoulders and a many layered skirt – a one-off in a collection that also includes schoolgirl tailoring with narrow ties, white shirts and black blazers, subverted by a front-buttoning basque/waistcoat curved under the breasts. Off-the-shoulder embroidered peasant blouses are trimmed with ribbon-threaded broderie anglaise, as is a frilled top and black and white vertically striped pants, with a kick of frills at mid-calf.

1999 **Referencing Zorro with slashes and masks: the film *The Mask of Zorro* (1998) is a core thematic impulse for autumn/winter.**

The storyline of the collection opens with an unambiguous establishing shot: models garbed for fencing practice in quilted bodices, tight trousers and compulsory Zorro masks. The slotted bandana only disappears after a sequence of black outfits, bordered with tufted bands of clipped tulle or detailed with the curved buttoning of the *carabiniere* uniform. Black gowns are chopped or tasselled, tiered, slashed or flimsily crocheted. Black and white colour-blocked suits have voluminous prison trousers, and outfits are then subjected to intense slashing before becoming soberly orthodox for a brief time. A topcoat is slashed and long black dresses are lavishly distressed, with the addition of crystal-studded foliage or open trellises – fraying as if cut raw.

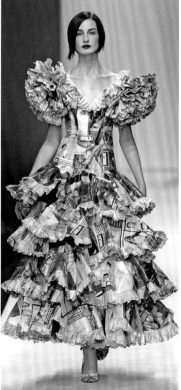

2002 **An ebullient show of sharp tailoring and chiffon by Vincent Dare.**

An oversized T-shirt proclaiming 'Luxury is Relative' continues the Moschino subversion of fashion codes, this time with text emphasizing the denim workwear gathered skirt. Elsewhere, an ironic homage to Chanel reads 'Moschino n'est pas un style, c'est un pastiche!'. Deconstructed frilled and draped dresses contrast with the severity of a navy frock-coated trouser suit with mismatched buttons.

2004
A playful collection of pieces including flirty dresses and Chanel-style suits.

A demure fit-and-flare princess-line coat in Parma violet with a Peter Pan collar represents a coy 1950s feel. The autumn/winter collection also features neat tweed suits with pencil skirts and edge-to-edge jackets with patch pockets trimmed with braid and with a perky bow at the neck. Fur stoles are positioned at right angles over one shoulder, accessorizing vivid print dresses and a black silk top.

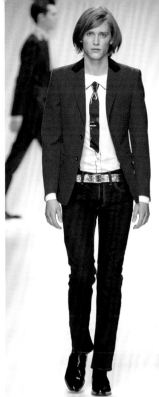

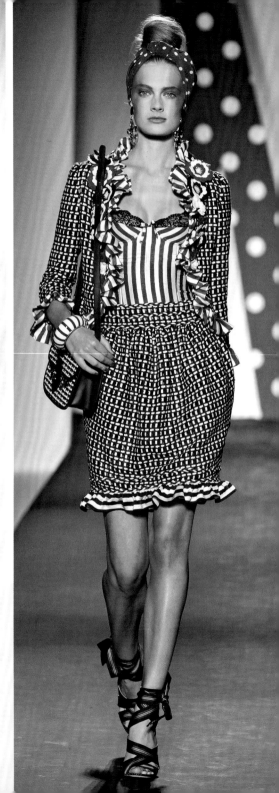

2007
Traditional tailoring with preppy styling includes parkas and blazers with witty touches.

A slim-cut two-button jacket with black velvet lapels is worn with a T-shirt – printed deceptively with a shirt and tie – and narrow black jeans belted with silver leather.

2011
More is more in a collection of spots, stripes, ruffles and Mexican-inspired appliqué flowers.

Striped ruffles finish the edge of a black and white tweed suit – in red and white on the jacket, matching the basque beneath, and black and white on the tulip-shaped skirt's hem.

MULBERRY

www.mulberry.com

British leather goods firm Mulberry retains traditional craft methods and materials alongside the ability to create the latest covetable handbag. Recently, the label has produced yet another best-seller, with a waiting list of thousands: the upgraded satchel-style Alexa bag, named for *Vogue* cover girl Alexa Chung.

The Mulberry label was established by Roger Saul (1950–) in 1971 with a range of handcrafted snakeskin chokers and belts. The suede and leather bags that followed these early successes were produced using traditional saddlery methods in an old forge in Chilcompton, Bath. Somerset continues to be the Mulberry Company's hub of activity, where seasonal ranges are produced by highly skilled craftspeople at the Rookery, a purpose-built site that opened in 1989.

Mulberry has pursued creative collaborations with various handbag designers. Nicholas Knightly was design director from 2002 to 2004 and responsible for the Bayswater, Roxanne and Elgin. Stuart Vevers, previously the creative force behind Italian luxury goods company Bottega Veneta (see p.72), joined Mulberry from 2004 until 2007. His designs included the Maggie, Poppy, Mabel, Roxanne Tote, Calder Tote and the Emmy. British designer Luella designed the Gisele (named after the world's highest paid model), a multi-strapped giant of a handbag with a double love heart label, which helped ignite the whole 'It' bag trend in 2002.

Now under the creative directorship of British designer Emma Hill, Mulberry's expansion into ready-to-wear has grown to include leather jackets and shoes as well as outerwear. A flagship store opened in London's New Bond Street in 2010.

◄ **A burnt-orange skirt suit is accessorized with the Tillie bag for the S/S 11 collection.**

1997 Classic British tailoring by Roger Saul with velvet-collared tweed coat.

Mulberry was one of the first British lifestyle brands, creating the vogue for 'le style anglais' – an expression of traditional values and bespoke designs. This heritage was extended into interior products in 1991 when the company added its At Home range. A cross-fertilization of ideas followed, with the use of large-scale repeats, heavy tapestry cloth and *passementerie* appearing in the fashion range.

2010 Designed by Emma Hill, an ingénue spring/summer collection is accessorized with a double-strapped 'must-have' Alexa bag.

A nude-pink suede is worked into a cropped gathered skirt featuring a pair of roomy bound and piped pockets, accompanied by an easy-fitting jacket with matching pockets. Worn with a carnival-inspired multicolour print top with a big flattened bow beneath the scooped neckline, the outfit resonates with girly femininity, seen elsewhere in a collection of soft suede separates and whimsically styled dresses featuring a carousel horse's head print. Skinny low-rise jeans in sky-blue denim are worn with a belted and zip-pocketed denim jacket, also seen in buttery yellow and nude suede, the latter bound in black. Denim hotpants, with bows on the pockets and a printed romper suit with elasticated legs take the collection further into a 1970s-inspired teenage dream.

2009 A youthful spring/summer debut collection for men and women by Emma Hill.

Skinny jeans partner a double-breasted collarless camel bomber jacket in leather with gathered sleeves, the fringed scarf adding a note of student chic. Elsewhere in the collection are empire-line dresses, cropped gathered skirts and shrunken leather jackets. Safari-style pleated, bagged pockets feature on the hips of shorter than short skirts, on minimal citrus-coloured shift dresses, and on the jackets and skirts of more formal suits, secured with gilt buttons. The collection also introduces variations on the best-selling Bayswater bag.

NARCISO RODRIGUEZ

www.narcisorodriguez.com

When he undertook the commission to design Carolyn Bessette's wedding dress for her marriage to John F. Kennedy Jr in 1996, Narciso Rodriguez (1961–) was a relatively unknown designer. The simple streamlined bias-cut white sheath dress was heralded as a triumph of understated chic, and was evidence of Rodriguez's talent for intricate garment structuring. Born in New Jersey of Cuban-American parents, Rodriguez received his formal education at Parsons The New School for Design in New York before starting his career as a designer under Donna Karan (see p.114) at Anne Klein. A move to Calvin Klein (see p.80) followed, and then he was appointed design director at TSE in 1995, simultaneously performing the same role at Cerruti in Paris. While with Cerruti, he designed the wedding dress that would propel him to front page status.

In 1997, Rodriguez launched his own label in partnership with Italian manufacturer Aeffe, presenting his first collection in Milan for S/S 98. The designer's style comprises a pure and architectural line combined with strong colours in luxurious fabrics. Adjustments of volume and sophisticated tailoring techniques take the place of detailing and embellishment.

Rodriguez received Best New Designer at the *Vogue*/VH1 fashion awards in New York and the Perry Ellis Award for Womenswear in 1997, and Womenswear Designer of the Year in 2003 from the Council of Fashion Designers of America. Rodriguez terminated his agreement with Aeffe in 2001, returning to show in New York.

◄ **Painterly sleeveless silk-chiffon shifts and collaged colours of lilac, cobalt and ruby in 2011.**

1998 Streamlined sequinned dressing in coffee, aqua, pink and cream.

Sleek modern lines and minimal detailing feature on this halter-neck, fine-gauge, silk single-jersey top with cutaway armholes and deep rib, worn with a lamé pencil skirt. Rodriguez's own line retailed at high-end fashion stores such as Barneys and Neiman Marcus. The designer also produced a full women's ready-to-wear line for Loewe, the Spanish luxury house established in Madrid in 1846 and owned by LVMH since January 1997.

2009 Ninja star prints and strapped body-sculpted dresses inspired by the *kinbaku* (bondage) images of photographer Nobuyoshi Araki.

An appliquéd mosaic of emerald, jade and lemon is intersected by bondage straps, criss-crossed over the breasts and hips to form the infrastructure of this body-con cocktail dress. Martial arts are represented elsewhere by zip-up jackets with moulded shoulders and sleeves, worn over black and white horizontally striped leggings or bandage skirts. A minimalist kimono-style top is worn with a pencil skirt. The kimono is also the template for a burnt-orange loosely fitting dress with diagonal-zipped pockets and a black satin sleeveless jacket. Exposed zips snake up the front of a lime-green tunic and brown satin sheath dress with cap sleeves. Elsewhere, the bondage effect is rendered more covert with wraps rather than straps exposing areas of the body.

2001 Showing in New York, an urban collection of adroit tailoring for autumn/winter.

A sleeveless wrap coat in ginger-coloured wool features a back yoke of black and is bound with a black leather belt, evidencing the clean lines and lack of extraneous detailing inherent throughout. A cropped, sleeved version appears with pleat-fronted narrow trousers in both brown and black. Other sleeves are cropped to bracelet length – on double-breasted seven-eighths jackets, tan stretch-wool tube dresses and an off-white trouser suit. Swarovski-encrusted dresses contrast with simple draped mid-calf sheaths for evening.

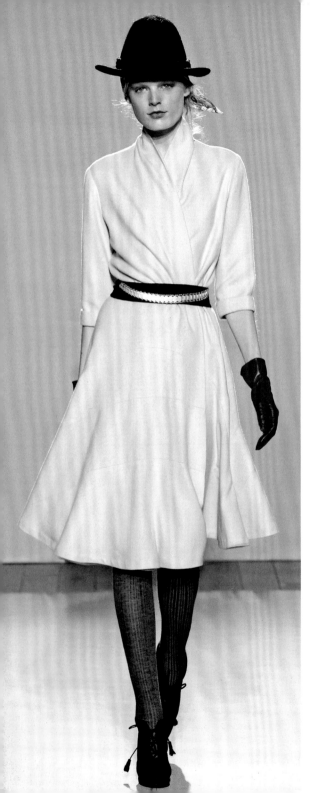

NICOLE FARHI

www.nicolefarhi.com

French-born designer Nicole Farhi (1946–) has developed a women's line that is subtle in impact and rich in the textures and subdued colours of luxury. The Farhi wardrobe infers that a woman has both a profession and a life, with clothes that offer a seamless transition from active days to sophisticated evenings.

Trained as a fashion illustrator at the Studio Berçot in Paris, Farhi initially designed garments for dressmaking patterns for magazines *Marie Claire* and *Elle*, for whom she also illustrated the couture collections. She later met Stephen Marks and began designing for the company that subsequently launched French Connection, sourcing fabrics from India in response to the demand for Eastern influence in the early 1970s. The collaboration with Marks developed into a personal relationship and when French Connection was floated on the stock exchange in 1983, Farhi launched her own label and first boutique with Marks's backing.

Farhi sought to differentiate her own collection from the successful French Connection brand by appealing to an older, more sophisticated demographic. In 1989, the Farhi brand launched a menswear range, focusing on elegant urbanity, simplicity, careful detailing and quality fabrics. She gained the Classic Designer prize at the British Fashion Awards in the same year and the British Design Council Award in 1991. Further diversification ensued, bringing shoes, accessories, swimwear, home furnishings, evening wear and even restaurants into the Nicole Farhi lifestyle stable. There are several Nicole Farhi outlets in London and concessions across the globe. OpenGate Capital bought the label in 2010, with Farhi remaining as creative director.

◄ **Softly tailored staples in grey and camel for 2008, including wrap coats and dresses.**

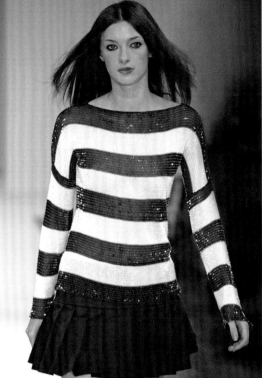

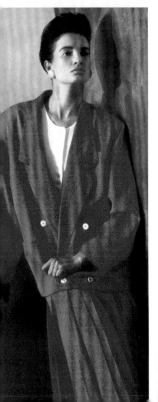

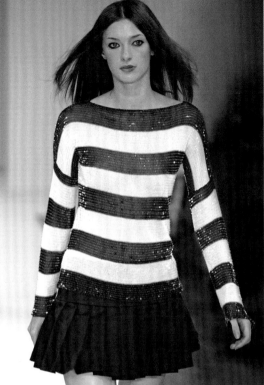

1985 Dressing the 1980s glamazon, a suit by Nicole Farhi for Stephen Marks.

This skirt suit observes all the prerequisites for 1980s power dressing: the extended padded shoulders, gilt buttons and vibrant colour. The buttons are positioned low on the hem of the jacket, from which point the rounded lapels open to emphasize the upturned triangle of the narrow-hipped, big-shouldered silhouette – in mimicry of the man's business suit. Bold earrings feminize an overtly masculine look.

2011 The label's first collection under the aegis of OpenGate Capital.

With pleated offset seams and a staggered hem, a sheer knee-length dress in sugar-pink silk chiffon exudes a fresh airy look redolent of 1920s modernity, supported by the use of reflective materials. Shimmering fabric overlays geometric or muted digitalized floral prints, while silk-satin tunic tops, trench coats, lamé blazers and all-white pieces lend a futuristic quality to the collection.

2001 A spring/summer collection of simple separates and understated dresses, comprising bias-cut stripes, off-the-shoulder necklines and sheer layers of black chiffon.

A knife-pleated skating skirt worn with a lamé sweater in broad horizontal black and white stripes references Farhi's roots in understated French chic, as does the same sweater partnered with a burnt-orange shirt and narrow trousers, evoking Jean Seberg in Jean-Luc Godard's *A bout de souffle* (1960). Skirts are pencil and A-line, the former worn with a loosely cut white top with a deep 'V' and balloon sleeves gathered into narrow cuffs; the latter in black leather, gored for fullness at the hem, accompanying an off-the-shoulder, asymmetrical top of black and white bias-cut stripes. A crisp cream coat is worn over a matching hipster mini and transparent top, while shorts suits are white with a black leather jacket or all black with an embellished semi-transparent top. A single print of stylized flowers occurs on an easy-to-wear drop-waisted dress with an accordion-pleated frill from the hips.

NINA RICCI

www.ninaricci.com

With a timeless romantic style of airy chiffon dresses, the house of Nina Ricci was founded by Maria 'Nina' Ricci (1883–1970) and her son Robert (1905–88) in Paris in 1932. Maria Nielli was born in Turin, Italy, before moving to France where she married jeweller Luigi Ricci in 1904. Ricci joined the house of Raffin in 1908 as a designer, eventually becoming a partner until, aged forty-nine, she left to create her own design house.

The company expanded over the next few decades, with the feminine aspect of the brand summed up in the house's best-selling scent L'Air du Temps, introduced by Robert Ricci in 1948, which still remains in the French top twenty perfumes. The iconic bottle with the stopper formed by two doves was crafted by glass-maker Lalique.

In 1998, the Puig fashion group bought the company, and in the following years the design direction changed hands several times. Belgian-born Olivier Theyskens joined as creative director in 2006, and he successfully incorporated the house's romantic style with his own predilection for the avant-garde, combining ethereal *dégradé* chiffon pieces with hard-edged tailoring. Theyskens was followed by British designer Peter Copping, the fifth designer to take the helm at Nina Ricci in a decade. A graduate of Central Saint Martins College of Art & Design and the Royal College of Art, London, Copping was formerly chief design deputy of Marc Jacobs at Louis Vuitton (see p.190) for twelve years, following three years with Sonia Rykiel (see p.280). His first collection in 2010 exploited the label's heritage, combining a pastel frou-frou of frills, ribbons, ruffles and bows with delicately designed pieces.

◀ **Sculpted and jewelled glamour from the final collection by Olivier Theyskens in 2009.**

1996 The second collection by Myriam Schaeffer for Nina Ricci ready-to-wear consolidates the rejuvenation of the label.

An equestrian-inspired jacket and trousers have a hint of the ringmaster dominatrix, with the wielded whip and use of white leather, as do the black PVC pencil-skirted suits. This constituted a volte-face for the French couture house that – before the appointment of Schaeffer as creative director in spring 1995 – was more used to catering for the haute bourgeoisie. The designer's previous experience of seven years with Jean Paul Gaultier is evident in the juxtaposition of irreverent tailoring and luxurious evening wear. Fur softens severe black suits, and is either fashioned into a collar and matching cuffs, or thrown around the shoulders in a stole.

1947 Mid-century glamour in this form-fitting black lace and full-length silk-satin dress.

The horizontal line of the strapless bodice in this evening dress is emphasized by the black lace gloves that replace the sleeves of the gown. The same lace is cut and appliquéd on to the bodice of the dress below the line of the satin base fabric, giving the impression of a deeply décolleté basque. The layer of satin then flares out into a full draped skirt. Such cut and detailing reflects the designer's ultra-feminine approach to design, which was in keeping with the post-war return in fashion to the hourglass figure.

2007 The first show by Olivier Theyskens combines tailoring with ethereal chiffons.

A black silk trouser suit with flying revers, and worn with over-the-knee leather boots, provides a hard edge to a collection mostly devoted to cobweb-light chiffon dresses in pearl, grey and white with unfinished hems forming tendrils of fabric allowed to float free. A strong diagonal line that spirals from top left to bottom right occurs throughout the collection and is formed by a variety of effects, from zips, pin-tucks and godets, to feather-light knitted ribs and seams, giving the illusion of lightness and movement.

ORLA KIELY

www.orlakiely.com

With her distinctive graphic style and signature palette of bright colours, Dublin-born designer Orla Kiely (1964–) has developed her brand from a small range of hats for British store Harrods to an international lifestyle label, encompassing men's and women's ready-to-wear, accessories, homeware products and scent. Kiely's print designs, including variations on the simple leaf and stem pattern that forms the Orla Kiely logo, seamlessly adapt to a variety of applications, from custom-made wallpaper to the Citroën DS3.

After studying at Dublin's National College of Art and Design, Kiely obtained her Master's degree from London's Royal College of Art in 1993. The Orla Kiely Partnership was formed in 1997 with her husband Dermott Rowan, and the label showed that same year at London Fashion Week, securing their first export orders. Kiely Rowan Ltd was formed in 2000, followed in 2004 by Kiely Rowan Plc.

Kiely designs ceramics and wallpaper for UK homeware store Habitat and sits on the Dulux Design Council. She has designed three capsule collections for Tate Modern in conjunction with its summer exhibitions. The designer has won two UK Fashion Export Awards and the UK Fashion Exports Gold Award and was recently awarded the prestigious title of Visiting Professor of Textiles at the Royal College of Art.

Orla Kiely has two stores in Japan and one flagship store in Hong Kong. The London shop opened in September 2005 in Covent Garden and expanded to accommodate a showroom in 2006. Wholesale US business is growing rapidly, while Europe is Kiely's largest export market.

◄ **An ingénue collection, incorporating the 'apple a day' print for S/S 11.**

2009
A judicious use of colour, texture and pattern that combines 1960s styling with mid-century motifs.

Patterned tights are the connecting theme between ultra-short baby-doll dresses and cropped A-line coats with elbow-length sleeves. A printed mini-dress with a white collar and deep buttoned cuffs revisits the clean lines and body-skimming shapes of the 1960s, as does a petrol-blue fit-and-flare dress, decorated with a white piqué collar, placket and cuffs. An all-in-one shorts suit in navy is worn over an orange knit, while a pale turquoise cape in felted wool is matched to a turquoise and brown printed skirt.

2006
Neutrals and tones of brown and grey are used to ground the brighter colours in a collection of dresses for autumn/winter.

A demure empire-line dress in sage-green matt satin is secured with a ribbon bow at the waist and features gently cuffed sleeves and rows of pin-tucks each side of the bodice. The discreet touches of print on the clutch are evidence of the designer's distinctive colour palette and flat graphic approach to pattern design. Stronger colour appears in a turquoise block-printed skirt, and the signature shade of vibrant orange features in the tree-print dress, a hallmark one-directional pattern of overlapping tree silhouettes reduced to a pure geometric form. The same print is worked into a dress with puff sleeves. The empire line reoccurs in a monochrome printed pinafore dress worn over a grey sweater, typical of the easy mid-century style of the label.

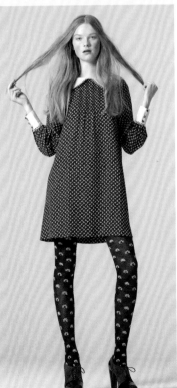

2010
Meticulous detailing on an uncluttered silhouette.

Pleat-front shorts in a double jersey are partnered with a cardigan that has a *trompe l'oeil* collar in oyster over black. Elsewhere, the colours are vibrantly autumnal: a textured russet cardigan over a multidirectional print of falling leaves, a burnt-orange A-line coat with bold square buttons and seamed at the hip. A sketchy large-scale leaf print is worn beneath a violet cardigan with cream pockets and button band, edged in grey frills.

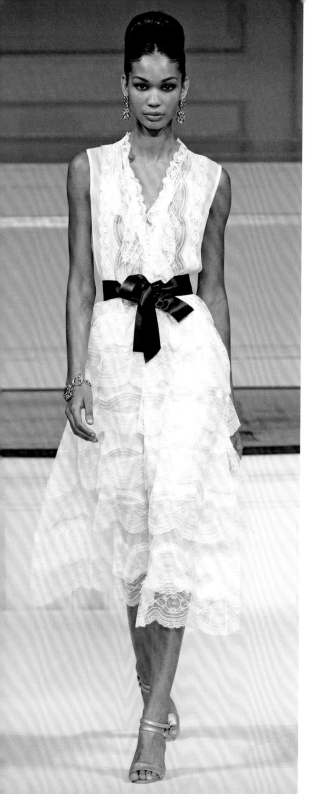

OSCAR DE LA RENTA

www.oscardelarenta.com

Ultra-feminine sophisticated evening wear with a Latin nuance has allowed Oscar de la Renta (1932–) to sustain a high profile in fashion for nearly half a century, from his first ready-to-wear collections in 1965 to receiving the CFDA (Council of Fashion Designers of America) Lifetime Achievement Award in 1990 and the Womenswear Designer of the Year Award from the same organisation in 2000 and 2007. Born in Santo Domingo, De la Renta left the Dominican Republic when he was eighteen to study art at the Academy of San Fernando in Madrid, which was followed by a period at Balenciaga's (see p.56) Madrid couture house Eisa sketching the collections. In 1960, De la Renta went to work as an assistant to Antonio del Castillo at Lanvin-Castillo, where he developed his talent for creating feminine romantic evening wear. He moved to New York in 1963 to design a couture collection for Elizabeth Arden, later joining Jane Derby Inc as a partner in 1965. He founded his own ready-to-wear label the same year.

International acknowledgement came with his appointment as designer for the French couture house Pierre Balmain (see p.60) in 1993. De la Renta launched his first perfume in 1977, for which he received the Fragrance Foundation Perennial Success Award in 1991. It was his scent Ruffles, however, that reflected the highly feminine aspect of his clothes. The introduction in 2001 of accessories, bags, belts, jewelry, scarves and shoes reflected his passion for the ornate decoration of his native Dominican Republic.

◄ **Ingénue glamour with fragile layers of lace secured with a black taffeta bow, for S/S 11.**

1969 De la Renta's signature ruffles on an early black cocktail dress.

Circular frills of silk organdie are sculpted into an above-the-knee cocktail dress that creates a dramatic silhouette, evidencing the influence of De la Renta's sojourn in Spain and the period spent with Balenciaga. Other pieces from the period include an interpretation of de luxe hippie, including fringed ponchos and evening vests embroidered in rhinestones with such words as 'peace'.

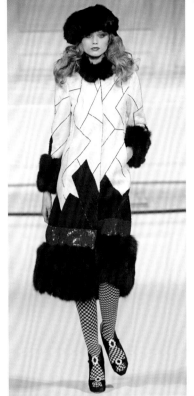

2011 A single-colour ball gown has a fitted bodice with ruched and tucked volume on the skirt and De la Renta's signature sweetheart neckline.

Renowned for his opulent statement pieces since the 1980s, when the inauguration of Ronald Reagan as president heralded the return of formal entertaining, De la Renta continues to include the billowing skirts of full-on evening glamour in his contemporary collections, while also offering elegant daywear crafted with the scrupulous precision of couture. This wide-ranging collection of more than 300 pieces runs the gamut of styles: flirty knee-length dresses in single-colour prints; classic navy and white sporty separates; and richly hued cocktail dresses with asymmetrical ruffles across the body. Youthful chic is apparent in the frilled and fluted printed dresses worn beneath lightly textured tweed jackets decorated in braid and accessorized with ribboned boaters.

2010 Fur is dyed and worked as fabric into luxurious outerwear.

Shearling (lambskin) has the malleability of cloth, and is intensely worked into art deco patterning on this mid-calf coat for autumn/winter. It is trimmed with a deep band of sable fur on the hem to match the collar and cuffs. An insert of red paillettes provides a flash of De la Renta's favourite colour. Fur is a feature throughout this collection of sophisticated yet easy dressing; it is used as a trim on three-quarter-length coats worn over mid-calf pencil skirts. Evening dresses provide trademark Oscar de la Renta feminine glamour.

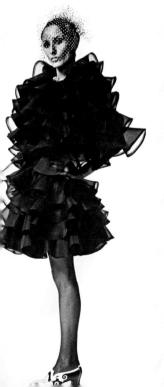

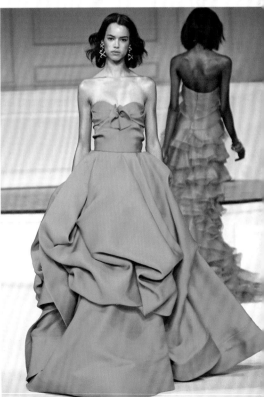

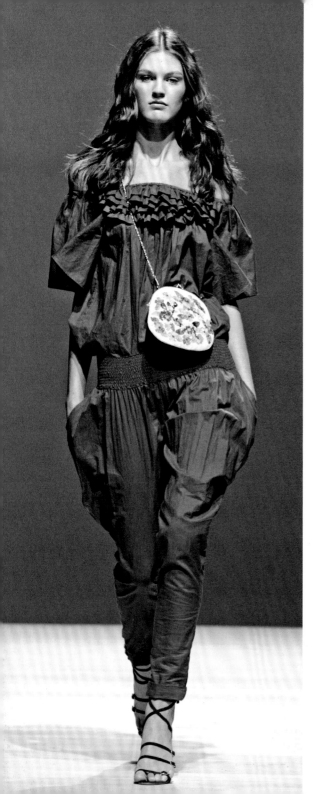

PAUL & JOE

www.paulandjoe.com

Garments by French label Paul & Joe verge on the prim, but are enhanced by offbeat prints and light-hearted touches such as quirky detailing or eye-catching accessories – a cartoonish button, a patent boot or a vividly coloured stocking. Named after her sons, the Paul & Joe label was founded in 1995 by Parisian-born Sophie Albou (1967–).

After six years' working for her parents under their label Le Garage, Albou launched a collection of menswear that demonstrated her preoccupation with vintage and retro styles and her eye for interesting fabrics. Encouraged by the number of women buying the menswear for themselves, she produced her first womenswear collection in 1996 following a similar aesthetic but with the addition of feminine detailing.

Albou opened her first shop in 2001 on the rue des Saints-Pères in Paris's fashionable Left Bank district, the same year that Paul & Joe Beauté was launched. In 2005, she introduced the Little Paul & Joe line for four to twelve-year-olds. A second store was opened on the avenue Montaigne in 2008. The Paul & Joe Sister diffusion label is aimed at the more urban customer, featuring printed tops and embellished dresses. Shoes, bags, swimwear and scarves were launched in 2008, the same year that the designer began a long-term collaboration with the legendary Pierre Cardin (see p.246) label. This collaboration sees Albou reworking pieces from the archives and is distributed under the name Paul & Joe for Pierre Cardin.

Paul & Joe La Maison was launched in 2009 – a natural extension of the brand, which has always had a strong vision of a very particular lifestyle.

◄ **A shirred and frilled all-in-one in an insouciant collection of playful separates for S/S 09.**

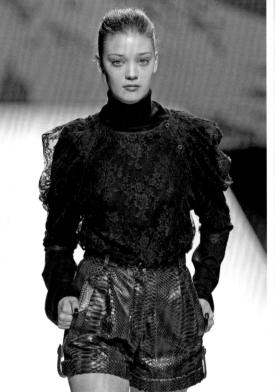

2001 A narrow-hipped silhouette with big bold shirts for spring/summer.

A floral-printed shirt is open to the waist and worn with hip-hugging white trousers, as are unzipped bomber jackets in a bravura display of hippie machismo. Flat 'bad boy' caps are matched to shirts, either in large-scale houndstooth, geometric prints or single colours (such as a scarlet shirt with cut-off sleeves). A floral chintz print is worked into a trouser suit, resonant of the Summer of Love, as are khaki safari-style jackets.

2011 Full-on femininity with kitten prints and floral flowing maxi-skirts.

A silk-chiffon print of full-blown peonies flows from the constraints of an obi-type curved and stiffened bodice, from which gathered sleeves billow into a frilled cuff. Metallic tasselled obi belts also feature above printed shorts and over a frilled off-the-shoulder tutu dress. A wide-legged halter-neck jumpsuit in orange satin is more tailored, defined at the waist with a narrow red patent belt.

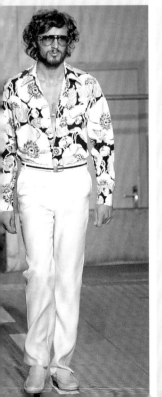

2008 The first autumn/winter collection produced for the Paris catwalk, featuring ponchos, quirky narrative prints and coats of vintage inspiration in muted plaids.

Tabbed turn-ups on reptile-skin shorts lend a lederhosen quality to a collection that also includes a lace-up folk dress of vernacular inspiration in a fluorescent orange worn over a white lace shirt. Traditional plaid blankets in muted shades of blue and grey are casually employed as throws, or worked into fringed wrap skirts or a dressing gown–style coat. Plaid is used again for workmanlike shirts, worn under a camel wool poncho or layered beneath a turtleneck (the sleeves rolled up to reveal a contrasting underside), matched to wide-legged slouchy trousers. Printed ponchos with the 'aaahh' factor feature a flower-garlanded unicorn and a deer at rest in the forest. Other prints include sequinned large-scale foliage on pink for a 1960s-style mini-dress and on white worn under a boyfriend-cut tailored jacket.

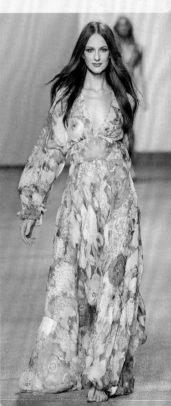

PAUL SMITH

www.paulsmith.co.uk

Designer, creative retailer and fashion entrepreneur Paul Smith (1946–) is renowned for an eccentric and eclectic style that has garnered him the title of Britain's most commercially successful designer. Opening his first shop in his home town of Nottingham in 1970 for two days a week, he was the first retailer to make Covent Garden a shopping destination with his London store in 1979.

In the 1980s, changing attitudes towards consumption and substantial increases in disposable income for the young urban professional – the yuppie – rendered the Paul Smith suit for men the standard wear for this conspicuous consumer, alongside accoutrements such as the Filofax and fountain pens also retailed by the designer. Described by Smith as 'classic with a twist', the suit allied traditional tailoring techniques with subtle yet idiosyncratic touches, such as a bright paisley lining to the jacket or a coloured buttonhole.

By popular demand Smith was persuaded to launch a womenswear range in 1993, a line that continues to convey his essentially English aesthetic of juxtaposing formality with quirkiness, with the emphasis on vibrant prints. The signature polychromatic stripes, printed in fourteen colours, often feature in his garments, and also appear on handbags, china and rugs.

In contrast to architect-designed retail emporiums, Smith rejected the homogeneity of the high street, and in 1998 he introduced the then novel concept of the shop as personal space with the opening of his premises in Westbourne House, Notting Hill, setting in motion the idea of 'lifestyle' marketing. Paul Smith was awarded a knighthood in 2000 for his services to the fashion industry.

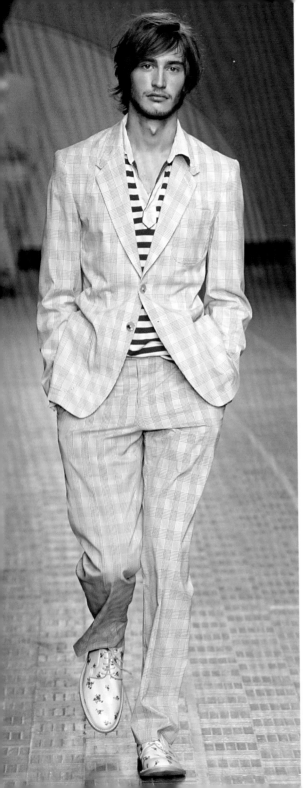

◄ **A collection of preppy-inspired mismatched pastel checks and striped blazers for 2008.**

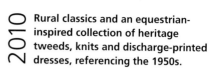

1989 Summer colours, no socks, perma-tan feet and Bermudas.

Classic 1980s menswear: brightly patterned loose-fitting shirts and knee-length shorts feature for spring/summer, and play-hard leisure is the common target of international designer menswear. To an anthem of Gipsy Kings' 'Bamboleo', resort life is animated by the Paul Smith hallmark of bold colour – echoed by others such as Versace and Byblos. Clothes are accessorized by a long-term favourite: the white lace-up deck shoe.

2010 Rural classics and an equestrian-inspired collection of heritage tweeds, knits and discharge-printed dresses, referencing the 1950s.

A scattering of blooming roses on a full-skirted silk cocktail dress is worn over a sheer fine-ribbed sweater, toughened up with torn fishnets and rubber shoes: off-duty dressing for the country girl. A lemon-yellow basque (the traditional colour of the countryman's waistcoat) is layered beneath hand-stitched cosy cardigans and cropped sweaters in angora, embroidered with pony story illustrations. The basque is also worked in flecked Donegal tweed, appearing under a muted check tweed jacket and a just-above-the-knee pleated A-line skirt. A cape – worn over plus fours, a deeply cuffed shirt and a knitted top – is pulled together with a broad black leather belt. Flat caps and green hose, printed as riding boots, create a stable yard aesthetic.

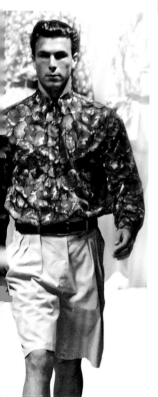

2005 Stripes are juxtaposed with seed-packet prints for quintessentially English florals.

A shrunken cardigan of staggered polychromatic stripes, one side including black, propagates garden party dressing when worn with a flower-bedecked skirt. Elsewhere, prints of stripes combined with photo-realistic garden flowers are engineered into swimwear, single-buttoned silk jackets and a ribbed blouson over stripy shorts. Liberty Tana Lawn makes tough trench coats pretty and softens a shirtwaist silhouette. Floral prints are mismatched: a cap-sleeved sheath in green and white has ballooning sleeves in pale blue.

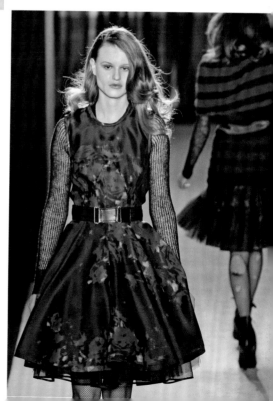

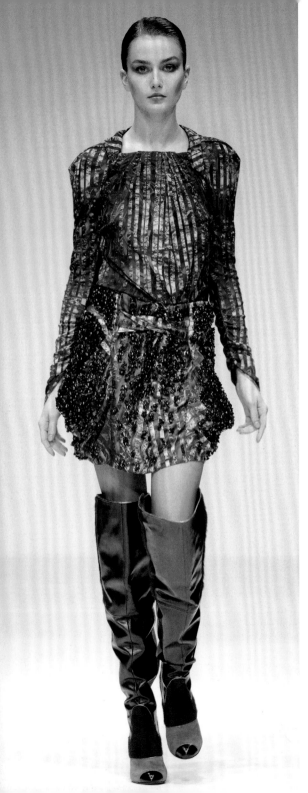

PETER PILOTTO

www.peterpilotto.com

Draped cocktail dresses in elaborately futuristic printed chiffon and silk – sometimes offset by elements of structured tailoring – are the defining components of the Peter Pilotto look. There are two designers behind the London-based label: Pilotto (1977–) and fellow alumnus of the Royal Academy of Fine Arts in Antwerp Christopher De Vos (1980–). The couple graduated in 2004 and launched their first joint collection in 2009, although Pilotto had shown previously without De Vos. On graduation, Pilotto served an internship with Vivienne Westwood (see p.314), with De Vos acting as her personal assistant.

Pilotto is half Austrian, half Italian and De Vos half Belgian, half Peruvian, creating a rich cultural background that enables the designers to draw on many sources of inspiration. Although the boundaries between print and garment design are fluid, Pilotto focuses on highly worked digitally manipulated print design with references to scientific and natural phenomena, while De Vos is responsible for garment design featuring complex draping and pleating offset by corseted bodices, and incorporating sculptural elements of Plexiglas and embossed jewelry by Scott Wilson.

In 2009, the designers were awarded the Swarovski Emerging Talent Award at the British Fashion Awards. A collection of shoes created with shoe designer Nicholas Kirkwood was launched in 2011. Peter Pilotto is sold in twenty-nine countries and is available at Colette in Paris, Harvey Nichols in London and Saks in New York.

◀ **For 2009, a natural
history–inspired collection
of vibrant prints and
embellishment.**

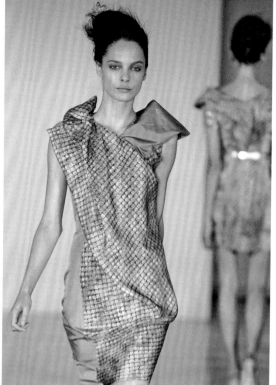

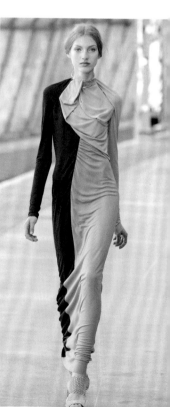

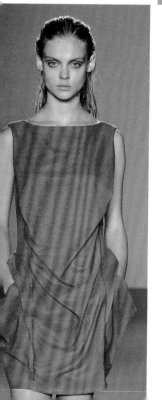

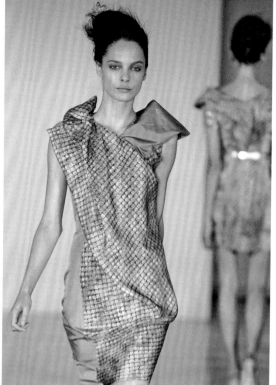

2008 Solid-shade garments and futuristic prints for spring/summer.

A tangerine sheath dress, with complex folds around the hips incorporating vertical pockets, features in a collection that veers between complex origami shaping – in bra tops and skirt folds – and simple dresses that exploit variations on a futuristic print of pipes, twisted cords and vapour trails. The same print inspiration recurs on Lycra bodies and on leggings worn beneath a scoop-neck tuxedo.

2011 Engineered knits are exploited in a sportswear-inspired collection.

A colour-blocked silk georgette dress with open raglan sleeves and a cowl neck is held in place with a metal collar. The controlled colour palette of turquoise, pale blue and navy recurs throughout the collection. Form-fashioned knitwear uses plaited and deflected two-tone ribs to delineate the streamlined body graphically, and is worn with sculpted abstract-print tops. Ankle-length dresses billow beneath biker jackets.

2010 Dresses in ombré metallic shades of blue and rust in industrial-effect printed chiffon tucked around the body incorporate studded areas of Swarovski crystals.

Playing with light and shade, a panel of *trompe l'oeil* chain-mail-printed fabric is set into the front of a knee-length dress that extends to create a softly sculpted shawl collar, twisted to show the plain reverse fabric. The print is used elsewhere for light-as-air skirts, tucked and caught up to create light-catching surfaces, worn with grey satin bustiers. Sharp-shouldered dresses feature the *dégradé* print that bleeds across the colour palette, from grey to rust to yellow, or from green to blue. These colours are also seen in the edge-to-edge jackets with narrow shawl collars. Studded tops are worn beneath bib-front tweed-effect pinafore dresses and form-fitting trousers. Sashes encrusted with silver studs are thrust through intricate folds of printed organza in black, blue and rust, or contrasted with a diagonally placed black silk ruffle. Metallic buckled belts appear throughout the collection.

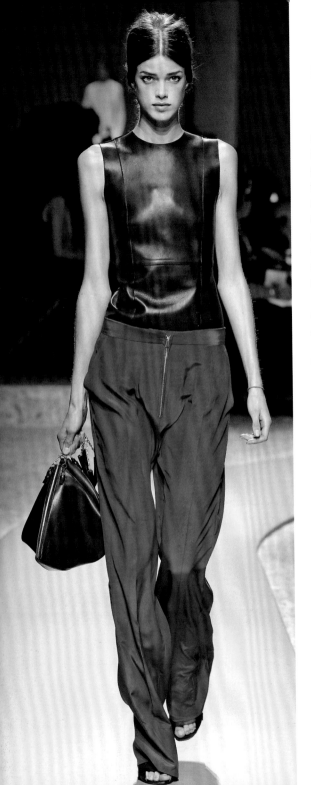

PHOEBE PHILO

Providing grown-up glamour at French fashion house Céline (see p.84), British designer Phoebe Philo (1973–) is one of three British women – the other two being Hannah MacGibbon at Chloé (see p.90) and Stella McCartney (see p.284) – who are redefining contemporary fashion for the modern woman with a cooler, more minimalist, unadorned approach. All three were educated at Central Saint Martins College of Art & Design in the early 1990s, and all share a sensibility that promotes comfort and ease.

Fellow graduate McCartney became creative director of Chloé in 1997 and invited Philo to be her assistant, a controversial decision by Chloé because they were both relatively inexperienced. McCartney's sexy tailoring was replaced when Philo took over her role in 2001 with a return to Chloé's signature look of girlish femininity tempered by Philo's trademark high-waisted jeans. Sweet without being sentimental, Philo's collections for the label included soft blouses embellished with pin-tucks and ribbons, military-inspired jackets and floating silk dresses that resulted in a plethora of high street copies. The designer also produced one of the most coveted 'It' bags of the era, the multi-padlocked 'Paddington'.

Philo left Chloé in 2006 to spend more time with her young family, returning to the fashion scene on her appointment at Céline in 2008. Reinvigorating a tired brand – Céline had lost its focus with the departure of Michael Kors (see p.216) in 2004 – was a major task in times of recession, but one that Philo achieved with her collections of streamlined separates. Philo was awarded British Designer of the Year in 2010.

◄ **Slouchy mannish crisp linen trousers with severely cut leather for Céline in 2011.**

2002 — An influential debut collection for Parisian label Chloé.

A soft trumpet-sleeved chemise with an unemployed drawstring below the hips features patterned lace cut-outs on the hem, a doily-like effect that also appears diagonally on long-line flared trousers and forms a frill on the gigot sleeves of striped cotton blouses. Lingerie meets tailoring in single-buttoned fitted white linen jackets with scalloped edges, and frilled miniskirts attached to sheer vest tops.

2010 — Luxurious minimalism in tan, beige and black for Céline.

A clean-cut camel coat with black leather facings and patch pockets is worn over black trousers. This forms the template for a collection of high-necked jackets, coats and tunic dresses, in cashmere, bouclé and felted wool. Some are worn over knee-length skirts or narrow trousers. Black leather is also crafted into wrap skirts, simple T-shirts and an oversized double-breasted coat.

2004 — Revisiting the 1970s with high-waisted stonewashed denim and cheesecloth shirts, with craft elements of patchwork and macramé leather belts for Chloé.

Cropped hotpants in stonewashed denim – featuring pin-tucked front pockets and a macramé-effect double waistband – are worn with a striped cheesecloth shirt buttoned low: vintage elements in a collection that also celebrates 1970s style with patchwork dresses, front-fastening mid-calf denim skirts and knee-length culottes. The other staple of the era, dungarees are tight on the torso before flaring at the ankle, the straps pulled together with white lacing. Knee-length white linen shorts and blouses with transparent panels of lace are anchored with both belt and braces, while flared trousers are put with tailored lace jackets. A vintage banana print is applied to scoop-neck T-shirts and jersey dresses. Pink and black horizontally striped rugby shirts are reworked into cropped summer dresses with deep armholes, or shortened under the bust and worn over a stripy swimsuit.

PIERRE CARDIN

www.pierrecardin.com

Italian designer Pierre Cardin (1922–) was instrumental in modernizing haute couture in the 1960s, alongside Emanuel Ungaro (see p.294) and André Courrèges. Following the acclaim for his revolutionary 'bubble' dress in 1954, he was expelled from the ranks of haute couture practitioners in 1959 for designing a ready-to-wear collection for Printemps department store, although he was later reinstated. He further challenged the status quo with the launch of his 'Space Age' collection in 1964. Cardin created hard-edged, sculpted clothes – mini tabards over skinny rib jumpers – which exemplified his modernist approach to fashion.

Cardin moved to Paris in 1945 where he worked with both Jeanne Paquin and Elsa Schiaparelli before heading Christian Dior's *tailleur* atelier in 1947. He founded his own house in 1950 and began his haute couture practice in 1953. Cardin resigned from the Chambre Syndicale in 1966 and from 1971 showed his collections in his own venue, the Espace Cardin in Paris. Throughout the 1970s, Cardin confirmed his reputation for fashion-forward collections, influenced by aspects of popular culture and street style. An early protagonist of lifestyle marketing, Cardin attempted to promulgate the brand with extensive global licensing deals. However, although commercially successful, the brand was ultimately devalued as products appeared on the market over which the designer had no control. Pierre Cardin was designated a UNESCO Goodwill Ambassador in 1991.

◄ **An haute couture dress in orange silk shantung with sequinned, embroidered waist cut-outs, from 1966.**

Pierre Cardin's 'Cosmocorps' collections achieved wide currency on the fashion futurism scene throughout the 'high sixties' of 1963 to 1968.

With the solid geometry of architecture, Cardin rationalizes the relationship of the constructed garment to the natural forms of the human body. In a 'unisex' series running through several years, the concept of outer prime shapes cocooning less resistant undergarments – often knitted – seen in the outer carapace of the pinafore, was recurrent evidence of modernist principles at play. In the 1965 seasons, large découpé apertures occasionally created stylized florals in female garments, exposing a contrasting colour beneath. Textured and coloured tights were integral to the overall look, in the same way that special helmets, eccentrically designed sunglasses and co-ordinated shoes were compulsory components of the Cardin vision. The Parisian 'modern' look of the sixties couturier rang a different, more bourgeois, note than the democratized fashion impulses of the London mod scene of the same era.

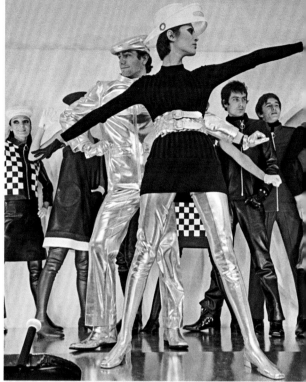

1968

Shiny vinyl, skintight catsuits and all-in-one boots and tights feature in a collection inspired by the exploration of space and contemporary films such as *2001: Space Odyssey* (1968).

Cardin initially unveiled his 'Cosmocorps' collection – comprising white knitted all-in-ones, tabards worn over leggings and tubular dresses – in 1963 in an attempt to combine science and technology with fashion. The male and female silhouettes converged: the notion of unisex garments was intrinsic to the era. Metallic surfaces and outsize hardware were also features of futuristic fashion, seen here in exposed zips and belts. The 1960s appropriation of op art practitioners such as Victor Vasarely and Bridget Riley is evidenced in the panels of black and white chequerboard patterning on skirts and jackets. As the decade progressed, the designer developed an interest in man-made fibres, resulting in the use of increasingly futuristic silhouettes and materials, including Cardine, invented in 1968, an uncrushable fabric of bonded fibres that retained raised geometric forms in complex patterns.

1988

An haute couture collection for Cardin by André Oliver, artistic director of the label.

In a subtle recollection of floral structure, the dress has a soft cape of petals around the core sheath of the stem. The dramatic hat presages the extreme volumes of the evening wear. The collection also features a strapless lace bodice that continues into a hobbling tussah skirt with doubled panniers and long trains. Oliver headed the haute couture collections in 1987 and showed a sensitive use of the softer materials and constructions of evening wear. He shared catwalk accolades with Cardin for more than forty years.

1973

An haute-hippie kaftan in ethnic-inspired printed chiffon woven with gold thread, by André Oliver for the autumn/winter collection.

The space odyssey of Pierre Cardin's 1960s pre-eminence had passed beyond its apogee by 1973 and the designer absorbed the hip influences of an earthly inspiration: that of the exotic and internationally travelled jet set. In the S/S 73 collection, the remnants of Cosmocorps could only be traced in the exaggerated pagoda outline of the men's suits and the zip-fronted men's tunic. However, in his licensing diversification, Cardin was still empowered to add NASA overtones to the modular designs that he produced for the interior of the American Motor Corporation's Javelin. His global achievement was recognized in 1973 by the Basilica Palladiana Prize for the most influential Venetian of the time.

2000

Restrained tailoring in pastel shades and printed or ruffled chiffon.

Overlapping squares are featured in Sergio Altieri's collection: here, as fabric plates decorating the top of a midriff-baring outfit; elsewhere, enlarged and edged in black to form geometric layers worked into a shoestring-strap dress or as an asymmetrical tunic-top dress and wrap skirt. Deeply ruffled printed chiffon provides a flounced contrast, along with minimally tailored coats and jackets worn with matching skirts that have dagged hems.

2006 Timeless event gowns are shown at the Ciragan Palace in an Istanbul retrospective.

Cardin's predilection for architectural apparel is renewed with a sequinned pagoda dress of narrow triangular crinolines, with a dark nacreous patina. The collection reassembles the designer's essays in the rendering of the cardinal geometric shapes into 3D forms. Boned curving frills and hems make dramatic spirals standing away from the figure. Elsewhere, a rectangle forms a tassled serape over a columnar sheath, and an elegant evening sheath is carved diagonally into stark black and white sectors with a ribboned corsage in red fabric at the intersection.

2009 After a break of fifteen years, Cardin shows at his Cannes home.

Constructed from an oversized square, the dress is caught at cuffs and knee. The black and white print superimposes its own dynamic on the torso in a collection of shape-shifting outfits for both men and women that integrate architecture and garments.

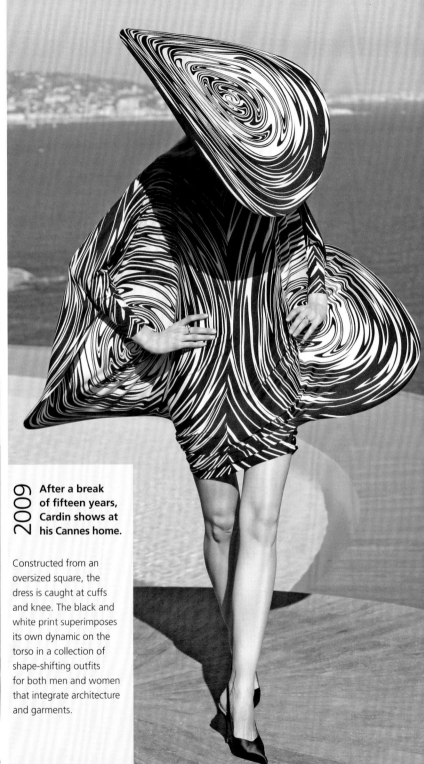

PRADA

www.prada.com

By pursuing a consistent and singular vision, Miuccia Prada (1949–) has turned a small store specializing in luxury leather luggage into one of the foremost brands in fashion, selling clothes and accessories in more than eighty countries around the world. A former mime student and with a PhD in political science, Miuccia took over the family business founded by her paternal grandfather Mario in 1913. A significant turning point in the brand's success was the introduction of the much imitated backpack made from black Pocono industrial nylon with a discreet small triangular logo that was the antithesis of the 1980s vogue for luxurious excess.

The first ready-to-wear collection was launched in Milan in 1988, and in 1992 a 'little sister' line was introduced, named after the designer's childhood nickname Miu Miu (see p.220). Miuccia has an unconventional and disciplined approach to design that eschews glamorous excess in favour of a subtle femininity. Very little flesh is on show and there is a refined ladylike edge to the clothes, which often incorporate large-scale print designs.

The Prada label has been further expanded through acquisitions, with stakes held in Church & Co, a UK footwear manufacturer. Prada owned more than half of designer brand Helmut Lang (see p.144) and was in full control of Jil Sander (see p.170) until 2006; it also held stakes in Gucci (see p.136). Building a relationship with LVMH, Prada sold its Gucci stake to the French luxury giant and formed an alliance to acquire Fendi (see p.124) in 1999. Further moves included a partnership with Azzedine Alaïa (see p.54), buying Carshoe and selling its Fendi stake back to LVMH in 2001.

◄ **Referencing the 1950s and early 1960s with hourglass shapes and abstract prints in 2010.**

1991 Long lines over elaborate shorts with – or without – embellishment.

An enveloping knitted djellaba conceals the 3D decoration on the fitted shorts below. In other styles, a sweater dress hides geometrically embossed and two-tone stitched shorts. The languid styling of post-sun relaxation continues with an ankle-length knitted gilet over a one-piece sun and swimsuit in the same soft knit, worn with sandals that are laced to daisy-tipped greaves.

1996 Dresses, polo shirts and skirts feature 1950s-inspired prints.

A demure two-tone shirt dress in chocolate-brown silk-satin with a contrasting collar, yoke and button placket in white piqué lends a businesslike air to a collection of button-through dresses, A-line skirts and ribbed sweaters. Prints in purple sgraffito-like marks or brown, sage-green and cream modular shapes are worked into sheath dresses and A-line skirts, and worn with textured woven tweeds.

1992 Backed up by a Steven Meisel campaign styled to evoke the big hair, the collection presents simple clothes in the Jean Shrimpton doll-like look of the 1960s.

An unadorned mini coat dress sets the tone for a stripped-down collection that has simplified detailing redolent of the miniature-scale garments of the doll's wardrobe. The colours are kept clean: peach, peachy white, lemon, primrose and laundry white. Daywear is a delicately shaded suit with a no-fuss blazer and fitted miniskirt or a cap-sleeved and square-necked shift in white linen, cut immaculately to the body and halting mid thigh. Nuances of cut are carefully respected; where the suit jacket has a round Peter Pan collar, the centre-front hem divides on a coherent curve. Playwear remains prim in solid hues; tailored shorts and cropped vests are accessorized with plain white or daisy-chained sandals. Another playsuit takes the daisy into white on white relief embroidery. Knitwear goes beyond the twinset to include knitted shorts, with the cardigan thrown as a shawl.

1999
A collection that veers between the utilitarian and the feminine.

Establishing the brand, easy-fitting shorts display the Prada logo on the outside of the leg, and are matched to a sleeveless pocketed battledress, accessorized with black leather and a textile backpack similarly embellished. Elsewhere, techno fabric is folded into pleated skirts, worn over a buckled tank top. In contrast, knee-length dresses float from an empire-line waist with ribbons of fabric looping vertically to the hem.

2003
Verging on the prim, the autumn/winter collection reworks traditional Arts and Crafts prints and classic knit patterning in brown and green.

A William Morris Arts and Crafts print in sage and pea green with a hint of pink enlivens a demure knee-length dress with a high round neckline and elbow-length sleeves. The same print in royal blue and orange is worked into a shirt, tucked inside loose low-slung tweed trousers, a feature of the collection and often layered with an argyle sweater in shades of chocolate brown and mint. Mannish cashmere knits are narrowly belted over printed shirts and worn beneath cropped classic tweed coats or knee-length trench coats in tan leather or milky-brown suede, accessorized with a tweed trilby and knee-length tan boots. Sheath dresses and flowing wide-legged silk trousers with a floral motif form a lighter edge to the collection.

2001
Emphasis on the midriff in a season of subtle pastel tones and unassuming tailoring.

A charcoal-grey facecloth jacket is caught in at the waist with a broad buckled belt of the same fabric, and then tucked inside a full pink skirt of unpressed pleats. The midriff is accentuated throughout the collection, either left bare between cropped cardigans or bandeau tops and fluid gathered skirts, or wrapped in a wide band of jersey knit. A below-the-knee pencil skirt in a single-colour floral print in lime is partnered with a pearl-grey polo shirt, while tailored tangerine shirts provide a hit of colour.

2009
Classic tailoring, leather T-shirts and fine knits for men.

A pale-grey shirt with studded front panels is matched to mid-grey studded trousers in an all-grey collection.

2011
An ebullient and playful collection of bold stripes and quirky prints.

Worn with a stripy fur stole, a horizontally striped sundress in clashing orange and pink has a deeply flounced frill at the hem.

2007
African-inspired prints, leather fringing and 1940s styling.

An emerald-green empire-line skirt is belted on the natural waist, securing a loose-fitting top in cream for spring/summer. Jewel-like colours – ruby and amethyst – are used for satin shorts, sleeveless tops and loose-shouldered tunic dresses caught at the waist with a double belt. Vertical rows of brown leather fringing form sheath dresses, while other dresses have a hint of safari style with leather belts.

PREEN

www.preen.eu

With an androgynous take on tough-looking tailoring combined with the piecing and seaming of contrasting weights and surfaces of fabric, Justin Thornton and Thea Bregazzi launched British label Preen after working together on Helen Storey's A/W 96/97 collection. Both originated from the Isle of Man; Thornton graduated from Winchester School of Art and Bregazzi from the University of Central Lancashire. The duo offer body-conscious clothes that incorporate transparency and cut-out panels. The designers frequently use elements of bondage – for example the 2010 collection was inspired by *kinbaku*, Japanese rope bondage – that lend a provocative edge to an essentially complex and modern look. Their book *Decade* was published in 2006 to celebrate their first ten years, and charts a clientele that includes Kate Moss, Amy Winehouse, Arctic Monkeys and Chloë Sevigny.

From their atelier in Portobello Green, the design pair frequently reference political and cultural phenomena. Each Preen collection includes references to its predecessor through colour, texture or volume, with signature pieces reinterpreted each season, such as the lapelled wrap dress or sheer chiffon men's shirt. The second more affordable Preen Line was launched in February 2008 on the runways of Copenhagen Fashion Week. Showing in New York, the label has developed a fresh and sophisticated version of body-con that continues to retain an element of androgyny softened with the introduction of print.

The label is distributed in twenty-five countries with 120 stockists. A men's collection was launched in 2010 with Savile Row tailors Gieves & Hawkes.

◄ **A vibrantly hued hand-embroidered block-printed collection for A/W 11/12.**

2004
Referencing 1950s underwear, a collection in nude, cream, white and black.

A strapless dress with displaced asymmetrical bra cups forms origami-like folds around the body in a collection that plays with the accoutrements of lingerie – wayward suspenders, re-sited bra cups and *trompe l'oeil* garter belts. Vest tops are stretched and twisted around the body, partnered with loosely fitting printed stockings held up with suspenders or worn beneath an asymmetrical jacket with elbow-length sleeves. Distressed black leather is worked into cropped jackets worn over narrow trousers.

2001
An emphasis on sleeve detail and asymmetrical tailoring.

A cropped tabard in patchworked fur is decorated with suede tassels and pompoms at the shoulders. The collection also features gigot and heavily frilled or ruched sleeves. Slouchy trousers with double-front pleats are worn with checked shirts or fragile lace tops. Asymmetrical godets are inserted into the side of cream leather mid-calf skirts, partnered with slim-fitting blouses or tops.

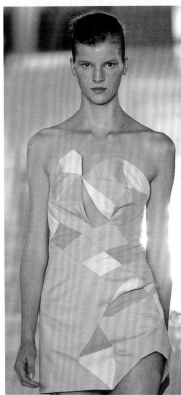

2010
Tailors Gieves & Hawkes's first collaboration with a womenswear label results in a mix of traditional tailoring and feminine florals.

For autumn/winter, a complex composition of stretch-jersey pieces form a body-conscious high-waisted skirt attached to a black bra top with a gathered scoop of purple cloth either side of it, exposing a flash of flesh both above and below. The shoulders and arms are covered by a tight black cardigan. Referencing Peter Saville's floral album cover design for New Order's *Power, Corruption & Lies*, floral prints soften a harder, more masculine edge, seen in the black frock coat with a hit of yellow at the collar, worn over a petticoat-print and lace dress. A sweater, cropped to above the bust, appears over a floral bustier and is worn with slouchy black trousers, and with a print dress, cut to expose the skin in front and the bra strap at the back.

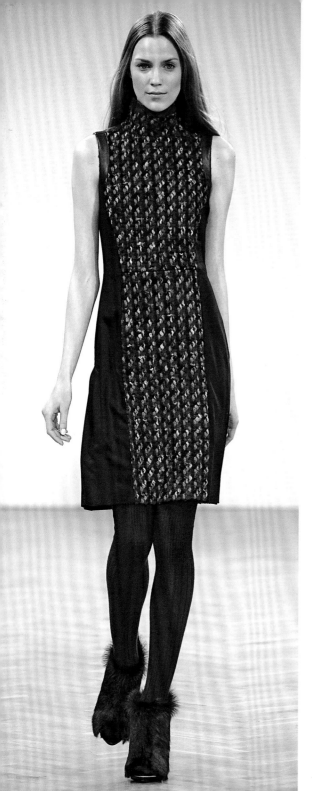

PRINGLE OF SCOTLAND

www.pringlescotland.com

One of the oldest luxury goods labels in the world, Pringle of Scotland was founded by Robert Pringle in 1815 and is now given a contemporary edge by the adoption of avant-garde actress Tilda Swinton as the campaign face of the brand.

From the manufacture of hosiery and underwear in the 19th century, the company moved into outerwear with the introduction of the iconic twinset in the 1930s, worn by Hollywood stars such as Grace Kelly and Audrey Hepburn. The company is also credited with the creation of the intarsia design known as the argyle pattern – popular with the golfing set of the 1920s – which Pringle revived in the 1950s for the Ryder Cup golf shirt. This marked the beginning of the company's men's knitted outerwear, and the association with golfing professional Nick Faldo in the 1980s.

The brand became known as Pringle of Scotland Ltd in 1958. In 2000, the company was bought by the Hong Kong–based Fang brothers in a move to transform the almost moribund label into a high fashion brand, aided by Clare Waight Keller, who was Pringle's creative director from 2005 until 2011.

The first women's collection was shown at London Fashion Week in 2002, followed by the first menswear show in Milan in 2003. Pringle 1815 was launched in 2007. Contemporary artists were invited in 2010 to form a capsule knitwear collection of one-off designs – '195 Collaborations' – that were exhibited in London's Serpentine Gallery and sold in a limited edition of 195.

◀ **Knit jacquards reworked for a 2011 collection of blanket capes and ponchos.**

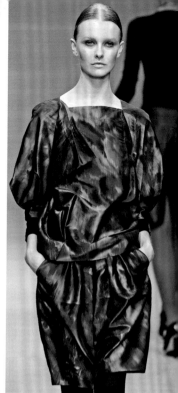

2003
Traditional argyle check, Scottish vernacular dress and floral intarsia for contemporary knitwear.

The label's signature argyle check (derived from the tartan hose that were originally cut and sewn from woven cloth and worn with the Scottish kilt) is reworked into a classic trench, oversized sweaters and cropped waistcoats. Black or white kilts, complete with the two-buckled fastening and pleats, are positioned to fall obliquely across the shoulders, worn over plain jersey tops and narrow skirts. Simply constructed sweater dresses, capes and sleeveless tanks appear in soft pink and blue rose-patterned intarsia knits.

1964
The fully fashioned 'Higgins' cardigan – after Professor Higgins in *My Fair Lady* (1964) – has semi-inset sleeves in mustard cashmere.

Knitwear as a fashion commodity for men, rather than a utilitarian product, emerged with the post-war emphasis on design and the increase in leisurewear and sporting activities. The classic V-neck sweater, the front patterned in an argyle check, the polo shirt with logo and, in the 1960s, the turtleneck sweater in one of the new synthetic fabrics such as Orlon became a wardrobe staple for the off-duty man. Between the two World Wars, the international knitwear industry had developed rapidly, and because Pringle was renowned for the best quality but not for the most fashionable knitwear, the company employed Viennese-born Otto Weisz in 1934, the first full-time professional designer to work within the British knitwear industry.

2008
A tightly edited collection of cocoon coats and oversized knits.

A drop-waisted silk-satin dress with a blouson bodice and gathered skirt features a diffused abstract print in shades of intense blue, a colour that recurs in a similarly cut top. Cocoon-shaped ankle-skimming trench coats with balloon-shaped sleeves form an ovoid shape replicated elsewhere in a navy blue silk-satin dress. The label's signature trapeze-line sweaters are extended into above-the-knee dresses.

PROENZA SCHOULER

www.proenzaschouler.com

A high-end fashion label, Proenza Schouler combines sophisticated technical skills and traditional tailoring techniques with a modern confident look. Lazaro Hernandez (Proenza, 1978–) and Jack McCollough (Schouler, 1978–), the design duo behind the label, met as students at Parsons The New School for Design in 1998. While Hernandez interned at Michael Kors (see p.216) and McCollough at Marc Jacobs (see p.196), they developed key relationships with factories and suppliers. The couple co-designed a graduate show that was bought on sight by exclusive department store Barneys. Consulting work followed while the designers established their company, launching the label in 2002.

Initially popular for its modern interpretation of bustiers and corsetry, the Proenza Schouler line now features tailored coats in luxurious materials such as raccoon and painted leather, pencil skirts and colour-blocked chiffon evening wear. More recently, the designers returned to the aesthetic of the US preppy, incorporating such classics as the toggle jacket and plaid pinafore and kilt. There is a waiting list for the best-selling satchel bag, the PS1, which taps into the trend for minimalist pieces.

In 2007, 45 per cent of the business was bought by the Valentino Fashion Group. With two Council of Fashion Designers of America awards – Womenswear Designer (2007) and Accessories Designer (2009) – the label boasts Kirsten Dunst and Demi Moore as fans. Proenza Schouler collaborated with Giuseppe Zanotti on a line of shoes in 2009.

◀ **A rubberized graffiti print is inspired by the paintings of Christopher Wool for 2010.**

2003 Proenza Schouler's debut collection hits the catwalk in New York.

A satin bustier is defined by black binding and tucked into a high-waisted lamé skirt with a small fishtail. Elsewhere in the spring/summer collection, the bustier is partnered with slim pencil skirts, or lengthened and criss-crossed with ribbon ties over soft suede trousers. Featuring such sombre colours as anthracite, muted brown, black and white, the collection is enlivened by metallic silver.

2009 Sporty tweed appears alongside signature twisted chiffon bodices.

Innovative tailoring techniques are seen in this coat of contrasting panels of camel and black. It is double-breasted with a stand-away collar that incorporates a zip to accommodate a hood. Tweed and leather knee-length shorts and tulip-shaped skirts worn with grey woollen tights accompany a shorter version of the coat. Twisted bodices on dresses are sculpted around the body.

2007 A collection that asserts the designers' evolving confidence in building and expanding on an established repertoire of successful design solutions.

The influence of Paul Poiret can be seen in this black and white brocade coat dress with hugely cuffed sleeves in fur and an upright face-framing collar. Cocoon-shaped coats, low 1920s waistlines and small neat headwear confirm the reference. Brocade also forms the skirt of a simple sleeveless dress with a bodice decorated in rows of faceted, black, turn of the century–inspired beadwork. Chiffon is pleated, draped or tucked around the breasts, or worked into ribbon streamers in metallic shades of copper and rust or petrol blue and deep pink. Mannish tailoring offers a contrast to loose boyfriend-fit trousers slung low on the hips and worn with black leather letterman jackets, the label's logo in place of the letter. Cropped duffel coats with knitted sleeves and cropped jackets held with a single central button are also partnered with these trousers.

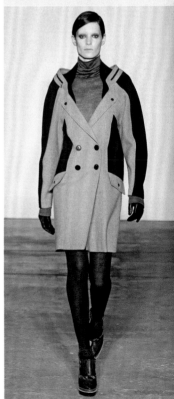

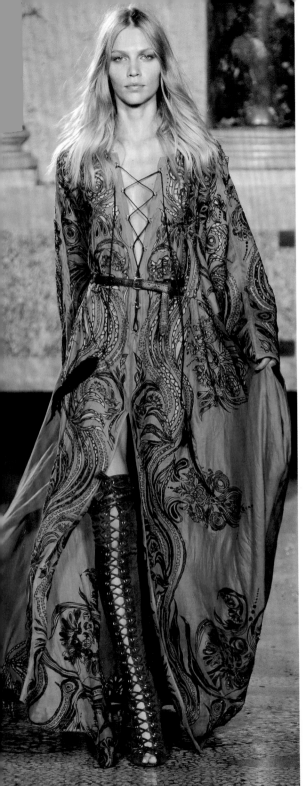

PUCCI

www.emiliopucci.com

Using instantly identifiable prints, Emilio Pucci, Marchese di Barsento (1914–92), designed relaxed glamorous leisurewear in innovative lightweight fabrics that became synonymous with the jet age and was worn by celebrated beauties such as Marilyn Monroe (she wanted to be buried in her favourite Pucci), Audrey Hepburn and Jackie Kennedy Onassis. In contrast to the constructed formality of contemporary couture, Pucci introduced stretch into fabrics with the 'Emilioform', an elasticized silk shantung that he developed in 1960 and which liberated women from constricting girdles and layers of underwear.

Pucci trained as a pilot in the Italian air force, and while on leave in Switzerland was photographed wearing his own skiwear designs, the images appearing in US fashion magazine *Harper's Bazaar*. Subsequently, Pucci left the air force and set up business in the fashionable resort of Canzone del Mare on Capri, later moving to Rome, with headquarters in Florence.

The desire for Pucci's status clothes was undermined by the plethora of cheap copies on the market and by an era of minimalist fashion. However, Pucci remained enormously influential and inspired both Stephen Sprouse and Gianni Versace (see p.306). Laudomia Pucci, Emilio's daughter, is now the director of the fashion empire. In 2000, the French luxury conglomerate LVMH bought a majority stake. In 2002, ten years after Emilio's death, Christian Lacroix (see p.96) was appointed as artistic director with a resultant upturn in sales. Matthew Williamson (see p.210) replaced him in 2005, followed by Peter Dundas in 2008.

◀ **Hippie de luxe 2011 by Peter Dundas with front-laced kaftans, fringing and feathers.**

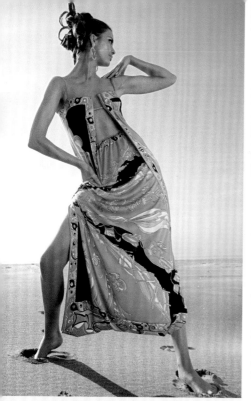

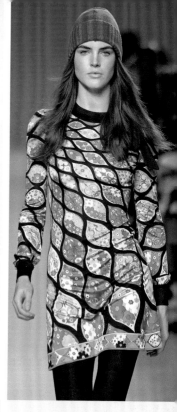

2002

The final collection by Julio Espada, appointed artistic director of the label in 2000.

Resort wear from the 1960s is revisited in a collection that includes this straight-cut swimsuit with matching oversized hat. Other prints include shattered stripes in a neck to floor column of colour. Marbleized yellow, black and white swirls feature in dirndl skirts worn with bra tops. Equally vintage-inspired are satin split-front capri pants worn with printed tunics in shades of aqua and turquoise, bandeau tops and high-waisted billowing chiffon harem pants. Roman sandals, cross-gartered to the knee, complete the look.

1966

Resort wear, such as kaftans, swimsuits and beach wraps, in Emilio Pucci's distinctive print and colour palette for the jet set.

Emilio Pucci drew inspiration for his distinctive print designs from many sources, including Renaissance paintings, the regalia of the Palio horse race in Siena and the indigenous colours and patterns of countries such as Bali. These were transmuted by the designer into abstract forms and psychedelic swirls of colour, often controlled by borders of contrasting print at a different scale, and signed simply 'Emilio'. A renowned colourist, Pucci used vivid combinations rarely seen before: fuchsia and geranium, sapphire and blackberry, khaki and lavender. These kaleidoscopic prints were made of an uncrushable material, with each garment weighing less than 250 grams (8 oz), and therefore popular with the well-travelled jet set.

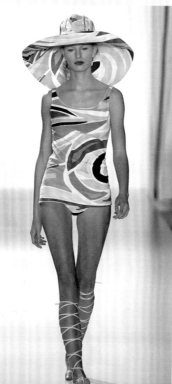

2006

Williamson's debut collection in shades of purple with black.

A multicoloured spiralling ogee print features on a short tunic with black collar and cuffs, updating the Pucci print for the 21st century. The autumn/winter collection runs the gamut of purple from lilac to Parma violet, and the colour is paired with black, white and grey. High-waisted miniskirts are adorned with semi-precious stones on their belts, and mohair sweater dresses have cowl necks.

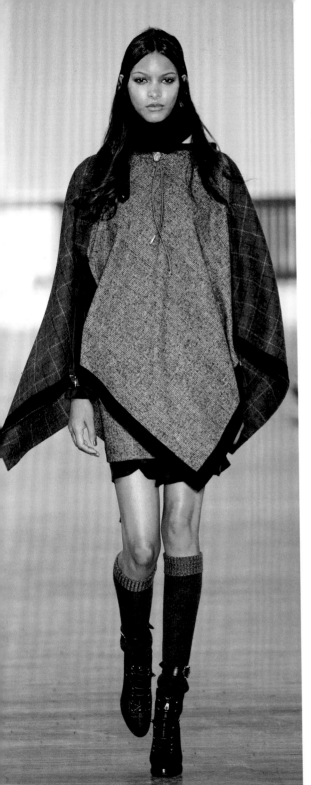

RAG & BONE

www.rag-bone.com

With its provenance in English heritage and US craftsmanship, the burgeoning lifestyle brand rag & bone – named after English rag and bone men who collect unwanted items – offers classic yet modern sportswear for men and women that combines utility and military overtones with an almost romantic look. British-born Marcus Wainwright (1975–) and David Neville (1977–) formed their label in 2002 after visiting the now-closed factory Kentucky Apparel. Their aim was to make clothes that they and their friends would love to wear on a daily basis. With no formal fashion training, the couple set about learning how to make jeans.

With Wainwright as the designer and Neville handling the business side, the brand uses traditional manufacturers such as the tailor Martin Greenfield in Brooklyn, the Bollman Hat Company, Norton & Sons of Savile Row and Waterbury Button, the oldest button manufacturer in the United States. These suppliers lend an authentic edge to a label that espouses quality with informal high-end fashion. The brand is sold worldwide, with the flagship store in New York.

rag & bone launched its men's line in spring 2004 and expanded the label to offer a full women's collection by autumn 2005. The A/W 07/08 season marked the introduction of accessories for both men and women. In 2006, rag & bone was selected as a finalist for the Council of Fashion Designers of America (CFDA)/*Vogue* Fashion Fund Award and won the 2007 Swarovski Award for Emerging Talent in Menswear. In 2010, Neville and Marcus were named Menswear Designer of the Year by the CFDA.

◀ **2010 brings layer upon layer of heritage tweeds and poncho-style textured knits.**

2006 A pared-down collection of garments with minimal detailing.

An equestrian-inspired tweed hacking jacket is worn with jodhpur-cut trousers in cream. Cream represents the major colour in the collection other than dark denim, which is used for mid-thigh tunics and narrow trousers. Knee-length pencil skirts are partnered with neat silk shirts, and menswear includes knee-length coats with matching or white trousers, and zip-fronted bomber jackets.

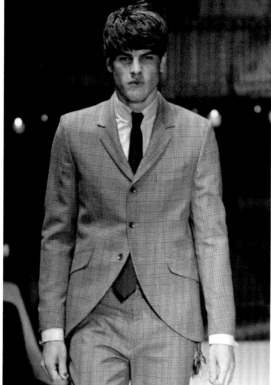

2008 Military overtones appear with gilt buttons and belt embellishments.

Referencing male 19th-century riding dress, the jacket front cuts away to reveal a steel-blue skirt, the only assertive colour in a subdued palette dominated by grey, khaki and taupe. The military theme for autumn/winter is expanded further with seamed jackets, pin-tucked shirts with minute Peter Pan collars, smooth moleskin and zip-fronted quilted jackets worn over double-breasted coats for men.

2007 Traditional tailoring techniques are used on natural-tone fabrics with a utilitarian edge for both men and women, and accessorized with skinny ties and scarves.

A windowpane-check two-piece suit worn with a button-down shirt carries the same styling details as the womenswear elsewhere in the collection. The neat fitted jackets with narrow lapels, slanted pockets, high buttoning and curved centre fronts are worn with high-rise trousers by the men and with knee-length kilts by the women. A version of a safari jacket features for both sexes; it is worn belted – as are light-knit cardigans – over narrow trousers. Caps, khakis and biker boots roughen up the tailored pieces, as do fingerless gloves and a fashion version of the utilitarian donkey jacket for men. A shorter version for women is partnered with knee-length shorts, and both sexes sport waistcoats over white or denim shirts. A more feminine silhouette comes from the form-fitting jackets with hook-and-eye fastenings and cutaway fronts, worn over A-line tunic dresses.

RALPH LAUREN

www.ralphlauren.com

Combining old-world style with discreet wealth, Ralph Lauren (1939–) recreates a vision of the past with his upmarket casual clothes that represent a US version of English country-house style. Lauren's collections have over the years referenced pursuits such as croquet and boating, safari expeditions in Kenya, shooting in Scotland and, of course, the game of polo, which was the inspiration behind the label's logo and the short-sleeved mesh shirt, launched in 1972, and which continues to sell in its millions.

Ralph Lauren was born Ralph Rueben Lifshitz in the New York City borough of The Bronx to an immigrant family. The Lauren global fashion empire was founded in 1967 with his first-ever tie shop; later, he moved on to shirts and in 1971 he introduced his womenswear label. When Lauren designed the clothes for the film *The Great Gatsby* (1974), he consolidated his reputation as an interpreter of the United States's past that was to be an essential component of all his collections: prairie knits worn with denim, cream cashmere cardigans with tennis whites, the navy and white striped sailor's maillot. In 1981, Lauren produced the 'Sante Fe' collection, an influential evocation of the colours, textures and patterns of the Navajo Indians of the American Southwest.

The brand was floated on the US stock market in 1997, with Lauren remaining the biggest shareholder. The label now includes Polo Ralph Lauren, Polo Sport and the Ralph Lauren Collection.

◀ **A 2010 elegy to Dust Bowl America, with fabric torn, faded and dyed to look like denim.**

Textured intarsia knits and plaid skirts come together to create a winter prairie look.

Mid-calf gathered plaid skirts deeply flounced at the hem are worn over flannel petticoats and partnered with chunky patterned knits, gloves and tweed socks to summon up images of winter on the prairie. Checked fringed scarves and round-brimmed hats add to the effect, as do the piecrust frill collars and cuffs peeping from beneath the layers of outer garments. Knits feature traditional stitches and include a generic Fair Isle pattern, while checked lumberjackets in strong deep colours add a homespun 'down at the farm' feel.

1974 **Ralph Lauren depicted Jazz Age elegance from the summer of 1922 in his designs for Robert Redford as the hero of *The Great Gatsby*.**

The three-piece suit with a straight-edged double-breasted waistcoat in brown pinstripe paved the way for an interest in fashion nostalgia. Theoni V. Aldredge received an Academy Award for her costume designs for *The Great Gatsby*, but it is Ralph Lauren's styling of the film's lead that introduced the label to a wider audience, particularly when Redford appeared as Gatsby on the cover of men's fashion magazine *GQ*. The film shows classics such as khaki trousers, silk ties, linen suits and rugby shirts, all in pink, pale yellow, light blue and cream. Garments have a refined elegant masculinity that subsequently associated the label with upper-class US style, and kick-started the trend for the 'preppy' look.

1996 **A long lean look of pared-down trouser suits and pencil skirts.**

A single-breasted trouser suit includes all the accoutrements of masculine tailoring: the stiffened shirt collar, the tie, the cufflinks and the pocket handkerchief. This predominantly androgynous autumn/winter collection is in a sombre palette of navy, black and camel. Long halter-neck and strapless sheath dresses appear throughout. Volume comes from luxurious outsize camel-colour trench coats.

2005 **Palest pastels in a spring/summer collection that exudes vintage glamour.**

The barely there blue of the narrow high-fastening shirt and the on-the-knee pencil skirt offer Lauren's view of 1930s sporty leisurewear. The collection also includes contemporary versions of jodhpurs and tennis whites. The full-on glamour of the era is represented by silk-satin bias-cut dresses in palest pink, silver and cream, featuring floating chiffon cap sleeves. Knee-length dresses with fluted skirts define the waist with narrow coloured belts. Tailored pieces include cream blazers, cropped trousers, linen shorts and summer coats.

2001 **Urban tweeds and sweaters in shades of brown appear in a 1970s-inspired collection of miniskirts and maxi-coats.**

An oversized windowpane-check coat and short leather skirt are partnered with the students' favourite, the black turtleneck sweater, referencing the college graduate Ali MacGraw in the romantic weepie *Love Story* (1970). Elsewhere, Lauren features the miniskirt and an abbreviated kilt with long flowing maxi-coats, capes and preppy-style tweed hacking jackets. The equestrian theme continues with form-fitting jodhpurs and a red jacket with a black velvet collar. Easy-to-wear shirt dresses come in brown leather to the knee or ankle-length in black wool. Cream and brown sweater dresses with low-slung belts add to the young urban appeal. Spaghetti-strapped dresses in paisley-printed velvet provide the evening wear.

2009 **A safari-inspired collection with elements from the Orient.**

For spring/summer, the sophisticated shaping on a knee-length black strapless sheath dress is formed by horizontal pleats that go on to create a 'V' shape on either side of the waist. Only the black turban that accessorizes the dress references the themes of the collection, the majority of which offers Lauren's version of 1970s safari wear or the voluminously draped harem pants of Marrakesh.

2010 — Archetypal preppy style reinterpreted from the 1930s.

From the rowing club sweater to the newsboy cap and club collars, Ralph Lauren calls up the privileged regalia of the Gatsby-era Varsity regatta. The menswear collection retells a preppy genesis myth in the cut, colours and fabrics of yesteryear, while the flipside image of the Dust Bowl hardships is evoked in distressed work clothes for the womenswear collection.

2011 — The early 20th-century Wild West with lace and fringed leather.

A princess-line sheath dress with frilled cap sleeves and a froth of chiffon from mid-thigh appears in a collection that focuses on Western detailing such as fringing combined with a lavish use of lace. The delicate fabric is also styled with conker-brown suede and accessorized with concho belts and huarache sandals. Whipstitching occurs throughout the collection, shaping butter-coloured leather into a form-fitting trouser suit or used for decoration around the edges of a jacket.

RICHARD
NICOLL

www.richardnicoll.com

Richard Nicoll (1977–) takes basic apparel and textile components and reworks them into new proportions and relationships. His clothing references are primarily structural and of Western origin, although not gender limited. A mannish tuxedo revers may become the single-shouldered anchor of a flimsy cocktail dress. To emphasize the re-formed detail, Nicoll generally limits his collections to shades of a single colour, establishing playful contrasts through variations in fabric texture and behaviour. For example, a gauzy but structured shirt may be worn over a tailored opaque satin bra and partnered with voluminous peg-top trousers in jersey.

A London-born Australian, Nicoll gained his Master's in fashion at Central Saint Martins College of Art & Design in 2002. Dolce & Gabbana (see p.110) bought up his student collection. After collaborating with Marc Jacobs (see p.196) at Louis Vuitton (see p.190), Nicoll launched his own womenswear collection in 2004.

Collections have drawn upon recognizable themes: tailoring, drapery and asymmetrical swags, corsetry, *passementerie* and lingerie. Nicoll has occasionally refreshed the line and its impact by flirting briefly with strong colour – either as a contrasting accent or in clashing colour bandings. With a reputation for developing a mature sophistication in his own line, in 2009 Nicoll agreed a three-season contract with Cerrutti to direct the relaunch of its womenswear label, and in 2011 the designer launched the 'Laurel Wreath' collection for sportswear label Fred Perry.

◄ **Bustier tops and architectonic skirts contrast with sporty tailoring in 2010.**

2004 Silk-satin is worked into futuristic frocks in Nicoll's debut collection for autumn/winter.

Mauve tailored shorts are worn with a matching T-shirt under a silk-satin top with twisted fabric bra cups, a knotting technique used throughout the collection on tunic dresses, creating an impression of an armour-like space-age tabard. Icy tones of pink and blue, from cerise and mauve to raspberry, feature on the outsize iridescent big-shouldered bomber jackets, padded parkas and ciré blousons. Tiny frills appear on tunic hems, the ends of narrow trousers and in rows on the sleeves of an otherwise simple jacket.

2011 A classically inspired collection combines pleats and piecrust frills with strict tailoring.

A pale nude pleated dress is held in at the waist with a deeper pink patent belt. A matching collar incorporates a free-flowing knee-length cape. Elsewhere, ankle-length dresses in the same colour bleed into a warmer pink-infused orange. Transparent polka-dot chiffon tops feature over black bras with crisp white mid-calf skirts, bound in black at the waist and pockets. Dresses have scoop necks with tiny piecrust frills. Complicated bib-front blouses are worn with wide chiffon trousers beneath accordion-pleat skirts.

2007 Androgynous layered tailoring incorporates easy oversized bib-fronted shirts featuring monochrome stars and stripes.

Five-pointed stars appear on the finely striped shirt-tail skirt, layered with a belted peplum and ribbed sweater, the scooped neckline showing the narrow shirt collar and white bib front beneath. Elsewhere, a shallow band of box-pleated satin flares below the waistband of skintight trousers that have body-shaping double seams at the front and laces at the ankle. Jackets have a Wild West feel with fringed plackets, epaulettes and front lacing. Tassels appear as necklaces in bright orange, with matching narrow belts and tights, the only hit of colour in a sombre collection. Some shirts remain unadorned, with star-shaped pockets serving as the only decoration.

RICK OWENS

www.rickowens.eu

California-born Rick Owens (1962–) initially studied fine art at Otis College of Art and Design before embarking on a pattern-making course and working for local sportswear companies. Featuring dramatically wrapped, tied and draped knitted pieces and distressed leather and silk jersey in a muted palette, the Rick Owens label was launched in 1994 in Los Angeles, although international recognition only arrived in 2002, when Owens won the Council of Fashion Designers of America Perry Ellis Emerging Talent Award. Initiator of the frequently copied waterfall-front cardigan and with a natural ability to sculpt cloth around the body, Owens has an elegant yet neo-gothic style.

In 2001, Owens signed with Italian sales agent Eo Bocci Associates for worldwide distribution, and his production moved to Italy. His first womenswear catwalk collection took place in 2002 during New York Fashion Week, followed by a menswear collection in 2003. After his second catwalk show in New York, Owens moved the studio from Los Angeles to Paris to show during the Paris collections. He also began his long-standing collaboration with the stylist Panos Yiapanis, who has worked with Owens on all his catwalk shows. Owens marked the anniversary of his tenth season with the launch of a retrospective book named *L'ai-je bien descendu*. In 2007, he was given a Cooper-Hewitt National Design Award.

The opening of his first shop in the Palais Royal in Paris also launched his furniture range and stocks his various clothing lines from the ready-to-wear diffusion line Lilies and the denim range DRKSHDW to the exclusive fur range, Palais Royal.

◄ **Asymmetrical quilted armour is offset by soft draping on these warrior women in 2010.**

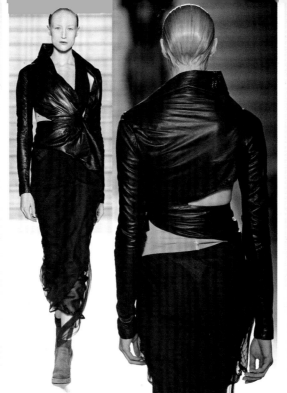

2002 A technically adroit New York debut from the cult label.

Layers of luxurious texture – soft suede and leather, silk jersey knits – form an almost monastic silhouette, an effect heightened by the predominantly brown colour palette, coifs, cowl necks and all-concealing floor-sweeping dresses with distressed hemlines. Elsewhere in the collection, simple wrap coats are caught at the neck with a single pin, falling freely to create a billowing profile.

2008 Subtle shifts in shape formed by innovative cutting, tucks and pleats.

Silk gazar, a sheer fabric with a crisp finish, is pleated and tucked to fall in origami-like folds around the body, forming an airy silhouette. Monochromatic op art–inspired printed chiffon is layered into multidirectional striped tunics or caped tops, the transparent fabric disclosing layers of stripes beneath. Minimalist all-white or all-black ensembles provide a severe look.

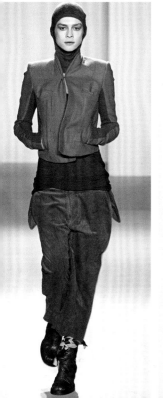

2006 Ankle-length skirts and asymmetrical draping of translucent silks and chiffons in a near monochrome colour palette are shown with the softest leather.

Combining tough with tender, distressed leather drapes across the torso to fasten on the hip in an outsize sculpted fan of fabric, worn over a mid-calf tight jersey tube skirt. Constructed from two fabrics – a jersey knit and suede – the sleeves are tight-fitting yet mobile. Other suede jackets are fastened with an outsize safety pin and worn over wide-legged trousers in thick wool or cord. Nude chiffon has opaque silk panels in grey, cream or pink and is draped over bosom and hips giving the impression of free-floating lingerie. Ruched and appliquéd panels of soft suede and organza appear on matching jackets and trousers, the infrastructure, such as pocket bags, visible through the transparent fabric. Elsewhere, organza and silk taffeta are shaped into shell-like undulations, frills and curves around the hips of a narrow jacket, worn with drapey silk trousers.

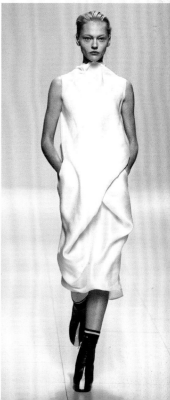

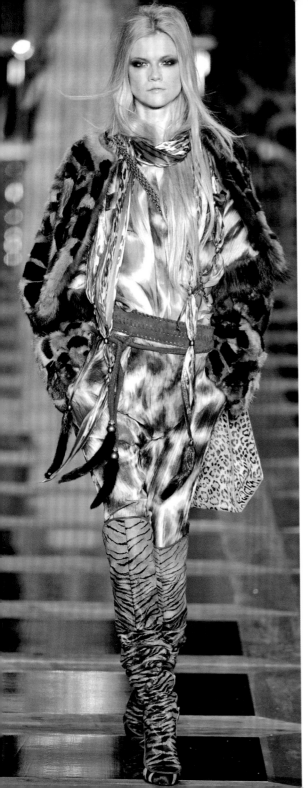

ROBERTO CAVALLI

www.robertocavalli.com

Exponent of high-octane glamour, Florence-born Roberto Cavalli (1940–) celebrated forty years of expressing his uniquely Italian point of view on the red carpet in 2010. His exuberant and ebullient approach to fashion includes the lavish use of animal prints and fabric embellishment to project a brazenly seductive look. Following his debut show in Paris in 1970, he opened his first boutique in Saint-Tropez in 1972.

The French Riviera was the ideal location to sell his pieces, featuring the innovative printing on leather procedure that he had patented in the early 1970s and that won him commissions from Hermès (see p.146) and Pierre Cardin (see p.246). When 'designer denim' emerged in the 1970s, Cavalli successfully embellished and patchworked it into a series of sexy separates. Since the early 1990s, with the encouragement of his wife and business partner Eva Düringer, the designer has produced dazzling, slashed to the thigh, animal-print dresses for the modern glamazon.

The main line is sold in more than fifty countries, and Cavalli launched the more youth-oriented Just Cavalli line in 1998. In 2002, he opened his first cafe-store in Florence, decorating it with his trademark animal prints. This was followed by the opening of the Just Cavalli cafe and another boutique in Milan. In 2010, Cavalli confirmed an exclusive worldwide licensing agreement with Ittierre for the production and distribution of the Just Cavalli menswear, womenswear, apparel, bags, shoes and accessories collections.

◀ **For 2010, a plethora of animal and reptile furs and skins: some printed, some real.**

1995 Exposing the lingerie beneath, form-fitting black evening dresses are semi-transparent.

Unlike Milan-based Versace and Armani, Cavalli had continued to show his seasonal collections in Florence until 1994, an indication of the brand's marginalization during a period of understated minimalism. Cavalli's second wife, Eva, is credited as the inspiration behind the mid-1990s renaissance of the label, resulting in the emergence of the signature animal-print showgirl gowns at the end of the decade. Appealing to a new generation of celebrities, the label attracted such luminaries as Madonna, Jennifer Lopez and Christina Aguilera.

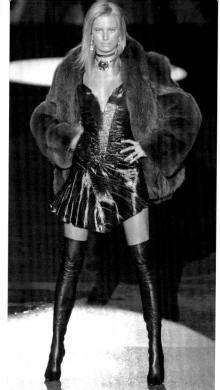

2007 A Mexican-inspired collection of fringed and tasselled tailoring in vibrant colours.

Printed tiger stripes are worked into a flowing kaftan, the statutory animal print in a collection otherwise inspired by the work of Mexican painter Frida Kahlo. This includes ruffled shirt fronts, tied at the neck with baby-blue satin ribbon, and embellished jackets – all accessorized with hoop earrings and beaded belts. A cobalt-blue silk-satin top is worn with an emerald-green skirt; the black macramé fringed sleeves match the frilled flamenco-inspired skirt. Full-length evening gowns appear in billowing chiffon.

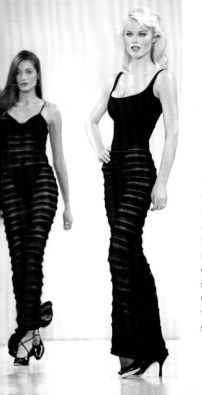

2003 Slashed and plunging, raunchy Las Vegas showgirl fashion with neon-bright feathers and spray-on prints.

An electric-blue ostrich feather coat opens to reveal the plunging décolleté of a skintight sequinned dress, cut to the thigh, worn with boots. Also evidencing the overt sexuality of the collection are 'spray-on' Warhol-inspired prints on skintight catsuits, and jewelled dog collars. Jeans are scattered with sequins at hip and thigh and worn with cropped shearling jackets. Leather leggings appear with sequinned micro minis. Puffs of black-tipped lime-green ostrich feathers obscure sequinned shift dresses beneath. Animal prints, a Cavalli staple, are worked into barely there dresses, with halter-neck bodices suspended from a single centre-front point.

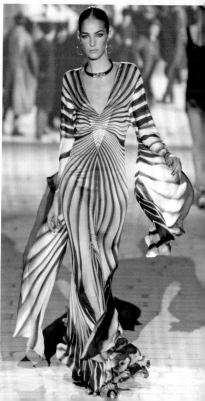

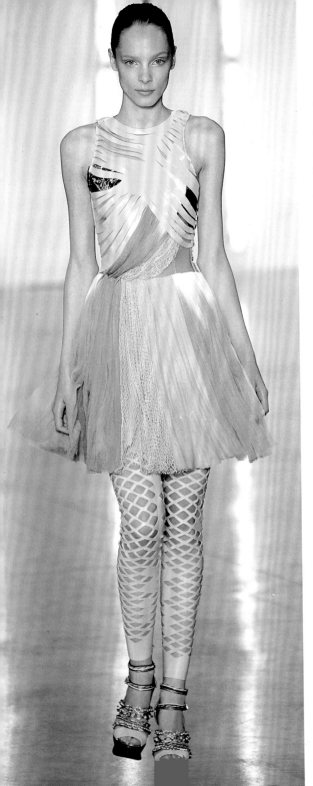

RODARTE

www.rodarte.net

The catwalk collections of US label Rodarte are conceptual rather than commercially fashionable, steeped in the literary traditions of founders Kate and Laura Mulleavy's backgrounds in the liberal arts. Their specialisms – Kate in 19th- and 20th-century literature and art, Laura in the development of the modern novel – provide sources of inspiration for the design duo, from the gothic novel to the wit of Dorothy Parker. When the first Rodarte collections were presented, their otherworldly fine art feel and painstaking attention to detail in cobwebbed lace and fluttering petals of fabric were considered by some fashion editors to be unwearable.

However, the ever astute Anna Wintour at US *Vogue* was an early supporter, as were US retail giants Bergdorf Goodman, Barneys and Neiman Marcus. By 2005, all doubts were assuaged when Rodarte attracted a number of industry awards and successfully collaborated with Gap and Target. In 2008, the sisters from Pasadena won the Swiss Textiles Award, the first women and non-Europeans to achieve this accolade. More recently, they have teamed up with Knoll Luxe to design three drapery and five upholstery fabrics named after their favourite writers. For example, Dorothy Parker is the inspiration behind 'Dorothy', an innovative and ethereal material, reminiscent of their A/W 08/09 collection of knitwear with its textured threads sandwiched between layers of gauze. In 2009, Rodarte reached its most high-profile customer when Michelle Obama was spotted wearing the label in the Oval Office when hosting a reception for Queen Rania of Jordan.

◀ **S/S 09 – inspired by views from space, confluences of rivers and Degas's ballerinas.**

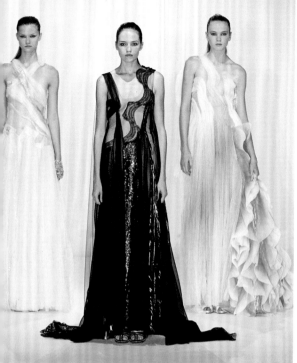

2010 The Rodarte emphasis on hand-worked textiles remains strong in this layered and patched collection of rough-hewn fabrics inspired by Mexican outworkers.

Bulky blanket weaves in fat twisted yarns and chunky crochet and knitted shawls are drawn high around shoulders and necks, and are partnered with print draped skirts revealing substantial tweed or narrow trousers. At other times a delicate floral print is knotted into a dress worn over a chunky homespun bustier in knitted mohair or an embellished sheepskin jacket. The colour palette has sensual roseate accents, with ecru and natural backgrounds forming the cohesive framework to support the 'pick and mix' approach of improvised dressing in myriad fabrics. Individual garments are rarely without hand embellishment in the form of fringes, crochet trims and other inserts. The resulting bricolage includes sheer lace leggings, floral-printed trousers and fur-trimmed gloves. Platform shoes with ribbon ties laced up the ankle were designed in collaboration with Nicholas Kirkwood.

2008 Hayao Miyazaki's film *Spirited Away* (2001) is a source for a collection that evinces a whimsical romanticism combined with organically patterned loose knits.

Three elemental goddess dresses from the spirit world of an anime storyboard are created from flowing chiffon and rivers of sequins, with a swirling mist of symbolic decorative dyeing and embroidery. With a design philosophy more often based on literary associations, the Mulleavy sisters were inspired by oriental culture for this collection following a design trip with Gap to Japan. Designs range from ethereal diaphanous and delicately coloured chiffon pieces to the structured rigidity of sunray-pleated and petticoated lantern skirts. A palette of pastels and black is interspersed with various shades of blue. Often bespoke structured textiles are used to suggest dereliction and fragmentation – metaphors for societal dislocation in the movie. Frayed weaves and drop-stitched knits are used in outfits; at other times, bourgeois dress is echoed for effect.

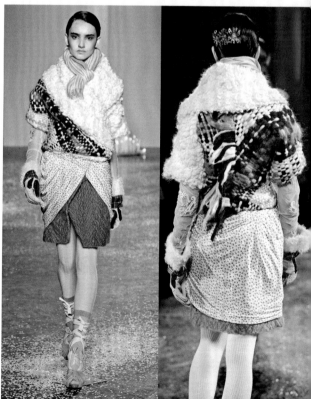

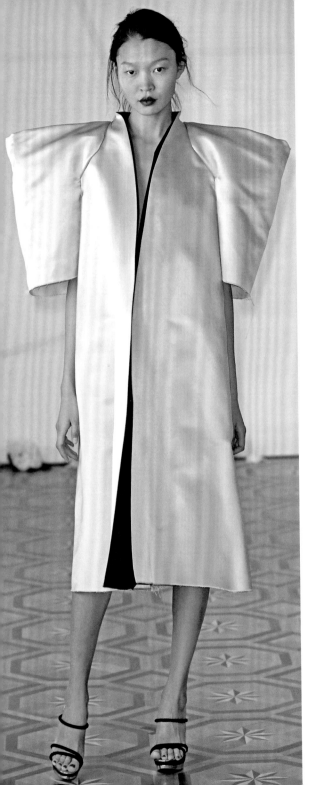

ROKSANDA
ILINCIC

www.roksandailincic.com

The eclectic Ilincic collections include high-drama silk-satin gowns, which flirt with a wide variety of oddball extravagances such as tiered tulle-stuffed pagoda sleeves and bows the size of elephant's ears on the hip or shoulder in duchesse satin. The demi-couture garments, combining a sculptural silhouette with heavy embellishment, are hand-stitched by seamstresses in Ilincic's home town of Belgrade, Serbia.

The ex-model initially studied applied arts and architecture at the University of Belgrade before moving to London to study at Central Saint Martins College of Art & Design. In 2002, Ilincic launched her own womenswear label and for the following three seasons was sponsored by Fashion East. With aid from Topshop's New Generation initiative, the designer presented her first catwalk show of thirteen dresses at London Fashion Week in 2006, where she has since become a fixture.

Later Ilincic collections have found a clearer and cleaner style by the elimination of superfluous flounce. This is also apparent in the collaborations that the designer has pursued with Whistles under Jane Shepherdson (previously of Topshop) and the luxury Damaris lingerie label. Ilincic lists a clientele that includes Claudia Schiffer, Cate Blanchett, Gwyneth Paltrow and Barbie, whom the designer dressed for the doll's fiftieth anniversary in 2009, retailing in Colette in Paris and London's Dover Street Market. Ilincic sells in twenty-two countries worldwide and also has a range of bags and swimwear.

◄ **Exaggerated shapes are combined with lingerie in glossy silk-satin and taffeta for 2008.**

2007
Eccentric flamboyance and gravity-defying confections.

A double-layered frill in oyster-pink satin that encircles the head and obscures the body exemplifies Ilincic's playful subversion of the silhouette. Elsewhere, strips of silk tulle are appliquéd in a frenzy of fragile texture on to a knee-length sheath dress or set vertically into the seams of a princess-line dress. A black caped dress is cut off at the crotch and partnered with pearl-grey tights and a top hat sprouting tulle feathers.

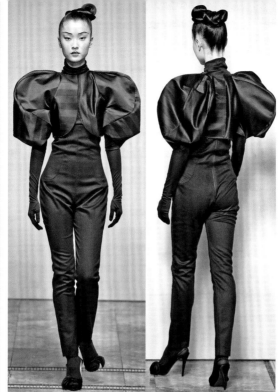

2011
An ethereal collection using a pastel palette has a softer edge.

A bubblegum-pink dress with a minutely fringed hem provides a contrast to previous collections. Intimations of the 1970s appear in the collection: silk kaftans – sometimes with wide-legged trousers – and draped and knotted headscarves. Sheer blouses are teamed with linen trousers or ankle-length skirts, and frivolous swathes of chiffon form wrap skirts or drift across the bodice of ruched dresses.

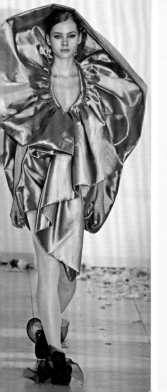

2008
Architectural form disguises or enhances the body through the construction of distorted extraneous detail in jewelled signature silk-satin for the autumn/winter collection.

An enveloping one-piece forms a figure-hugging shell, which turns into an exaggerated silhouette by the addition of a short bolero of chocolate and black stripes with outsize lantern sleeves, an effect heightened by the integral gloves. These also feature with high-waisted, high-necked gowns with either a gently gathered skirt to the ankle or a fishtail hem, leaving only the face on view. Narrow trousers or mid-calf striped skirts complement edge-to-edge jackets with deep stiffened peplums. The shape-shifting theme is sustained by cocoon-backed coats with caped sleeves, amplified peg-top skirts and dresses with stiffened lampshade-like folds of fabric on the hips that stand away from the body. Contrast is provided by satin dresses in shocking pink with a swag or a train from one shoulder. Mid-calf black dresses have sinuous insets of emerald green snaking up the front.

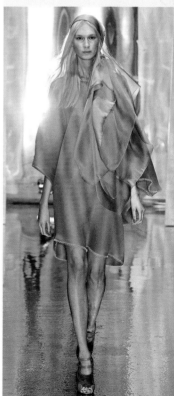

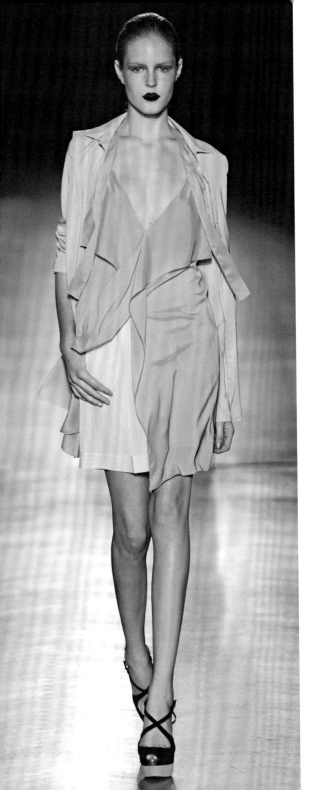

ROLAND MOURET

www.rolandmouret.com

A frenzy of publicity surrounded French designer Roland Mouret's Galaxy dress when it first appeared in 2005. The flattering waist-whittling 1940s-inspired dress signalled the end of the boho look and became a modern classic, worn by every fashion A-list celebrity from Naomi Watts to Cameron Diaz.

Mouret's fashion training consisted of three months in a Parisian fashion college in 1979. His career-long technique of cutting and wrapping fabric on the square into draped and figure-hugging dresses is self-taught. An instinctive designer, Mouret (1962–) launched his own label in 1998, and the designer made his debut at London Fashion Week in the same year. In 2000, he entered into a partnership with Sharai and André Meyers. After five years and a move to New York, Mouret introduced the Galaxy dress in spring 2005.

Less than two months after the dress's catwalk debut, Mouret shocked the fashion world by resigning from the company, losing the right to use his name commercially. There followed a two-year hiatus, during which Mouret designed a one-off collection for Bergdorf Goodman, for which he personally signed each of the thirty-six dresses, and a limited edition dress line for Gap.

In 2007, he co-founded a new company, 19RM, with Simon Fuller, entertainment mogul and founder of the Spice Girls. The line RM By the Designer Roland Mouret held its inaugural fashion show in 2007 in Paris. In 2010, Mouret regained the right to use his full name and introduced the menswear line Mr.

◀ **Trading again under his own name, a Roland Mouret 2011 collection of unstructured tailoring.**

With a radical return to the hourglass figure, Mouret created an iconic dress that defined a new era in fashion. Worn just below the knee, the form-fitting garment, achieved by a powerful infrastructure within the lining, is emphasized with the square décolleté and built-on shoulders balancing the hips and reducing the appearance of the waist. Elsewhere, the dress is transformed into high-waisted pencil skirts with a fishtail kick behind the knee, and appears in both black and windowpane checks.

2002 A lingerie-inspired use of silk and chiffon in muted colours.

Caught in at the waist with a stiffened corset belt and ribbon ties, a feature that recurs throughout the autumn/winter collection, this unstructured mid-thigh dress has full cuffed sleeves that extend into a waterfall frill. The subtle barely there colours are interspersed with chocolate-brown satin and lace and black silk, emphasizing the boudoir appeal of the garments.

2010 Pieces in the autumn/winter collection are formed by draping directly on to the body without the use of patterns.

Fabric leaves fan out to form ombré circles on a form-fitting dress that is a stand-out piece in a collection chiefly concerned with cutting and wrapping fabric on the square to form tunic tops, skirts and hooded coats in sombre colours. Elsewhere, Mouret returns to his favoured palette of putty colours, pinching, catching, tucking and draping nude, pink and grey jersey around the body to create full-length evening dresses, including a long dusty-pink dress with a black ribbon tied in the small of a bared back. Patterned grey-on-grey twinsets feature a short sweater and longer cardigan. Stretchy tube skirts are worn with matching grey-flecked jackets and tights, while a dash of fuchsia is fashioned into hooded sleeveless dresses.

SONIA RYKIEL

www.soniarykiel.fr

Labelled the 'Queen of Knits' by *Women's Wear Daily* in 1970 and now a French institution, Sonia Rykiel (1930–) opened her first boutique in 1968 on Paris's Left Bank at a time when women were rejecting the rigours of haute couture and seeking clothes that projected a more youthful and modern image. Rykiel was one of the first designers to deconstruct fashion, leaving edges unhemmed and reversing the seams. In the early 1980s, the designer emblazoned her clothes with text in a collection of rhinestone-embellished evening wear. Renowned for her witty detailing and light-hearted approach to design, Rykiel has a signature style of stripy horizontal knits, cardigan dresses, outsize textile rosettes and *trompe l'oeil* effects in an array of bright colours that are usually partnered with black.

Rykiel diversified into household linens in 1975; childrenswear, menswear, shoes and fragrance followed in 1993, all of which are available in her flagship store on the Boulevard Saint-Germain, which opened in 1990, the same year that the sister line, Sonia by Sonia Rykiel, was launched. In 1996, she was the recipient of the Officier de la Légion d'honneur, and promoted in 2008 to Commandeur de l'Ordre National de la Légion d'honneur. The designer's thirtieth anniversary show in March 1998 was held at the Bibliothèque Nationale de France. In February 2005, New York boutique Henri Bendel launched an in-store shop for the Sonia Rykiel Woman line, and, in 2009, Sonia Rykiel worked with Swedish retailer H&M on a lingerie collection. An interiors line was launched in 2010, embodying the label's Left Bank style. The designer's daughter, Nathalie, is president and artistic director of the brand.

◀ **In S/S 09, signature stripes and jewelled berets mark the label's fortieth anniversary.**

1986 Throughout the 1980s Rykiel subtly developed her signature look.

Rykiel favours a looser silhouette than the power dressing of the era, seen here in this long cardigan with ribbed cuffs and hem with graded bands of coloured stripes, matching the V-necked sweater beneath. The knitted jersey trousers have horizontally placed patch pockets on the hips. However, even relaxed dressing requires sharp shoulders, and Velcro shoulder pads are featured in the knitwear.

2006 The spring/summer collection features Rykiel's favourite things spelt out in black text – *la musique, le noir, le beau* – and the Tour Eiffel.

Emblazoned with the words *le beau*, the slash-necked jersey-knit top is decorated with a jewelled half belt and accessorized with a black trilby with an outsize corsage – a Rykiel signature. A black coat with red piping has a colour-blocked sleeve in fuchsia, orange and yellow, in keeping with the trapeze-line dresses of broad horizontal stripes of colour with black lace petticoat tops. Elsewhere, stripes are narrow and feature on yokes of bright yellow jersey. Ruffles appear on dresses and coats, accessorized with shoes tied at the ankle with a flourish of ribbon bows. Sporty oversized sweater dresses in broad stripes of black or red fall off the shoulders, and are in contrast to delicate chiffon dresses with faded stripes.

1998 Daytime chic for the spring/summer collection with ribbed knits and printed chiffon.

A cropped sweater dress of ribbed mohair in peachy-pink has a deep neckline and matching hat. The edge of the dress is embellished with a pair of knitted leaves, a motif that also appears as the fastening on a navy blue ribbed jacket. The same weight and texture of the knit is also worked into pastel-coloured wrap coats of pale blue and pink. A lighter knit of fine pinstripes becomes a trouser suit, which is worn with a Garbo-esque hat. The ambience of the 1930s is also recalled with the floating chiffon printed tea dresses.

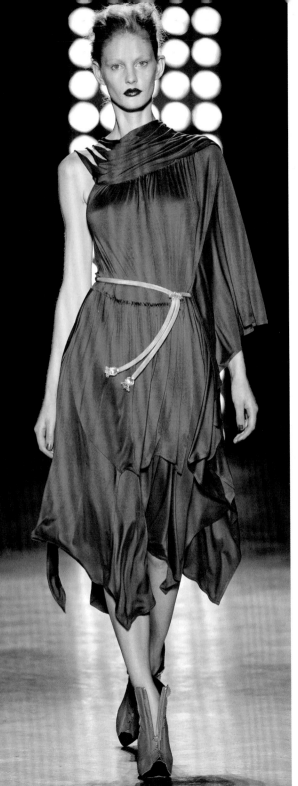

SOPHIA KOKOSALAKI

www.sophiakokosalaki.com

Sophia Kokosalaki (1972–) was able to put her design credentials before the global consciousness when 7,000 costumes, bearing both her name and her style heritage, were worn for the opening and closing ceremonies of the Athens Olympic Games in 2004.

A literature graduate in her native Athens, Kokosalaki started her fashion career making a small collection of dresses to sell in a local boutique. From this beginning in 1997, she gained a place on the womenswear Master's course at Central Saint Martins College of Art & Design in London. By 1999, she had established her own company and secured a design contract with Ruffo Research, the Italian luxury leather brand, from which Kokosalaki withdrew after six acclaimed collections.

Recurrent themes in Kokosalaki's work lie in references to eastern Mediterranean cultures – primarily Hellenic but also touching upon Cretan and Egyptian decorative motifs. The independent vision that she has shown with her repeat visits to the Attic ethnic sources – and which gained her wide acclaim from the outset – has continued to attract accolades. In 2002, she won the *Elle* Designer Award and the Art Foundation for Fashion Award, and in 2004 she was declared the New Generation Designer. Kokosalaki was briefly creative director at Vionnet from autumn 2006 to spring 2007.

The Kokosalaki brand was taken over by the Only the Brave group for two years before reverting back to her, and the designer has been responsible for the Diesel Black Gold (see p.108) design direction since 2009.

◄ **Reworking classical references in 2010 with a pleated and draped one-shouldered peplos.**

2004

Chiffon defines the body with sculptural draping, twisting and knotting in a collection that evokes the designer's Greek roots.

Double layers of shell-pink silk chiffon provide sporty femininity in roll-edged shorts and a bandeau top, worn with a bicoloured plaited belt in tones of palest terracotta and yellow. Other shorts are partnered with pleated chiffon tops patchworked in sherbet yellow, pink, oyster and pale blue, the predominant colour palette throughout the collection. Millefeuille layers of raw chiffon are shaped into a bra top over a chiffon tank, and, elsewhere, high-gloss fine pleats of chiffon form a columnar skirt below a bra-framing bodice. Pale blue is teamed with terracotta to form a draped one-shouldered top worn over an oyster-coloured skirt. Swarovski crystals are scattered over a sleeveless dress and across the bodice of a transparent tunic.

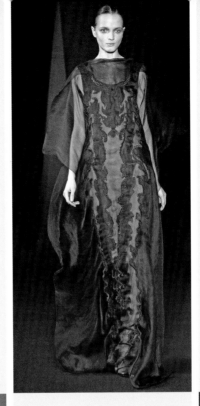

2009

An Egyptian-inspired collection in lapis lazuli and gold.

Python skin is shaped into a bolero, accompanying a delicately pleated, draped skirt in gold. Gilded python also appears on a dazzling mini-dress, along with shaped paillettes and stud work. Drawn threads and beadwork form a regal faux collar on a black sheath dress, and skinny low-rise trousers with midriff-baring shaped jackets with raglan sleeves and raised collars are secured with a simple stiffened loop.

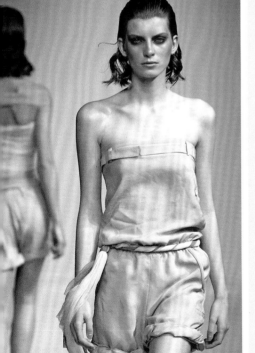

2008

Grecian detailing and motifs on matt black, worked into tunics, trousers and leggings.

A sheer and opaque organza evening gown with delicately detailed and appliquéd rococo flourishes running vertically from hem to neck provides sensuous gothic glamour for autumn/winter. Curlicue cut-outs and quilted coils of fabric decorate the neckline of matt black knee- and ankle-length dresses. Sleeves constructed from eddies of fine pleats end in a frozen upturned wave at the elbow – an effect seen elsewhere on twisted and knotted print dresses. A lyre motif forms the bodice of an ankle-length bias-cut sliver of silk-satin.

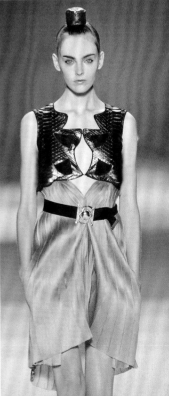

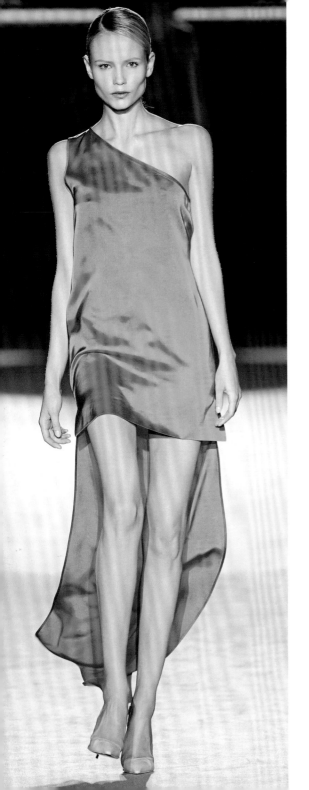

STELLA McCARTNEY

www.stellamccartney.com

British-born designer Stella McCartney (1971–) is renowned for her sharp tailoring, ultra-feminine sexy clothes and her strict adherence to vegetarianism, which results in all her collections being fur and leather free. Following a brief internship at Christian Lacroix (see p.96) and a period working for Savile Row tailor Edward Sexton, McCartney went to study at Central Saint Martins College of Art & Design, where her graduate show was notable for being modelled by family friends Naomi Campbell and Kate Moss.

Her appointment as creative director of Chloé (see p.90) in 1997, two years after her graduation, led to accusations in the fashion press of publicity seeking by Chloé. However, the designer quickly asserted her authority over the label with her Savile Row–inspired tailoring and vintage lace petticoats. She was assisted at Chloé by Phoebe Philo (see p.244), who later replaced her as creative director when McCartney left to launch her own label in 2001 under the umbrella of the Gucci Group. Accessories and fragrance followed, and in 2007 an organic skincare line, CARE, was launched.

In 2000, Paul McCartney presented the VH1/*Vogue* Designer of the Year Award to his daughter. She launched a line with Adidas in 2004, adding a further line, Gym Yoga, in 2007. In 2005, McCartney designed a range of clothing and accessories for high-street label H&M. In 2009, she collaborated on a childrenswear collection with retailer Gap, which led to her own children's line, Stella McCartney Kids, in 2010.

◀ **Minimal detailing in luxurious fabrics results in grown-up easy-to-wear glamour in 2010.**

1995 McCartney's graduate collection from London's Central Saint Martins College of Art & Design.

All the elements of McCartney's future signature style are evident in this two-piece suit modelled by Naomi Campbell. Precision tailoring is shown in the hip-length jacket with sharp revers released from a single central button, and in the mid-calf pencil skirt that creates a long lean silhouette. A 1970s-inspired silk shirt, with a deep wide collar and pointed cuffs, combines femininity with sophistication. A skinny bustier top dress with a gathered skirt is worn by Kate Moss. The collection was bought up by London boutique Tokio.

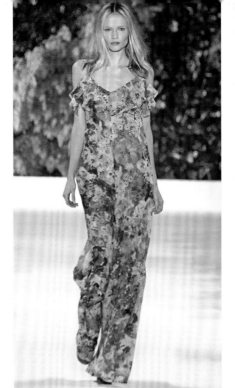

2010 Inspired by McCartney's mother Linda, a collection of denim and printed apron dresses.

The simple button-through denim skirt in two lengths – mini and just below the knee – heralded a multitude of copies, from mass-market brands to designer labels. Here, it is worn with a tailored blazer and a lingerie-inspired top of guipure lace. The laid-back informality is maintained by simple gathered skirts and vest tops, billowing white shirt dresses and easy-fit jersey. Egg-yolk yellow, royal-blue and flame-orange satin taffeta, fashioned into high-waisted hotpants and frilled muumuus, provides contrast.

2008 Sharp tailoring is juxtaposed with ruffles and all-over floral prints drawn from an English country garden.

A multicoloured floral chiffon all-in-one, with ruffled bodice and shoestring straps, represents the designer's continuing preoccupation with the styles of the 1970s, which also includes high-waisted flat-front trousers worn with short-sleeved belted safari jackets in cotton drill. Elsewhere, oversized shirts in washed-blue silk and playful printed romper suits appear. Crisp A-line skirts are worn with white muslin blouses accessorized with 1970s wedges. Knitted woollen swimsuits are patterned with a multidirectional shark motif and the classic twinset is given an edge with the sweater extending into an all-in-one body, partnered with a lightweight cardigan.

TEMPERLEY LONDON

www.temperleylondon.com

The Temperley London label has found a niche in the global market with its essentially British approach to fashion, which includes an eclectic range of decorative sources providing a boho edge combined with discreet eccentricity. Designer Alice Temperley (1975–) uses intricate beading and embroidery, intarsia knits, in-house-designed prints and leather for her London label, which she and husband Lars von Bennigsen launched during London Fashion Week in 2000.

After Temperley graduated from Central Saint Martins College of Art & Design, she studied fabric technology and print at London's Royal College of Art. Initially, the designer launched under the label Alice Temperley. She was awarded English Print Designer of the Year in 1999 and Young Designer of the Year at the *Elle* Style Awards in 2004. Following the first Temperley boutique in London's Notting Hill in 2002, three further stand-alone stores have opened their doors in New York (2003), Los Angeles (2005) and Dubai (2008). She produces four collections a year, including ready-to-wear, bridal, accessories and an exclusive Black Label range of evening dresses.

A sister line, ALICE by Temperley, was launched in 2010 and consists of four collections a year. Designed in London's Notting Hill, the label embodies the London look with affordable and easy-to-wear separates. For her A/W 09/10 show, Temperley hosted a two-day presentation with a simultaneous online multimedia video launch rather than a catwalk show.

◄ **Lace and leather for a seductive silhouette and signature embellishment in 2008.**

2003 Ermine-tipped White Russians and Léon Bakst ballet references.

Scattered with black-beaded and perforated fabric discs, this princess-line prom dress in ecru affirms Temperley's preference for monochromatic patterning. Elsewhere, white tasselled beading on black sweater dresses and cropped jackets in white felted wool decorated in black suggest the traditional dress of the Cossacks. A textured turtleneck is edged at the neck and extended cuffs with black binding, and partners a black frilled mid-calf skirt.

2010 Alluding to characters from the *commedia dell'arte*.

Horses canter across the broad leather belt of this single-sleeved scarlet dress with circus frills falling off one shoulder. It is embellished with brass studs across the hem and neck. Elsewhere, intarsia knits feature harlequin patterning, and striped tops are layered under a sleeveless jumpsuit and a purple tank top. Stripes run vertically on the peplum of a purple blouse, worn with a grey jacket and a ringmaster's top hat.

2007 Bold colour – cobalt blue and orange – and lace and gilded embellishment are injected into an autumn/winter collection of graphically defined tailoring.

A cobalt-blue chiffon blouse with gently gathered sleeves and a corded black collar is worn with a silk velvet bolero and a crisply pleated tulip-shaped skirt that has a broad black patent belt threaded through tabbed and buttoned loops. Satin-bound belt loops also appear on dove-grey pantaloons, gathered to just below the knee, and worn with a black chiffon blouse with lace insertions. Demure coats and dresses with outsize Peter Pan collars and accessorized with fur scarves have bound button bands and pockets – the binding following the line of the seam to the yoke and the shaping of a raglan sleeve. Fit-and-flare dresses in bright orange or cream fall in double-layered chiffon from a deep jewelled yoke, either worn over velour tights or falling to the ankle. Prints are styled into abstract paisleys, appearing on the hem of silk smock dresses beneath simply cut coats in black.

THAKOON PANICHGUL

www.thakoon.com

From its inception in 2004, the Thakoon label has explored clear uncomplicated looks in coordinated fabrics with little dramatic touches effected by textural or colour contrasts. This angst-free approach has won the designer a growing fan base, which connects with the understated and wearable femininity of the label, something that attracted Michelle Obama as a client in 2008. US *Vogue* magazine's own first lady, Anna Wintour, also endorsed the brand, which led to Thakoon gaining a contract with Gap in 2007.

Thakoon Panichgul (1974–) was born in Chiang Rai Province, Thailand and moved to Omaha, Nebraska when he was eleven years old. After graduating from Boston University in 1997 with a business degree, he went on to study at Parsons The New School for Design from 2001 to 2003. In September 2004, Thakoon produced his first ready-to-wear collection. He quickly became a favourite with the fashion press, top editors and stylists for his capacity to successfully absorb developments in the market and to play felicitously with garment proportion and construction.

In addition to his collaboration with Gap, Thakoon developed accessories with Nine West in 2006. He worked with Hogan and Target in 2008 and Aloha Rag in 2010. Launched in 2009, Thakoon Addition is a second more affordable line from the New York–based designer, a collection that mirrors his luxurious catwalk creations with an emphasis on wearable wardrobe essentials.

◄ **Chiffon florals, varied in scale and style, are scooped, draped and piped into layers in 2010.**

2006 Thakoon's second season held to a tight agenda of low-key gamine femininity.

A *trompe l'oeil* satin bustier dress with a panelled contrasting top and vertical pockets is worn with a beret for prim Parisian chic. Patent boots also feature, topped with crisp white pleated linen or cuffed with engraved leather. Hems and borders are decorated with white ribbon or lace, adding to the controlled chic of modulated severity. Short and three-quarter sleeves emphasize the delicacy of unadorned youthful wrists. A square décolletage on a tunic or a soft collar on a white brocade suit maintains a demure tone.

2009 For spring/summer, light surreal touches render a hint of decadence to the usual Thakoon prettiness.

Crystal organza with a soft print is pleated into opaque tiers of stripes and caped at the collar. The collection includes boots as heeled sandals, and Chanel's cardigan suits are rendered in gathered chiffon – not tweed. A modest bow-collared blouse is made racy by harem pants. The colour palette is quietly neutral except for a ruby-rich satin print that features on a short duster coat over a sprigged evening bikini. Gathers and pleats soften seam lines at the neck on raglans. Broad transparent binding characterizes a trench coat and ruched and captured swathes of chiffon add a layer of decorative fullness to goddess gowns.

2011 A seductive wardrobe of staple pieces from the boudoir forms the unifying narrative.

A smocked shift dress in nude mousseline is trimmed with the hook-and-eye tapes of the corsetière, in contrast to a crisp biker jacket in white piqué with a built-on waspie that sits above a ticking-tailed shirt fragment. A broderie anglaise tunic dress, daintily fastened by hook-and-eye tapes, is strategically panelled with opaque safari pockets and worn over a flimsy chiffon petticoat. Sprig-printed tulle tops are piped in solid shades of skinny binding, with the print recurring on loose white sateen trousers.

TOMMY HILFIGER

usa.tommy.com

As all-American as his red, white and blue logo, Tommy Hilfiger (1951–) takes Ivy League menswear classics as the basis for his relaxed sportswear ranges of button-down shirts, chinos and blazers. Hilfiger's design process relies on reworking and updating rather than inventing from fresh. The look is youthful and accessible and is matched by the pricing.

An outstanding example of resilient determination, Hilfiger, after building and losing his upstate chain of laid-back boutiques in the late 1970s, relocated to New York City to pursue a career as a freelance designer. With the backing of Mohan Murjani, the Tommy Hilfiger menswear label was launched in 1985. In 1988, Hilfiger bought out Murjani and formed an alliance with Hong Kong manufacturer Silas Chou. In 1992, the company went public and entered a period of rapid expansion, spending US $20 million annually on maintaining brand visibility. In 1996, Hilfiger introduced womenswear to the label, driving turnover above US $500 million.

The Hilfiger range of personal lifestyle products extends to childrenswear, glasses, scents, sportswear, and domestic furnishings. H Hilfiger was introduced as a premium brand in 2004. Hilfiger was sold to Apax Partners, who duly sold it on to Phillips–Van Heusen, the owners of Calvin Klein (see p.80), for US $3 billion. More recently, the collections have a strong contribution from designer Peter Som, who offers the Hilfiger canon of classics with a twist, attracting high-calibre audiences, including Jennifer Lopez and Christina Hendricks.

◄ **A red, white and blue patriot in a sea of Cossack references in the 2008 collection.**

Logoland nirvana, where the Mondrian-inspired graphics determine both the product and the label.

Harnessing a heavy marketing budget to supermodel and rap-star celebrity, Hilfiger brand management took logo visibility to another level. The dominant theme in the entire sportswear-based collection is the brand itself, with trademark colours and graphics forming the complete architecture of the product range, resulting in permanent recognition of the red, white and blue identity. The overstatement of the logo is also reflected in the exaggerated scale of numerous lines – particularly in the rapper-focused menswear with hyperbolic dungarees and anoraks.

1988

Old Glory, new money: Hilfiger's all-American yuppie palette.

Brass buttons enliven a navy jacket with velvet needlecord collar layered over a red cardigan and navy shirt tucked into a pleated knee-length skirt. The idea of status and style being accessible through buying into the implicit 'values' of the Hilfiger brand was the essential message of the highly leveraged marketing campaigns of the mid 1980s, funded by Indian designer Mohan Murjani.

2007

Clark Kent's preppy overtones are evoked by Hilfiger through the use of pinstripe, flannel duffel, club ties and Oxford shirts.

A plaid-mad miscellany dominates both the menswear and womenswear collections, subordinating other cloths from the classic British menswear inventory. A hint of the Ivy League is sustained by textured tights and crisp piqué bibs for the women and horn-rimmed glasses and half-Windsor knots for the men. Men wear an unlimited number of clan tartans, including Black watch in waxed cotton over Dress Stewart plaid trousers. Female flamboyance is contained: the flourish of opera gloves with a red shift or primary-coloured court shoes worn with pinafore dresses in neutrals. Wardrobe staples are kept fresh by exercises in re-proportioning and exaggerated detailing: a shortened duffel coat has added motion from A-line expansion.

TORY BURCH

www.toryburch.com

US designer Tory Burch (1966–) has an acute awareness of her label's position in the fashion spectrum and a clearly defined understanding of her customer. Based on her own personal experiences and preferences, she has a consistent vision of easy-to-wear chic modern clothes that reference, without being in thrall to, modern sportswear. Maintaining her distinctly US sensibility, Burch adds to the mix a slightly boho use of colour, print and texture, putting a twist on US staples with graphic prints, a bold colour palette of vibrant oranges and olive greens and ethnic detailing. The brand encompasses a ready-to-wear line, handbags, shoes and jewelry.

Brought up on a farm outside Philadelphia, Burch gained experience working at Ralph Lauren (see p.264), Vera Wang (see p.304) and Loewe before perceiving a gap in the market for luxurious sophisticated clothes at an accessible price point. In 2004, with the financial help of her now ex-husband Chris Burch – a venture capitalist who has stayed on as co-chairman – she launched her line from her uptown Manhattan apartment. A year later, Oprah Winfrey declared on air that the designer was 'the next big thing in fashion', prompting countrywide recognition of the brand. The flagship boutique in downtown New York, designed to feel more like a room in Burch's own home than a traditional retail store, was awarded the Rising Star Award for Best New Retail Concept by Fashion Group International in 2005. All her boutiques have orange lacquer doors and mirrored walls. In 2007, Burch was accepted as a member of the Council of Fashion Designers of America. Celebrity fans include Hilary Swank, Cameron Diaz and Uma Thurman.

◄ **Winter luxe with a white fur-trimmed gilet worn over a gold embellished dress in 2009.**

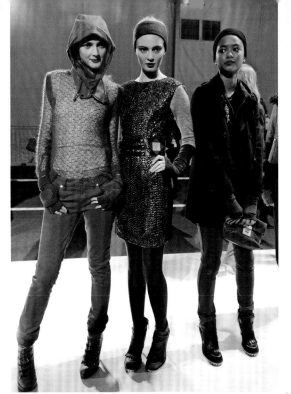

2007 An easy-to-wear versatile collection is accessorized with Reva flats.

A subtle layering of knitted dress and fine-knit cardigan worn over a printed blouse with full gathered sleeves exemplifies the ladylike formality of a collection that includes shift dresses, bound-edged trench coats and printed twinsets worn with button-through skirts. All outfits are accessorized with the round-toed ballerina flats featuring the T-logo medallion on the front, and named Reva after the designer's mother.

2011 Citrus colours apply verve to modern casual wear with a 1970s feel.

Abstract leopard-inspired animal print renders an edge of sophistication to this frilled and corseted dress that displays more than a hint of Swiss heroine Heidi's costume. Elsewhere for spring/summer, embellishment is more restrained, with drapey blouses in orange crêpe de Chine with shirt collars partnered with flirty knee-length skirts, trouser-fronted leather skirts or vertically striped trouser suits.

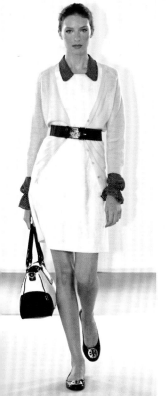

2010 An eclectic mix of flecked and checked mismatched tweeds, lightweight knits and embellished tailoring comprises relaxed high-end clothing for autumn/winter.

Low-rise blue jeans and a fine-gauge lacy knit sweater with reinforced shoulders are given an edge with fingerless gloves and hefty boots laced with Burch's favourite bright orange, which colour matches the sou'wester. A single-jersey top is worn beneath a metallic tunic dress that is pulled in at the waist with an armour-like belt. Textured leather, suede, sheepskin, feathers and felted wool are formed into jackets, shorts, cropped skirts and a sweater that declares the wearer to be 'DIVINE DIVINE DIVINE' in bold type. Elsewhere, splashed and scribbled images inspired by abstract expressionism bring playfulness to an all-in-one, worn beneath a parka in shades of royal blue. Jersey is layered under a glossy fur cape and beaver-fur gilets. Three-quarter-sleeve coats in camel are worn over frayed and textured tweeds, which are also used for a trouser suit with a cropped box jacket.

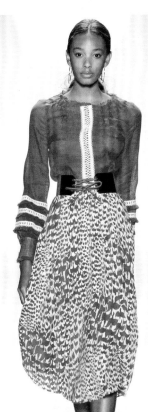

UNGARO

www.ungaro.com

One of the 1960s pioneers of the new haute couture, alongside André Courrèges and Paco Rabanne, Emanuel Ungaro (1933–) opened his couture house in 1965 with the assistance of Elena Bruna Fassio and Swiss artist Sonja Knapp. Although he had previously studied with the master couturier Balenciaga (see p.56), Ungaro rejected the couture traditions of the past, instead evolving a precision cut and unadorned silhouette entirely in keeping with 1960s minimalism, shortening skirts to unprecedented levels and using vivid colours. A menswear label, Ungaro Uomo, was launched in 1973, and his first scent, Diva, ten years later.

The renaissance of haute couture in the 1980s, a strong US dollar and the high prices being charged for ready-to-wear signalled the house's success as one of the 'big five', alongside Chanel (see p.86), Dior (see p.92), Givenchy (see p.132) and Yves Saint Laurent (see p.320). Ungaro's colourful signature look of ultra-feminine dresses in a mix of vibrant prints that drape and wrap around the body tapped into the era's desire for lavish occasion wear, resulting in international recognition for the brand and a high profile in the United States.

On retirement in 2005, Ungaro sold the label to Internet entrepreneur Asim Abdullah. A series of designers followed, culminating in 2007 with Colombian-born Esteban Cortázar, who was fired two years later after his refusal to work with Lindsay Lohan who was subsequently and controversially appointed as artistic adviser, a decision that undermined the label's credibility. British designer Giles Deacon (see p.130) was appointed by the company as creative director in 2010.

◀ **Esteban Cortázar revives Ungaro's signature ruffles and wrapped torso in 2009.**

1965 Ungaro launches his collection of bold innovative daywear.

An all-encompassing hooded cape and knickerbockers represent Ungaro's protest against fashion formality. The designer deliberately eschewed the idea of evening clothes, a couture staple, presenting only daywear in his first collection. During the 1960s, the structure of fashion experienced a period of change with the development of the ready-to-wear industry.

1980 The 'New Baroque' collection for the era of excess that was the 1980s.

This short tightly wrapped dress with shoulder emphasis is instantly recognizable as Ungaro at the height of the designer's success as couturier to New York moneyed socialites. Diagonally draped and ruched skirts, important shoulders and gigot sleeves in jewel-toned silk jacquard fabrics or print and pattern mixes in vibrant florals were the 1980s evening alternative to the power dressing of the boardroom.

1972 Restrained retro style for spring/summer daywear with the sporting overtones of tennis whites photographed in a setting of futuristic furniture.

A tailored day dress in white has a centre-front placket that opens to the hips, from where a knife-pleated skirt falls to just on the knee. A narrow self-fabric belt defines the natural waistline. In keeping with the influence of the 1940s on fashions of the early 1970s, the outfit resonates with a vintage feel, particularly when accessorized with a wrapped turban, a string of beads and 1940s-inspired white lace-up shoes with a chunky heel. The deep cuffs of the gently gathered sleeves and floppy pussycat bow are bereft of the modernism evident in Ungaro's previous aesthetic, and retain a contemporary understated practicality. During a period when fashion was in flux, with the influence of the counter-culture uppermost, Ungaro maintained his significance within the couture system by purveying on-trend bespoke fashion.

1996

A pageant of opulent garments and ornate fabrics in a collection that offers conspicuous chic.

A marabou-hemmed goddess gown in scarlet is layered to the mid-thigh beneath a floral lace overslip, accessorized with a yellow diaphanous shawl and opera gloves. Layering is a theme as the collection progresses from public event daywear through cocktail and evening wear to ambassadorial reception wear. The richness of florals and exquisite encrusted laces is tempered in daywear by plains, in the form of piped and banded jackets and coats. The wrapped sarong skirt and the tunic coat surface intermittently.

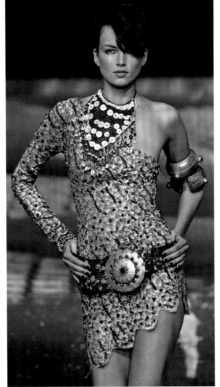

2003

A collection born of the *fin de siècle* boudoir, evoking the decadence of the Moulin Rouge.

A florid tip-tilted veiled hat and floating peignoir accompany a peach silk-satin bias gown, cut to cling to the body, in a couture collection that celebrates the lavish excess of the belle époque. Tea dresses in faded florals are reworked into draped bodices with a deep décolleté. White rose-printed dresses plunge in a deep 'V', filled with strings of jet, while silk tulle fizzes on the shoulders. A fitted jacket worn with printed harem trousers features a surreal appliqué of a cigarette drooping from a red-lipsticked mouth.

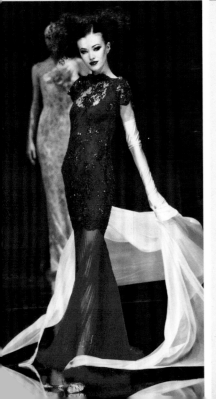

2001

An haute couture collection for autumn/winter inspired by a plethora of cultural and historical references.

This one-shouldered dress is shaped like an animal skin casually drawn around the body. The patterning of the animal is replicated by various shaped paillettes in the camouflage colours of shades of brown. A broad studded belt placed low on the hips is fastened with a circular brass buckle, and the neck is adorned with tasselled beads and cowrie shells. Other cultures are summoned to the catwalk, from ankle-length chitons, to embroidered sarongs and draped cholis. Feathers appear at the neck of transparent lace dresses with fishtail hems, and the influence of Paul Poiret can be seen in the embroidered silk and velvet opera coats.

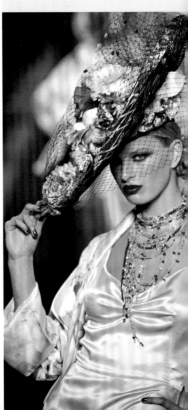

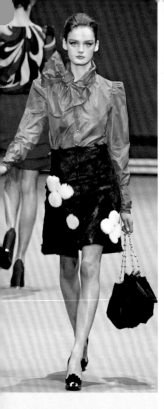

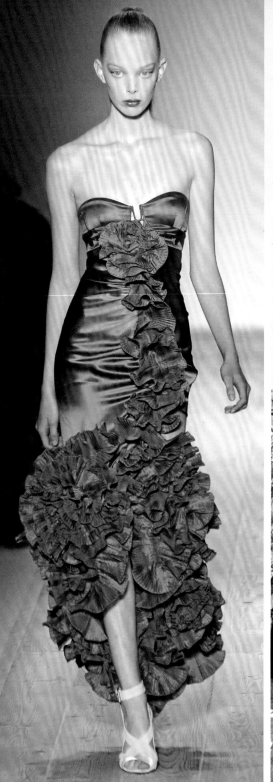

2006 Norwegian
Peter Dundas
creates high-
octane glamour.

Cascading gathered frills
in pleated and piped
satin fall from a strapless
turquoise bodice, forming a
flamenco-style trailing skirt.

2011 Giles Deacon's
debut represents
a return to
vivacious glamour.

A lace blouse with a
tie neckline tucked into
cropped trousers features
in a collection of frills and
lavish embellishment.

2005 A decorous
collection by
Vincent Darré for
autumn/winter.

Outsize gigot sleeves
feature alongside equally
eye-catching bows at the
neck, as seen in this burnt-
orange blouse in washed
silk. It is worn with a black
shearling skirt decorated
with playful fur pompoms
– a feature also essayed
on a dyed jade shearling
coat with appliqué fur
flowers. More formal
are slim-fitting coats and
skirt suits in geometric
patterned weaves worn
with narrow belts.

VALENTINO

www.valentino.com

With celebrities engaged in pursuing the *dolce vita* signing up to his version of dramatic and intricately detailed opulence, a level of international distinction has been accrued by Italian designer Valentino Garavani (1932–). His über-glamorous designs are the fruit of half a century of design output, beginning with his exodus to Paris to study at both the Ecole des Beaux-Arts and the Chambre Syndicale de la Couture Parisienne. While in Paris, he was apprenticed to Jacqueline de Ribes at Jean Desses, later moving on to work for Guy Laroche.

Valentino returned to Rome to open his own small atelier in 1959. The following year, he moved his business to the Via Condotti and to another level of acclaim. Valentino's long-time business partner Giancarlo Giammetti lent his entrepreneurial strength to the development of the Rome-based couture house, which, in 1967, introduced both the celebrated 'White' collection and 'V' logo and label, winning the prestigious Neiman Marcus Award. In 1969, the designer opened his first ready-to-wear stores, in Milan and later in Rome, leading to a consolidation and expansion of his label throughout the 1970s and into the 1980s.

Valentino was inducted into the French Légion d'honneur in 2006 and retired in 2007 after five decades of design work. He marked the event at a final show in Paris by appearing amid thirty models adorned in Valentino red. Former Gucci designer Alessandra Facchinetti took over as head designer but was replaced after her S/S 09 collection by Maria Grazia Chiuri and Pier Paolo Piccioli, who together had previously designed accessories for the brand.

◄ **Valentino haute couture designed by Maria Grazia Chiuri and Pier Paolo Piccioli for S/S 11.**

A couture version of hippie de luxe, photographed by the Arch of Constantine in Rome.

Providing a luxurious version of the new length – the maxi – Valentino taps into the contemporary trend for ethnic-inspired colour and patterning with this textured patchwork coat with the Positano foulard design. Cut with a narrow torso and high arm scye, the coat has an empire-line waist – marked with a narrow belt – and a neat high collar, both of which emphasize the long lean lines of the silhouette. A high-crowned hat with a wide undulating brim further recognizes the infiltration of hippie style into high-end fashion.

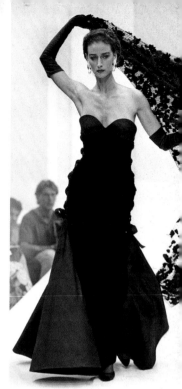

1968 **Valentino's celebrated 'White' collection – an all-white spring/summer collection famous for the 'V' logo – is shown in Rome.**

The 'White' collection was modelled in the Rome apartment of US non-figurative artist Cy Twombly. Pearl-encrusted jackets over ankle-length dresses are matched for glamour by the man's frilled shirt and Nehru-style jacket. Elsewhere, a knee-skimming A-line coat has the signature 'V' notched into the top of two pairs of matching pockets; another features a pin-tucked midriff. Both are accessorized with a deeply crowned hat to accommodate the bouffant hairstyles. By the mid 1960s, Valentino was considered the undisputed leader of Italian couture, dressing the international jet set, including Elizabeth Taylor and Marisa Berenson, and in 1968, he designed the white lace dress that Jacqueline Kennedy wore for her wedding to Aristotle Onassis.

1989 **Uber-glamour on the runway at the haute couture show in Paris.**

A devoré lace wrap accompanies a seductive strapless black velvet evening gown with a sweetheart neckline. The sensuous lines of the dress are disturbed by the triangular godets of silk taffeta, inserted at thigh level to billow around the ankle, marked with a ribbon bow. Resonant of the gowns of screen goddess Rita Hayworth, the *Gilda* (1946) moment is emphasized by the elongated opera gloves.

1995

A series of haute couture little black dresses and tailored daywear.

Naomi Campbell models a halter-neck dress featuring a draped duchesse satin detail on the skirt, worn with ribboned opera gloves and a black and white fascinator. The scalloped edge of black lace forms the bodice of a boudoir-inspired cocktail dress inserted between side panels of finely pleated chiffon. Daywear relies on tailored suits with pencil skirts and square-cut shoulders, buttoned to the neck in various shades of pink.

2005

Rural classics are given an urban sophistication in noble fibres.

A shearling double-breasted coat with soft tie belt is alternatively fabricated in luxurious vicuña. Elsewhere, chunky sweaters – in Aran patterning and natural colours – and wrap cardigans with shawl collars partner classic windowpane tweeds, pinstripes or grey flannel. Fur is worked into chevrons to form a sleeveless gilet, with a high rib-knitted neck, worn over a horizontally ribbed jumper. Oilskin capes in putty provide protection.

2003

The distinctive 'rosso Valentino' – Valentino red – is a patented crimson colour and the house trademark, first seen as a cocktail dress in the designer's debut collection of 1959.

A sunray pleat is cut on the bias to produce a flared effect, shown here on an ankle-skimming evening dress from the ready-to-wear collection. The pleats end in a broad double band, adding to the width at the hem, a technique that is seen throughout the range on both short and long day and evening wear. The dress, in signature Valentino red, is held at the waist with a broad taffeta ribbon, the bodice constructed from ostrich feathers, dyed to match. It is one of a series of red gowns that includes a bias-cut dress formed by diagonal bands of alternate matt and glossy duchesse satin and a columnar frilled dress cut straight across the bodice with shoestring straps. Elsewhere, a rich Palma violet is worked into a duchesse satin trench coat worn over a matching skirt and lace top; black with old gold creates luxurious evening wear impact.

2010
A romantic collection of ethereal dresses in weightless fabrics.

A spiral of lemon-coloured silk organza is caught at the waist before unfolding into a waterfall of undulating layers to the hem of the dress.

2011
Ultra-feminine ready-to-wear by Chiuri and Piccioli for Valentino.

A black lace skirt and white top, delineated with pearls, in a collection of demure shapes that rely on transparency and embellishment for effect.

2007
The debut haute couture collection by Alessandra Facchinette.

A form-fitting suit of pencil skirt and moulded jacket, with square buttoned pockets positioned at centre front and hem, has a stand-away collar, outlined in silk-satin and tied off-centre with a bow. Eschewing the Valentino archives, Facchinette concentrates on restrained tailoring with artisanal detailing such as intensely worked surfaces in luxurious fabrics, including furs, in a cool colour palette dominated by greys and blues.

VANESSA BRUNO

www.vanessabruno.com

Vanessa Bruno (1967–) creates prêt-à-porter fashion for the sophisticated professional woman who espouses bohemian values as epitomized by Vanessa Paradis, Charlotte Rampling and Charlotte Gainsbourg – all of whom are clients. Bruno is known for her incisive tailoring and refined approach to layering. Her accessories, in particular, have achieved cult status. Bruno's tote bag, the *sac cabas*, and her soft leather Lune bag, named after her daughter, are key parts of each season's collection. Her particular fashion sensibility is attributed to her family background and training. Bruno's mother was a Danish model and her father founded the influential Emmanuelle Khanh label, which was at the vanguard of the French ready-to-wear movement in the 1960s. Bruno became a model at fifteen, but later chose design as a career, training in Paris under Dorothée Bis and Michel Klein.

Her designs first appeared in 1996 in Paris's high-end Le Bon Marché department store, where they attracted a loyal clientele. Like fellow French label agnès b. (see p.32), Bruno's collections are very popular among the Japanese. Her first boutique opened in 1998 in Paris, followed by branches in Tokyo, Australia, Taiwan, South Korea and Kuwait. A London branch opened in 2010. Her eponymous label is complemented by a diffusion range, Athé, which presents an understated and more relaxed version of her designs, distilling current trends in an affordable and accessible way. Bruno has also created ranges for the catalogues La Redoute and 3 Suisses.

◀ **Boudoir prints inspire a cobweb collection of prim lace and leather cuffs for 2010.**

2007 Victorian gothic meets modern urbanite, and romantic minimalism is reinvented.

A hooded cowl top emerges from beneath a severely tailored jacket to wind around the shoulders in an extended scarf. The monochrome palette segues from winter white to charcoal, with an elusive flash of camel. Heeled ballerina cross-strapped shoes soften the austere silhouette, as do the materials used: cashmere for tights, silk-satin and wool. Isadora Duncan scarves appear over conservatively buttoned blouses. Strictly belted kimonos are the most extreme examples of the many cinched waists on coats and dresses.

2011 Hawaiian garlands bloom on canvas bags, accessorizing feminine 1950s-inspired prints.

Tailored orange shorts, lace tops with cut-outs, wispy all-in-ones, simple summer dresses and floral 1950s housecoats are all accompanied by boldly printed tote bags. Bruno also offers faded baby-blue Cacharel-inspired prints, worn with printed shifts, shorts, low-hipped jackets and delicate sandals, finished with ruffles of coordinating fabric. Tones of bold parrot blues vie for attention in embroidered shirts worn with cropped trousers and printed riding boots. For evening, lilac and copper silk shorts suits emerge.

2009 Shorts suits by day, Studio 54 by evening: 1970s drapery plays with a metallic colour palette for spring/summer.

The simple lines of straight-cut shorts contrast with the volume of shrugged-on boyish jackets and billowing Princess Leia capes. Plunging maxi-dresses in white are cinched and slashed to expose the torso, while cinematic references to *2001: Space Odyssey* (1968) are seen in shifts and cowboy lacing. Bruno's favourite silks dominate in hues of burnt orange, mustard and brown, contrasting spectacularly with flashes of Space Age gold. For evening, jet-black dresses with jagged necklines are suspended over baggy T-shirts, while alien life forms meet the renaissance in 1980s bodies, slashed with gold and finished with stiff ruffled boleros.

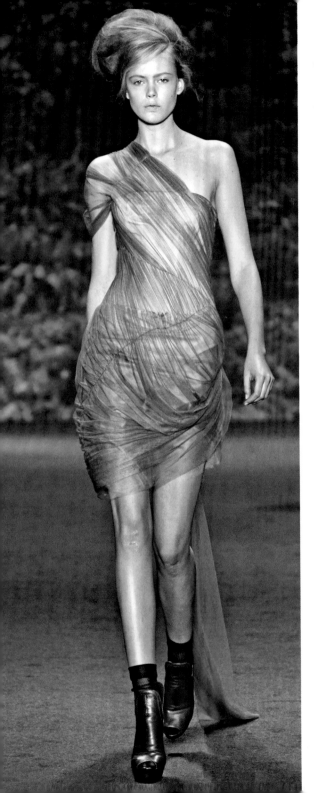

VERA WANG

www.verawang.com

One of the best-known names in the luxury wedding gown market, Vera Wang (1949–) started her company after her own unsuccessful search for the perfect wedding dress. Born in New York City to Chinese parents, Wang initially planned a career as a professional ice skater, but while also studying at the Sarah Lawrence College she found the training too demanding. She spent a brief period in Paris before returning to the United States to study for an art history degree in 1971. Wang's first job in fashion was at *Vogue* as an assistant to fashion director Polly Mellen, becoming senior fashion editor at the age of twenty-three. Wang left the magazine after sixteen years and, in 1987, went to work for Ralph Lauren (see p.264), where she was employed as design director of accessories.

On her marriage to businessman Arthur Becker in 1989, Wang found that the majority of wedding gowns were aimed at the younger bride, and that there was a niche in the market for the understated elegant dress. The business was launched in 1990 out of a salon in the upmarket Carlyle Hotel on Madison Avenue in New York. Wang's success in the competitive world of bridal fashion was in part due to her elevating the whole consumer experience to encompass all aspects of the ceremony, creating an image of exclusivity and luxury.

In 1993, the Vera Wang evening wear line was introduced. Arbiter of the high-end wedding, Wang released her first book, *Vera Wang on Weddings*, in October 2001. Her first scent was launched in spring 2002 under agreement with Unilever Cosmetics International. She presented the accompanying men's fragrance in 2004.

◄ **Skeins of intricately pleated silk chiffon are drawn across the body in the 2011 collection.**

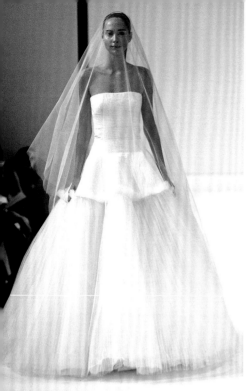

Silks, satins and lace with discreet transparency provide boudoir femininity for spring/summer.

A delicate accordion-pleated edge-to-edge jacket is caught in at the waist with a ribbon of nude-coloured lace, and worn with a matching skirt that frills out into a froth of chiffon tendrils. Elsewhere, lace insertions are added to define the seams of the high-waisted evening wear that features muted floral prints. These pieces end in Wang's signature fishtail hem, a feature that also appears on slithery cream silk-satin bias-cut dresses that are redolent of 1930s Hollywood glamour, the draped bra tops suspended from invisible straps.

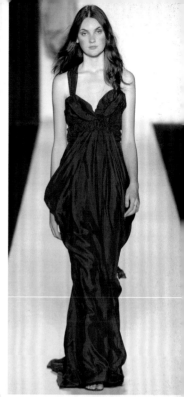

2000 **Minimal decoration and a clean-cut silhouette are key to the Wang bridal aesthetic, which combines high fashion with tradition.**

A boned strapless bodice extends to a circular peplum that sits above the layers of a swirling silk organza ball skirt. It is accessorized with an unadorned silk tulle veil that is allowed to fall in simple folds, following the line of the dress. With the introduction of her bridal gown line, Wang offered brides an alternative to the tiara, taffeta and crinoline excesses of the 1980s. Renowned for her philosophy of less is more, she popularized the strapless bodice when previously it had been deemed inappropriate to leave arms and shoulders bare during the wedding ceremony. Wang's tubular silhouette, often with a fishtail hem and understated embellishment, offered a new sophistication and elegance for the high-end fashionable wedding.

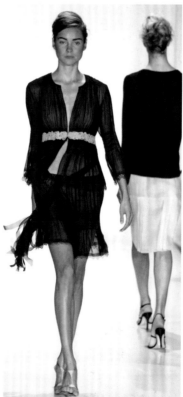

2006 **The Wild West is tamed with rich brocades and Matisse colours.**

Inspired by the mythical 'good-time gal' of the Western saloon, Wang introduces an element of déshabillé into this evening dress of maroon silk taffeta. Elsewhere, moiré taffeta and brocade are worked into jackets with gigot sleeves and balloon-shaped skirts, all toughened up with leather belts and sturdy sandals. Deconstructed satin jackets are thrown back off the shoulders and held together with ribbon ties.

VERSACE

www.versace.com

Renowned for the exuberant excess of his designs, Italian-born Gianni Versace (1946–97) was the instigator behind the glamorizing of fashion during the era of the supermodel, putting the top five – Christy, Linda, Naomi, Tatjana and Cindy – together on the catwalk in 1993. Versace was born in the town of Reggio Calabria in Italy and began his career as a designer in 1972, working for Complice, Genny and Callaghan, before starting his own label in 1978.

Versace's logo of the Medusa's head alludes to the classical historical references evident in the designer's work, a decadent mix of mannerist-inspired prints and ultra-sexy dresses, including the safety-pin wonder that put the designer's name on the front of every newspaper when it was worn by British celebrity Elizabeth Hurley to a film premiere. In 1989, he opened Atelier Versace, a couture workshop, and throughout the following decade the designer pioneered form-fitting clothes in dazzling colour combinations for the super rich. Versace launched Versus, a more youthful line, in 1990 under the directorship of Donatella, his sister and muse.

On her brother's untimely death in 1997, Donatella Versace took over responsibility for the label. Under her aegis, the label has moved away from the über-glamour of the Gianni years to offer a more restrained aesthetic rooted in fabric manipulation, such as draping and pleating, and devoid of decoration or embellishment. Donatella is chairperson of London's Fashion Fringe, a competition devoted to finding and nurturing new talent. Since 2009, British designer Christopher Kane (see p.100) has been creative consultant to the label.

◄ **High-voltage glamour in a metallic leather dress by Donatella Versace for 2010.**

1991 Florid shapes and colours with classical allusions are combined with surrealism and pop art.

Vividly coloured prints appear on an abbreviated dress worn under an outsize jacket with turned-back cuffs. Worn by glamazons, the gym-honed power-dressing women of the era who epitomized old-fashioned Hollywood glamour in contrast to the prevailing fashion for waiflike models, Versace's style represented the death of grunge and established the relationship between fashion and celebrity. The designer's obsession with famous faces was also evident in ankle-length dresses printed with images of Marilyn Monroe and James Dean.

1994 Modern haute couture in a fairly restrained spring/summer collection by Atelier Versace.

A draped-bodice dress with a short pleated skirt in metallic silk jersey appears in a neoclassical-inspired collection of togas and full-length fluid goddess dresses. In 1994, Versace attracted global editorial coverage for his safety-pinned dress, and the ready-to-wear collection has many iterations of the pin as jewelry as a closure mechanism to contain seismic faults in slotted dresses. The Atelier Versace collection is more grown-up with only subtle reminders, such as the gilt lion-headed dungaree clasp of a sheath.

1992 Full-blooded Versace hyperbole, pitching supermodels into the realm of Parisian catwalk celebrity.

A celebration of regal excess with lavish embellishment on a checked tweed jacket and a gold lace tutu is worn by supermodel Christy Turlington. Elsewhere, floor-length gold trench coats are decorated with rich armorial linings in a cerulean, sable and golden ogee print. Linda Evangelista's flares flash from within, in flame red, and a leather gilet in gold-spattered white pins down a simple white shirt. Inciting a global paroxysm of conspicuous consumption, the Versace brand created an ambience of decadence. Gold everything was permissible: from fringes to lamé suits to lace, burnished and bordered with gilded surfaces.

2000 Exemplifying Versace's overt sexuality, this dress was a red carpet hit when worn by Jennifer Lopez.

Floating free from a single clasp low on the hips, the dress of transparent chiffon in a vivid jungle print reveals the contours of the body, modesty preserved by a pair of matching knickers and the judicious use of body tape. Elsewhere, halter necks and minimal wraps on ankle-length dresses supply the same sexual charge, as do skintight satin trousers in black, peach and olive green worn with bustiers, fitted suede jackets or diagonally striped sleeveless tops. The same stripes feature on knot-fronted dresses.

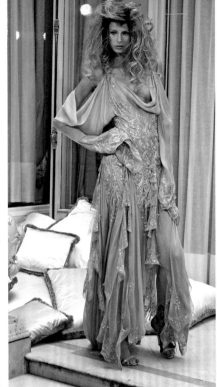

2005 A landmark collection forges a change in direction by diffusing sex with softness.

Signature gold Versace print on a knee-length dress shows the label's new approach, a restraint seen elsewhere in the cover-up printed shirts, softly draped wrap dresses and the muted colour palette of oyster, pink, lilac and lemon. However, satin button-through shirt dresses are left undone to the thigh. Nude-coloured silk-jersey swimsuits are barely there and knee-length halter-neck flirty dresses are lengthened and split to the thigh for evening. Cream safari-inspired jackets with tailored shorts provide off-beach glamour.

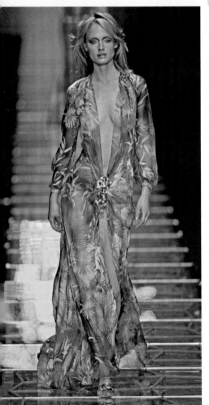

2003 A small haute couture collection of pastel goddess dresses with technically sophisticated embellishment.

A cowl-neck dress, suspended from embroidered straps, drapes revealingly across the breasts before segueing into a bias-cut torso of metallic embroidery. Embellished godets cascade to the floor and sleeves extend over the hand in a medieval-inspired point. Eschewing the slashed to the thigh and plunging décolleté of the signature Versace style, Donatella offers more subtle and covert sexiness, relying on luxurious fabrics for effect: a marabou jacket half conceals a dress comprised entirely of diagonal shell-pink chiffon frills, and the skirt of an eau-de-Nil dress is intricately embroidered with single strands of ostrich feather.

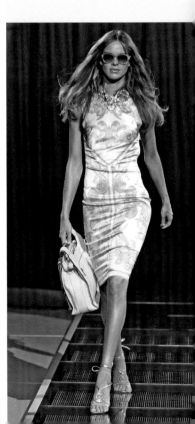

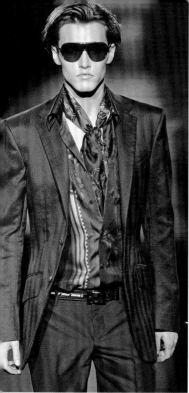

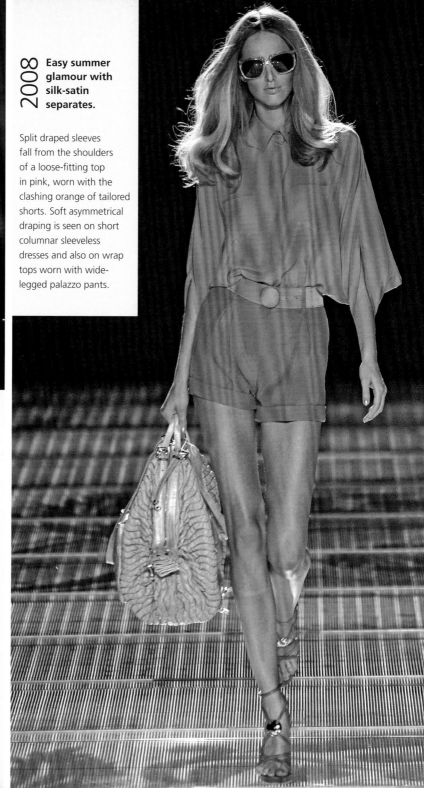

2008 Easy summer glamour with silk-satin separates.

Split draped sleeves fall from the shoulders of a loose-fitting top in pink, worn with the clashing orange of tailored shorts. Soft asymmetrical draping is seen on short columnar sleeveless dresses and also on wrap tops worn with wide-legged palazzo pants.

2006 Body-con tailoring from Donatella incorporates shine: silk-satin and high-gloss mohair.

A shot-silk two-button long and lean jacket is worn with a silk-printed shirt, matching cravat and low-rise trousers. In contrast, grey worsted is worked into trench coats and oversized aviator jackets. Second-skin grey denim is cut tight on the thigh with a small flare at the ankle, and is also seen in white with a navy two-button blazer and cravat. Black leather gloves lend a sinister edge. Sportswear is acknowledged with narrow satin trousers featuring rubberized kneecaps, worn with a hooded sweater and ribbed gauntlets.

VICTORIA BECKHAM

www.victoriabeckham.com

Widely experienced in visibility management, Victoria Beckham has made an astute transition from pop star through golden coupledom to successful red carpet designer, sporting her own name fragrances. With five collections drawing accolades from the industry and press, Beckham is finally achieving fashion credibility and confounding scepticism that she is the designer behind the brand. Beckham's first foray into design was a limited edition line for Rock & Republic called VB Rocks in 2004, followed by a range of sunglasses in 2006 and a denim label dVb Style.

Beckham's initial aesthetic incorporated a tailored body-con style with minimal adornment that moulded the body from neck to mid calf. As the scope of the dress range has grown – from twelve pieces in 2008 to thirty pieces for S/S 11 – likewise brand Beckham, owned by the 19 Entertainment group of Simon Fuller, has expanded to include denim, eyewear, fragrance and accessories. Beckham's intelligent distillation of glamour dressing has produced an innocuous array of event gowns that – within the parameters of a few simple silhouettes – flatter the gym-fixed figure. Each tightly edited collection has since offered variations of this signature look, with the designer now incorporating draping and innovative cutting techniques for a softer more fluid silhouette. In 2010, the label presented handbags in collaboration with accessories designer Katie Hillier. Beckham was nominated for the Designer Brand of the Year at the 2010 British Fashion Awards.

◄ **Beckham extends her repertoire to encompass coats in 2011, alongside the trapeze-line dresses.**

2009 Beckham's second collection of twenty-three sculptural pieces.

A streamlined silhouette for autumn/winter is formed by subtle adjustments to a form-fitting, below-the-knee dress with a slightly stepped hem, the strapless bodice folded back at an angle. Elsewhere, this line is interrupted by a deep curved peplum forming an hourglass shape, emphasized by the curved bust darts on the bodice extending to an elevated shoulder.

2011 A collection of tucks and pleats with draping for spring/summer.

Lightweight parachute silk is draped and folded into an ankle-length gown, caught at the waist in a loose knot and split to the crotch for red carpet glamour; a shorter version appears in intense violet. Crêpe dresses are carved into Beckham's signature hourglass shape with cleverly curved seams, and extend to the ankle for evening. In contrast, shift dresses skim the body in egg-yolk yellow.

2010 A body-sculpted collection of complex and subtle pattern manipulation, referencing 1930s comic book *Dick Tracy*, softened by draping, tucking and pixelated patterning.

Artfully deployed arrow-shaped seaming across the hips and an oversized zip snaking up the back of the dress provide the contours of this futuristic dress. The centre-front line extends into an asymmetrical fold, finishing on the shoulder of a slashed high neckline; the whole dissected by a broad grosgrain band. In contrast, a mid-thigh burnt-orange dress in wool crêpe bypasses the waist. It has tucks and folds at the neck and hem, and the sleeves are cut in one with the bodice to form a seamless whole. The same silhouette appears sleeveless for evening, the armholes and neck left raw. For the red carpet, a strapless dress in royal blue is deceptively simple, wrapped around the torso and held at the breast with a fold of fabric. Grosgrain ribbon also holds in place the asymmetrical draped bodice of a nude silk-jersey gown that clings to the body before pooling in a fishtail of fabric at the floor.

VIKTOR
& ROLF

www.viktor-rolf.com

Claiming a radical change at the interface of art and apparel, Viktor Horsting (1969–) and Rolf Snoeren (1969–) teamed up as fashion students at the Arnhem Academy of Fine Arts in 1992 and moved to Paris. Initially working as interns for labels such as Maison Martin Margiela (see p.208), they produced their own clothes to show in art and fashion circles. In 1993, their first public collection, refabricated from existing garments, won three prizes at the Salon Européen des Jeunes Stylistes. Viktor & Rolf presentations – like many in this genre of imaginative showiness – belie proposals of eminently wearable garments.

They presented, in 1998, their first underground and unauthorized 'haute couture' show during Paris Fashion Week as a successful act of press provocation. Their show concepts have remained rigorous throughout the trajectory of their brand development: a brand that now boasts ready-to-wear, menswear (named Monsieur) and fragrances for women and men. Le Parfum was a limited edition perfume that could not be opened and had no scent. This esoteric experiment contrasts with their mass-market collaboration with H&M in 2006, which sold in twenty-four countries and 250 stores.

Behind the 'folie-à-deux' indulgences, Viktor & Rolf has consolidated its place in the global panoply of designer brands. More significantly, its diffusion look is accessible, while the designers' visibility as artists – with sixteen exhibitions in numerous countries to date – outreaches most other design houses.

◄ **Sugared-almond shades feature with black sculpted tulle and pleated silks for 2010.**

2003 Tonality and geometry in a show-closing poly-collared suit.

The autumn/winter collection opens with a solitary Tilda Swinton as a mannered auburn Hamlet in stark black. She is illuminated by the white of a loose shirt. The collection explores the rescaling and replication of recognizable garment components, with some outfits comprising five jackets. Collars and lapels go forth and multiply; minimal coats are in contrast to multi-buckled trenches.

2008 A monochrome collection uses classic formal fabrics as a canvas.

A grey trench coat that morphs into the word 'No' implies the theme for a collection that is purportedly resisting the fast-changing pace of fashion. With the ingenious restructuring of garment volumes and the liberal use of metallic staples, tent coats become pleated hobble skirts, or a rectangle of fabric turns into a fitted skirt by the folding and fixing of triangular flaps.

2007 Theatricality apart, the creativity of the label is evident in the refinement of cut and fabric. Dismantled and re-proportioned, the garments make wardrobe sense.

In the autumn/winter collection, horizontal pin-tucks across the bodice evolve into full gathered sleeve heads. Sedate prints are animated by geometric beadwork, reflecting the heavy beaded chokers that add an historical resonance. Centres of gravity are implied within silhouettes by a variety of means: immaculately controlled pleats eddy into scrolls of fullness at the shoulder or a jacquard braid is clustered as an elaborate flounce at the waist. The perimeters of layers and garment panels are defined by piping, while elsewhere a jersey tabard is edged in *trompe l'oeil* cables rendered in welts of clustered silver beads. Close examination reveals a sophisticated coherence in fabric qualities: the quiet check of a blouse later becomes the trim of a print dress, and the beaded floret on a top is echoed on heeled clogs painted blue and white.

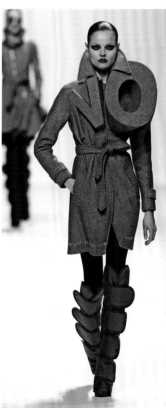

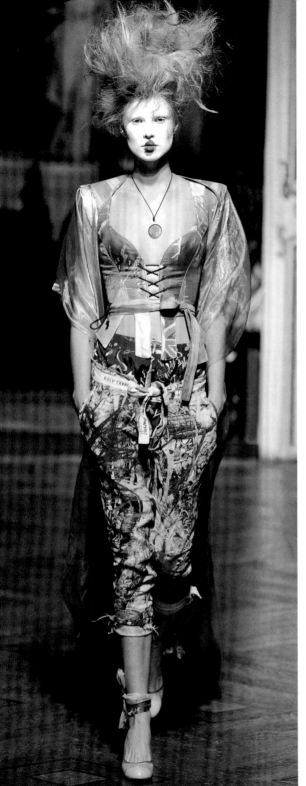

VIVIENNE WESTWOOD

www.viviennewestwood.co.uk

Maverick designer Vivienne Westwood (1941–) was one of the architects of the punk movement in Britain in the 1970s, when social unrest became the creative catalyst for avant-garde fashion. Born in Derbyshire, Westwood worked as a teacher before opening a shop with partner Malcolm McLaren on the King's Road, London, called Let it Rock in 1971. It was renamed Too Fast to Live, Too Young to Die in 1972 and SEX in 1974, finally evolving into Seditionaries in 1976. Westwood launched her first fashion collection, 'Pirate', in 1981, an indication of her preoccupation with historical revivalism and innovative cutting techniques. Following the end of the designer's emotional and creative partnership with McLaren, she moved to Italy. In 1985, the designer launched the 'mini-crini', forerunner of the puffball skirt.

Westwood reworks the silhouettes of the 17th and 18th centuries, referencing the paintings of Jean-Antoine Watteau and François Boucher, and first introduced the corset into outerwear in 1987. Her respectful relationship with the traditions of British craftsmanship has the designer using long-established manufacturing processes and 'indigenous' materials, including Scottish tartans and Yorkshire tweeds to produce garments that combine meticulous construction and finish with radical design. Westwood's empire comprises the demi-couture line Gold Label, the Red Label ready-to-wear line, Vivienne Westwood Man and the diffusion line Anglomania. In 2006, Westwood was made a Dame of the British Empire for her services to fashion.

◄ The 2010 collection
is titled 'Planet Gaia'
after the idea of a self-
regulating planet.

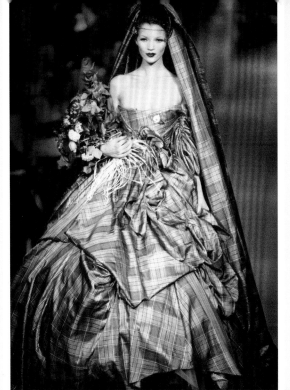

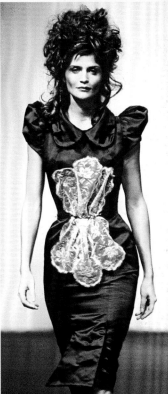

1981 The 'Pirate' collection presaged the New Romantics' 'pirating' of ideas.

Eager to disassociate herself from the 1970s punk movement, initiated by her and McLaren, Westwood produced a synthesis of ideas drawn from such diverse sources as English 17th- and 18th-century tailoring combined with serpentine African-inspired prints. This fusion foreshadowed the plundering of other cultures in future collections, such as Aztec and Mexican motifs for 'Savage' in 1982.

1997 'Vive La Bagatelle' signalled an insouciant and romantic styling.

Emphasizing the hourglass silhouette, Westwood plays the French maid card in a game of flirty female typification for spring/ summer. She goes on to show a demure and simple little black fitted jersey slip dress with a broad tan belt under a coronet-badged cardigan. An event gown in heavy raspberry jersey is wrapped like a sarong to the waist and then lifted and folded in bows to a deep décolleté.

1993 Anglomania refers to the French passion for English tailoring in the 1780s, inspiring the use of bespoke tartan, traditional knitting techniques and heritage fabrics.

A wedding dress has the signature Westwood bustier, a stiffened bodice in the style of the 18th century, above a skirt of tucked and draped swags in printed faux tartan. The designer created her own clan for the collection, represented by the McAndreas tartan in shades of red and turquoise, named after her third husband and creative collaborator Andreas Kronthaler, and made to order by Locharron of Scotland. Variations of the distinctive checked cloth are combined in a single garment; diverse scales and colourways are crafted into tailored jackets and mini kilts. Over-the-knee hose introduce the traditional argyle check. First used on a sweater in the 1920s for the Duke of Windsor, the argyle design comprises elongated diamonds in two-colour intarsia, overlaid by a linear check. Accessories include the notorious platform shoes with ghillie laces threaded through parallel loops.

2002 Vernacular Scottish dress and Tudor-inspired doublet and breeches.

The Highlands revisited – ghillie lacing, argyle socks and a cropped tartan kilt are worn with a Fair Isle twinset. A three-piece suit in a muted tartan, with coordinating shirt and tie, is offset by the iconic plaid bondage trousers of the punk era, worn with a classic moleskin jacket. Skinny knitwear is frayed at the edges or slashed to show the fabric beneath, and partnered with oversized drawstring breeches.

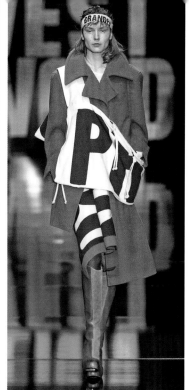

2007 A bricolage collection, titled 'Wake Up, Cave Girl', features the wedding dress worn by Sarah Jessica Parker in *Sex and the City* (2008).

Distressed knits, curtains, blankets and recycled clothing are utilized in a collection that combines prints and textures in a multiplicity of layers. A brocade cape in old gold has a pinch-pleated edge, resonant of old curtains, and is worn with a narrow jacquard jersey patterned skirt, several loosely textured scarves and turn-down boots. Outsize tartans are worked into an off-the-shoulder pinafore dress and high-collared coat. Printed animal skins form a sprawling motif on loose-fitting shifts, and naive cave paintings form a graffiti-like scribble over jersey dresses and a cropped white blouse. A brown tweed suit with a stand-away collar and an exaggerated shoulder line provides an uncluttered silhouette amid the layering of skirts, shirts and chunky cardigans.

2005 Westwood's statement text among layers of draped knits references political issues.

Making a stand for the liberation of Leonard Peltier, an activist believed to have been wrongly imprisoned by the FBI, Westwood unfurls a huge white cotton banner emblazoned with the word 'Propaganda', and winds it around a chocolate-brown tailored coat. Regal evening wear includes the 'propaganda' dress in coffee-coloured satin, draped and spiralled around the body in one unbroken length. The designer's hallmark tartan is worked into one-shouldered pinafore dresses, and 18th-century faux military coats are really *trompe l'oeil* knitwear.

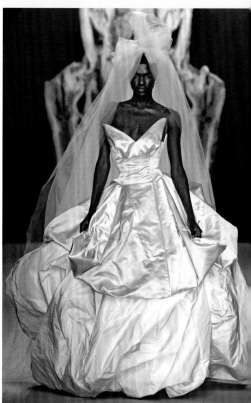

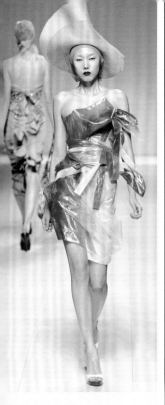

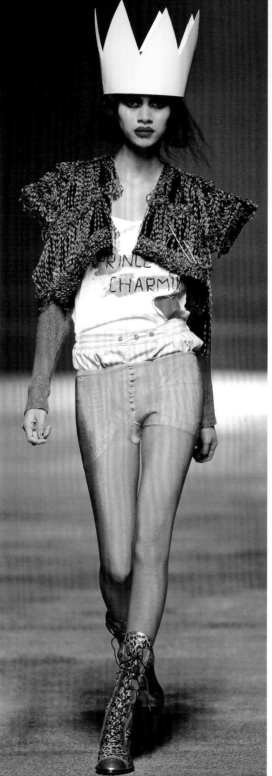

2010
Dishevelled royalty raids the dressing-up box for autumn/winter.

Royal-blue tights are pulled up over stripy boxer shorts with a sloganed T-shirt tucked inside, topped with a distressed cape.

2011
Signature Westwood: innovative cutting, tartan and stripes.

A high-waisted skating skirt tied with a silk-satin bow is partnered with a cream blouse in brocade, featuring asymmetrical frills.

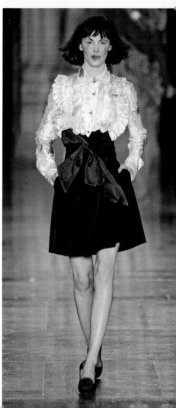

2009
Westwood ingeniously continues her edict to 'do-it-yourself'.

For spring/summer, mundane plastic sheeting is elevated to high fashion with ombré effects of gold on burnt orange and green, bound and knotted into a strapless bustier and wrap skirt. Elsewhere, pastel-striped silk is appliquéd on to organdie in a frenzy of baroque shapes, embellished with a sequinned yoke. Tailored boxer shorts are combined with a silk taffeta bustier with a swag of fabric over one shoulder.

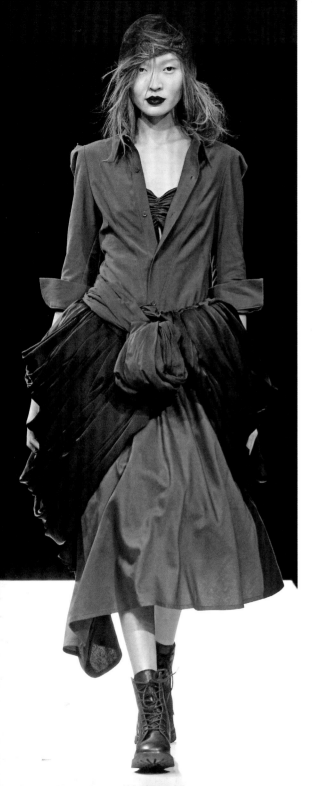

YOHJI YAMAMOTO

www.yohjiyamamoto.co.jp

Japanese designer Yohji Yamamoto (1943–) has created a post-modern eloquence of form, clothing androgynous humanity in Zen-like confections intended as expressions of quality, beauty and asymmetrical balance. In 1971, he established his own line in Tokyo, proceeding to lessen the Western obsession with trends in a philosophy-based move to deactivate the fashionability of fashion. From a first catwalk show of womenswear – the line Y's for Women – in Tokyo in 1977, the brand was extended with a menswear line in 1979 and Y's for Men in 1981, the same year that he showed in Paris for the first time. In the later heat of the DC (Designer Character) brand boom – a phenomenon that introduced more affordable lines by designers such as Yamamoto, Rei Kawakubo of Comme des Garçons (see p.102) and Issey Miyake (see p.158) – Yamamoto became the only Japanese fashion designer to be awarded the French Chevalier de L'Ordre des Arts et des Lettres. Yamamoto also received the International Award from the Council of Fashion Designers of America. These honours recognize the global impact of his ranges, now extending to Yohji Yamamoto, Yohji Yamamoto POUR HOMME, Yohji Yamamoto + NOIR, Y's, Y's for Men, Y-3 and Y's for Living.

The durability of the Yohji Yamamoto label was put to the test when the company filed for bankruptcy in 2009, exactly forty years after Yamamoto graduated from the Bunka Fashion College in Tokyo. The company has now been stabilized with funding from investment group Integral Corporation.

◄ **An exercise in tonality: swagged, sashed and bustled asymmetric skirt and shirt for S/S 11.**

1999 'Wedding Collection' addresses rites of passage and the symbolism of discarded apparel.

In an elegant *coup de théâtre*, Yamamoto explores the drama of the wedding feast. Small miracles of transformation and disrobing lead the story through epiphanies and relationships: the maid, the widow and the father of the bride are each transformed by the allusive exposure of underlayers. A jersey bustier and a satin half-slip are all that remain after flyaway tulle rectangles are abandoned along with detached print panels. Finally, the crinoline underdress disgorges the bridal ensemble from within its hooped skirts.

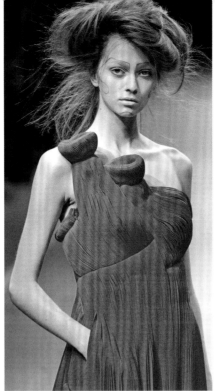

2010 Radically reformed workwear and uniforms in a palette of navy, charcoal and cream.

A strapless flannel dress, with deep box pleats, hangs to the heel behind and to the shin in front. The pool of reference is wide: chefs' jackets, pleated school tunics, dungarees, pilot shirts, sailor tops, fishermen's sweaters, dress shirts and gaberdine mackintoshes. The result of broad strokes of deconstructive creativity, a navy trench coat is sawn rawly in half to make a double-breasted skirt and jacket. Split and spilt seams froth at the shoulder of a two-tone coat dress and a frock coat has a runaway kilted hem.

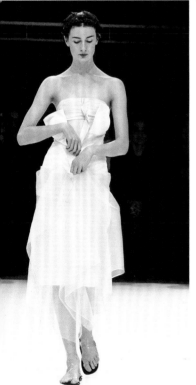

2005 Exposing Edwardian resonances, ranging from long line riding habits to statuesque pleated evening gowns.

From solid sculpted swirls of fabric at the shoulder, fine scarlet pleats are constrained by single threads to form waves of undulating chiffon over the breasts and hips. The palette is rich and largely sombre: Oxford blue, deep orchid brown and cool black form the backdrop for linens in shades of palest green and old lace. A minority of outfits make symmetrical statements to redress the balance of the out of kilter, but immaculately composed, majority, where hems dip and pleats flourish. Ankle-length semi-opaque dresses feature flounces of clustered chiffon on one shoulder or form draped wings at the back of the dress.

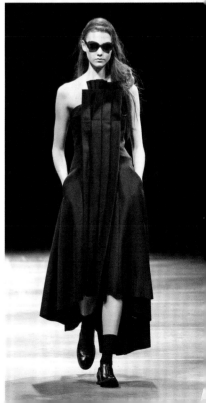

YVES SAINT LAURENT

www.ysl.com

The most significant of post-World War II designers, Yves Saint Laurent (1936–2008) disseminated Paris fashion to a wider audience through the promulgation of ready-to-wear. He had the ability to seize trends and render them iconic. Other designers may have been there first with the tailored trouser suit for women, but it is Saint Laurent who is remembered for the tuxedo suit, 'le smoking', in 1966.

Born in Algeria to French parents, Saint Laurent trained at the Chambre Syndicale de la Haute Couture in Paris before becoming assistant to Christian Dior (see p.92), taking over after Dior's death in 1957. Subsequently drafted into the army, the designer suffered a breakdown and spent time in a military hospital. He was replaced at Dior by Marc Bohan.

The Yves Saint Laurent label was founded with the designer's partner Pierre Bergé in 1962. The first collections were restrained exercises in chic glamour, and it was only with his 1965 collection that Saint Laurent introduced a harder edge and Left Bank bohemianism to haute couture. In 1966, he launched a range of less expensive clothing under the Rive Gauche label. In 1993, the house was sold to Sanofi and the ready-to-wear line was designed by Alber Elbaz (see p.34) from 1998 to 1999. In 1999, when Gucci bought the brand, Tom Ford took over until 2004, when he was replaced by Stefano Pilati, with Saint Laurent continuing the couture collection. On Saint Laurent's retirement in 2002, the couture house closed.

◄ **Labelled 'Utilitarian Chic', a collection by head designer Stefano Pilati for S/S 10.**

The tuxedo became a style staple, giving the authority of high fashion to women wearing trouser suits.

The first le smoking was shown in the haute couture collection of 1966; it was followed later by the ready-to-wear version. Constructed in black wool or velvet, the tuxedo is paired here with a ruffled white shirt, a black bow at the neck and a satin cummerbund. Satin stripes run down the outside of wide-legged trousers – as seen in Helmut Newton's iconic black and white photograph of 1975, *Le Smoking*, featuring an androgynous model. Variations of the tuxedo came to be included in Saint Laurent collections for the next thirty years and 'smoking' has since become a byword for any kind of black tie clothing.

1965

The 'Mondrian' collection appropriated the chromatic geometry of painter Piet Mondrian.

A simply cut jersey shift dress, falling straight from shoulder to knee, is used as a canvas for exhibiting the work of Mondrian, a leading contributor to the De Stijl art movement. The basic form used by the group was the rectangle; the basic colours the primaries: red, blue and yellow. Saint Laurent continued to engage with modern art and contemporary pop culture, with work inspired by the pop art movement that was prevalent in the 1960s and the work of Andy Warhol and Roy Lichtenstein.

1988

An haute couture collection in the YSL signature vivid colour palette for A/W 88/89.

A colour-blocked strong-shouldered jacket in pink, gold and raspberry silk-satin has a faux waistcoat in white, decorated with important gilt buttons. The perky forward-placed hat and the almost military detailing is resonant of a bellboy uniform, particularly with the use of brown for the skirt. Elsewhere, a cornucopia of richly encrusted flowers and fruit cascades over one shoulder of an edge-to-edge jacket in vivid scarlet, and also outlines the deep 'V' of a royal-blue dress, ending in a cluster of grapes and vine leaves on one hip.

1999

An homage to Saint Laurent with pinstriped suits and jewel colours by Alber Elbaz.

A fur shrug lends a luxurious edge to tailored pleat-front trousers with a tucked-in turtleneck sweater. Elsewhere, trousers are side-fastening and wide-legged, a narrow belt looped around the natural waistline. All-over fuchsia pink provides a contrast in a wet-look coat worn with matching tights and shoes. Glossy satin in inky blue, fuchsia, chartreuse or royal blue is shaped into evening dresses: one-shouldered, strapless or sleeved, all with minimal detailing. Lime green is added to the colour palette for outerwear.

2004

An injection of Tom Ford's mix of sensual glamour and hard-edged androgyny.

Nude chiffon falling from a diamond-shaped focal point, resonant of 1930s Hollywood glamour, represents the more feminine aspect of a collection that includes Ford's interpretation of the iconic Saint Laurent trouser suit. This is a louche silk-satin sharp-shouldered jacket, caught at the waist with a twisted half belt, and worn over plunging sheer vests and peg-top trousers, tight at the ankle. Body-sculpted satin skirts worn with triangular barely there tops are harnessed with strings of miniature pompoms.

2002

The 200th and final show by Yves Saint Laurent: a retrospective of the designer's career, featuring iconic pieces.

Inspired by the Ballets Russes costumes of Léon Bakst and using all the skills of the atelier, including embroidery by Lesage, the influential 'Russian' collection first appeared in 1976. Hundreds of past garments, celebrating the designer's creativity and importance in 20th- and 21st-century design, were shown to an audience of 2,000 guests. The collection included the Mondrian dress, le smoking, the 1968 safari-style collection and sheer evening dresses from the same year. The motifs of the 'Cubist' collection of 1988 were revisited with colour-blocked juxtapositions of vivid shades such as purple and orange.

2008 A collection by Pilati features capes and little black dresses.

Stiffened rows of silk ruffles are worked into a beehive-shape caped top, worn over a short buttercup-yellow A-line skirt.

2011 Signature YSL: consummate tailoring by Pilati for spring/summer.

A crisply cut skirt is worn with a squared-off top, softened with a ruffled bow. Chiffon blouses and flounced skirts also feature.

2006 Aviator jackets and double pleat-front trousers by Stefano Pilati.

A 1940s-inspired double-breasted tuxedo jacket – with a narrow, long hip-hugging line and wide satin lapels – is worn with loose trousers or under a shaggy fur-collared ostrich-leather coat. A softer autumn/winter silhouette is provided by the bouclé wool tweed jackets in grey and pale terracotta, worn with cream trousers and pulled together at the waist with an oversized safety pin.

SWATCH DIRECTORY

ALBERTA FERRETTI

› pp. 36–37

The dreamy allure of Alberta Ferretti's label lies in the luxurious embellishment of her romantic draped and pleated dresses, the result of traditional handcrafted practices. These range from crystal encrusted lace, pin-tucking, pleating, beadwork and embroidery with Italian silk Mikado, platinum threads and semi-precious stones.

ALEXANDER McQUEEN

› pp. 38–41

Remarkable for the dramatic visual representations of his concept-led fashion aesthetic, Alexander McQueen brought horror and beauty to the catwalk. Surface embellishment was an integral element in the British designer's vision, whether it was a bird of paradise print or his signature skull motif.

ANNA SUI

› pp. 44–45

American designer
Anna Sui integrates
art deco-inspired motifs
and the use of sugar-
sweet sherbet colours
with the addition of
an edgy post-punk use
of black for definition.
The result is a combination
of boho vintage with
elements of ingénue
rock chick, overlaid
with a kitsch-like
sensibility expressed
in print and texture.

ANTIK BATIK

› pp. 46–47

Antik Batik works
ethically with craft
producers in village
workshops in India,
Bali and Peru, placing
a strong bohemian
inflection on the character
of their products. The
emphasis on recherché
techniques of fabric
decoration is evocative
of the treasure-trove
approach of the hippie
traveller, both in
sensuality and eclecticism.

ASHISH

› pp. 52–53

Born in New Delhi, Ashish
Gupta deploys lavish
embroidery created by
hand-processes in India,
enabling the decoration
to be engineered to the
garment form. The Ashish
label is synonymous with
an extravagant use of
sequinned imagery that
often has a humorous
and surreal incongruity,
juxtaposing elements
from both popular culture
and fashion stereotypes.

BASSO &
BROOKE

› pp. 64–65

Bruno Basso and
Christopher Brooke use
modern printing practices
to convey multi-coloured
kaleidoscopic images
drawn from sources as
disparate as fairy tales
and the visual ephemera
of other cultures. These
are patchworked into
simple, structured
garments that highlight
the print virtuosity
of their collections.

BORA AKSU

› pp. 70–71

Exploiting the languid vocabulary of the corsetière and the neutral tones of the trousseau, Turkish-born Bora Aksu has found a romantic line in sinuous organic graphics, diaphanous layering and retro-brocade references to sustain the feminine ambience of his collections, which gain an edgy modernity from mesh leggings emblazoned with fluid patterning.

CHLOÉ

› pp. 90–91

Chloé captured the mood of flirtatious boho dressing for more than a generation of rock chicks. Under the direction of Karl Lagerfeld, Stella McCartney and Phoebe Philo, the company delivered fluid dresses of boudoir-inspired fabrics and ingenuous prints of fruit and flowers that held to this ambience. Under Hannah MacGibbon, the label offers a more pared-down minimalism.

DIANE VON FURSTENBERG

› pp. 106–107

The iconic jersey wrap dress, first produced by US-based designer Diane von Furstenberg in 1973, has continued to be a fashion staple in the contemporary woman's wardrobe. Constantly updated in various materials and dominated by bold print designs, the label produces a comprehensive high-end ready-to-wear line.

DOLCE & GABBANA

› pp. 110–113

Domenico Dolce and Stefano Gabbana have assimilated the glamour of the Sicilian femme fatale into contemporary fashion. Utilizing underwear as outerwear and combining elements of masculine tailoring and lush floral imagery with their signature use of leopard-skin, the label represents assured red-carpet glamour.

DRIES VAN NOTEN

› pp. 116–117

Dries van Noten's aesthetic is sustained by the use of opulent materials with complex, rich and textured surfaces. These are fashioned into loose, draped, multi-layered and sculptural pieces utilizing printed and embroidered embellishment. He characteristically combines colours, fabrics and forms into an eloquent, painterly composition.

ELEY KISHIMOTO

› pp. 118–119

The Eley Kishimoto label is hard core, print-based fashion, using the power of cleverly constructed repeat print designs to energize complementary garment shapes. The designs are emphatic, using strong colours and motifs to draw the eye around the fabric-clothed figure or accessory. Their hallmark design 'Flash' is as recognizable as any logo.

ERDEM

> pp. 120–121

The Erdem label has a strong reputation for both eloquent floral and complex abstract prints that allow the interplay of seductive colour and engaging form. The lavish print designs are generated and produced digitally, using the technology to enrich the visual material without simply producing an homage to electronic futurism.

ETRO

> pp. 122–123

Etro was strongly identified with rich orientalist textiles long before it became a fashion brand. Originally a luxury fabric supplier to high-end designer labels in Milan, the Etro line carried forward the richly ornamented visual identity it had established within this role into extravagant accessories and later complete catwalk collections.

GILES DEACON

> pp. 130–131

Using print designs that reflect his idiosyncratic and subjective approach to fashion, Giles Deacon selects imagery that projects a quintessentially British sense of humour, including eccentricities such as monkeys, spiders and psychedelic dormice – all mediated through the designer's controlled use of unexpected colour combinations.

HERMÈS

> pp. 146–149

Globally synonymous with the most luxurious accessories, Hermès is among the world's oldest brands. Using materials and expertise of uncompromising fastidiousness, the company creates quality products that merit their heirloom status. From handprinted silk scarves to artisan luggage, the label signifies conspicuous investment.

HOLLY
FULTON

› pp. 150–151

Holly Fulton's interest in
graphic forms and motifs
from the 1930s, 1960s
and 1980s has produced
a fusion of art deco, pop
culture and images of
the Manhattan skyline.
Feeding on eras when
print was dominant in
fashion, Fulton's signature
style has also extended
into bold pieces of
jewelry, some for the
couture house Lanvin.

ISSEY
MIYAKE

› pp. 158–159

Since the Miyake Design
Studio was founded in
the 1970s, the company
has consistently produced
ingenious garments to
exploit the potential of
innovative textiles and
materials. The coherent
interplay of form and
fabric – visible in
landmark ranges such as
Pleats Please! and APOC
– lies at the heart of the
designer's philosophy.

JEAN PAUL GAULTIER

› pp. 164–167

The ironies and subversions of the Jean Paul Gaultier narrative are dependent on exploding the gender stereotypes of cloth and clothing. Consequently the full gamut of the textile lexicon is core to the Gaultier styling – be it the duchesse satin of a Madonna bustier or the designer's signature Breton stripe.

JEREMY SCOTT

› pp. 168–169

Jeremy Scott's collections are animated by polemical graphic prints in vibrant primary colours, ranging from retro-punk to the pop art exaggeration of the late 1960s. Diverse subject matter includes cherubim, fast food, vintage telephones and a playful subversion of the classic French furnishing fabric, wood-block printed toile de jouy.

JOHN GALLIANO

› pp. 172–173

As one of fashion's premier showmen and chief romanticists, John Galliano engages fully with the eloquence of apparel and all its components and esoteric resonances. The designer has the vast appetite of a connoisseur for the entire lexicon of textile formulae, used to elicit maximum impact for his fashion collections.

JOHN ROCHA

› pp. 174–175

Over a long career Rocha has experimented with most fabrics – tweed and tulle, cashmere and crochet, Venetian cloth and velour – but the palette remains neutral. The drama is attained by relationships of texture, transparency and volume – such as laser-cut overlapping leaves and outsize hand-knits with feathers.

JOHN SMEDLEY

› pp. 176–177

The John Smedley brand is indivisible from the fine-gauge knitwear in merino lambswool and sea-island cotton that it produces. Up until the 1990s, fully fashioned production was limited to striping in three colours per garment, unless it was geometrically patterned on a specialized intarsia frame.

JONATHAN SAUNDERS

› pp. 178–179

An understanding of the geometry of scale and proportion in relation to the depth and brilliance of colour gives the work of Jonathan Saunders a cerebral elegance when allied to form-flattering frocks. He manipulates line and graduations in texture to optimum effect, using unexpected florals with areas of solid colour.

JULIEN MACDONALD

› pp. 180–181

Julien MacDonald
expanded his initial
knitting techniques by
opting for the sensual
attractions of glossy
fabrics – satin, lamé, ciré
and sequins – alongside
the fluff of mohair and
the opulence of racoon
and ostrich. Latterly the
designer has appropriated
romantic gossamers of
flimsy boudoir layers of
lace for red carpet chic.

LIBERTY

› pp. 188–189

Liberty initially imported
textiles and *objets d'art*
from Asia and popularized
the creations of 19th-
century designer William
Morris. The retailer
showcased the work of
Lucienne Day in the 1950s,
the art nouveau revival
in the 1960s and 1970s,
and the directional
prints of Liberty's design
director of the same
period, Bernard Nevill.

MATTHEW WILLIAMSON

› pp. 210–211

Since 1997 print has been a key element of every collection by British designer Matthew Williamson. His bold and experimental use of elaborate pattern and intense colour have come to epitomize a romantic bohemian style in which a delicate balance is sustained between the cut of the garment and the print.

MISSONI

› pp. 218–219

At the end of the 1960s, the dynastic Missoni label set the benchmark for branding based around a distinctive textile formula. The unique combination of kaleidoscopic colour and aggressive pattern – expressed principally in warp knits and attained by technical virtuosity in coloration and textile structuring – became inseparably associated with the label.

MOSCHINO

› pp. 222–225

With wit, exuberance
and visual puns, the
high-end Italian label
Moschino subverts the
concept of mainstream
fashion, often utilizing
text to this end. The
Moschino brand is
committed to the use of
bold, vibrant pattern and
colour-blocked primaries,
overblown florals and
rhinestone embellishment
– with coin-sized polka
dots as a favourite.

ORLA KIELY

› pp. 234–235

The simple, stylized leaf
and stem logo of Orla
Kiely is representative
of the Irish designer's
graphic acumen and
approach to colour.
Pattern is predominant
in her fashion collections,
accessories and homeware
lines. The use of flat,
bright colour, particularly
orange and green,
and retro styling
evidences a mid-20th-
century sensibility.

PAUL & JOE

› pp. 238–239

Sophie Albou's signature range Paul & Joe and diffusion line Paul & Joe Sister often comprise simple tailored pieces of draped and pleated daywear dresses and casually styled trousers. The Parisian collections feature retro-inspired prints such as faded paisleys and chintz, subtle art deco, text, geometric motifs and whimsical animal prints.

PAUL SMITH

› pp. 240–241

Stripes are one of the most satisfying and versatile print motifs, where variation is reliant on proportion and colour. The signature polychromatic stripes of Paul Smith are instantly identifiable, whether in flat, graphic straight lines or incorporated into a digitally enhanced floral design. 'Conversational' prints also feature, such as landscapes and flags.

PETER PILOTTO

› pp. 242–243

Designers Peter Pilotto and Christopher de Vos use abstract textural prints and textured structures with overprints to section the body's silhouette into zones of asymmetrical drapery, interplayed with solid shade materials. Colours are applied in large-scale suffused zones to reinforce the flowing manipulated forms of the garments.

PUCCI

› pp. 260–261

Emilio Pucci was one of the most significant print designers of the 20th century. In the 1960s, his flamboyant clothes were synonymous with the jet age – an enduring status symbol, worn by style setters and celebrated beauties. His abstract prints and psychedelic swirls of dazzling colour combinations earned him the title of 'Prince of Prints'.

ROBERTO CAVALLI

› pp. 272–273

The leitmotif of the Cavalli look has been the replication of fauna – and occasionally flora – on cloth. Animal and reptile skins have been printed, brocaded and knitted; leathers and suedes have been lashed together; and patchworks appliquéd, serrated and layered with the primitavist regalia of decadent dressing.

SONIA RYKIEL

› pp. 280–281

The 'Queen of Knits', Rykiel transformed the pullover into a signature piece as well as inventing inside-out stitching and 'hemless' and 'no-lining' dressing that reflected her new fashion philosophy 'la démode'. The brand quickly became an ambassador of a very Parisian style, with black, stripes, lace, strass, and quirky icons and messages emblazoned on sweaters.

SOPHIA KOKOSALAKI

› pp. 282–283

The decorative elements intrinsic to Kokosalaki's work lies in her Eastern Mediterranean culture, primarily that of Greece, but also embracing Cretan and Egyptian motifs. Whirls of tucked and pleated chiffon, ribbed knits and beaded and embellished surfaces are worked into vernacular subject matter such as the Greek lyre and shell-forms.

TEMPERLEY LONDON

› pp. 286–287

Promulgating the 'London look', archetypal British designer Alice Temperley represents a quirky boho, couture-led approach in terms of production, with in-house workshop beading, print design and embroidery. Pattern is integrated with bold, graphic, intarsia knits and fabrics featuring splashy floral prints and stylized animal prints.

TORY BURCH

› pp. 292–293

Accessible luxury label Tory Burch offers a contemporary urban, New York style of relaxed separates leavened by a more casual approach. This is implied by the intermittent use of strong colour, graphic print and the deployment of variations of the 'T' motif as print, buttons and the T-logo plaque on ballerina pumps.

VIVIENNE WESTWOOD

› pp. 314–317

Taking inspiration from other cultures, ranging from African prints to French rococo art, Vivienne Westwood integrates surface pattern and texture into her references to 17th- and 18th-century dress. This bricolage of ideas supplies a subtext to the collections of her innovatively constructed clothes.

GLOSSARY

Atelier: A workshop of highly skilled craftspeople attached to a couture house.

Appliqué: Fabric pieces cut out and sewn to a base cloth for decoration.

Arm scye: The fabric edge of the bodice to which the sleeve is sewn.

Barathea: A soft fabric with a hopsack twill weave giving a lightly ribbed surface.

Bertha collar: A wide, flat, round collar, similar to a short cape, worn with a low neckline during the 19th century.

Bespoke: Made to order.

Bias: A line that crosses a woven fabric at 45 degrees from edge to edge.

Brocade: A woven fabric with decorative, non-reversible surface originally produced in silk. The word 'brocade' is now used to describe any jacquard woven design.

Chemise: Historically, a woman's undergarment, but also used to describe a loose columnar dress.

Chemisette: A piece of fabric, usually lace, inserted into the neckline of a low-cut dress for modesty during the Victorian period.

Cheongsam: A form-fitting dress originating in China, made fashionable in the 1920s.

Chiffon: A transparent fabric woven from silk, rayon, cotton or a synthetic fibre such as nylon.

Chiton: An open-sided tunic constructed of two large rectangles.

Choli: A short-sleeved blouse often worn beneath a sari.

Ciré: A lustrous high-gloss finish that is created by passing the fabric through heavy rollers.

Cloqué: A cotton, silk or rayon fabric with a raised woven pattern and a blistered or quilted look.

Conversational prints: Those that portray recognizable images such as landscapes.

Crepe: A woven fabric with a highly twisted yarn that produces a pebble effect, capable of drape.

Crinoline: A stiff underskirt designed to support a full, circular skirt

Crushed velvet: A fabric that is run between rollers, sending the pile in various directions to give an irregular waved effect. It is made from silk, cotton or synthetic yarn that can also be imitated on a knitting machine.

Damask: Originally a silk fabric that was made in Damascus. Densely woven in cotton, linen or synthetic yarn, the floral pattern is defined by a smooth and lustrous surface, created with a sateen weave.

Dart: A method of suppressing excess fabric to fit the body.

Décolleté: A neckline that exposes the neck and shoulders.

Devoré: A velvet-like fabric with a raised pattern created by disintegrating some of the pile with chemicals.

Dirndl: Originally a type of traditional dress worn in southern Germany, the skirt became fashionable during the 1940s, identified by a horizontal hip seam and two vertical pockets.

Djellaba: A robe with a hood and wide sleeves, worn in the Maghreb region of North Africa.

Dolman: A sleeve that is wide at the armhole and tapers to a tight wrist, often seamlessly incorporated into the bodice of a garment.

Duchesse satin: A closely woven lightweight, glossy satin with a smooth, lustrous surface.

Dupion: A crisp fabric woven with irregular slubs in the yarn, creating a textured surface.

Faille: A fine, vertically ribbed silk fabric.

Fichu: A triangular scarf draped over the shoulders to fill a low neckline.

Furbelow: A pleated or gathered ruffle or flounce.

Gaberdine: A durable fabric for outerwear created by Thomas Burberry during the latter part of the 19th century.

Gazar: A loosely woven silk with a crisp finish.

Georgette: A very sheer, lightweight fabric, woven from silk, cotton or a synthetic yarn.

Ghillies: A low-cut, tongueless shoe with loops instead of eyelets for the laces, which cross the instep and are sometimes tied around the ankle.

Gigot: An exaggerated sleeve head, fashionable in the 1830s and 1890s. Also called a 'leg o' mutton sleeve'.

Godet: A tapering panel of cloth inserted into a straight seam to add volume.

Himation: A wide rectangular wool or linen mantle worn in Ancient Greece.

Huaraches: A type of Mexican sandal in woven leather. Originally a peasant shoe that became a fashion item in the 1930s.

Jabot: An ornamental cascade of ruffles at the throat of a shirt, originally to hide the opening.

Jacquard: A fabric woven on a particular loom, producing a sophisticated and intricate design.

Jersey: A soft stretchy fabric knitted on a circular machine.

Kurta: A loose-fitting, knee-length shirt traditionally worn in Asia.

Lamé: A fabric woven with metallic threads that catch the light to give an impression of liquid silver and gold.

Linen: A crisp, cool, lightweight fabric, woven from fibres of the flax plant, that holds its shape but creases easily unless dressed with starch. It may be mixed with synthetic yarns to make it more manageable.

Maillot: A one-piece swimsuit with a tank-style top, originally made in jersey with straight-cut legs.

Millefeuille: A French term for one thousand leaves of paper.

Moiré: A ribbed woven silk finished by being run through rollers. This crushes the rib in different directions, giving it a 'watermark' effect.

Net: A sheer fabric with a mesh-like structure creating very fine hexagonal holes. Otherwise known as maline, tulle and illusion.

Ombre: A French term meaning shaded or a gradual deepening of tone, or colours that bleed together.

Organdy: A light, fine, white cotton fabric with a stiff, translucent finish, often used for details, such as cuffs and collars.

Organza: Heavier and stiffer than organdy, a transparent fabric that holds its form well when making dramatic shapes.

Paillette: An oversized metal or plastic sequin.

Palazzo pants: Wide-legged trousers that fall straight from the outside of the hip.

Pannier: An oblong cage made of metal, cane or wood to support the sides of a skirt, resulting in a silhouette that extends at the side but not at the front or back.

Paper taffeta: A very crisp silk taffeta that folds and creases like paper.

Pareo: French Polynesian in origin, this wraparound is also known as a sarong (India), lava lava (Samoa), kikepa (Hawaii) and sulu (Fiji).

Passementerie: Fringing, tassels and braids, made by hand or on a narrow fabric machine, generally used for furnishing trimmings.

Peau de soie: A fine, soft, high-quality silk with a low lustre effect.

Peplum: A flared piece of fabric attached to the waistline of a jacket or dress.

Piqué: A tightly woven cotton fabric with a fine, subtle, horizontal stripe in the weave structure, often used for cuffs and collars.

Placket: A reinforced opening in the upper part of trousers or a skirt, or at the neck or sleeve of a garment.

Plumassiers: Craftworkers who prepare feathers for fashion and interior designers.

Polonaise: Dating from the late 18th century and originally known as a *robe à la polonaise*, the gown has a fitted bodice and cutaway draped overskirt inspired by Polish national costume. Also known as a 'milkmaid's dress'.

Princess-seam dress: A dress with vertical seams from shoulder to hem, unbroken by a waist seam

Raglan: A sleeve that extends in one piece to the collar, creating a diagonal seam from the underarm to the neckline.

Rouleau: A narrow strip of fabric cut on the bias to form a rolled loop, often used to secure a button.

Sarouel: Trousers with a low crotch that either taper to, or are gathered at, the ankle.

Satin: A densely woven silk fabric with a smooth surface that reflects the light.

Serape: Originally a brightly coloured Mexican riding blanket.

Shantung: A crisp fabric with a slubbed irregular surface woven from Tussah silk.

Shirr: Fabric gathered into tight parallel rows secured with a running thread.

Spencer: A woollen outer coat with the tails removed dating from the 1790s, named after George Spencer, the 2nd Earl of Spencer (1758–1834); later adopted as women's dress.

Strass: Rhinestone invented by Georg Friedrich Strass (1701–73).

Taffeta: A plain, smooth, closely woven silk fabric that holds its shape.

Toile: The first stage of a couture garment, used to create the pattern and test the fit.

Tulle: A sheer fabric with a mesh-like structure creating very fine hexagonal holes. Can be produced in silk, nylon or rayon. Also known as net, illusion or maline.

Tussah silk: A plain weave fabric from 'wild' silk worms with irregular thick and thin yarns that create an uneven surface and colour.

Velvet: A thick fabric with a short cut pile that creates a warm, plush finish, soft to the touch. A silk velvet is expensive, but it is also produced in cotton, rayon or with synthetic fibres.

FURTHER READING

Beaton, Cecil
The Glass of Fashion: A Personal History of Fifty Years of Changing Tastes and the People Who Have Inspired Them
Weidenfeld & Nicolson, 1954

Bell, Quentin
On Human Finery
Hogarth Press, 1947

Bender, Marilyn
The Beautiful People: The Marriage of Fashion and Society in the 60s
Coward-McCann, 1967

Blum, Dilys E.
Shocking! The Art and Fashion of Elsa Schiaparelli
Yale University Press, 2003

Bolton, Andrew
Wild: Fashion Untamed
Yale University Press, 2004

Bolton, Andrew
Alexander McQueen: Savage Beauty
Yale University Press, 2011

Breward, Christopher
Fashion
Oxford University Press, 2003

Bryan, Robert E.
American Fashion Menswear
Assouline, 2009

Buruma, Anna
Liberty and Co. in the Fifties and Sixties
ACC Editions, 2008

Charles-Roux, Edmonde
Chanel and Her World
Weidenfeld & Nicolson, 1981

Chenoune, Farid
A History of Men's Fashion
Flammarion, 1993

Chenoune, Farid
Yves Saint Laurent
Editions de la Martinière, 2010

Coleridge, Nicholas
The Fashion Conspiracy: A Remarkable

Journey Through the Empires of Fashion
Heinemann, 1988

Chase, Edna Woolman & Chase, Ilka
Always in Vogue
Victor Gollancz Ltd, 1954

Craik, Jennifer
The Face of Fashion: Cultural Studies in Fashion
Routledge, 1994

Dior by Dior
Weidenfeld & Nicolson, 1957

Evans, Caroline
Fashion at the Edge
Yale University Press, 2003

Fogg, Marnie
Boutique: A 1960s Cultural Phenomenon
Mitchell Beazley, 2003

Fukai, Akiko
Future Beauty: 30 Years of Japanese Fashion
Merrell, 2010

Gerschel, Stephane
Louis Vuitton: Icons
Assouline, 2006

Grosicki, Z.J.
Watson's Advanced Textile Design
Longmans, Green & Co, 1913

Hulanicki, Barbara
From A to Biba
Hutchinson, 1983

Jackson, Lesley
Twentieth-Century Pattern Design: Textile & Wallpaper Pioneers
Mitchell Beazley, 2002

Jenkyn-Jones, Sue
Fashion Design
Laurence King, 2002

Johnson, Anna
The Power of the Purse
Workman Publishing, 2002

Laver, James
Costume and Fashion: A Concise History

(World of Art)
Thames & Hudson, 1969

Lee-Potter, Charlie
Sportswear in Vogue Since 1910
Condé Nast Publications, 1984

Mears, Patricia
American Beauty
Yale University Press, 2009

Merceron, Dean & Elbaz, Alber
Lanvin
Rizzoli International Publications, 2007

Milbank, Caroline Rennolds
New York Fashion: The Evolution of American Style
Harry N. Abrams, 1989

Morais, Rishard
Pierre Cardin: The Man Who Became a Label
Bantam Press, 1991

Quant, Mary
Quant by Quant
Cassell & Co, 1966

Steele, Valerie
Fifty Years of Fashion: New Look to Now
Yale University Press, 1997

Tungate, Mark
Fashion Brands: Branding Style from Armani to Zara
Kogan Page, 2005

Vercelloni, Isa Tutino
Missonologia: The World of Missoni
Electa, 1994

Walker, Myra
Balenciaga and His Legacy
Yale University Press, 2006

Wilcox, Claire
The Art and Craft of Gianni Versace
V & A Publications, 2002

Wilson, Elizabeth
Adorned in Dreams: Fashion and Modernity
Virago Press, 1985

INDEX